VERTIGO

A CENTURY OF MULTIMEDIA ART, FROM FUTURISM TO THE WEB

Edited by
Germano Celant
with
Gianfranco Maraniello

VERTIGO

A CENTURY OF MULTIMEDIA ART, FROM FUTURISM TO THE WEB

SKIRA | MAMbo
Museo d'Arte Moderna di Bologna

MAMbo
Museo d'Arte Moderna di Bologna

VERTIGO
A CENTURY OF MULTIMEDIA ART, FROM FUTURISM TO THE WEB

VERTIGO
A Century of Multimedia Art, from Futurism to the Web

MAMbo Museo d'Arte Moderna di Bologna
Bologna, 6 May – 4 November 2007

Exhibition curated by
Germano Celant
with
Gianfranco Maraniello

Research
Francesca Cattoi, Eva Fuchs

Installation Design
Studio Santachiara, Milano

Coordination
Uliana Zanetti

Organisation
Eva Fuchs, Carlotta Guerra,
Alessia Masi, Sabrina Samorì,
Lorenza Selleri, Nicoletta Ferriani

Administration
Annalisa Fontana
Fabio Stefano Gallon
Gabriella Iachini, Oriano Ricci
Annamaria Franci

Communications Office
Giulia Pezzoli, Daniele De Florio

Public Relations
Patrizia Minghetti

Educational Department
Cristina Francucci, Ines Bertolini,
Veronica Ceruti, Silvia Spadoni
in collaboration with
Anna Caratini,
Manuela Comoglio,
Paolo Maria Costantini,
Ilaria Del Gaudio, Serena Della
Porta, Francesca Guggi,
Alice Maxia, Giulia Zucchini

Press Office
Gabriella Castelli, Camilla
Consorti, Francesca Rossini –
Laboratorio delle Idee, Bologna

Graphic Design
Maurizio Navone, Ida Lorenzon,
Paolo Pileggi, Linda Tarantola –
Studio Navone Associati, Milano

Installation
Modular S.r.l., Osteria Grande
(Bologna)
Anna Rossi (coordination)
Claudio Musso
Arterìa

Condition Reports
Mariella Gnani

Video Scrubbing
Fabiola Naldi

Video Editing
Cms Video S.r.l., Bologna

Sound Editing
Piergiorgio Martinetti

Audio and Video
Immagini e Suoni S.n.c., Zola
Predosa (Bologna)

Insurance
Epoca Insurance Broker S.r.l.,
Bologna
Aon Artscope, Amsterdam
Aon Belgium n.v., Antwerpen/
Bruxelles
Augusta Assicurazioni S.p.a.,
Torino
Axa Art, Milano
GPA Assiparos, Torino
Huntington Block, New York
Kuhn & Bulow
Versicherungsmakler GmbH,
Berlin/Zürich
Progress Insurance Broker, Roma
STAI/Banco Vitalicio, Madrid

Shipping
Arterìa

Audio Guide
Tonwelt, Berlin

*Additional thanks to the following
for their fundamental
contributions*
Ministero per i Beni Culturali,
Rome
DARC – Direzione Generale per
l'Arte e l'Architettura
Contemporanee, Rome
Soprintendenza per il Patrimonio
Storico, Artistico e
Demoetnoantropologico, Bologna
Circoscrizione Doganale di
Bologna

Catalogue edited by
Germano Celant
with
Gianfranco Maraniello

Research
Francesca Cattoi
Eva Fuchs
with
Alessandro Castellano

Coordination
Alessia Masi
Francesca Cattoi

In collaboration with
Silvia Benvenuti
Marta Borsi
Marcella Ferrari
Carlotta Guerra
Angela Pelliccioni
Sabrina Samorì
Lorenza Selleri

Texts by
Giovanni Maria Accame
Carlo Antonelli
Francesco Bernardelli
Alberto Boatto
Andrea Branzi
Germano Celant
Ester Coen
Elio Grazioli
Giovanni Lista
Gianfranco Maraniello
Claudio Marra
Carlo Montanaro
Peppino Ortoleva
Marco Senaldi
Antonio Somaini
Ugo Volli

Acknowledgements

*Special thanks to the following
for their contribution to the
catalogue*
Bruno Bani, Fabrizio Begossi,
Angelo Cereda, Paolo Galli,
Emily Ligniti, Francesco Mion,
Sara Salvi, Digital Project

*Additional thanks to the following
for their indispensable assistance*
Gianluca Farinelli, Luisa Ceretto,
Andrea Meneghelli, Andrea Morini,
Davide Pozzi, Elena Tammaccaro,
Giandomenico Zeppa – Cineteca
Comunale di Bologna
Stefano Passigli, Patrizia Cacciani,
Gaia Englaro – Istituto Luce, Rome
Fondazione Cineteca Italiana,
Milan

*Special thanks to the lenders of the
exhibition*
ASAC – Archivio Storico delle Arti
Contemporanee, Porto Marghera
(Venice)
CAMeC, Centro per l'Arte
Moderna e Contemporanea,
La Spezia
Centro per l'Arte Contemporanea
Luigi Pecci, Prato
Germanisches Nationalmuseum,
Nuremberg
GNAM, Galleria Nazionale d'Arte
Moderna, Rome
Greek State Museum of
Contemporary Art, Salonicco
IVAM, Institut Valencià d'Art
Modern, Generalitat, Valencia
Kunsthaus Zürich, Zurich
Kunstmuseum Winterthur,
Winterthur
MART, Museo d'Arte Moderna e
Contemporanea, Trento and
Rovereto
Musée d'Art Moderne de Saint-
Etienne Métropole
Museo della Comunicazione Mille
voci…mille suoni, Bologna
Musée Départemental d'Art
Contemporain, Rochechouart
Museo di Storia della Fotografia
Fratelli Alinari, Florence
Museo Nazionale del Cinema,
Turin
Pinacoteca Casa Rusca, Locarno
Städtisches Museum,

Gelsenkirchen
Sprengel Museum, Hannover
State Museum of Contemporary
Art – The G. Costakis Collection,
Athens
Theaterwissenschaftliche
Sammlung, Cologne
Andy Warhol Museum, Pittsburgh
Archivio Block, Berlin/Kassel
Archivio Yves Klein, Paris
Archivio Opera Piero Manzoni,
Milan
Archivio Veronesi, Milan
Biblioteca Comunale, Treviso
Biblioteca Nazionale Centrale,
Florence
Università IUAV, Dipartimento di
Urbanistica, Venice
Fondazione Lucio Fontana, Milan
Fondazione Marconi, Milan
Fondazione Merz, Turin
Fondazione Mudima, Milan
Fondazione Mimmo Rotella, Milan
Fondazione Sandretto Re
Rebaudengo, Turin
Kurt und Ernst Schwitters Stiftung,
Hannover
Caldic Collectie, Rotterdam
The Dakis Joannou Collection,
Athens
Marzona Collection, Berlin /
Vienna / Villa di Verzegnis
Oldenburg van Bruggen Studio,
New York
The Gilbert and Lila Silverman
Fluxus Collection, Detroit
Galleria Alfonso Artiaco, Naples
Galeria Manuel Barbie, Barcelona
Galerie Berinson GmbH, Berlin
Galleria Cardi, Milan
Galleria Massimo De Carlo, Milan
Cheim & Read, New York
James Cohan Gallery, New York
Paula Cooper Gallery, New York
Galerie Johannes Faber, Vienna
Pace McGill Gallery, New York
Marian Goodman Gallery, New
York/Paris
Howard Greenberg Gallery, New
York
Galerie Kicken, Berlin
Galleria Giò Marconi, Milan
Galleria Martini & Ronchetti,
Genoa
Galleria Mazzoli, Modena
Galerie Neu, Berlin
Galleria Franco Noero, Turin

PaceWildenstein, New York
Galleria Lia Rumma, Milan /
Naples
Sonnabend Gallery, New York
Galleria Tornabuoni, Florence
Donald Young Gallery, Chicago
Shangart Gallery, Shanghai
Sperone Westwater, New York
Studio Trisorio, Naples
Valente Artecontemporanea,
Finale Ligure (Savona)
Galerie Ronny van de Velde,
Antwerp
White Cube, London
Edition & Gallery Hundertmark,
Las Palmas de Gran Canaria
Electronic Arts Intermix, New York
Hans Richter Estate, Icking –
Irschenhausen
Lothar Wolleh Estate, Berlin
Giovanni Aldobrandini, Rome
Antonella Vigliani Bragaglia, Rome
Udo Breger, Basel
Simone Leiser, Antwerp
Hattula Moholy-Nagy, Ann Arbor
Giancarlo and Danna Olgiati,
Lugano
Carlo Palli, Prato
Annemarie Sauzeau, Rome
Gino Viliani, Casale Monferrato
*Thanks also to the exhibition lenders
who wished to remain anonymous,
and all the artists.*

*Thanks to the following individuals,
without whose generous assistance
the exhibition could not have
been realised*
Matteo Agrati, Massimo Alberghini,
Andrea Albertini, Anthony Allen,
Carlotta Arlango, Alfonso and
Cristina Artiaco, Joke Ballintijn,
Alberto Barbera, Manuel Barbie,
Roberta Basano, Marco Bazzini,
Valdemaro Beccaglia, Christoph
Becker, Gabriella Belli, Pierangelo
Bellettini, Catherine Belloy, Fabrizia
Benedetti, Anna Benedusi, Hendrik
A. Berinson, Franco Bernabè,
Laura Bernardini, Luisa Bernareggi,
Claudio Bertani, Christophe
Bichon, Biblioteca Centrale di
Architettura – Politecnico of Milan,
Sofia Bocca, Agata Boetti, René
Block, Daniela Bonn, Gabriele
Bonvini, Maurizio Boriani,
Benedetta Bovoli, Udo Breger,

Simona Brighetti, Cécile Brunner, Elmar Buck, Greg Burchard, Craig Burnett, Giorgio Busetto, Donata Pesenti Campagnoni, Mariacristina Cappellazzo, Agostino Cappelli, Riccardo Carazzetti, Consuelo Fiscar Casaban, Laura Casagrande, Ursula and Roberto Casamonti, Clinio Trini Castelli, Ilaria Cesari, Simona Cevenini, Paula Cooper, Anna Costantini, Massimo De Carlo, Renato Cardi, Laura Chiari, Lucia Chimirri, Maria Vittoria Marini Clarelli, Alexander Clarke, James and Jane Cohan, Carol Cohen, Kristen McCormick, Bruno Corà, Luca Corbetta, Giulio Contrucci, Marcello Contrucci, Barbara Crespigni, Francesca Dall'Armi, Gianfranco and Monica D'Amato, Anaïs de Balincourt, Daniele Del Pozzo, Iveta Derkysova, Giusi Di Giunta, Simona Di Sciullo, Dirk Dobke, Daniela Dresti, Susan Dunne, Johannes Faber, Marzia Faietti, Roberto Fattori, Paoline Faure, Ken Fernandez, Antonia Ida Fontana, Nadia Forloni, Olga Fota, Galerie Schmela, Galleria Fonte D'Abisso Arte, Marian Goodman, Karoten Greve, Melania Gazzotti, Bianca Girardi, Giovanna Giusti, Giuliana Giustino, Evelyne Granger, Ulrike Graul, Howard Greenberg, Judith Greve, G. Ulrich Grossman, Gerardo Guccini, Margherita Gusella, Sophie Haaser, Lóránd Hegyi, Reinhard Hellrung, Jon Hendricks, Marion von Hofacker, Ellen J. Holdorf, Antonio Homem, Webke Hooites, Michaela Hutner, Geralyn Huxley, Uchenna Itam, Jay Jopling, Xenia Kalpaktsoglou, Kurt Kladler, Monika Klocker, Heather Kowalski, Ulrich Krempel, Nini Ardemagni Laurini, Roberta Lazzari, Antoine Levi, Light Cone, Emilio Lippi, Anja Löchner, Marieke van Loenhout, Brian Loftus, Dominique Lora, Rose Lord, Sue MacDiarmid, Monica Maffioli, Tiziana Malaguti, Michele Mangione, Carla Mantovani, Annalisa Mariani, Karen Marks, Caspar Martens, Giovanni Battista Martini, Olga Martynova, Egidio Marzona, Piero Mascitti, Luisella Mauceli, Emilio Mazzoli, Lissa McClure, Ingrid Mecklenburg, Mediaset, Francesca Mei, Enzo Mengoli, Luisa Mensi, Beatrice Merz, Susanne Meyer - Büser, Philippe-Alain Michaud, Olivier Michelon, Enzo Minarelli, Monica Minghetti, Daniel Moquay, Lucia Monaci Moran, Yolanda Montañés, Roberto Morgantini, Cristina Mulinas, Brigitte Nandingna, Franco Noero, Lorcan O'Neill, Tullia Ontani, Karin Orchard, Emmanuelle Ollier, Beatriz Palacios, Lauren Panzo, Irene Papanestor, Rosalia Pasqualino di Marineo, Matteo Pavesi, Giovanni Pelagalli, Giuseppe Pero, Annalisa Perrone, Carlotta Pesce, Silvia Pesci, Ursula Peters, Stefano Pezzato, Elena Pirazzoli, Tania Pistone, Natasha Polymeropoulos, Centre Pompidou, Monica Proni, Sara G. Rafferty, Christopher Rawson, Simone Repetto, Eva Riehl, Gaetana Rogato, Annamaria Rossato, Lia Rumma, Milena Sacchi, Ludmilla Sala, Gianni Salvaterra, Elisabetta Salzotti, Patrizia Sandretto Re Rebaudengo, Davide Sandrini, Denis Santachiara, Annemarie Sauzeau, Gianni and Mariapia Scagliarini, Leane Schäfer, Tomaso Schiaffino, Ina Schmidt-Runke, Isabel Schulz, Dieter Schwarz, Berta Serrano, Christopher Sharits, Harry Shunk, Philippe Siauve, Chiara Spangaro, Gian Enzo Sperone, Nico Staiti, Cecile Starr, Viviana Succi, Elena Tavecchia, Maddalena Tibertelli, Barbara Tomassi, Lucia Trisorio, Maria Tsantsanglou, Tiffany Stover Tummala, Christine Uecker, Alice Urban, Mario Valente, Miriam Varadinis, Francesca Velardita, Ronny van de Velde, Marco Vianello, Alexis Vidakis, Christoph Vitali, Samuel Vitali, Scott Cameron Weaver, Kara Vander Weg, Wendy Williams, Charles Wilp, Oliver Wolleh, Queenie Wong, Valentina Zanchin, Ilzite Zeltina, Carlo Zucchini.

With the support of

Final thanks are due to the individuals who made a fundamental contribution to the museum and its inaugural events
Dede Auregli, Claudio Babini, Elisa Baldini, Luciano Begani, Alessandro Bergonzoni, Daniela Bertinelli, Vittorio Boarini, Alessandro Borghi, Piero Bottino, Paola Bottoni, Raffaela Bruni, Giacomo Capuzzimati, Lorenza Cariello, Alessandra Carretti, Federico Castellucci, Daniele Cinti, Gianfranco Coliva, Stefano Corbelli, Loreno Cremonini, Anna Depietri, Simona Di Giovannantonio, Mauro Felicori, Guido Gaddi, Gianfranco Giacomelli, Carlo Grazzini, Daniele Laffi, Massimo Lanzarini, Patrizia Lucchetti, Vincenzo Lucci, Christian Macchiavelli, Andrea Mari, Daniele Martelli, Gaetano Miti, Carlo Monaco, Rino Orsoni, Roberto Pirazzi, Andrea Pizzi, Claudio Poppi, Massimo Romeno, Marco Santarelli, Roberto Scannavini, Sonia Sorbi, Stefania Storti, Angela Tassinari, Fabio Tassoni, Renza Zanacchini, Luca Zarri.

Apologies to anyone whose name may have inadvertently escaped this list.

In any community's history, symbols have an incredible power; this is one of the reasons I am particularly proud to take part in the opening of the new branch of the Museo d'Arte Moderna di Bologna at the former City Bakery, one of the city's most significant buildings over the past century, which has now become a home for the culture of the future.

What has long been an extraordinary, innovative page in the civic history of Bologna is now becoming one of the main cultural points of reference in our city. The affiliation with DAMS (Discipline delle Arti, della Musica e dello Spettacolo, the University programme for fine arts, music and theatre), the Cineteca (Film Archives) and the city's number-one cultural centre, the Manifattura delle Arti (Arts Factory), provides Bologna's youth, and countless others, an extraordinary tool for uniting their studies and passions – a once-in-a-lifetime opportunity not to be missed.

The beauty and sheer functionality of the new Museo d'Arte Moderna di Bologna make their debut with an exhibition I consider highly significant. Vertigo: A Century of Multimedia Art, from Futurism to the Web, allows visitors to retrace the most important steps of the fertile contamination and intermingling between cultural, musical, media-based and artistic languages – which only seem different from one another, yet are in reality all intent on documenting the changing perceptions of reality brought about by the advances in new technology. Innovation – a particularly strong characteristic of our region's administrative and cultural history – is the protagonist of this voyage through the twentieth century, and there is no place better suited than MAMbo to host its extraordinary fruits.

On behalf of the city, I would like to extend a warm welcome to all visitors. I am sure this exhibition and its special location will leave you with many splendid memories.

Sergio Cofferati
Mayor of Bologna

The opening of MAMbo represents much more than just the move of the Galleria d'Arte Moderna from its old spaces (on the Piazza della Costituzione) to a more central and spacious home; this transfer is also a transformation or, if you will, an enrichment upon the city's modern art gallery and its characteristics as they have existed up until now. Indeed, its arrival at its new home in the former Manifattura Tabacchi (the tobacco factory renovated as an 'arts factory') strengthens its role as a museum while maintaining its role as an accessible exhibition space as established by its predecessor, the Galleria d'Arte Moderna. It is therefore enriched with a dimension vital to any modern art gallery, in light of the fact that preserving and representing the past is the best way to move into and welcome the future. With this added dimension, the Galleria d'Arte Moderna di Bologna joins the ranks of major public museum institutions throughout Italy – in particular those of Rome and Turin – which, in addition to their interest in the present, have always taken good care and devoted attention to the developments of figurative art over the past 150 years, at least. Naturally, to help give strength and consistency to this new dimension – which here in Bologna will essentially be launched with the opening of the museum's new location – the Director is prepared to dedicate his greatest efforts, ideally backed with the necessary economic resources. But if preserving the past is one of MAMbo's distinctive objectives, it is first and foremost characterised by a new mission – that of creating the spaces and conditions capable of stimulating artistic practice toward new forms of development and stylistic characterisations. A devoted interest in contemporary work and culture is the real, most profound programme the Board of Directors and Director have set for the new museum, knowing full well it would be a shame to risk losing the extraordinary opportunities for expression that seem to be arising – particularly in this day and age, when communicative strategies are taking on increasing significance (in their media-based intermingling). This point of view is precisely what led to the decision to move the 'GAM' (Galleria d'Arte Moderna) to the area near the former tobacco factory, where the city's Cineteca (Film Archives) and the university's music and theatre studios were already up and running. So it was a decision based on the hope and need for the three institutions – the DAMS, the Cineteca and MAMbo – to work on a mutually unifying programme that responded to the surpassed, crumbling confines that formerly separated film, figurative arts, theatre and music, bringing them together as tributaries of a shared idea and real project. In truth, the visual arts have been in close collaboration for some time now – but the perspectives that become possible when they work together toward the goal of new developments, and results that already have zero tolerance of growth limits, remain to be seen.

So I must emphasise that, for MAMbo, this isn't simply a straightforward move from the old location to the new one; it is, rather, a veritable rebirth, capable of augmenting the important role the institution has played thus far with new opportunities and a broader horizon of new goals.

Angelo Guglielmi
Chief Cultural Councillor of Bologna

The exhibition Vertigo: A Century of Multimedia Art, from Futurism to the Web, *curated by Germano Celant and Gianfranco Maraniello, makes the major potential of MAMbo – the new Museo d'Arte Moderna di Bologna – a concrete presence for researchers, art-lovers and the public at large.*

Finally, as of 5 May 2007, our region will have a priceless institution where everyone may reflect upon and deepen their knowledge of the major linguistic merges that – from the early twentieth century up to today – characterised (and continue to characterise) the artistic experiences and movements that marked (and continue to mark) our daily lives, our contemporary world.

So it is here, in the splendidly renovated former Forno del Pane (City Bakery), that Marinetti and Duchamp, Warhol and Viola, Nam June Paik and Laurie Anderson will all convene, together with gramophones, the earliest radios and the iPod – all because the goal of a multimedia artistic practice and its relationship to technological progress constitute the basic elements for understanding the evolution of 'modernity' in the artistic experience.

For the Cultural Counsel of the Emilia Romagna Region, MAMbo's opening and inaugural exhibition are a fundamental step on the path toward diversifying the regional cultural offerings and making the most, on all levels, of contemporary artistic expression. The new Museo d'Arte Moderna di Bologna marks a new chapter in the civil and cultural growth of the Emilia Romagna Region, with its endless opportunities for all visitors to learn and – why not? – have fun. It's also the perfect chance to send our sincerest wishes for a rich and enjoyable time at work on this special project to all those who have contributed to the realisation of this unparalleled museum.

Alberto Ronchi
Chief Councillor of Culture, Sports and Youth Initiatives for the Emilia Romagna Region

Vertigo: The MAMbo Manifesto

With the opening of Vertigo: A Century of Multimedia Art, from Futurism to the Web *and conversion of a building constructed in 1916 as the main bakery for the city of Bologna into a new museum, the Manifattura delle Arti project is complete. This project involved refurbishing a former tobacco factory complex into an 'Arts Factory', creating a cultural city-within-a-city in which the University, Cineteca and Museo d'Arte Moderna share an area of the city that had fallen into disuse and is now brought back to life thanks to the recent transfer of such important cultural institutions.*

Vertigo *is not just MAMbo's inaugural exhibition – above all, it represents the new museum's ethos, and acts as its manifesto.*

MAMbo, which is the natural evolution of Bologna's Galleria d'Arte Moderna, is dedicated to modern and contemporary artistic practice in all its various forms. In addition to offering the public an up-to-date, 360-degree view of the most innovative art scenes, the museum will also be an educational centre dedicated to helping the public become more familiar with contemporary art, as well as a tool for showcasing recent Italian art. In short, this event marks the debut of a new space for artistic experimentation and its history, and is dedicated in particular to today's younger generations, in keeping with Bologna's role as a privileged site for contemporary culture.

The exhibition's visitor itinerary, which makes the most of the spectacular exhibition design and installation conceived by Denis Santachiara, allows the viewer to look at twentieth-century art history as a period of radical change, invention and innovation.

The twentieth century was a time in which art articulated its own unique language in a way never explored before – through the advent of multimedia and the attendant sense of euphoria that had characterised artistic practice since the turn of the century – sweeping artists' work up into a vertiginous vortex of new opportunities and modes of expression.

Vertigo *aims to establish a framework for all the media-based communicative forms of the past century – from radio to the telephone, photography to film, television to the web – through an exhibition plan that begins with art's first historic incursions and wanderings into the field of technology. It spans from the sound- and poetry-based experiments of Marinetti and Schwitters to the visual and film-based experiments of Duchamp and Dalí, and moves from the work of Andy Warhol on to pop art, conceptual art and the work of artists like Léger, Picabia, Picasso, Magritte, Klein, Manzoni, Bourgeois, Beuys, Kiefer and Viola, all the way up to the major figures of today's international art scene.*

It is, therefore, a visual retelling of the century in which art emphatically thrust its own traditional forms of expression into a profound crisis, and appropriated media-based tools used for artistic ends, forging new approaches that characterised the period's technological evolution.

Vertigo *is also an exhibition with rich educational content, with the aim of helping spectators approach and get a closer look at the many languages of contemporary culture through a familiarity with the paths artistic practice helped pave over the past hundred years. Indeed, MAMbo strives above all to be a space that has a real dialogue with its users, and does so by disassembling the (often esoteric) mechanisms surrounding modern and contemporary art, renouncing all elitist views of exhibition planning while nevertheless maintaining the scientific rigour so essential to fully representing the complex reality of the most advanced artistic practices.*

Vertigo *therefore contributes to its visitors' understanding of how technological developments have influenced our perception of reality, its representation, its very statutes, and consequently elucidates how the artistic universe, in all its many declensions, effectively became multimedia – or, to use curator Germano Celant's term, a truly 'off-media' phenomenon.*

Given the special occasion of this important exhibition, I cannot help but to extend yet another heartfelt thanks to the museum's Director and all its staff for the excellent work they have done. Thanks also to Germano Celant, who – in addition to curating the exhibition – provided major support to the museum's opening with his most helpful suggestions. I also thank Mayor Sergio Cofferati, who wanted to see MAMbo come to life as much as I did, and, above all, I thank the many supporters who helped make the project become a concrete reality: the Region of Emilia Romagna, the Fondazione Cassa di Risparmio di Bologna, the Fondazione del Monte di Bologna e Ravenna and the UniCredit group.

This new museum is dedicated in particular to the Italian artists who – through their research, their artistic practice and the unparalleled quality of their work – constitute an authentic stimulus for the country's cultural growth and help reinforce the credibility and authority of its museums.

Lorenzo Sassoli de Bianchi
President of MAMbo – Museo d'Arte Moderna di Bologna

The opening of a 'new' museum is a fundamental event in the cultural history of a city. Bologna, which boasts one of Italy's most important museums of modern art and is so closely linked to contemporary history and Italian culture, welcomes this moment of cultural transition – with the museum's move from one place to another, one 'container' to another – with high expectations. Over the past three decades, the versatile building of the Galleria d'Arte Moderna, an early seventies work by master architect Leone Pancaldi, hosted works by many key Italian and international artists. Today the baton is passed to another location, the renovated Forno del Pane, originally an industrial building erected at the beginning of the twentieth century.

Architectural history is also a part of contemporary history, and the museum's move is not without some significance.

The Fondazione Cassa di Risparmio di Bologna has always believed in the importance of contemporary art, in all senses; its support ranges from youth initiatives to exhibitions centred on living artists, conservation and – now that the structure of the city's future museum is definitively taking shape – the archiving and appreciation of contemporary culture.

Our participation in the new MAMbo is, therefore, not just the fruit of 'sponsor-based' politics, but is rather an indication of the strong faith that the Fondazione Carisbo continues to have in this city's institutions, with particular attention to those dedicated to history and art history.

Fabio Roversi Monaco
President of the Fondazione Carisbo, Bologna

MAMbo's opening also marks the advent of a never-before-seen space – in an image-filled, vertiginous vortex of a debut – for exalting the links and interrelations that connect Bologna to the national and international cultural scene, through a synthesis of different realities united in the aim of translating ideas into expressive forms and visions of the new. Contributing to the support and spread of culture is, in fact, a fundamental calling of the Fondazione del Monte di Bologna e Ravenna, a foundation that also fulfils the task of promoting art-historical heritage to benefit the entire community.

Supporting MAMbo, therefore, means belonging to one of the key cultural spaces that connotes contemporary Bologna, with the passion and sensitivity to art and culture that distinguish the activities of our foundation – an institution that has always been open to the illumination unique to artistic creativity and expression.

This exhibition is the first step of the entire path – which I hope will be lively and intense – of what is to come for the Manifattura delle Arti complex, which from today forward welcomes MAMbo as an expressive barometer of culture, artistic practice and investigation of the contemporary fields of visual, performative and multimedia art.

On behalf of the entire foundation, I send MAMbo our most heartfelt congratulations, and welcome it to this unique city as a partner in the development of 'networks' and new collaborations on a local and national level with the key cultural centres.

Marco Cammelli
President of the Fondazione del Monte di Bologna e Ravenna

The inauguration of the new home of Bologna's Galleria d'Arte Moderna marks the dawn of a new, highly important chapter in the activities of the UniCredit group in support of culture, centred on promoting the many languages of contemporary culture.

The collaboration between UniCredit and MAMbo has particular characteristics, unique in Italy, that are worth mentioning here: this partnership is, in fact, founded on a joint effort to promote young artists – young Italian artists in particular – and help them produce works that will then, after initially being long-term loans, become a permanent part of the museum collection.

For UniCredit, to produce means to attentively listen to and then concretely gather and sift through the proposals and most interesting stimuli coming from the vast realm of artistic creativity. It means acting as direct interlocutors in new, ambitious projects in order to increase their visibility on a national and international level.

The constructive collaboration between a major European banking institution and a museum that has already proven its ability to take a place among the key figures on the international stage is founded upon the conviction that, through shared strategy and through joint participation in ambitious projects, it is possible to breathe new life and a new energy into an essential part of the lives of all citizens – not just art-world specialists: a first-hand experience with beauty.

The museum is one of the main places a community's identity is forged; because of this, UniCredit proudly supports and participates in this new adventure, attesting to its deep local roots and involvement which is also expressed through the group's willingness to look to the future and help build it together.

Alessandro Profumo
Managing Director of UniCredit

Contents

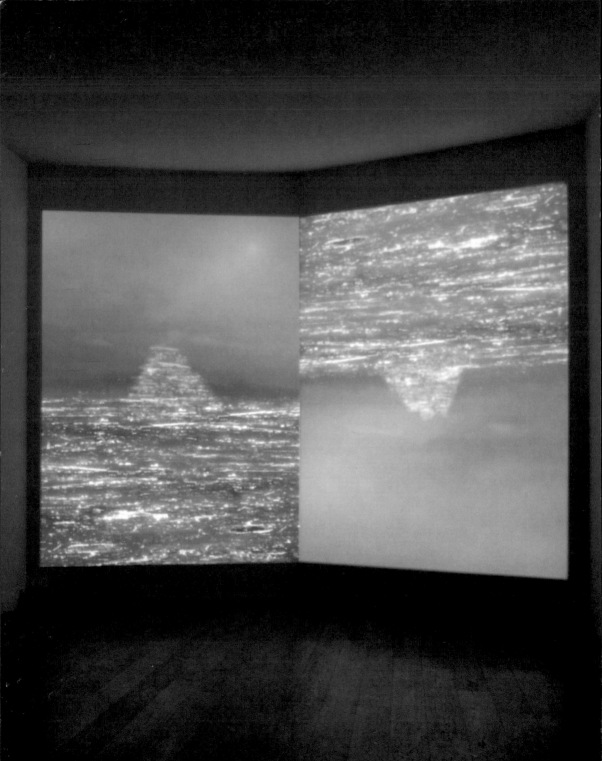

Germano Celant

The Reasons for Vertigo

Grazia Toderi
Rosso babele, 2006
video installation

A Fading Away, or a Fade-in, Fade out?[1] After years of radiant eu-
phoria, today the art system is filled with unease and insecurity due
to the precarious, marginal space that has opened up before it ever
since it allowed the autonomy of its arguments and assumptions –
based on an ideal nature – and economic materiality to be placed on
the same level. The result is a betrayal of its aims and its critical role,
and a lessening of its otherness and its *raisons d'être*. It also runs the
risk of becoming a meta-historical entity, isolated and separated from
the world, without any social approval or recognition if not that of
its followers and of the market. For those who maintain that art is
an elite value that helps oppose the disengagement affecting society
at large, the risk is enormous; the loss of political meaning seems to
be compensated for by a mass consumption that gives it a merely dec-
orative function. This corrodes the roots of its identity – as well as
its ethical and critical role – and transforms it into an overrated fetish,
the object of a barely perceptible reality. The consequences of this
popularity are as much the concealment and dissipation of the rep-
resentative and utopian structure of art, as the enthusiasm and ex-
ultation of an inefficiency and superficiality caused by its 'spectacu-
larisation', which involves the homogenisation and depersonalisation
of the imaginary. Similarly, change-related problems seem to make
the differences between pure and applied research obsolete – the dif-
ferences that separated artistic value from utilitarian value. Today we
are witnessing a fusion of various positions. Art – defined by its strong
otherness and its refusal to be a communicative 'profession' – has un-
dergone a process of adaptation to become a mere consumer prod-
uct. It has allowed itself to be dragged into a market that has reduced
it to a luxury good, such that it is increasingly identified with use and
function; the latter, up until the 1950s, had always been considered
separate from – and secondary to – art's existence, because "au-
tonomous art at least contained a heteronomous pretence, that of be- 3

ing an absolute alternative to the economic world."[2] The fall of an ideal artistic realm, paired with the arrival of a functional artistic realm, imply that metaphysical and instrumental values are becoming nearly equivalent. These positions mediate one another, enveloping and underlying the suppression of their limits and differences: art becomes an aestheticised behaviour, with no meaning other than the one given by the consumer. A similar condition seems to be pushing artistic practice toward a horizon – characterised by a sceptical, nihilistic attitude – with a dissolution of roles and effects, and a loss of identity that renders both products and images equal. This leap toward dissolution is accompanied by a dispossession and alienation that favour a merely functional role – a role which could just as easily be that of design, architecture, fashion, graphic design or advertising. Nevertheless, for those who lay claim to a pure idea of art, based in radical subjectivity, this transition to a situation of linguistic precariousness can be defined as a 'fading away' and hence total disappearance. For others – those interested in maintaining the need for an affinity between art and communication – it can rather be defined as a 'fade-in' or 'fade-out', in the cinematic sense; a slow decanting that selects and accepts the presence of opposites, surpasses any conflict, and integrates it all. This type of fade is not the triumph of one language over another, since traditional oppositions are suppressed, but rather the advent of a new aesthetic statute wherein a blending of knowledge and pairing of research goals is developed. Art does not appear above and beyond all else, but declares itself complicit in a cultural and social totality based on mixture and juxtaposition, dialogue and transformation. Without doubt, such a metamorphosis opens up yet 'an other' space, articulated on the concept of diffuse aesthetics and both a synthesis and osmosis of their various languages. If this is true, what does the operative and scientific statute of the museum become? What are the norms that define its behaviour with regard to the proposition and interpretation of the artistic past and present? If art's identity is suspended between other identities, is it necessary to look for its meaning in a more generalised aesthetic? Must we contextualise it, without any solemnisation, in order not to conceal its ties, implications and consequences with (and on) various other languages? Personally, I believe the museum must go beyond the monotheism and theology of art in order to represent its ties to other 'archipelagos' of communication and creation. The aim is to arrive at a critical point of view[3] that takes on different forms of exhibition, analysis and historicisation of visual language, understood as a dynamic energy and transgressive movement between the arts. The overlapping or, at the very least, the involvement of all visual practices is fundamental to understanding an entire historical period – even more so if the period becomes symbolic of a change or transformation of a culture or society. Coverage of a cultural period shouldn't acknowledge any disciplinary borders. It is rather the history of images and ideas, objects and documents, and thus must include all aesthetic languages, in all their multiplicity and versatility: art, photography, cinema, literature, fashion, design, architecture, cartooning, theatre, etc. Still, such convergences are rarely carried out,[4] because people prefer to support a theology of art that defends its existence as an absolute, unique religion. This, in the monotheistic and idealising intentions of its historians, mustn't betray the presence of any dialectic relationship to the plurality of other languages of communication, from advertising to television, cinema to music.[5] This defence of the sanctuary of art makes an exception when the subject is removed from recent contemporaneity, and deals instead with the past, with history. An analysis of the relationships between art and culture, with the dissipation of their mutual limits, is not an 'at-risk' endeavour. The horizon of these relationships even broadens, since the historic avant-gardes – from futurism to neo-plasticism – call for their expansion, and an intertwining of the various languages. In an exhibit, this can be shown by placing paintings and manifestos, photographs and sculptures, clothes and maquettes, objects and

books, films and drawings on the same floor; groupings of objects with various visual and plas-

tic affinities manage to offer a cultural totality, relevant to a city or historical period or trend. If this is possible for historical events, why not adopt it for the present time, so as to confirm the currents and movements, proximities and distances, that intervene between the arts of a given period? And, even more logically, to emphasise the anti-historical nature of any schism between an art and the arts, as well as the slow dissolution of art's grasp on reality in favour of a theoretical and interpretive dialogue with parallel linguistic forms, in order to find other types of reference? Similar observations and questions came up[6] as I sought out a logic and methodology for curating an exhibition of Italian art from 1943 to 1968, organised in 1994 at the Solomon R. Guggenheim Museum in New York under the title *The Italian Metamorphosis, 1943–1968*. The answer was to interweave, or at least bring into parallel, various languages – from art to architecture, photography to music, fashion to design, literature to cinema. This approach was also dictated by an identification with Italy's philosophical and artistic cultural characteristics, which present an eclectic nature emerging from the multiplicity of grafts and juxtapositions, mixtures and combinations, layerings and tangles of both the historical and modern cultures that, over time, have taken place and been overthrown in Italy. This departure from the codified system of art, and fusion of the arts, led to the 1996 *Arte & Moda* (Art & Fashion) event in Florence; and to the 2004 *Arti & Architettura* (Arts & Architecture) event in Genoa. At both, artistic work and research were historicised in relation to the whirl of fashion's fluid images and the constructive surveying of the architectural process. Today, the radicality of artistic thought, and its historical *raison d'être* as a critical response to the 1990s, runs the risk of falling prey to a total, definitive cancellation and entering into the spiral of the market, which solely values commercialisation. *Otherness* cedes to saleability, where the sole perspective for existence is the end satisfaction of the buyer, who is attracted only by marketable products, or ones that symbolise luxury and define social status. At the same time, the degradation of art's oppositional and analytical value with respect to real value in favour of economic value, in pushing art toward a more decorative function, be it of the surroundings or the illusion of buying power, definitively brings it closer to the realm of design. It is becoming 'functional' through its symbolic and commercial use, such that it is becoming subordinate to consumer demand. This position makes the need for its existence – as a process that transcends the needs and wants of the public – vacillate, and inevitably immerses it in a universe of appetising 'things', notwithstanding its apparent and unrealistic opposition to the commercial consumer system. Reduced to the production of 'objects' and 'things', albeit with different intents and on a different scale, art loses any pretext of autonomy, and becomes just another 'product', as foreseen by pop art and Andy Warhol. It melds and is confounded with other industrial entities, and shares their system of promotion, commercialisation and media consecration, set in the highest strata of luxury goods. If this is what is taking place, the reading of its productive progression brings into question its philosophical and political motives, its negative, oppositional role, and makes it mere fetish – a fetish that, if not forced[7] to adapt to the traditional and conservative demands of the market because it hopes to create that market with its own new images, can do nothing but respond to the 'innovative' impulses of industrial society, the impulses that become 'tastemakers' for the larger public. Since 1990 these impulses have been linked to a negotiation with technological communication practices based on physical entities, from cameras to camcorders, and virtual entities, such as computers and the web. These prosthetics with which people communicate have acquired a certain exposure in social and aesthetic realms, such that all distinctions between person and medium seem to have been erased, leading them to cohabit, if not utterly become one. Networks of interactions erase all traditional differences and categories, such that multiple, fragmented formations based on new technologies emerge. This technical, cultural process involves another type of fade – between the various me-

dia now navigating shared networks and developing new aesthetics and new spaces. To survive, art is forced to face these new adversities, but more than anything, it has finally understood that, in order to posit itself as a process of continual reinvention and new encounters, not only must it accept intertwining and osmosis with other languages – from architecture to fashion, and from design to cinema – but it must also express itself with the flexibility of all other media. Throughout the twentieth century the dominant force of emergent technologies – such as photography and radio, telephone and gramophone, recording devices and television, cinema and the computer – now finds its own 'natural' tempo, allowing such media to live side by side and intertwine without difficulty. In fact, what all the historic avant-gardes, from futurism to surrealism, considered 'the future' – that is, the 'decodification' of the imaginary as a result of the fall of all limits and confines between art and technique – in the twenty-first century has become an established, recognised system. The realm of art – or, better, of creativity – can come to include any and all communicative and discursive elements. It has become a multifaceted entity open to any change in social or technological behaviour, above and beyond the unitary, monistic identity that had sustained it. Now its practice produces paintings and photographs, sculptures and films, books and discs, music and plays, video and architecture, networks and virtual systems: it has become an absolutely multimedia subject. If this is the case, then the complexity of modern and contemporary art history, the function of a new museum, can be reread and reanalysed primarily as an intertwining and mixture of traditional techniques and experimental technologies, revealing its fractures, its multiple identities. In particular, the museum institution tends to become a 'magnetic field' in which all the aesthetic languages converge, and from which energies tied not solely to their container, but also to their urban context, radiate, creating reverberations on a national and global level. As this stream of communication has created networks between innumerable entities and identities, a museum could be configured as the centre of an open system that, in a 'virtual' and concrete way, interacts with other museums of art and architecture, cinema and music, photography and television . . . but above all this museum could enter into instantaneous communication with other cultural areas throughout the world. This is precisely what we attempt with *Vertigo: A Century of Multimedia Art, from Futurism to the Web*.[8] This exhibition and catalogue aim to give an account of the fluidity of confines between artistic media, including not *all* the tools of communication, but those which, following information technologies, have directed and constructed its present state. At the same time, an interaction above and beyond institutional barriers is begun in order to converse with other agencies that share this communicative belonging, such as film libraries and public libraries, which live within the same urban system of communication and, in the future, through new technologies, will join a network with other cultural institutions worldwide. This modus operandi transforms the museum institution and its territorial approach, bringing it into a spatial habitat where any and all aesthetic vectors, in an almost zero-gravity condition, can freely navigate. *Vertigo* is an open, high-speed creative context where there is profuse interchange between pluralities of artistic modes with no distinction made between various media: a high-level, exponentially growing museum-based frequency. It proposes an escape route from the 'compartments' that define other museums – from the Museum of Modern Art in New York to the Tate Gallery in London – because it transforms the museum into a place of 'integrated' media, an open territory for instantaneous communication. Nevertheless, its realisation is still theoretical, while the related exhibition is concrete, and demonstrates the 'conjunction' of techniques and technologies that have shaped and influenced the art that, in the twentieth century, saw itself as an apparatus of media-, communications- and community-related production. It was an intense century, in which new techniques and new technologies came to involve – if not downright overwhelm – painting and sculp-

ture. The latter remained vital and enriched the discourse, bringing it into a 'community' of languages and into a network of terminals that helped ideas and images circulate. The effects of this further metamorphosis shifted research to focus on emergent technologies, and brought about the definitive establishment – and therefore extinction – of the utopia promoted by the historic avant-gardes. Indeed, first with the dissipation of linguistic confines, and now with the complete zeroing of all technical and technological distinctions, the creation of artistic hierarchies so desired by the art establishment falls into crisis, thrusting the image out of its illusory state and forcing it to face reality, to then transform it into reality itself: a sub-division and sharing within arts, techniques and technologies that effectively brings about a complete democratisation. This concludes the historical cycle of 'art's death', which, having cannibalised all visible and plastic languages and media, cancels itself out and dissolves in the promiscuity of all that is *real*; art leaves behind the conflicted realm, which had kept it distant from the world, and opens itself to systems of total relation and complete connection. It is mutual sharing with 'others' in the realm of art's subjects that creates a system of infinite connections where aesthetic tides freely circulate and flow outside of the immobile vision of traditional aesthetic order. At the same time, in entering this new whirl of communication, the arts and their techniques come to build a shared language – one of everyday life, banality, things and instruments – making it easy to attract a great number of viewers and consumers. In fact, since the 1990s, the public's desire to participate has grown, both because the cultured population has grown, and also because artistic practice, having pushed art for more than a century toward adaptations to technical and technological revolutions, can now communicate on par with a larger audience that is highly informed about the media that form its everyday context. The result is twofold: the arts begin to venture outside their remote, privileged sphere, and come to permeate the informational media read and consumed by the masses, insofar as they celebrate the insignificant and banal aspects of domestic products and life, such that the issue of comprehension, and 'getting' something,[9] is transferred from *viewing* an artistic product to *living* it. This is a transition from the linear motion of art consumption to a circular motion, which does not solely offer one-sided aims, rigorously dictated by the theories and philosophies of understanding and observing, but rather falls under the scope of a confused and insatiable realm, a way of living with no polarity between high and low, major and minor, qualitative and quantitative. This results in a vortex that sucks up all experiences, in which all the elements of artistic communication enter into a complex system that is irreducible, manifold and circular, within which it is impossible to determine any hierarchical order: a whole that presents itself as multiform and enigmatic, in light of which traditional, habitual artistic thought must be rescaled. And how are we to manage this complexity, which within our framework should be organised into a museum system capable of accepting and conversing with such complexity? The answer could be to simply leave the field open to the 'vertigo' of circuitous connections, even without a defined plan,[10] bringing together the cells but letting them fall as they will and organise themselves, such that they move according to their own stimuli. This would be a particularly fascinating discourse, which could enrich our way of thinking about creativity; almost like creating a centre for arts and technologies that replicates a massive anthill of sorts, in which each single creative element – be it from the realm of art, fashion, design, architecture, music, cinema, theatre, etc., and supplied in all possible media, from painting to photography, video to film, books to clothes, objects to sculpture, CD to DVD, computer to web – obeys no linear, directional creative prescriptions, nor possesses any idea of the project, but rather 'vertiginously' moves according to individual impulses, following situations offered and taken along the way, to arrive at an enigmatic, complex product: an absolute artistic circularity.

Multimedia Avant-gardes. The determining feature of any dialectic between arts and techniques is the movement that allows for the passage – along with the successive fusion or mimetic contagion – from one polarity to another. With futurism, artistic languages found themselves subject to an energetic process that would not be contained within one single representative model or medium. Heterogeneity and the expansion and overlapping of previous limits – through their powers of correlation, multiplication and irradiation – are the general assumptions upon which the originality of futurism's affirmations are based; it is from this movement, with its discovery of the aesthetic harmony of linguistic and materialistic simultaneity, that *Vertigo*'s journey begins. This exhibition aims to visualise, through a combination of concretely different image-related incidents – including books and magazines, film and photography, sound and music, radio and music recorded on disc – the indistinct aspects of twentieth-century art. Painting and sculpture remain strong reference points, albeit 'dispersed' throughout the multimedia magma, which mixes forms and volumes, images and film clips, noises and voices, objects and environments, videos and sculptural and cinematic installations. All these create a complex, enigmatic whole expressed in the spectacularity of Denis Santachiara's installation.

Here, played out through overlapping and crossbreeding, the visual research developed across linguistic and technical fields joins to form an intertwined, almost inextricable mass, a magma of sorts that is difficult to trace back to its simplest elements without losing the essential logic of the exhibition. Nevertheless, it also inevitably represents a weaving made up of a warp and weft whose characteristics can be explained and 'unravelled' without undoing the unity of various interwoven elements. The elementary particles, on a media-related level, are unified in a building made up of a four-dimensional continuum, in which what came first and what came last are confused, because the only thing that counts is the level of correspondence between images. Everything is chosen on the basis of the possibilities that can emerge within the broader terms of an art that has opted for a total circularity of technique and technology. The vision we have attempted to convey is that of a whole greater than the sum of its parts, because it creates a complex, uncontrollable universe wherein the crowding of research, in all possible directions, predominates over the mere selection of this or that artistic product by one artist or another. Everything melds in a swarm of individualities – object-based, pictorial, photographic, film-, sound- and television-based – which end up forming a complex perspective on twentieth-century multimedia art. It is clear that from the end of the nineteenth century, when the initial foundations of an information- and communications-based society (like the one resulting from the invention of cinema and audio recording, from the Lumière Brothers to Thomas Edison, or the photographic shots of Louis Daguerre and William Henry Fox Talbot, or the electric transmission of sound, by telephone and later radio, with Guglielmo Marconi) were laid – artistic pursuits changed direction and adapted to new techniques of visual recording. The creativity that had previously been entrusted to traditional instruments, from paint and brush to chisel and burin, and the successive execution in marble or metal alloy, was pushed to interact with a pre-industrial factuality, involving complex conceptual operations; such operations were implied in the concepts of reproducibility and transmission of a product in faraway places. The transfer of original to reproduction made artists face the 'creation' of objects that were the result of other artistic techniques. These reproductions were initially compared with the painted, drawn surface, in the form of a paper support like lithographs; over time, these came to illustrate books of poetry and literature, and are later recognised as autonomous forms of art. This is what happened during the cubist period, in collaborations between Guillaume Apollinaire and Pablo Picasso, Georges Braque and Erik Satie, and soon results in the visual book, to be 'seen' as well as read. Italian and Russian futurism, returning to the typographic liberties taken by Stéphane Mallarmé, make writing

'spectacular', intertwining it with the graphic components of advertising – from Francesco Cangiullo to Paolo Buzzi, Filippo Tommaso Marinetti to Fortunato Depero, Varvara Stepanova to El Lissitskij – and the audio component of spoken scores, to enrich it with noises and sounds. Such artistic production passed from painting and sculpture to serial and mass production, in which the artistic creation undergoes the influence of other non-codified languages, such as photography – from Anton Giulio Bragaglia to Wanda Wulz, Aleksandr Rodchenko to El Lissitskij – to enter into the reality of expanded communication. This was the first attempt at dissolving art's identity as an original, and the first step into the realm of visual multiplications as possible transitions, which could be transferred onto all possible surfaces. It became an overwhelming vortex that inevitably touched upon all possible visual expressions, creating a vertigo that cancelled out any and all stable identifications of the artistic process. The attentions aimed toward reaching a totality[11] of expression were, between 1909 and 1918 in both Italy and Russia, manifest in the range of combining forms and languages, where every linguistic identity is dissolved in favour of the image's *mise en scène*, as demonstrated in artists' linguistic passage from photography to film. When this phenomenon is championed in futurism's manifestos and art works, and later in dadaist and surrealist works, it is an externalisation of art which appropriates the performances of other media so as to no longer produce decorative objects, as painting and sculpture could seem, but instead attempt the creation of a 'vertigo' that overwhelms artistic practice itself as much as it does the public. And because this loss of control is linked to a continuous modification of vision, such that forms and languages merge, art tends to 'deploy' itself in other territories. Italian and Russian futurists then venture into politics, cinema, design, architecture, music and the definition of the new media of mass communication such as newspapers, magazines and radio, with the goal of reconstructing the social and cultural universe according to a certain vision of the future. From a destructive, critical point of view, the dadaists and surrealists attempted the same thing, playing with the deconstruction of images and objects. For them as well, the beginning is linked to the typographic revolution – in the form of cover inscriptions of soft, tactile materials that transform the object into a manifestation of sculptural eroticism, as well as a philosophical complex: these include Marcel Duchamp's box *Eau et gaz à tous les étages* and the book *Le Surréalisme en 1947*, whose cover he drew in the form of a soft breast. But their greatest contribution was in their production of things and figurations without any orthodox function: they worked on material entities and combined them according to the most heterodox approaches, such that the works' articulation invariably inspires a response of surprise and wonder. Even in their use of languages taken from photography and cinema, architecture and design – from Marcel Duchamp to Salvador Dalí – their aim is to design conglomerates, in photography and film, which deny or negate traditional techniques of seeing. Man Ray's *rayographs* or André Breton's poem-objects – which are the result of a 'block' in the processing of photographic development or the cropping and montage of materials, from object to newspaper clipping to photographic image – combine all these to create signs by bringing various elements into contact with one another. For the dadaists and surrealists, just as for the futurists, what counts is the continuous ebb and flow of new media. They are interested in an unstable, unpredictable transmission, full of imaginary investments, made up of residue and scraps. Multimediality also counts for them, hence they take interest (Marcel Duchamp and Max Ernst above all) in the residual object, the thing that, taken from daily life into another realm, can be charged with fortuitous effects. It's important to note that up until the 1930s the principle of disorder, prompted by the adoption of new techniques and materials, lives on fortuitous collisions, creating a new energy. At times it is developed in collaborative projects like, in the case of cinema, the one between Salvador Dalí and Luis Buñuel, and at others it records a visual dy-

namism due to montage and rhythm, such as with Francis Picabia and Hans Richter. Nevertheless, this tension is still confined to the sparks produced by the fortuitous meeting of volumetric objects and surface – it moves, that is, between painting, sculpture, photography and cinema, all the while maintaining the specificity of a single language. This is the same sphere in which phonetic poetry operates; originating in 1897 with Paul Scheerbart, who published the poem *Kikakoku!* in Berlin, and continuing in 1905 with Christian Morgenstern, to finally lead to the visual and sonorous poems of the Italian futurists, from Mario Petronio to Pino Masnata, and Russian futurists from Vladimir Majakovsky to Aleksei Kruchenykh. But the real media-advent came by introducing radio to the techniques of artistic communication. In 1933, Marinetti and Masnata drew up a manifesto titled *La radia*, followed that same year by broadcasts from the radio station in Milan. Fortunato Depero, author of 'radiophonic' poems, also took part in these. Over the following decades, the magnetic tapes recorded by artists reciting poems (such as *Ursonate*, which collects Kurt Schwitters's poems from 1919 through 1927 recited on the Süddeutsche Rundfunk, or Richard Huelsenbeck's and Raoul Hausmann's phonetic poems) are transferred to disks. This is yet another broadening of artistic practice and its circulation, as it increasingly becomes a vehicle for media-based messages in which the speed and distribution of the image are key, and which increasingly loses its traditional identity to become an ephemeral 'datum', is associated with a contingent moment and situation. It essentially becomes a visual and audio consumer product that satisfies public demand and offers itself in the form of quick communication, a consumable gadget subject to wear and tear and rapid obsolescence, in step with the tastes and fashions of the time. Yet the process of democratisation of these various languages is still not complete; it takes the advent of the Bauhaus, with its goal of reaching a total creativity, to abolish the hierarchies extant between language and media. At the first school in Weimar, and later the Bauhaus campus in Ulm, the first syncretism of the arts and techniques was attempted – that is, an undifferentiated use, in creating things and images, of any and all linguistic approaches and behaviours. Beginning in 1919, the 'informationalisation' of society develops, with the media-based spread of 'recording' tools ranging from the gramophone to the camera; similarly, the coexistence of rapid vehicles of exchange – from automobiles to telephones – accelerates the circulation of bodies and data. It is therefore inevitable that a creative school focuses on objects emancipated from the originals, and concentrates on design, graphics and pictorial experimentation across media such as Laszló Moholy-Nagy's telephone art – or recognises the inseparability of art from photography, design and cinema. Still, this synchronised movement is tied to the pure, idealised realm of visual research. It lives on its indeterminate nature, but is still reaching toward a utopian, preparation-oriented, informative realm. This develops into an exceptional state, is fuelled by particular, unique lines of thought that tend to capture the present but also want to anticipate the future – the future's modernity. The construction of a world defined by the principles of the Bauhaus coincides with Walter Benjamin's definition of an age in which art has lost its aura because of mechanical reproduction. This is a fundamental metamorphosis, causing pure artistic pursuits to lose any unique qualities they may have had, but it also allows them a new flexibility and greater degree of fluidity in the world of things – and last but not least, brings with it the benefit of reaching a mass audience.

From Warhol to the Web. In the 1960s, after the tragedy of war and existential rebirth of artistic individuality, the Bauhaus found its 'subjective' realisation in the form of Andy Warhol's Factory, where the quintessential pop artist elaborated his image strategy, working with the concepts of consensus and adhesion, power and promotion, developed through ephemeral, precarious visions that exult the instability and consumption of images and myths. He is a cynical, disillu-

sioned protagonist, utterly foreign to art's positive and proactive values, whose most extreme consequence leads him to deny any conceptualisation of the subject, passively recording the extant world through all the most contemporary technological tools, underlining the absolute lack of any image-based project, so typical of mass media, the self-proclaimed 'machines' of recording through sound, visuals, photography, silkscreen, television and film, to celebrate – key to consumer societies – not the *significance* of the product, but the tactics of promotion and sale. In all this, Warhol agrees with the sceptical, nihilistic character of contemporary society, which no longer believes in the richness of meaning, but rather the power of the insignificant, and exults contemporary images of the present because they recall the sheer absence of reality, meaning, faith and utopia.[12] This society is aware of the artist's pointlessness, but understands that such uselessness can't be shaken off with mere good will or eschatological perspectives; on the contrary, it must be accepted and emphasised, extended and generalised. Indeed, if the artist must continue being society's 'mirror', he must point out the lack of meaning, the superficiality of things. This is the reason behind his focus on banal, quotidian objects – meaningless, useless things such as a *Coca Cola Bottle*, a shoe, a dollar bill, a newspaper's front page, a do-it-yourself manual, a *Campbell's Soup Can*, up to the pointless culture of the 'star system' made up of actors and actresses, from Troy Donahue to Elvis Presley, Natalie Wood to Marilyn Monroe. Superficiality and pointlessness of both culture and art are no weakness, but rather become a strength that makes representative, ideological thought senseless and utterly useless. This is the most radical and interesting aspect of Warhol's 'acreative' process, which consists in rising to a reflective position on reality without, however, assuming a moralistic, judgement-tainted vision. He does not confer any critical legitimisation on art: he simply, through his unreality and pointlessness, reflects the unreal and meaningless aspects of contemporary society. With respect to artists like Jasper Johns and Robert Rauschenberg, Joseph Beuys and Yves Klein, who return to a *moral* conception of artistic culture as a *value* with which to counter social dissolution – metaphysical position par excellence – Warhol's position is decidedly *pragmatic*: one condition for being in society is to agree with its unreality and become indistinguishable from it, reflect it in order to keep it in the realm of unreality, of superficiality, and become an instrument to accelerate its failure. If indeed culture and art want to be candidates for taking on the succession of politics and ideology, they must be perceived as neither value nor power. Nor can they be seen as an excess of negativity used to confront a strictly utilitarian universe. Art is utilitarian only if it is involved in a process of 'de-realisation' that permeates society at large; a widespread refusal of alternative, marginal ways of life and acceptance of the dissolution and defeat of counterculture – even society's relatively powerless artistic margins. If this is the case, Warhol's position underlines a reality that is utterly extinct, and denotes nothing at all. He participates in its growing insignificance, its 'designification'. He emphasises it because of its fortuitous, insignificant aspects. Declaring himself useless, or at least susceptible to the uselessness of all that is real, Warhol critiques contemporary art that continues, through its symbolic and imaginary production, to obscure and cover up society's *idiocy*. Declaring himself obtuse, idiotic, absent, passive, indifferent and boring ("The reason I paint like this is because I want to be a machine. Everything I do, like a machine, is what I want to do"[13]), he signals the end of a devotional attitude toward art history and its metaphysical-theological bent, which has always led to decisions full of utopian ideas and delusions: "When I think about it, I realise that making paintings is wrong. It means setting a size for a way of thinking, and also colouring. My pictorial instinct tells me: if you don't think, you're doing the right thing. As soon as you have to make decisions or choose, it's wrong."[14] With his art, Warhol closed the door on utopianism, and opened the door to a new realm in which every thing and every person is equal to any other: "I think everyone should be just like

anyone else",[15] an equivalence that abolishes all illusions about ideas of difference and charismatic power and the cathartic power of culture, of art. Anyone who feels its absence remains in mourning of the death of a 'superior', for better or worse, and invariably awaits the arrival of some 'being' to dominate others. It is through art's lack of 'superiority' over life that Warhol finally creates a new realm of visual thought. Those who once proclaimed the insignificance of certain languages or subjects – such as television, fashion, advertising, cinema, commercial art and the media as much as a sickle, a hammer, a torso, a shadow, a pistol, a knife, Vesuvius, the Empire State Building, an electric chair, an outsider, a dollar – now find themselves outside [mainstream] society. So to be within society it's now necessary to agree, as Warhol did, on its insignificance and banality, in the sense of a *double* that is no longer meant to counter the world, but is rather a *copy* of it. This is the quest of an art that is not transformed into a tool for dominating reality, but rather acts as a simulacrum of it. At the peak moment of creative passivity, peak amorality, peak lack of criticism with respect to the social realm, the artist decisively refuses the devotional approach to art as the only 'high' language. Allowing other languages to flow into this one, or at least putting them on the same level – from fashion to cinema, advertising to publishing, commerce to catering, music to playbills, television programming to photographic montage – the artist perturbs and sabotages identity, bringing it into a world of hybrids where the ban on creativity weds the passivity called for by the quest for make-believe and seduction, thus becoming an active process. This process expands the confines within which art operates, thanks also to the blows it received beginning in 1964 from other pop artists and the Fluxus group, from George Maciunas to Jack Smith, Robert Filliou and George Brecht. This brings it to a roiling, boiling state, with the introduction of languages like performance art and happenings, photography and comics; no longer considered pure terrain, art becomes a global crossroads, spanning all types of activity, from pornography to comedy, event to spectacle, commercialism to dandyism, diversity to radicality. It also allows for free circulation among the various fields within the 'star system', as well as realms of quotidian, political, cultural, religious, sexual, commercial and cinematographic banality. This linguistic indetermination, begun in the 1960s in service to conceptual investigations like Arte Povera and body art, further incites the "reinvention of the medium", as Rosalind Krauss phrased it.[16] Here the traditional medium, used and put to use by Warhol and the pop artists, morphs into a hybrid entity, almost aesthetically autonomous. Indeed, if you look at the works of Dan Graham, Bernd and Hilla Becher, James Coleman, Victor Burgin and Ed Ruscha, the photographic image has become a reproducible entity in and of itself. No longer a document or portrait of people and things, as in the realm of pop, but a source that (again citing Krauss) defines the 'postmedium' condition. Everything developed in the use of various media through conceptual procedure strays from the mimetic process, which frames reality and tends to 'imitate' it, reaching toward a modus operandi in which medium – from film to television and the work of Paul Sharits, Michael Snow, from photography to sound recording, Art & Language to Lawrence Weiner – has become a tool of self reflection and reflection on its own linguistic and philosophical characteristics. In its 'look' and logic, the artistic entity becomes a mirror of itself and of its linguistic problems. With regard to book and magazine production, which continues to produce pages upon pages, the advent of the 'Global Village' leads art publishing to an ever greater mingling of image and text. With respect to historic publications – such as *Lacerba* and *Azimuth*, spanning from futurism to neo-dada – a paper support is no longer needed as a vehicle for the reproduction of works, and becomes a work of art in and of itself. This explains why Robert Barry, Joseph Kosuth, Bruce Nauman, Mario Merz, Carl Andre, Douglas Huebler, Michelangelo Pistoletto and Dara Birnbaum, from the 1970s on, exclude artwork labelling from their publications, in order to let the material and

images speak like words, as they constitute moments within the philosophical and creative discourse. Thus the book intermixes and intertwines with the other media of artistic expression, and is no longer identifiable according to traditional criteria, but becomes absolute visual communication, in both intellectual and optic ways. In accord with the same point of view, sound-based events are organised using telephones and other communication-based media and transmitted by disc or radio programmes, such as *Art by Telephone* (1969) and *Air Waves* (1977). Audio-discs also bring concerts by bands including artists like Larry Poons and A.R. Penk to the public; musical events reflecting the performances of Hermann Nitsch, Dieter Roth and Lawrence Weiner are staged and finally the 1990s feature rock bands like that of Robert Longo and Glenn Branca. Artistic approaches derived from the use of other communication tools, like telegrams and Xerox copies (famously, the *Xerox Book* by Ian Burn of 1968) are no different; in the same period television recording exploded onto the scene as an artistic instrument. The roots of the widespread interest in television led back to the *Manifesto del movimento spaziale per la televisione* (Manifesto of Spatial Movement for Television) – drawn up in 1952 by a group that included Alberto Burri, Lucio Fontana and Tancredi, among others. This text proclaimed, "We 'spatialists', for the first time anywhere, broadcast via television our new forms of art based on concepts of space . . . For us, television is the medium we waited for in order to unify and integrate our concepts."[17] At the end of the 1950s came the object-based experiments of Wolf Vostell and technological experiments of Nam June Paik; with them, television as-instrument was transformed into a revealed entity, fully declared in its formulation as object and electronic process. Its context is that of an event; it could be a décollage of materials brought to the screen, or an alteration of television-based language as a process determined by electronics. The results of such multimedia visions, for now, are 'distortions' and 'alterations', and are part of neo-dadaist and Fluxus processes. In the 1970s, this displacement of medium makes way for other media: first came the performances of 'land artists', including Gerry Schum's watershed *Videogallery*; then came the 'body artists', from Vito Acconci to Bruce Nauman, William Wegman and Carolee Schneemann; it finally became a discourse on the very idea of *medium*, from Marcel Broodthaers to John Baldessari. Videotapes came into production, and were initially commercialised as works of art by the Howard Wise Gallery in New York. These led to an analysis of the medium, disassembled into its various interactive components, in the work of Peter Campus and Frank Gillette. Elsewhere, reactions to video's invasion into the world of communication begin to arise, such as Joseph Beuys's *Filz TV* (1968), but its uses are fundamentally directed toward creating completely new works, like Paik's videosynthesizer, in which the televised image, recorded and modified, makes ways for an image that constructs itself, as a 'thing'. At this point all video works, from 1970 to 1990, oscillate between two poles: first, a broadcast that reflects, in both real and deferred time, the context of action; second, self-generated images, resulting from intertwined electronic figurations and abstractions. The same can be said of photography and cinema, which between 1960 and 1990 are expressed as autonomous entities in which the image is no longer a reflection of a real condition, but rather of a fantasised construct. From Stan Brakhage and Jack Smith to underground cinema, and collage artists and photographic portraitists from Bruce Conner to Cindy Sherman, film and the photographic image depend on the poetics of the artist. They no longer mirror a reality, but instead reflect a fantasy-based dream world. The morph into 'scenes' in which the artist makes a spectacle of himself and his vision, using material and technical tricks as often as behavioural and process-based fictions: this leads to the construction of an 'improbable' reality – a reality also enigmatic and surprising, from Gregory Crewdson to Vik Muniz and Sam Taylor-Wood. Thus the surfaces of the 1990s – lit by film screens or developed on photographic film – are transformed into an 'intermediary' between straightforward

medium and a more interpretive approach to it, such as in the work of Bill Viola, Jeff Wall, Douglas Gordon, Gary Hill and William Kentridge. Such work no longer guarantees a story, but rather offers a judgement articulated in the analysis of speeds and styles, montages and fictions, illusion and the history of the means *mise en scène*. Elsewhere, cinema's expressivity returns to considering the narration of history, stories and facts, and finds itself used to distribute portrayals of both reality and fantasy, as in the films of Julian Schnabel, Mimmo Paladino, Robert Longo, Matthew Barney, Yang Fudong and David Salle. Here, film acts as a package dealing with art (Julian Schnabel's *Basquiat*, 1996), literature (Mimmo Paladino's *Quote*, 2006), science fiction (Robert Longo's *Johnny Mnemonic*, 1995) and fable-like tales (Matthew Barney's *Cremaster Cycle*, 1994–2002); it makes magnificent both visible and invisible realms – fuelled by artistic, poetic and technological 'glory'. Elsewhere, film and video projection exist in a critical terrain, bent on the analysis of social status, and instead of recalling the enthusiastic language of communication, they refer to its political and critical uses. They shed the technical, spectacle-inspired ingenuity of the medium in order to create a discourse on anthropology and the history of ethnic and sexual minorities. Film and video are no longer 'Hollywood' productions, but become an exercise in artists' tragic and ironic experiences, from Steve McQueen to Pipilotti Rist, Eija-Liisa Ahtila, Francesco Vezzoli, Paul Pfeiffer, Krzysztof Wodiczko and Grazia Toderi. In all these experiences, also concretely expressed in the form of 'film and video-environments', the moving image aspires to establish itself as an 'object', a film- and television-based entity that no longer enters into broad circulation alongside – and in contrast to – other media, but establishes itself as a 'constructive', autonomous entity. This means that projections no longer tend to inform, but rather construct images and stories that broaden artistic logic, calling for different aptitudes and sensibilities. This coincides with the birth of DVD as product and video-installations as 'art environments'; the key to their interpretation is rooted in 'artists' architecture',[18] from Italian futurism to Russian constructivism, dadaist settings, the dream architectures of surrealism, pop art environments and the minimalist spaces of light and sign. To these we now add projection, which increments visual information and restores narrative and active aspects in the form of environmental art. Projections are no longer mysteries, luminous reductions in space adhering to traditional metaphysical, abstract veins – rather, they are accumulations of information and data, stories and experiences whose contours reflect upon concepts of public and private society. Its electronic extension – which tends to transform the physical display of the art object into a virtual broadcast – while it aims to establish itself as a *thing*, inevitably pushes artistic research and practice toward virtual imagery, forms connected to the interactive, digital realm. Beginning in the 1990s, artistic practice became the creation of images as a result of electronic aggregations, and also became transmittable at extremely high speed, across all sites and networks of the web or Internet. Such transmissions occur on a planetary level, and open up the final frontiers of visual production. The images produced by an artist can now appear on the screen of any and every computer and constitute a communicative event – to such a degree that they bring all cultures, across the globe, into contact. They can still continue to 'portray', abstract, modify and inform, just as they can create from scratch a discourse on the multimedia design of a new universe of characters and environments. The artist's digital alter ego extends the reach of his artistic practice, allowing him to construct 'immaterial sculptures and paintings' you can enter into and travel just like in the three-dimensional world, or interact with other virtual spaces, create an avatar to represent them or even make infinite modifications to the number of imaginary possibilities, as seen in the work of Lucas Samaras, Matt Mullican and Pierre Huyghe. This is the fullest extent of one reality of artistic imagination, now further enriched by another aesthetic experience – the virtual experience, totally multimedia and interactive. Here the frontiers of tech-

nology merge with perceptive qualities, as well as the spread of the 'public's' participation – but now the range of innovation is infinite and beyond all imagination. Additionally, the degree of communication's expansion has become exponential. Through virtual technologies, the creation of contacts is uncontrollable, such that the sensitive and formative extensions of art are no longer subject to any restrictive definition: this is yet another step in the direction of an extinguishing and dissolution of all that is real – and now all that is virtual – that art has always sought out, surviving early on as a place of privilege and, later, as common ground shared by all media, to finally reach, today, total mimesis, such that our imaginary is totally virtualised and coincides with the latest technological processes. History moves on.

[1] Translator's note: the original Italian phrase used is *Dissolvimento o dissolvenza?* The latter term has primarily cinematic connotations and is used for both fade-in and fade-out transitions; since the Italian does not discriminate between the two types, the English uses both.

[2] M. Perniola, *La società dei simulacri*. Bologna: Cappelli, 1980, p. 133.

[3] I have insisted on this 'critical' approach for decades: beginning in 1965 with my collaboration on the architecture magazine *Casabella*, then in my monograph on designer Marcello Nizzoli and ending up in the confusion and fusion of techniques and languages of Arte Povera in 1967. In 1976 it was expressed in my curation of the large, historic exhibition *Ambiente-Arte, 1900-1976 Dal futurismo alla body art* (Environment-Art, 1900-1976 From Futurism to Body Art, for the Venice Biennale) and continues throughout the following years. In 1979, for *Artforum*, I collaborated with Ingrid Sischy on a consideration of 'fusion' in the arts, which reached its height in the 'desecrating' cover dedicated to fashion designer Issey Miyake. This blows up in the 1980s with the series of exhibitions dedicated to the intermingling of the arts: *Identité Italienne* (Centre Pompidou, Paris, 1981); *European Iceberg* (Art Gallery of Ontario, Toronto, 1985); *Futurismo & futurismi* with Pontus Hulten (Palazzo Grassi, Venice, 1986); *Memoria del futuro* with Ida Gianelli (Museo Nacional Reina Sofía, Madrid, 1990); *Creativitalia* with Gaetano Pesce (Railcity Shiodome, Tokyo, 1990); *The Italian Metamorphosis 1943–1968* (Solomon R. Guggenheim Museum, New York, 1994); *Art & Fashion* with Ingrid Sischy (Florence Biennale, 1996); *Andy Warhol: A Factory* (Kunstmuseum Wolfsburg, 1998; Guggenheim Museum, Bilbao, 2000); *Arte & Architettura* (Genoa, 2004); *Tempo Moderno* (Palazzo Ducale, Genoa, 2006); up to the present with *Vertigo: A Century of Multimedia Art, from Futurism to the Web* (MAMbo, Bologna, 2007). All of this is

accompanied by countless books on the key figures of art, design, graphics, architecture and photography, including monographs on Marcello Nizzoli, Frank Gehry, Robert Mapplethorpe, Lella and Massimo Vignelli, Ugo Mulas, A.G. Fronzoni, Gaetano Pesce, Gae Aulenti, Mimmo Jodice, Giovanni Gastel, Mario Giacomelli, Giorgio Armani, Merce Cunningham, Richard Meier, Rem Koolhaas and Herzog & de Meuron.

[4] A strong push toward a more anthropological view of art came with Pontus Hulten and the series of exhibitions at the Centre Pompidou in Paris: *Paris–New York* (1977); *Paris–Berlin* (1978); and *Paris–Moscow* (1979). Its methodology influenced major European exhibitions, from Harald Szeemann's *Der Hang zum Gesamtkunstwerk* (1983) to Jean-Hubert Martin's *Art & Pub* (1990) and Jean Clair's *L'âme au corps. Arts et sciences 1793–1993* (1993).

[5] A prime example of this 'monotheistic' approach was *High & Low* (Museum of Modern Art, New York, 1990).

[6] G. Celant, "Reasons for a Metamorphosis", in *The Italian Metamorphosis*. New York: Solomon R. Guggenheim Museum, 1994, pp. XVI–XVII.

[7] M. Perniola, *La società dei simulacri*, *Op. cit.*, pp. 136–137.

[8] Translator's note: the original Italian title is *Vertigo. Il secolo di arte off-media dal Futurismo al Web*. 'Off-media' is a term the author coined in an essay on arts and media published in 1977. Used long before our adaptation of the now ubiquitous term *multimedia*, his phrase has much the same meaning.

[9] Translator's note: this is a play on words. The author states that "il problema di comprendere, del prendere con sé, si sposta . . ." Here *comprendere*, 'to comprehend', is deconstructed into its roots, *con* and *prendere*, which respectively mean 'with' and 'to take/get'. Hence *comprendere* can be understood both as 'comprehending/understanding' and 'taking with', as in a viewer 'taking' or 'getting'

meaning from a work of art he understands.

[10] The traditional idea of an interaction between art and technique, in either collective or individual form, was present in the twentieth century at both Walter Gropius's Bauhaus and Michelangelo Pistoletto's more recent Cittadellarte, where multifaceted and multimedia creativity were autonomously presented in a veritable universe of interactions, aligning itself with a much richer, more complex approach, partially based on chance and unforeseen factors. Still, today the idea of a 'site' open to any and all creative probabilities – be they called museums or something else – would have to more closely resemble YouTube, where uncontrollable, elementary experiences converge and are downloaded; the institution must interact with these phenomena.

[11] Regarding multimedia totality, see G. Celant, *Off Media. Nuove tecniche artistiche: video, disco, libro*. Bari: Dedalo Libri, 1977.

[12] Some of these observations on Andy Warhol are from G. Celant, *Andy Warhol: A Factory*. Wolfsburg: Kunstmuseum Wolfsburg, 1998.

[13] G.R. Swenson, "What is Pop Art? Answers from Painters," *Art News*, 62, November 1963, p. 26.

[14] A. Warhol, *The Philosophy of Andy Warhol: From A to B and Back Again*. New York: Harcourt Brace Janovich, 1975, p. 148.

[15] G.R. Swenson, "What is Pop Art? Answers from Painters" , *Op. cit.*, p. 26.

[16] See R. Krauss, *A Voyage on the North Sea: Art in the Age of the Post-Medium Condition*. London: Thames & Hudson, 1999.

[17] Cf. *Manifesto del movimento spaziale per la televisione*, Milan, 17 May 1952.

[18] Translator's note: the original Italian term used is *architettura d'artista*, a somewhat curious term in English, as it isn't the same as the perhaps more eloquent, albeit ambiguous term 'art architecture'; the closest parallel could be seen in the term *libro d'artista*

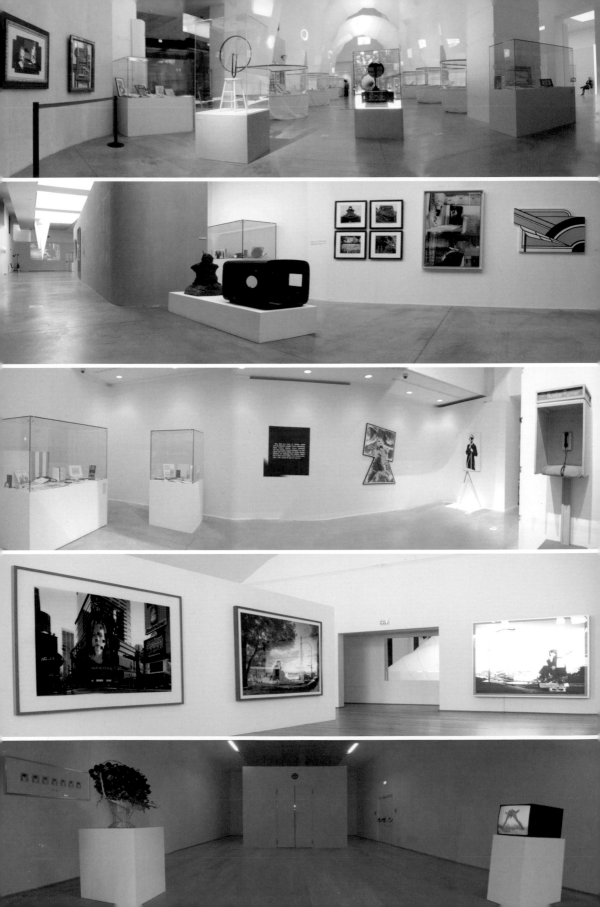

Gianfranco Maraniello **The Subject of the Media**

Vertigo exhibition views

The twentieth century is the era when technique becomes clarified as a paradigm that not only interprets reality but is one of its constituent elements, and this has been acknowledged as an inexorable upheaval. What seemed to be auxiliary has now become central. The world is informed by technique, and man is formed within it. The speed and radical nature of its developments, and above all its dissemination and pervasiveness, have produced anxiety in life practices and in the most wary philosophical reflections of the past century. It is not so much evidence of the progressive subjugation of man and his tools that is disturbing, but rather the consideration that we are by no means prepared for this radical change and "that meditative thinking is worthless for dealing with current business. It profits nothing in carrying out practical affairs."[1] Art is no exception. It has revealed itself within the mandatory conceptual matrix and has taken on the task of not only being produced, but also taking place, fully conscious of its own reasons. From the historic avant-gardes to the present, there has been no escape from the confrontation – both euphoric and dramatic – with the means at art's disposal and the resulting sensibility. The museum, demolished by furious futurist ideology or "packed away" by Marcel Duchamp in his *Boîte-en-valise* (*Box in a Valise*), also appears "without walls." This is what André Malraux described,[2] flattening artistic forms into the compendium of a book, creating a virtual collection, thanks to the power of photography and its "new democratic vision," which would have stripped works of their quality as objects, expropriating even their quality of originality. These are just the first symptoms of what continues to spur on not only the statute of art, but also our very forms of experience. Indeed, what could be the subject of representation, when it is proclaimed that reality is fundamentally shaped by the media? What ineluctable consequences result, and what must we take into ac- **17**

count for every reflection on the meaning of any figuration of a scene of the world? What does art look for, and where is it sought in the age of technique? What succumbs to the possibility and fact that Duchamp is "the author" of the ready-made and, at the same time, has painted a grandiose static image of movement with his *Nude Descending a Staircase*, tried his hand at experimental film, with the abstract *Anemic Cinema*, or turned his back on producing works of art and transformed himself into Rrose Sélavy, or devoted himself to playing chess, or turned his own life into the biography of a heteronym and a work of art?

The twentieth century has shattered the sense of time, disseminating the ecstasy of the present through the affirmations of radio, telephone, phonograph, cinema, television and the advent of the digital age. These are forms of writing and reproduction of the sensory world; they are media technologies that, without precedents in terms of speed, have contributed to a revolution in our perception of reality and of ourselves. "Vertigo" is precisely the disturbance of equilibrium that manifests itself through the sensation of a shift in the relationship between the body and its surroundings, or between the surroundings and the body. In this historical phase, the need for an adequate positioning of the ego, in a world that has experienced the instability of its coordinates, needs to be framed within a Copernican perspective. Locating oneself within the effects of the media revolution of the past century signifies harmonizing man's new horizons that have opened up from the decentralization created by technological vertigo.

This is not the century of inventions. The nineteenth century had created all the necessary conditions, and only a few decades were needed to mark the shift from a world of predictable possibilities to one contorted by the dissemination of new media. Art observes this phenomenon systematically. cubist simultaneity still seems tied to the outcomes of Paul Cézanne's painting. And yet the "present," the "here and now" of the work have gotten complicated. The coexistence of planes in cubism's analytical phase already points to the altered availability of images and to the heightened tension of the visual experience, fragmented and recomposed by virtue of a sensibility informed by new possibilities for recording and reproduction. Pablo Picasso and Georges Braque are among the first to look at the openings provided by various media that had burst onto the scene. Art readies itself for a confrontation with mass culture that is spreading through these channels. What is required is the practice of "montage", the give and take of meaning with regard to the impulses and occasions derived from communications and from the expressive modalities guaranteed by other (and not only artistic) disciplines and practices. It is no longer a question of "knowing-what-to-do," but of "knowing-how-to-do". The invention of papier collé presents a threshold for an ethical approach, according to which art escapes from the autonomous regime of the production of forms and is presented as a combinatory development of figures in a world removed from the enchantment of its presumed objectivity and permanence. News clippings arranged on canvas set the stage for a transitory and everyday existence that is taken on and distorted, rather than invented by the imagination of the painter/creator. Like twentieth-century science and philosophy, art takes advantage of its own premises, investigates its own possibilities to orient itself within the hypertrophy of technical production. And it discovers its own specificity, in its capacity to assimilate and reconfigure experience, in an era when new media are being introduced, along with prophecies about their effects. It is precisely these new tools, made available to art, that allow a proclamation of a future world, according to an ideology of tomorrow that begins with futurism and still exists in promises about developments in medicine, communications, finance or art making. And these promises are subject to specialized knowledge and to the need to entrust ourselves, with resigned ignorance, to "how we will live",

thanks to technological applications in the various sectors of science and culture.

Thus technique is not the tool, but the principle of the avant-garde, of a perspective that bets in advance on the present. Futurism understands not only its potential, but its historical necessity. It straddles the urgencies of the new media and labors under the illusion of dominating them. And it is no coincidence that it is in Le Figaro – in the pages of a newspaper – where the movement seeks to ally itself with mass culture, publishing its manifesto. The Futurist ideology is not limited to self-expression or to communicating; it is also propagandized. Magazines and megaphones, voices and light modulators announce the eruption into a new space and time, which surpass the static arts through the integration of its practices with the most advanced technologies. Indeed, time and space are declared to have died yesterday (*Le Temps et l'Espace sont morts hier*), in favor of "eternal, omnipresent velocity," according to a metonymic expression, because the past, the day just completed, should be considered death itself. However while Filippo Tommaso Marinetti's manifesto claims responsibility for the fact that the oldest in the group "are thirty" and that it is toward Italy that the "devastating and incendiary violence" is directed, futurism reveals an awareness of how to act directly on a social plane, but localizes its own activity in a specific time and place, in the contingency of a nation and in the name of a new generation, that is, turning art into an auxiliary tool of a plan for political action. It is according to these conditions that a program can be drafted; it is in the analysis of the time and tools available that a future world can be hypothesized and a utopia can be produced that becomes a shared project. This point does not escape Naum Gabo and Anton Pevsner, who, in their 1920 Realistic Manifesto, polemically observe that "space and time are reborn to us today" as unique forms upon which life is constructed and upon which an art can be built that must be measured, not with the yardstick of beauty, but with "the plumb line in our hand," like an engineer who designs bridges, like a mathematician who develops formulas of orbits. However this means not putting off to the future the true "constructivist" project, not yielding to the lies or consolatory ideas of a time that has not yet arrived. "Let us leave the future to the poets / We shall take today." This is the approach taken, a few months later, by Aleksandr Rodchenko and Varvara Stepanova, in their Program of the Productivist Group, which takes into consideration "the material elements" of the time and establishes "the tasks" of the proclaimed movement, in formulas that begin with: "1. Down with art, long live technique!" and conclude with "6. The collective art of the present is the constructivist life!" But what needs to be fulfilled on the basis of planning is evidence of an alienation that is in progress. The avant-gardes require participatory practices and conscious support; in other words they imply the abandonment of ingenuous subjective expression. Twentieth-century art also loses the autonomy it had made use of, from time to time, to free itself from being an instrument of power of the hegemonic or emerging class. The politicization of futurist movements – both Italian and Russian – or the anti-esthetic project enacted by dadaism, constructivism and surrealism, as Peter Bürger maintains[3], through the integration of "art and life", always and forever marks their subjugation to a history that is "yet to come". The progressive and emancipative ideology of the avant-gardes undermines fidelity to archetypes and to every type of classicism. A logic is imposed that trusts in incessant experimentation and in perennial renewal, precisely like an economy that necessitates constant growth. If recession becomes a nightmare for social and political stability, the art of the twentieth century is consigned to a state of entropy without pause and to a pursuit of the new, which is revealed to be a form of adaptation to the technical possibilities of the moment. These, however, assert themselves in new and pervasive ways, so accelerated that art makes invention coincide with discovery, with the capacity to collect and synthesize the contingencies of one's own time. For

the entire century, there is an obsession with the dating of works, with originality reduced to velocity of interpretation and appropriation. And this witnesses a regime of competition among artists, where the innovative or imitative character of a work can be determined by a matter of months, resulting in art that is subject to the rhythms of industrial production. To speak of a zeitgeist, a "spirit of the time," is a formula that obscures the fact that taste and research are influenced, and perhaps even determined, by the triumph of the power of technique, whose symbol is the assembly line: the factory is faster than man and the worker must learn to manage the fixity of his position while "the machine" revolves around him, forcing work upon him. These are the "modern times" that, in a famous film sequence, Charlie Chaplin challenges in Herculean fashion, interfering with the chain of production, arresting its rhythm and risking being devoured by its gigantic rotating gears. But escaping danger, he skips about, lubricant in hand, and begins to mischievously spray it in the face of whoever tries to stop him, as if to loosen up the gears that imprison him, but basically yielding to the reigning Taylorism and treating man like a machine that needs to be oiled.

The avant-gardes, celebrating technique and creating new "mythologies" that result in the automobile being considered "almost the exact equivalent of the great gothic cathedrals,"[4] actually capitulate to this phenomenon. The dominion of technique entails economic and military hegemony. The United States imposes new standards on modes of production and on a new "industrial culture." As measured by the metronome of Man Ray's Perpetual Motion, the accelerated rhythms of art turn to America as a territory that is a repository of a new progressivism, capable of absorbing technological advancement instead of framing it structurally in the service of the tragic ideologies that arose in Europe during the first half of the century. Once again, it is time that is an issue. While the Independent Group's exhibition at the Whitechapel Gallery in London is entitled, significantly, "This is Tomorrow" (1956), American pop art immediately shows itself to be an analysis and an appropriation of the everyday, an assimilation of the present. Mechanical repetition does not produce alienation, where one can recognize a social class destined to revolution. The people have become consumers, and industrial production models determine the principles of conscience of a pervasive and egalitarian mass culture. The repetition of forms and messages mirrors a society that mass-produces and advertises its own products, making them familiar to us and inducing us to prefer whatever has the best packaging. Paintings show the effects of encounters with other media: Ed Ruscha with cinema, Roy Lichtenstein with comic strips, James Rosenquist with posters, Andy Warhol with newspaper photos. Art seems to adopt the surfaces of screens and the supports of mass communications so effectively that controversies regarding complacency with or criticism of the specific historic moment are pushed to the background. Repetition forms the contemporary subject, familiarizes it with trauma and is itself a media filter that puts it in touch, televisually, with the violence of traffic accidents, racist attacks or the electric chair and, at the same time, allows it to participate, at a distance that can be modulated, with the dramas of society and entertainment icons, such as Jacqueline Kennedy after the assassination in Dallas, or the now deceased Marilyn Monroe or Elvis Presley. Warhol's silk-screen processes are the measure of the possible integration of affect and detachment produced by the triumph of technique, by the psychological catastrophe that leads the artist to confess a desire to be a machine that can mass produce images-goods that give back, in "real time," everything that its strategic nihilism has metabolized. Pop art is not avant-garde. And the "real time" formula declares the need to reify what the media have translated into virtuality, thanks to the possibility of transmitting even the present everywhere. What is real is what returns in repetition, what is real is what coincides with filmic time, like the six hours during which John

Giorno sleeps in front of Andy Warhol's fixed camera. While in Europe the avant-garde is reorganizing with Situationism and New Realism, with ambivalent desires to reposition the logic of consumption within a project for society's transformation, Warhol declares his adherence to media culture, maintaining: "just look at the surface of my paintings, my films and me, and there I am. There's nothing behind it".[5] Pop art, regardless of sometimes opportune historiographic reconstructions of a nationalistic nature, is endemically American. It is the triumph of eclecticism of a Duchampian matrix, in the light of new modes of production. And while Duchamp tries his hand at experimental film and turns the museum into "the cinematographic film"[6] for recording the occurrence of the readymade, Warhol legitimizes the industry itself as a place of cultural ideation, establishing the Factory, promoting music, film and every expressive form that emphasizes the present and the glamour of communications, to the point where he can transmit live, on Andy Warhol's TV.

Art does not compare itself with other practices; it is not the subject of multidisciplinary crossovers. Eclecticism and infinite exploration were implied by the need for a comparison with technique and the media possibilities that were progressively introduced and assimilated. This common denominator excludes orientations that it intends, knowingly, to give to its own activity. The history of twentieth-century art is the obligatory rethinking of what is constituently "off media". The acquisition of awareness and a restructuring of the artist's relationship with his own time reside in the recognition of being not subjects of technology, but subjected to it. And it is the subject itself that is referenced by all the neo-avant-gardes and by those emancipative movements that appeal to the need for the reawakening of the conscience, domesticated by dominant ideologies.

In George Maciunas's 1963 *Fluxus Manifesto*, the intention to promote a revolutionary flood is only a provisional statement for a movement that continually found itself paradoxically needing to state that it wasn't a movement. The desire is to no longer fall into enslavement to a task, but to be able to count on free contributions of participants who were not regimented by the production of "dead art", namely inertial and commodified objects. It is significant that Maciunas designed business cards for the Fluxus artists, attempting to give each of them specific typographic features, as if he wanted to symbolize the absolute individuality of each man, but without rejecting the technical possibilities of presentation and dissemination of the ego that is allegorically implied in the use of such personalized cards. In its polemics with pop art and with all "'intellectual', professional and commercialized culture", Fluxus does not negate history, but tries to remove its materializations through processes of mimesis and the defetishizing of its products, reactivated by performative possibilities and a receptiveness to chance, by vitalistic participation, involving all artistic registers (music, poetry, theater, graphic design), and paying particular attention to new media. Television, with its live recording, will be particularly investigated in various ways and will become the subject of technological, even anthropomorphic, collages, rapidly marking the passage from the combination of video and performance to the autonomy of "video art" as a genre, based on the certainty of the fact that, as Nam June Paik states, if "collage technique has replaced oil painting, so too will the cathode tube replace canvas". Television, video and the availability of low-cost video cameras lead the artist/director to a direct relationship with filming and the viewer to a familiarity with the screen, quite different from the ritualism and technique of the cinematographer. Video, in fact, becomes not only a voyeuristic occasion for a private view of images in motion, but a sort of technological mirror for observing oneself and reflecting on the traumatic alienation of self as a subject of dynamic representation. Video progresses from a documentary occasion to a privileged tool of investigation of precisely that body that the video

tape and cathode tube seemed capable of de-somaticizing. In Carolee Schneemann's trans-formative actions for video camera, Vito Acconci's eroticism and seduction in his invitation to the viewer to move beyond the screen, Bruce Nauman's studies of the position and prod-ding of his own body, and the extreme physical tests of Marina Abramovic or Chris Burden, the subject returns to the center of attention, in disturbing spatial-temporal dislocations. Like a solitary confinement cell, the TV box unleashes aggressive drives. The narcissism Rosalind Krauss points out[7] as an essential quality of video should be associated with the violent in-stincts that are turned upon the filmed body or the television itself. And if the rock musician terminates a concert by destroying the instruments of his performance before the public, Joseph Beuys had already rebelled against the medium and had worn boxing gloves to confront *filz TV* (1970), and in 1978 Vito Acconci, working at The Kitchen, that mythic laboratory in New York, created an installation that was significantly titled VD lives/TV must die. More than a form of renewed Luddism to annihilate the alienating power of technique, these attitudes seem aimed at the challenge that the subject presents, in order for the artist to comprehend his new positioning, as if media vertigo had brought out the pre-technological unconscious, in a phase of traumatic and sudden transformations. By repositioning himself, the artist also analyzes the architecture of the new media. Televisions become materials for sculptures, and the pos-sibility of using images in closed-circuit recordings leads Dan Graham and Bruce Nauman to create environments for radical investigations of self-observation that phenomenology and psychoanalysis could not predict. When Joan Jonas superimposes her own body on the in-verted and prerecorded image of herself and reconstructs – naming and signaling with her finger – every detail of her face in *Left Side Right Side* (1972), what becomes evident is the need for a recomposition of the self and an urgency for orientation within the scenario brought about by the unconventional perspectives of new technologies. These now provide the tools that accompany all the most relevant tendencies in contemporary art. From land art to con-ceptual art, from minimalism to Arte povera, none of the possibilities offered by the advent of the so-called "new media", or the influence that these have had on the rethinking of cin-ema, books or photography, are overlooked. It is not possible to ignore their use, because art ceases to search for absolutes and instead addressed "the changes, limits, precariousness and instability"[8] for which the media are the cause, not the evidence. The confrontation with tech-nique is a necessary passage because the subject discovers that it still can be the author of a story. Where there was a plan, there is now the self-assurance of an art that knows its own condition, but has lost the faith that, in the neo-avant-gardes, was derived from ongoing po-litical and economic processes and from utopias that are now, instead, disregarded. And yet we are witnessing a paradox whereby it is precisely that self-assurance that represents the re-sponse to the crisis in planning, and it is the egotism of a subject resigned to its own impo-tence that lets us see the availability of technique that is once again instrumental, although directed toward narcissistic creation. The fragmentation, if not the solitude, of man and of today's artist provokes a concentration on the self that is the other face of the cynicism and loss derived from the insignificance of acting within the social realm. The history of art and of the media, the history of art as "off media", is now framed by the freedom of manipula-tion of what is offered as "obsolescent and filed away" from the point of view of those who now feel outside a chronological continuum. The new tools accentuate this perspective. Video projection revives the cinematographic vision and, when it is not applied with direct refer-ences to art-historical precedents, it is precisely cinema that is offered as a material to be reused and turned into spectacle. The loop triggers continuous rhythms and violates the linear log-

ic of the story; digital manipulation entails a distrust in the image as a document of a pre-

sumably accepted reality; the Internet offers an inexhaustible and simplified sampling of information, always at hand and without verified authorship, which makes any source admissible. Just as the introduction of the computer has modified the way we write, and instead of sequences of ideas, we have begun to "think" in blocks of texts, so too history loses any eschatology because it is not framed within a linear perspective and, therefore, cannot be finalized. We do not arrive at the present through a chronology, but instead seek to make our own actions and research valid and current, with an ecological arrangement that filters out the disorienting spamming of contemporaneity. The dangerous drift of present-day loss resides not so much in the resignation of our own impotence, but rather in the plausibility of ignorance, in the apologetics of a new world, expanded beyond measure and impossible to grasp in its totality. Meanwhile, what is called for is a new anthropometry of the present, an ethics of the subject, capable of containing its own time and of affirming its own position amid the Odyssean vertigo that continues to call out to it.

[1] M. Heidegger, *Discourse on Thinking.* New York: Harper Perennial, 1969.
[2] A. Malraux, *Le musée imaginaire* (1947, Geneva). Paris: Gallimard, 1965.
[3] P. Bürger, *Theory of the Avant-garde.* Minneapolis: University of Minnesota Press, 1984.

[4] R. Barthes, *Mythologies.* New York: Hill and Wang, 1972.
[5] A. Warhol, in *America*, 1985.
[6] This image is borrowed from Nicolas Bourriaud, who, in his *Formes de vie. L'art moderne et l'invention de soi* (Paris: Editions Denoël, 1999), brilliantly analyses the rela-

tionship between cinematographic experimentation, the ready-made, art and life, in the work and actions of Marcel Duchamp.
[7] R. Krauss, "Video: The Aesthetics of Narcissism", *October*, no. 1, 1976.
[8] G. Celant, *Arte Povera.* Milan: Mazzotta Editore, 1969.

Vertigo

Germano Celant

Taking shape from the richly intertwined history of multimedia out-crossings in art, the exhibition *Vertigo* reflects its polymorphous twists and turns, drawing upon an itinerary where works of art, films and documents come together. This spectacular mixture, which takes shape in an exhibition design by Denis Santachiara, is distinguished by its elastic, flexible, extremely soft surface which, set against the walls or independently inflated, highlights the fluidity between the architectural elements housing the various currents of artistic language across different media. Each hall therefore becomes part of a warp and weft – made up of sounds and noises, photographs and paintings, sculptures and objects, videos and installations – that gives rise to a complex, multi-directional fabric. The exhibition begins with a dark room where we hear a combination of the voices and music of twentieth-century artists interested in the intermingling of technological experiments, from Marcel Duchamp to Filippo Tommaso Marinetti, Kurt Schwitters to Jean Dubbufet, Andy Warhol to Joseph Beuys, while their names are projected onto the floor. From this sound-filled, extremely compressed antechamber, viewers move into the vast space around which the architectural itinerary is organised, rotating from one floor to the next within the former *Forno del Pane*, or city bakery, which now houses the museum. The former bakery building has been filled with inflatable, self-supporting structures that run all the way up to the high ceiling and form five large arches that visually recall the shape of radio waves: this becomes an immaterial nave and in turn an aerial screen upon which film excerpts are projected, including work from Hans Richter to Dziga Vertov, Germaine Dulac to Luis Buñuel, Lazlo Moholy-Nagy to Luigi Veronesi. At the centre is a triangular showcase that acts as a concrete, visual backbone for the space,

displaying a stepped progression of technological equipment – from old gramophones to the first radios, the bulky movie camera to the imposing television monitor, the compact computer to the tiny iPod – which marked the development of media across the twentieth century. All around, on the mezzanine levels and display cases that form the plinths and supports of the inflatable arches, are paintings and sculptures, books and photographs, vinyl records and objects, all combined with sound poetry and artists' music. This eruptive sequence, created by echoes running between one vitrine and the next, attests to the complexity of the multi-sensory research carried out by the historic avant-garde movements, from cubism to futurism, constructivism to neoplasticism, dadaism to surrealism, all the way up to abstract or informal expressionism, Nouveau Realisme and Fluxus. The beginning of these intertwined lines of research is signalled by futurist works, archetypes of the movement that expanded the concept of aesthetic intervention to include all languages; those are then contrasted by the rigid formalism of the cubists, interested solely in the language of colour and volume. The former section includes paintings by Giacomo Balla and Fortunato Depero, photographs by Anton Giulio Bragaglia and sound recordings by Marinetti, while the latter section on cubism is represented with paintings by Pablo Picasso, along with books, films and magazines by Fernand Léger and Georges Braque. At the very centre, between these two opposites, is dadaism, with the 1913 *Bicycle Wheel* by Duchamp, a fundamental figure in terms of technical and object-based experimentation. In the large display cases set opposite one another, the exhibition unfolds with collages by El Lissitsky and Gustav Klucis, samples of sound-poetry by Raoul Hausmann and Tristan Tzara, photographs by Man Ray and Laszlo Moholy-Nagy

and books by André Breton and Salvador Dalí, finally arriving at Lucio Fontana's cuts and Alberto Burri's materials, the papers by Piero Manzoni and Enrico Castellani and the multiples by Bruno Munari and Luigi Veronesi. The main gallery concludes with the objects and groupings by Fluxus and a video installation by Nam June Paik, pioneer of video art and multimedia installation.
The side passage leads to a section on pop art, with its interest in filling the gap between high and low culture and its use of the new mass media, from comics to posters, advertising and consumer products. Although they nevertheless helped carry on the discourse regarding painting and sculpture, neodadaist Robert Rauschenberg and pop artists like Roy Lichtenstein, Claes Oldenburg, Jim Dine and James Rosenquist all felt a need to integrate pop culture iconography into their artistic languages, which also took the form of books and vinyl discs, photographs and performances. Certainly, the fundamental figure in this media-based uprising is Warhol, whose artistic practice ended up including all modes of communication – from films to silkscreen prints, photography to food, fashion to architecture, books to vinyls, his collaboration with the Velvet Underground and the production of his own television show, the "Andy Warhol Show".
Between the 1960s and 1970s minimal art, Arte Povera and conceptual art emphasised the expressive and informative properties of material and anti-material, the industrial and natural properties of both the physical and the mental, arriving at a progressive reduction of the means used in art making, ever more distant from painting and sculpture. Next to installations by Sol LeWitt and Carl Andre, the mirrored surfaces by Michelangelo Pistoletto and neon proliferations by Mario Merz are

24

books by Giulio Paolini, Alighiero Boetti and Luciano Fabro. On monitors that recall the advent of video art, a language intertwining art and television technologies, are the corporeal and ephemeral works produced during the period of body art and land art. The fundamental works here are videos by Gerry Schum, pioneer of this technological approach to contemporary artistic research, documenting the performances of Joseph Beuys, Gino de Dominicis and Bruce Nauman, as well as the land-based interventions of Walter De Maria, Michael Heizer and Robert Smithson. Following them, the experimental possibilities of the medium are explored by Vito Acconci, William Wegman, Michael Snow and Peter Campus. The conceptual artists – from Joseph Kosuth to Lawrence Weiner, Robert Barry to *Art & Language*, Hanne Darboven to Marcel Broodthaers, John Baldessari to Bernd and Hilla Becher – present their reflections on the theoretical and philosophical meanings of art, ultimately attributing value to the design and structural phases more than to their visual result. They dematerialise the work and find in both writing and photography the appropriately detached, impersonal means for communicating the logic of art.
In the 1980s came a return to pictorial tradition and more intimate, personal discourse, albeit focussed mainly on historic and erotic themes. This led art to assume an iconic monumentality – as in the work by Anselm Kiefer – that was also reflected by the need to address a broader, mass audience in the public at large, drawing upon the popular languages of cinema: indeed, Julian Schnabel and David Salle are both painters and filmmakers; Robert Longo not only draws, sculpts and photographs, but is also part of a rock group; Enzo Cucchi paints, but also experiments with refined, surprising editions; and Luigi Ontani outlines self-portraits in watercolour, ceramics and photography. Moving in the opposite direction, the need to contrast the material and chromatic properties of neoexpressionist painting leads artists to produce objects and images that are highly mediated by technology, realised by camera, projector or video camera. Richard Prince re-photographs American media icons, Cindy Sherman re-presents herself in all her infinite identities, Laurie Anderson dedicates herself to video-musicals and Christian Marclay carries out sound experiments, while Bill Viola's videos combine ancient representations with his present day, attesting to the definitive integration of media within the history of contemporary art.
Aiming to focus on the present, on the upper floor *Vertigo* introduces an open reading of the artistic practices currently taking place, set in relation to the more historical practices through the continuous comparisons established between both upper and lower floors and outlined in the central nave. Well aware of the fact that today there remain no linguistic confines, barriers or exclusions with regard to media – such that the tools of expression and self-expression can range from pencil to digital camera, computer to canvas, telephone to photography, iPod to paintbrush – the overall exhibition is articulated in relation to the museum's architecture. Opening with video installations by Grazia Toderi and Francesco Vezzoli, the exhibition continues with film stills by Matthew Barney, photographs by Vanessa Beecroft, Andreas Gursky, Gregory Crewdson, Jeff Wall, Thomas Ruff, Shirin Neshat, Thomas Struth and Vik Muniz. It proceeds with Tony Oursler's videos, films by Yang Fudong and Steve McQueen, and moves on to installations by Matt Mullican and Lucas Samaras, the preparatory drawings for films by William Kentridge and concludes with developments in video by Paul Pfeiffer and multimedia works by Pierre Huyghe.

Ground floor
MAMbo

First floor
MAMbo

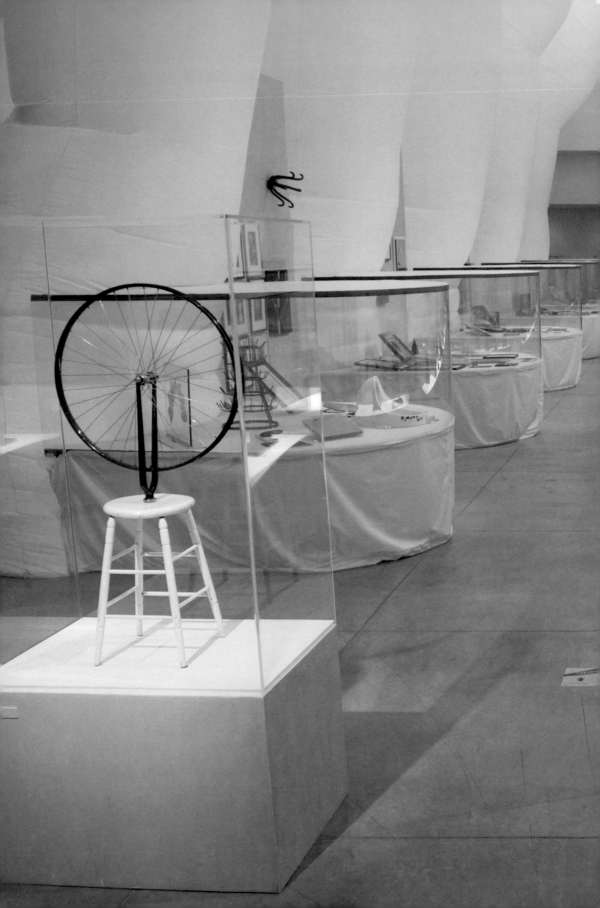

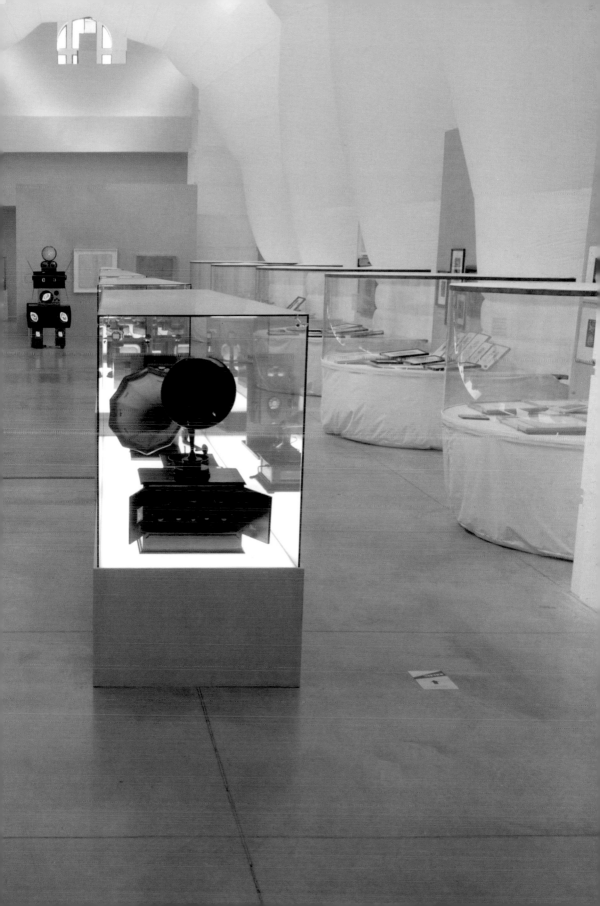

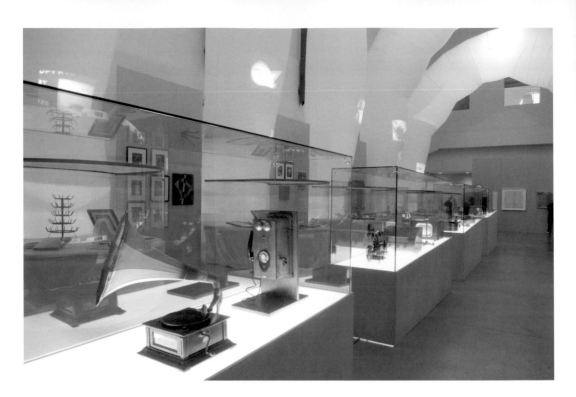

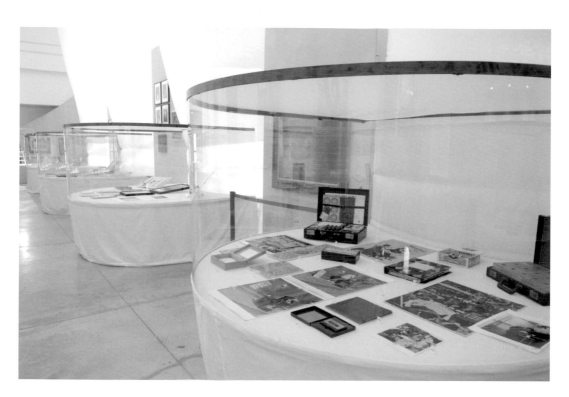

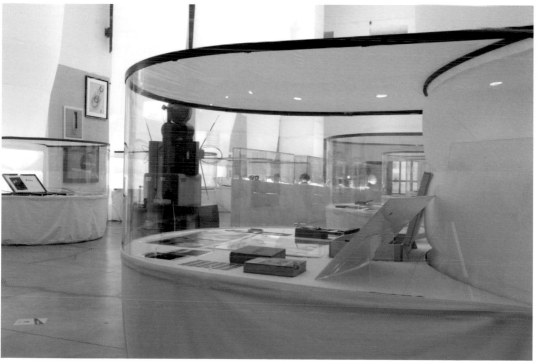

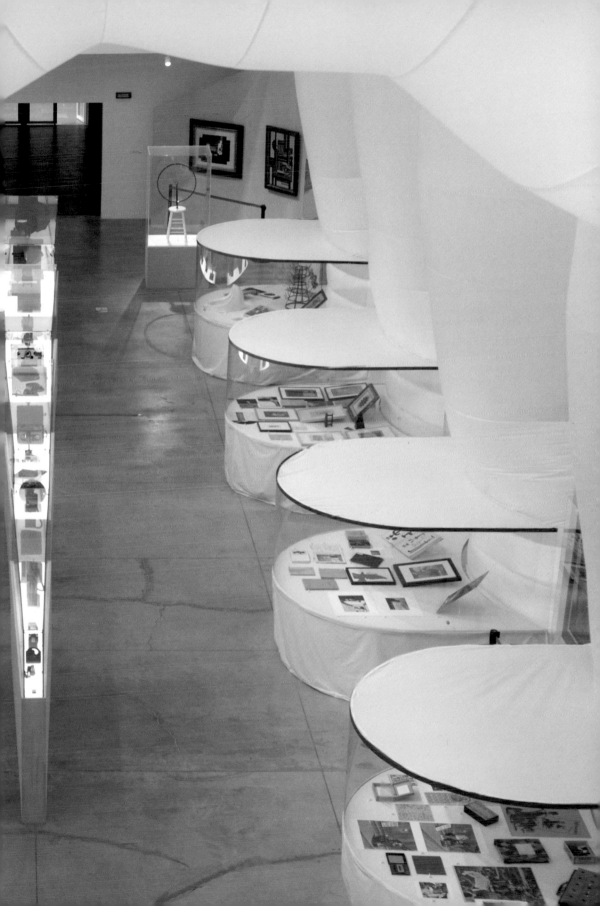

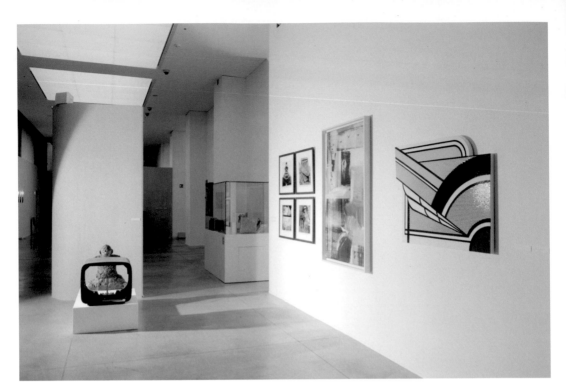

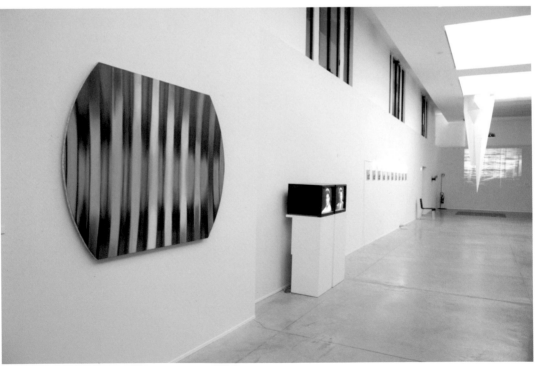

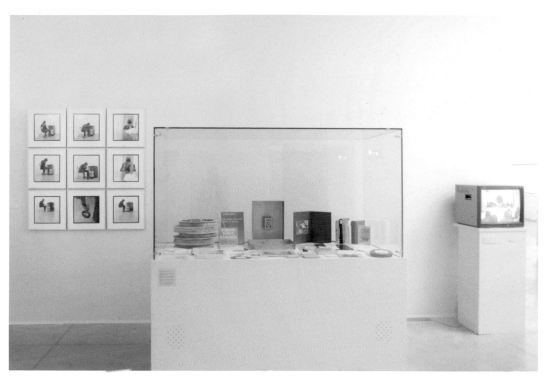

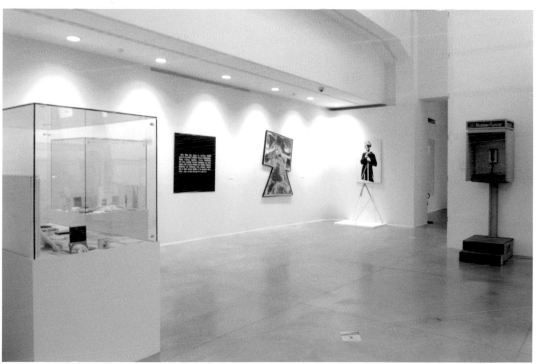

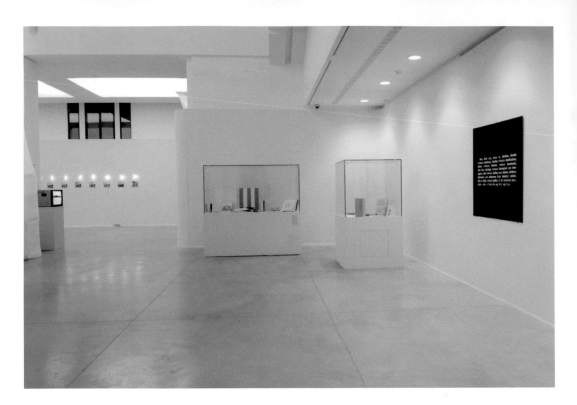

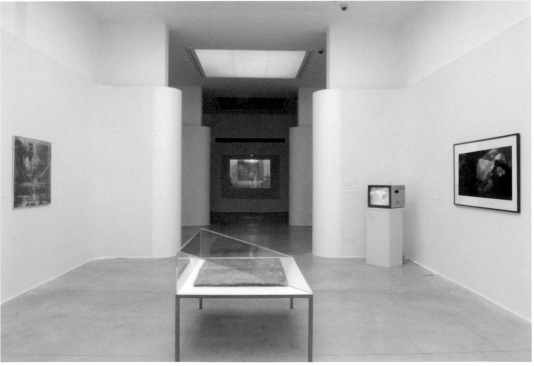

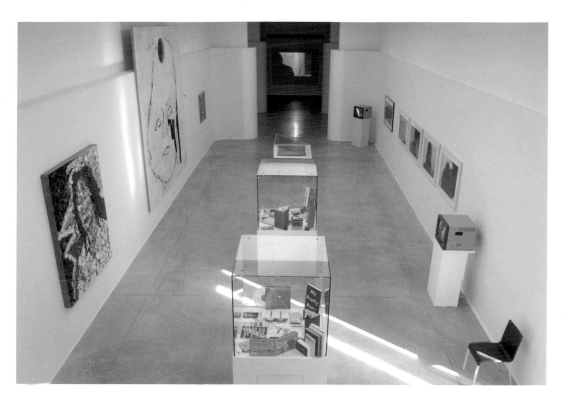

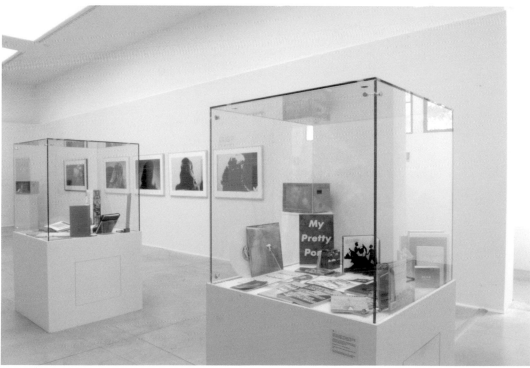

Following pages:
View from the first floor

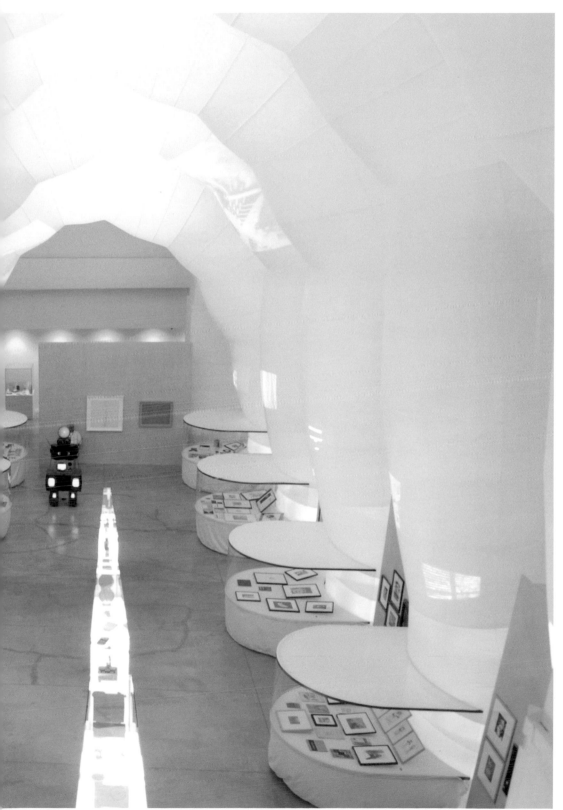

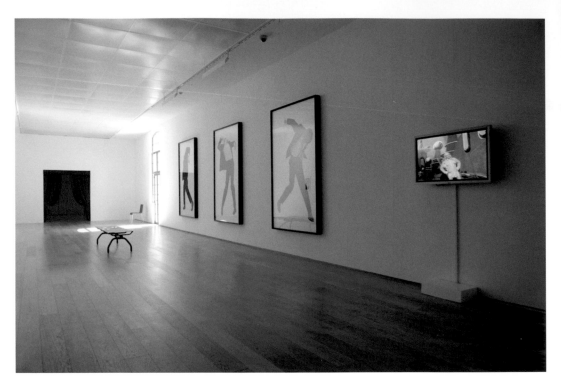

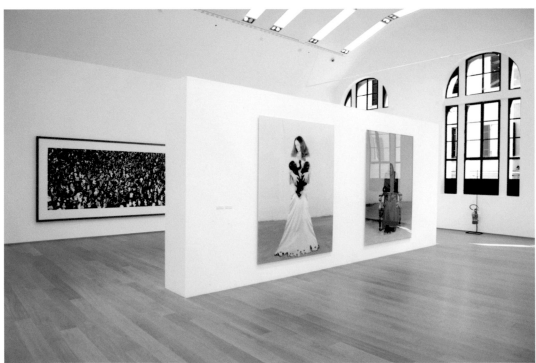

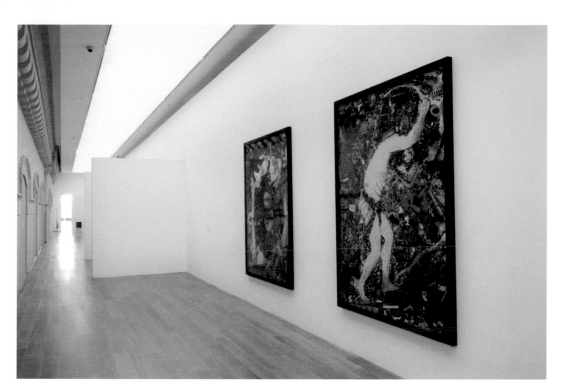

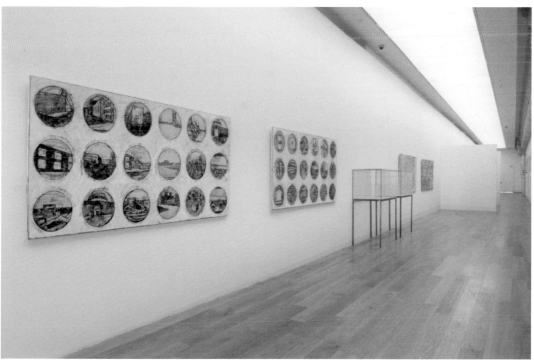

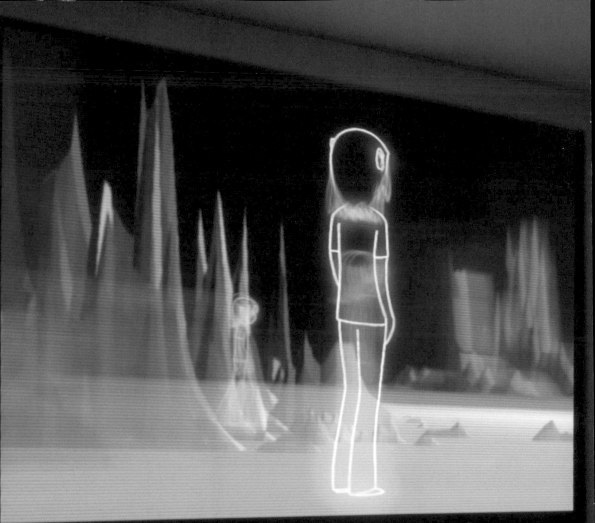

Nineteen Eleven Nineteen Sixty-two

Ester Coen

There Will Come A Time When Paintings Are No Longer Enough

"There will come a time when paintings are no longer enough: their immobility will be an anachronism with the vertiginous movement of human life. Man's eye will perceive colours like feelings in and of themselves: multiplied colours will have no need of shapes to be understood, and pictorial works will be luminous emanations, coloured gases, etc."[1] There is an almost prophetic sense in these words from a 1911 conference given by Umberto Boccioni. The great futurist certainly could not have imagined that in less than a century his chimeric fantasy, impossible to translate into reality at the time, would become the spontaneous motivation for so much artistic creation, inspiring surprise through the singularity of an original idea with such major visual impact, purely deduced from an attentive study of physical phenomena.

His vision was incredibly foresighted, unified with the design of a total dynamic, emotional and formal involvement that the futurists expressed with such irreverence, and such a combative nature against the inaction and inertia of past artistic movements. Within this framework, every substance aimed at imparting an absolute mobility to the subject falls under the realm of an interest that, in theory, closely aligns with the speed of the modern world and progress of history. 'Polymaterialism' and metamorphosis of material – like plaster treated with a bronze patina, creating a sensorial inversion of traditional sculptural perception – from now on displace the fixed nature of the artistic object. The cubists were reproached for this fixity, despite the fact that, even before the futurists, they had introduced fragments of the external world into the surface of paintings so that the work might autonomously live a life of its own and cease being a mere representation of reality. Pablo Picasso, with the genius of an alchemist, then transformed Georges Braque's profound intuitions into the materials of prodigious constructions, freed from all aesthetic chains, pushing the boundaries of all lifelike spatial dimensions.

Just as, in the early decades of the twentieth century, all possible solutions for transforming the work into a living essence were tried out, making unrestrained use of things – substances of all sorts, even objects produced by industrial machinery – even straightforward though presents itself as an alternative to a process whose limitations seem tied to the continuation of a romantic concept of the artist and creative genius.

The concept of accumulation – solidly structured in a growth between the organic and the architectural, leading Kurt Schwitters to patiently build a sort of cathedral of poverty and desperation in his own studio, piling up scraps and refuse found on the streets – had already infringed and expanded upon the realm of experience in the anti-illusionistic ideas of Marcel Duchamp. But in Duchamp that expansion had ended in the substitution of the work willed and modelled by the artist's hands, and resulted in the almost oneiric extension of its uniqueness and, at the same time, of its exaggerated and disconcerting banality. From impressionist painting to cubism's stylistic shattering, Duchamp had run the entire course that would eventually lead him to elect a bicycle wheel, bottle rack and urinal as forms of contemporary sculpture. After that gesture, only the selection of silence as sole 'aesthetic' protection, or chess as pure systematic spirit, can declare themselves the ideal measure of the equilibrium between the order of reason and the unregulated nature of chance. The idea of materiality is substituted by image – with its own logic, its own reason. In its very contemporaneity, this reason evokes anew the signs of a primitive knowledge, a science that prefers the synthesis of thought to mere enunciation – in all its mysteries, all its hidden secrets; hermetic, cerebral and at the same time clear, visible.

Behind all calibrated moves, behind the silent designs of Duchamp's meditative mind, behind primitive gesture, art is expressed in the tension of an ancient experience – an ancient event that rediscovers its primary cause, the essence of all phenomena, in the power of numbers. Throughout the twentieth century, the intensity of thought born of reflection on the creative and natural forces generates a new source of inspiration and artistic practice. It becomes a way of recapturing the archaic magic of primal instincts, the enchantment of a purified will – in Duchamp as in Brancusi, Malevich and many artists of the following generation motivated by the illusion of being able to change the very meaning of the world.

But the dadaists had sharpened the subversive parts of Duchamp's line of thought, offering the work as a ritual sacrifice and making the viewer custodian of the powers of survival. After them came a series of destructions and discoveries, verifications and experiences. The surrealists' style was to turn dada's negativity into positivity, multiplying the extra-artistic techniques and possibilities of expression – frottage, *raclage*, stratifications of detritus and sand – to develop the surface's body and provoke unexpected, surprising reactions in the unconscious. But the intellect plays an ever more active role in the significance and physical dematerialisation of the work of art, and no longer solely in the design phase. In Duchamp's wake, many artists of the 1960s look to his work, and to the coordinates that derive linearity and synthesis from space and time – some following the formalism of concepts and linguistic structures, others the mysterious progression of geometric structures.

Architecture of closed reflection on time and its passage, geometry of mental wanderings, golden section of hypothetical proportions, abstract synthesis of the multiple, pillar of symbolic concepts – numbers remain the secret, eternal root of human intelligence. In the system devised by the minimalists, the process of accumulating samples and tempos taken from artistic actions is underlined, emphasising the paradoxical physicality of contradictory sensations and the cold, coherent succession of a series of abstract signs brought to the level of metal plates.

In those years the creative tension of an entire generation of artists seemed to find a point of

union in the communal search for a place that denied art the power of artifice. For the artists of Arte Povera, that place was firmly attached to the reality of passing time, the materiality of physical action, the magic of natural elements, the perception of objective phenomena and the transcription of elementary developments of thought; all this in the space where each took place. Various idioms were unified in the search for the origin of gesture and ideas that can be represented in the instinctive appearances of primary forms, where the artist's mark strongly manifests itself in grabbing onto the fast traces of straightforward existence. Or in leaving its own imprint and stubborn mark as indication of a continuous flow of energy between itself and the universe – an energy that is full and cadenced at the same time, vibrating, violent, primitive energy. Unlike the self-destructive and highly narcissistic energy of the artists whose body, raised to the greatest level of theatricality in the unique event, is crudely offered to the public; here material is transformed into the solemn gesture of carnal exhibition, offered with desperate brutality and rage in a spectacle whose colours are shades of slag and bodily residue. Sweat, urine, saliva, faeces, tears and blood become the materials of compositions acted out by the artists themselves, who expose themselves to such visions of death in an almost mystical exultation.

Uniqueness and repetition alternate on stage and on screens that send, resend and recall images from the actions of daily life repeated to the point of giving a heightened impression of vanity and scorn. Or through artificial colours, in a synaesthetic whole made up of fragments of reality, reread through the tools of the ever more advanced technology. Still, many artists do not give up their attempts at giving spatiality and physical dimension to time, in an extreme attempt at defending themselves from the idea of an epilogue. Hence scansion reduces form; representation is set within the appearance of a model subjected to an extreme synthesis of characters or numeric data.

But the duality between planning and doing remains implicit in the configuration of work, which is still captured, albeit in a different form, in the contemporary sensibility – even of those artists who carry out their practice fully conscious of the changes in past techniques.

In a world already incapable of recognising otherness and mitigating conflict, in a reality that has become a metaphor for itself, the rituality of signs seems to resist the harshness and violence of the historical moment. The strong imprint of order becomes a prioritised element in the search for a new architecture of meaning; there is a strong impression of measure played out in exchanges, interweavings, passages and reversals of technique, thereby indirectly supporting the persistence of systems that still pertain to painting, sculpture, architecture, video, cinema, installation, advertising and fashion. This order, this sense of measure, oversteps the feeling of catastrophe and disaster felt during the unfolding of recent events. It is as if, through the acceleration of gaming paradigms or more stereotyped forms, we aim to predict the prelude of some atypical development of feelings tied to suffering and angst. Chips and fragments of a residual world; leftovers of culture that survive the threat of being crushed and reduced to a single model – a model where, in the absence of dialectics and with no effective contradictions, technology and progress can not have any influence on the system of organised fragility, if not through the most minor modifications. And in the frenetic race toward new models, toward other objects, in the tangled vision of societies admitting and anticipating change and revolution, the only revolution in 'becoming' is wrapped round itself. If, absurdly, we were to predict the sci-fi scenario of a spaceship from some other planet landing on our present-day planet, what would its occupants notice? They would find the last fragments of a civilisation of artists grabbed onto. They would see moulds and matrices of architectural forms robbed of their political, functional and artistic significance, replicas of human semblance and

images defending themselves from time in highly refined sculptural materials, poured out and stripped of all colour. They would still find the last surviving remnants of adventures resurfacing from the past, of stories that expose differences, discriminations, divisions; echoes of conquest, segregation, physiognomic resonance, deforming virtual interventions. And then, still, spectres of war. They would see images of destruction, would hear tales of exile and deportation, would stumble across aseptic vitrines – unapproachable inventories of suffering made even more distant by the coldness of form and technique, which, under the material's spell, seek out a surrogate to defend their very substance. And in this collection of voids and echoes resounding at the end of nostalgic notes, they would find tables and cases containing the icons of a civilisation suffocated by moss and naturally infused with plastic – the persistence of atrophied memories, the last glimmers of a humanity in search of answers. A humanity that inexorably launches itself toward a destiny of uniformity and chilling clones, but still fights against being turned into a group of replicants.

As for the causes of this exaggerated aesthetics of appearance, one cause can perhaps be recognised in limitations, whereby even viewers – who for years were pacified by semblances of death – in subtracting themselves from the meaning of things grasp the concept of exteriority with the same readiness with which they unwittingly consumed the seductive images sliding so quickly across the screen. An aesthetics of appearance that, despite its superior choreography, ceaselessly stages a series of missed acts. 'Hypertechnology' and carnality are the two terms that today, without any mediating principles, are juxtaposed to create spectacle and sensation, but also to reawaken and shake up sensorial perceptions while at the same time inspiring emotions and disturbances.

The undoubtedly complex and differentiated inventory of artists of the new generation also contains a sign of connection: the disturbing relationship to reality, the syntactic displacement of an artistic language wholly focussed on the object, in a maniacal fascination with morphology. Pictures of decline lived like pictures of life. Static images that do not convey any emotion because they are emptied of all pathos, because the idea of pain and suffering – much like the tragic nature of an event – often do not appear in their full, cruel form. Distance, a break from the real generates fetish. And it is in the object's transposition toward a cruel, deserted and silent otherness that the paradoxical encounter with the real world comes into play. Virtual truth takes the upper hand, a truth no longer rooted in the imaginary, which is now originated in a realm of indifference, absence and emptiness.

In order to distance the desire and disease of existence, the images of reality become trophies and icons. And if Damien Hirst exhibits his vitrines with shark, sheep, cow and pig preserved in a solution of water and formaldehyde, proclaiming he wants "the real thing", his staging is undeniably theatrical, making a strong, grandiosely spectacular impact. "I'm really obsessed with life," Hirst confirms, "and death is the point where life stops . . . Art's about life and it can't really be about anything else. There isn't anything else."[2] This desire to look death in the eye, and the coldness of being boxed up, come from the realm of detachment and a frightening separation from lived experience.

Whether the reference draws upon eroticism, cultural revisitation or the Westernisation of its own origins, the relationship with the real always remains unresolved. Closed, claustrophobic structures still represent the extrapolated sign of regurgitated, overflowing, poorly contained angst. This is now the domain of simulated pathology, repulsion, of that "sinister, violent, resolute *je ne sais quoi*" that Charles Baudelaire had already found "in almost all the works in the land of spleen".[3] The experiences of present-day sociological phenomena are mirrored in the virtual and homeopathic cures for disease, degeneration and perversity. Damien

Hirst's chilling declaration sounds like the manifesto of a return to contemporary reality: "I'm working on a car crash. There'll be no bodies, but I want that feeling of absolute horror, just after a crash – the wheels turning, personal possessions spilling out, the radio on, the horn going. I'm using a red car and a corporation grey car and calling it *Composition in Red and Corporation Grey*. I'm a traditional colourist at heart!"[4] Violence? Brutality? Perversion? Immorality? Depravation? Cruelty? No – it is rather a vision in search of exegetic composition, created by contemporary life, whose faraway source lies beyond all imagination. There is no violent emotion in the manifestations of phobio-obsessive or spiritual delirium of represented art; no oppressive disturbance, if not the precise, controlled complicity with the world of fashion and advertising, in staging a scripted event made to become the symbolic image of provocation. Absence and excess, light and darkness, claustrophobia and agoraphobia, in the waste of highly accurate technical formulas that are (for the most part) technologically irrefutable, once again emerge as exorcists, timeless codices, of a modern malaise redrawn as bright, brilliant, coloured, clear signs. The tension, therefore, lies not so much in the desire to represent the ills of our universe or the utopian visuals of our mind, as much as in the absolute determination to recall and resuscitate – through the most varied means – the vertigo of lived experience. But the figuration of this sentiment is tempered by the search for a logic of horror or beauty, and is limited to filling the formal, closed space of the work. The end of any century drags with it the ghosts and furor of the past, and opens the hopes of the future. The reverberation of unrest still surfaces in the imagined battle for the victory of good over evil. The vulgar and the common are viewed as aspects of a culture that denies even suicide the possibility of moral judgement.

Today, contemporary beauty is sought in the detail of the objects of reality. In the most scabrous certainty, where seductive images of fashion are often alluded to, a high gloss erases any signs of the discomfort that generated such visions.

How can the clarity of things be set in agreement with the mutation and regeneration of what is created? Is the revelation hinged, like for Maurizio Cattelan, on the challenge of – or search for – a representation that surpasses the visionary structures of reality itself? Or, better yet, in the charm of Jeff Koons's gigantic, splendid toys, with their glow and (equivalent) conceptual perversion? Don't they emanate the same glare of those other images of death? Despite the ever more sophisticated techniques and complex materials, artistic practice over the last few decades certainly has not had that extraordinary acceleration of inventiveness that characterised the first historic avant-gardes and their run-up of ideas, models, archetypes and utopias. Today a fallen utopia brings an oversized materiality back to both body and object, more illusory than reality itself, attractive and seductive, emptied of all feeling or reason; a reality that reeks of the hedonistic transience of the elements that make up its form.

[1] U. Boccioni, "Note per la conferenza tenuta a Roma" (1911), in Z. Birolli (ed.), *Altri inediti e apparati critici*. Milan: Feltrinelli, 1972, p. 34.

[2] S. Kent, "Hirst among Equals", *Time Out*, 1412, 10–17 September 1997, p. 18.

[3] Translator's note: this is a reference to Baudelaire's poem series "Le spleen de Paris".

[4] S. Kent, "Hirst among Equals", *Op. cit.*, p. 19.

Giovanni Lista

The Media Heat Up: Cinema and Photography in Futurism

Futurism, emerging at the end of the first decade of the twentieth century, was not a simple aesthetic programme, but rather an anthropological project aimed at elaborating the new ways of life, new social structures and new conception of humanity inherent to industrial society. For Filippo Tommaso Marinetti, its founder, it was a question of constructing the modern cultural identity of the new Italy, born of the Risorgimento and marching toward the future, as opposed to the Italy of archaeologists, museums and antiquarians. Futurism was therefore presented as a Herculean doctrine, and as activism. On the one hand, it was a work-in-progress aimed at the constant redefinition of art in a manner adequate to modern life. On the other, it was the militant desire for a global avant-garde culture capable of uniting art and life.

Taking Marinetti's side, Umberto Boccioni opposed the concept of 'modernity' orchestrated by Charles Baudelaire with the 'modernolatry' of Italian futurists – that is, their unconditional adhesion to the development of modern culture viewed as a life experience. The pragmatic ideology of futurism was therefore expressed in a constant shifting of theoretical positions and an incessant surpassing of works already completed, to go ever further in terms of experimentation and novelty. The vitalistic cadences of urban space, technological 'prometheism', the cult of progress and advent of a world dominated by dynamism, energy, ephemeral things and speed are the values that stamp futurism with the mark of a secular, materialist pantheism. The contradictions within futurism were not only the fruit of the historical climate of an Italy that had just gone through the Risorgimento, but the result of an ideological ambiguity. The radicality of voluntary participation in the new industrial culture did not necessarily preclude the survival of the more traditional humanist culture; instead, a reformulation of its parameters was proposed, to make it better suited to the new reality of

the machine. Contradictions came in particular from an attempt to reconcile a poetics of *élan vital* with the aesthetic integration of the new media produced by modern technology. In other words, not only was it a matter of making formal experience and sociological militarism coexist, but also of reconciling energetic vitalism and technological brilliance, the performative and aesthetic art of 'mechanical splendour'.[1]

The ideological contrasts futurism was founded upon help us understand why Marinetti's striking intuitions were not successfully embodied in futurist art. In *Fondazione e manifesto del futurismo* (Foundation and Manifesto of Futurism), proclaiming the aesthetic superiority of the automobile over *Nike of Samothracia*, Marinetti consecrates the mass-produced objects of modern industry. But it was Marcel Duchamp's porcelain urinal that got this programme underway, associating it with dadaist provocation.[2] In 1911, Marinetti affirmed that books must be printed in metal, thereby intuitively sensing the media's capacity for moulding our perception of the world. This is an idea he realised only much later, but which already illustrates the axiom that "the medium is the message", as Marshall McLuhan wrote soon thereafter.

On the basis of the 'modernolatry' proclaimed by Boccioni, the encounter between futurism and the new media of the 'mechanical eye' – cinema and photography – should have been immediate and prolific. Instead, it was slow and laborious – and came about primarily outside of the officially outlined futurist movement. This does not mean that futurism ignored the new technological media. From the very start, for example, Marinetti used both telephone and radio to recite his *composizioni parolibere*.[3] But in truth, futurism implicitly drew a distinction between 'hot media' and 'cold media', albeit not in the exact same way as McLuhan had formulated them.[4] For the futurists, hot media are those that, operating via direct broadcast, empower the artist's physiological vibration, physical and psychic energy, mobility and gesture. In any case, they are what intervene as 'prosthetics' of a sort, extending upon human capabilities and amplifying the intensity and uniqueness of the creative act. Cold media, on the other hand, are those that, via recorded, postponed broadcast, freeze the *élan vital*, bringing back only a mechanical restitution, devoid of life. For the futurists, both photography and cinema are cold media. Photography's weakness as a tool, accused since its inception of 'cadaverising' life, is reflected in the futurist polemic against the 'chronophotographic' images of Etienne-Jules Marey, accused of rigor mortis despite the fact that they aimed at portraying the human body's movement.

In reality, the futurists were very interested in cinema and photography, in which they saw a possibility for enriching artistic signs, but refused each as a viable medium – that is, as a new, autonomous expressive language. In other words, they preferred to integrate the perceptive data gained from cinema and photography into traditional media. The freeform words of Marinetti, Buzzi and Cangiullo portray the vital flow of reality with a film-like fluidity, adapting the word to the absolute and continuous process of becoming, cinematographically portrayed, as Piero Gobetti wrote, through "speed and variety, the superiority of physical elements over psychological ones, the kingdom of sensation".[5] Taking up the kinetic signs produced by Marey and Ernst Mach, or the transparency of bodies made possible by Wilhelm Röntgen, the futurist paintings of Boccioni, Russolo, Balla and Carrà adopts the formal tools unleashed by the photographic experiments that sought to detect the laws of movement and vital energy. The image produced by the lens was therefore preferred – not only as a tool for reading reality, but also as an expressive model for an art meant to conjugate dynamism, kinetics and energy. And yet it was totally excluded as a possible aesthetic medium. Neither cinema nor photography could be considered new forms of art. This was the paradox that the futurists – and in particular Boccioni, who was the group's theorist – took from Henri Bergson's thoughts on 'the

process of becoming and form'.[6] The 'mechanical eye' prodigiously scrutinises the fleeting nature and invisibility of the interactions between matter and energy, but then produces dead images, foreign to art as the futurists defined it – that is, as an immediate reflection of vital sensation, a lyrical transfiguration of the dynamism that fuels a perpetual process of becoming. A marvellous instrument for exploring infrasensorial and metaperceptive realms, the photographic or cinematographic image nevertheless remains a cold medium, as it does not contain any reflection of life force. In short, for the founders of futurism, the artist is still seen as the sole legitimate mediator between aesthetic experience and the sensory world, because the creative act implies a transformation in which the artist proceeds by intuition through a qualitative process of resistance and duration. Intuition, as the source of knowledge, and duration, as the latent, unconscious, unpredictable experience of the artist – the artist's subjective contribution – are irreconcilable with the mechanical determinism of the lens.

For the futurists, even insofar as it is a representation of movement, the photographic or cinematographic image destroys the energetic dimension of an act, relegating live occurrences to the immutable fixity of something that *has been*, and is the equivalent of a passive recording, as opposed to a dynamic perception of reality as an absolute process of becoming.

The complete coherence of these Bergsonian positions is confirmed by the fact that futurism invented the idea of performance as an expressive form in which the artist himself is involved, suppressing any instrumental mediation. The search for an intimate connection between art and life – even in terms of an active confrontation between the creative gesture and the work's very matter – further explains why the futurists almost wholly neglected lithography, woodcuts and other types of printmaking that had been fundamental to other avant-gardes, such as German expressionism. An image produced by mechanical means was considered an 'anaesthetic' medium, that is, ontologically refractive and aimed at translating a concept of art as the transmission of vital energy, or life force. Similarly, Luigi Russolo permanently excluded, even in his later *ricerche rumoriste*[7] of the 1920s and 1930s, the possibility of using recorded and manipulated sound, as did the concrete musicians. His *Rumorharmonium* was constructed on the principle of directly producing the orchestrated sound. For his part, Marinetti only sporadically, and much later in life, resigned himself to recording his *parolibere* performances on disc. In other words, there was not a single futurist aesthetic project or endeavour that did not remain closely committed to crossing all frontiers separating art from the sensory experiences of reality.

This contradiction, in futurism, between the exaltation of the new technological civilisation and the refusal of the new media that were its most direct result, could only be resolved from unorthodox, even heterodox points of view – that is, working outside of Marinetti's movement, or crashing into cinema and photography head-on in order to 'heat them up'. This last approach was specific to futurism, which introduced, for instance, the idea of simultaneity as a reflection of life actively countering the sequential nature of arts based on narration and words. The futurist typographic revolution literally exploded the 'normality' of the printed page, as established by Gutenberg, with the precise intention of 'heating up' the medium, bringing it closer to the concrete, sensory nature of life experience.

The first cinematographic experiments occurred outside the futurist movement. Between 1909 and 1910 in Florence, an avant-garde group – which included the brothers Arnaldo and Bruno Ginanni Corradini – launched an autonomous movement, 'cerebrism', which theorised an art based on the investigation of psychic values and cerebral energy. The cerebrists even developed a form of deconstruction, a hypostructural conception of the work of art as a simple assemblage of heterogeneous materials. The essential problem of cerebrist aesthetic creation was

not the mimesis of reality, even if it were interpreted from a vitalist viewpoint as Marinetti would have maintained, but simply the novelty of the relational statutes of the components of a work of art freely created – or actuated – by the artist. The experiments of the Ginanni Corradini brothers, carried out thanks to the cerebrist interest in psychic connections, were polarised by the issue of synaesthesia and the possibility of creating a 'music of colours'.

Painting directly onto the film reel, between June and October 1911 the brothers create four abstract films, now known by their inferred titles: *Accordo di colore* (Colour Chord), *Studio di effetti tra quattro colori* (Study of Effects between Four Colours), *Canto di primavera* (Spring Song), *Les fleurs* (Flowers). A fifth short, left unfinished in early 1912, called for a series of 'chromatic motifs' lasting a minute each. Lastly, by June 1912, they completed two more abstract shorts: *L'arcobaleno* (Rainbow) and *La danza* (The Dance).[8] In reality, these were not cinema, but a sort of cine-painting understood as an 'intermedia', performative art. These photograms, coloured with aniline, had all the uniqueness of a painting. During public projections, the viewers, dressed in white, found themselves in the centre of a room, also painted white, in which a mobile device with seven bulbs and highly luminous colours created chromatic atmospheres one after the other according to the various phases of the chromatic symphony taking place on the screen.

With these experimental investigations Arnaldo and Bruno Ginanni Corradini aim to launch a 'new art', a pure, visual, kinetic art, based solely on a chromatic, non-objective image in continuous movement. The recourse to cinema – their choice of a new technological medium – is in complete opposition to the specificity of cinematographic language as a mechanical art. In other words, their 'intermedia', performative cine-painting is the result of their attempt to heat up the medium.

Boccioni condemns this type of cinematographic experimentation, considering that futurist sculptural dynamism must necessarily originate from sensory experience and feed on the reality of life lived in a world that is in a state of becoming, rather than begin with the presupposed interior alchemy of a state of mind unleashed by the passage of time, understood in the Bergsonian sense of duration. But the Ginanni Corradini brothers' cine-painting counters Boccioni's futurist painting only insofar as it is the abstract expression of an art centred on dynamism. Working toward heating up the medium, on the other hand, conforms with the tenets of performative futurist art.

The history of futurist photography began with a similar episode. In the spring of 1911, the brothers Anton Giulio and Arturo Bragaglia invented 'photodynamism', an approach based on the trajectory of a body's displacement in space, as opposed to the positivist analysis of a kinetic event as happens in the chronophotographs of Eadweard Muybridge and Etienne-Jules Marey. They aim, in short, to heat up the medium by forcing it to reflect the emotion that comes with life experience. Therefore they give precise directions to their experiments: figuration of the sudden, unexpected gesture in lieu of the linear, continuous movement portrayed in chronophotography, and the evanescence of form translating the irreverence and immediacy of the kinetic event. They go so far as to arrive at the 'intermedia' integration of olfactory data; for example, the photodynamics portraying a carpenter sawing in *Il falegname che sega* (The Carpenter Who Saws) is associated with drops of 'isinglass and turpentine', the typical scents of a carpenter's workshop, so as to offer "the olfactory sensation as well, so as to reproduce the moving feeling of reality in a lively and most complete way".

A few months later, at a series of conferences in Rome, Anton Giulio presents 'photodynamism' as a new form of futurist art. Bringing back both the unity of gesture and the transition of energy, photodynamism eludes the mechanistic determinism that had previously defined the pho-

tographic medium and becomes an artefact – a fully complete work of art – redeeming its contamination with the colder aspects of technology. But Boccioni is not convinced, and the Bragaglia brothers are not admitted as members of the futurist movement.

In the essay titled "Fotodinamismo futurista" (Futurist Photodynamism), published in June 1913, Anton Giulio declares that his experimental research, in realising a 'transfiguration of the kinetic event', "comes to demonstrate that photodynamics are in much greater accord with modern-day needs than any of the representational means now in use".[9] In other words, modernity already requires the advent of a new medium, more efficient and direct, for aesthetic investigation. By presenting itself as the correct recording – that is, 'hot' recording – of the experience of reality, photodynamics can substitute traditional means of painting and sculpture in the expression of dynamism.

Anton Giulio Bragaglia's book met with a harsh reaction from Boccioni, who that August, in *Lacerba* magazine, wrote: "We have always refused even the most distant relation to photography with disgust and contempt, as it lies outside of art."[10] But Bragaglia persists, publishing new photodynamics that investigate other sensations of movement. Among these is a portrait made with the technique of 'sandwich montage', overlapping two negatives. This images offers yet another take on photodynamism: a suspended, expanded vision of reality, capable of signifying a movement perceived only in terms of its duration and the memory of it.[11] Subjective dynamism is one of the major Bergson-inspired themes in Boccioni's painting. Increasingly irritated, he decides to launch an accusation; in an announcement published in the October issue of *Lacerba* he officially condemns the Bragaglia brothers' photodynamism and excludes any ties to futurism.

Yet another attempt at heating up the artistic medium is then carried out by Fortunato Depero who, in a series of clamorous photographic self-portraits executed in early 1915, creates the futurist photo-performance.[12] Posing with determination and insolence before the lens, the artist exposes the conscience he has of himself, charges the image with a strong physiognomic expressivity and stages his own identity as the creator and militant revolutionary of the avant-garde.[13] Additionally, plunging into a multimedia practice, Depero creates hand-coloured photographs - images of his photo-performances completed by the artist's manual intervention. Photo-performance was an expressive direction that soon attracted Giacomo Balla as well, but it was not granted any space in the official futurist exhibitions. As a theorist operating in the Bergsonian vein of 'plastic dynamism', Boccioni exerted a dogmatic dominance that reflected all the contradictions of the futurist avant-garde. cinema.

Soon thereafter a film, titled *Vita futurista* (Futurist Life), was created by the cerebrists, who were now part of Marinetti's movement. In particular, it was inspired by the ideas of Arnaldo and Bruno Ginanni Corradini, who had taken the futurist pseudonyms of Ginna and Corra. Since lost, this film was created by a collective between August and November 1916; the group included Marinetti, Ginna, Corra, Settimelli and Balla. The filmstrip presents a grouping of narrative bits, illustrative fragments strung together in a dynamic, discontinuous way with no connection whatsoever between one and the next. For the film's premiere the group penned the *Manifesto della cinematografia futurista* (Manifesto of Futurist Cinema), which validated the hypostructural model for filmmaking in terms of 'polyexpressive symphony' and 'chaoticised reality', also foreshadowing an approach to cinema actuated as "an a-logical, fleeting synthesis of universal life".[14]

According to the cerebrist principle of the heterogeneity of assembled materials, various expressive approaches come together in film. The diptych *Come dorme il passatista* (How the Pastivist Sleeps) and *Come dorme il futurista* (How the Futurist Sleeps) has the peremptory

character of advertising, and features a *mise en scéne* with the allegorical figure of a malevolent dwarf, a Nietzschean symbol. In other sequences, resorting to the tautological strength of the 'truer than truth', Marinetti, Balla, Settimelli – the real-life futurists – play themselves, showing how the futurists live, play and improve their creative capabilities. Offering a paradoxical, superlative, provocative view of the futurist world as an alternative to the bourgeois world, the film is a parody of sociological and ethnographic reportage.[15] But it is also the first historic example of film-performance, à la Leopoldo Fregoli, who Marinetti considered "the precursor of the new cinematographic art". Adopting the 'hot' modes of expressive, performative, multimedia vaudeville, the futurists exhibit themselves in the flesh on stage before the film's projection begins, so as to offer a contrast between live reality and the mechanical image. With *Vita futurista* (Futurist Life), futurism finally accepts cinema as an art form,[16] but only insofar as it is an immediate, direct vision of a behavioural model caught precisely on the fine line of demarcation between art and life. With this clamorous creative experience – utterly specific and original because it has no parallels among the European avant-garde – Italian futurism begins the long lineage of film-performance, which runs right up to the famous sequences of Andy Warhol and Jonas Mekas's *Scenes from the Life*, showing real-life images of how an artist lives.

[1] Cf. F.T. Marinetti, "Lo splendore geometrico e meccanico e la sensibilità numerica", in *Manifesto futurista*, a brochure dated 18 March 1914.

[2] It is worth underlining the absence, among the Italian futurists, of research concentrated on the theme of technological art comparable to those carried out by the artists of the German Bauhaus or Zdeněk Pešánek in Prague.

[3] Translator's note: *parolibere* is a compound of *parole* and *libere*, meaning 'free words', or freeform word-based compositions.

[4] In his watershed text *Understanding Media*, Marshall McLuhan only defines the differential classifications of hot and cold media by antiphrasis.

[5] P. Gobetti, "Il futurismo e la meccanica di F.T. Marinetti", *Energie nuove*, 6, 15–31 January 1919.

[6] Boccioni had particularly assimilated the ideas expressed in the two texts *Matière et mémoire* (1896) and *L'évolution créatrice* (1907). In Italy an anthology of translated excerpts of Bergson's writings had been published by Giovanni Papini.

[7] Translator's note: noise-based experiments.

[8] These shorts have been lost, but Bruno Corra gave a description of them in his text "Musica cromatica", published in a collection titled *Il pastore, il gregge e la zampogna*. Bologna: Libreria Beltrami, 1912.

[9] The book originated in the text of the lectures held by Anton Giulio Bragaglia as early as 1911; the sole known manuscript, however, dates to early 1913, when Marinetti had planned to publish the book. The first edition, dated June 1913, was reprinted in a facsimile edition in 1970 by Einaudi, edited by Antonella Vigliani Bragaglia and featuring a philological appendix and important supplementary documentation.

[10] U. Boccioni, "Il dinamismo futurista e la pittura francese", *Lacerba*, I, 15, 1 August 1913, p. 171.

[11] These photodynamics were published in the magazines *Italia*, *Il Tirso* and *Primavera*. Cf. G. Lista, *Cinema e fotografia futurista*. Milan: Skira, 2001.

[12] Cf. G. Lista, *I futuristi e la fotografia: creazione fotografica e immagine quotidiana*. Modena: Galleria Civica, 1985.

[13] Cf. G. Lista, *Le Futurisme*. Paris: Editions Terrail, 2001.

[14] Cf. F.T. Marinetti, B. Corra, E. Settimelli, A. Ginna, G. Balla and R. Chiti, *Manifesto della cinematografia futurista*, dated 11 September 1916.

[15] For a reconstruction of the film's sequences, see G. Lista, *La scène futuriste*. Paris: Editions du CNRS, 1989.

[16] Immediately after, Marinetti wrote the script of the film *Velocità* (Speed), which was never made. I rediscovered the original manuscript in an American library and published it along with an analytical and contextual introduction. Cf. G. Lista, "Un inedito marinettiano: 'Velocità', film futurista", *Fotogenia*, 2, 1995.

Elio Grazioli

Artists and Books in the First Half of the Twentieth Century

Perhaps it all began with Stéphane Mallarmé's *Coup de dés* (1897), at least in the modern sense. Words and lines covering double spreads in different typefaces and weights, Eastern voids, and writing's process of becoming visual all led to the beginning not only of avant-garde experimentation, but even more to the avant-garde vision. On the one hand, words began to speak directly to sight – not by evoking images, but through graphic and typographic means; on the other, art opened itself to the modern world in all its manifestations – no holds barred, learning its devices, modes, methods and forms.

Mallarmé had already seen the city become a 'museum of the streets', covered as it was in writing, images and advertisements, becoming a book in and of itself – but it would be the avant-garde movements that really made the most, on a broad scale, of the first transgressions of a few individuals, following poets more than visual artists. It was no coincidence that Pablo Picasso spent more time with poets than his direct colleagues, first by generously working on illustrations, and then leaping ahead to cubism, making a total, conceptual, irreversible change. "Read aloud the brochures, the catalogues, the manifestos that sing / Here is today's poetry, there are always newspapers for prose" wrote Guillaume Apollinaire in *Zone* (1912) and the die is cast: the material is there, the future mass media, those are the forms, and art is to seek out some other place, some other specificity. Picasso can cubistically paint the landscape with all those poster advertisements and brand logos wedged between the cubes of buildings and lines of the streets: the city becomes just like a rebus, a puzzle uniting images and words and forcing a new reading, a new viewpoint, a new understanding. Even when it then continues to 'illustrate' – see, for example, André Salmon's *Le manuscrit trouvé dans un chapeau* (1919) – it seems to force the text to reshape itself according to the images, 55

rather than vice versa, and sometimes throws in some figures that have no direct or evident relationship to the text, hence asking the reader to look elsewhere for it. Going back to cubism, when it then decides to directly (as you'll have noticed, initially everything hinged on the idea of 'directness') put clippings, labels, the stuff of things into the picture – into pictorial space – painting and art exploded in all directions: everything becomes possible, and truly everything will be.

What then follows is a mad sequence of inventions that try anything and everything, because the new viewpoint, the new understanding no longer find the right material, and have to invent it. The book is undone and redone from all points of view, tested in light of every new idea and form; at the same time it becomes a new field for questioning the specificities presumed by all the other media and artistic positions. It is almost impossible to find any order, because the avant-garde could not care less about order, and wants to venture ever further; so let us retrace some of its tracks, and try to describe what determines their direction.

Futurism, that mixed movement of literary and visual artists, immediately gets the idea and, wanting to be seen more than anyone, throws itself in a dynamic and disorganised manner in all directions. Advertising strategies are taken to the highest level: the movement therefore needs to equip itself with a 'manifesto' right at the very start, and has to publish it where it would reach the broadest possible public. To capture their attention, it has to use a striking language and tone that remain vividly stuck in the public mind. Then they can move on to more specialised experimentation: their *parole in libertà* – 'free words', or free-form word compositions – liberate writing from the tyranny of being laid out in lines, and bring a lightness and elasticity to words that now fly across the page, are ironed out in letters repeated within words and take on forms that indicate how they are to be understood, and are dramatised like the characters in a story. Onomatopoeias – those non-word words, strange linguistic signs that hold together writing and voice, icon and index, sense and nonsense – multiply.

On the other hand, the futurists throw themselves wholeheartedly into the production of books that become monstrous, mechanical objects: book-collages (Ardengo Soffici's *Bif&zf+18*, 1915); covers of various materials, tooled bindings (*Depero futurista*, 1927); until Fortunato Depero turns words into veritable 'typographic architectures', books-as-architecture as seen in his Bestetti, Tuminelli and Treves pavilions (1927) and finally the Campari pavilion (1928).

In Russia another group of futurists – or cubofuturists, as they called themselves – also experimented, finding in poetry the most ardent, radical inspiration for new creation. The *Zaum* or 'transrational' poets were interested in another aspect of sound – the more clearly musical aspect that allowed them to reach a new understanding, leaping over the meaning of mere words and sentences; this sort of sound creates a different sense, one that reason cannot understand but which stimulates other parts of human sensitivity. Theirs is a writing we could call wholly 'abstractist', non-figurative and utterly autonomous, in the vein of self-dissolution much like abstract visual forms and as radical as the black square on a white ground painted by Kazimir Malevich, who does not hesitate to use such an idiom.

Some of them push the fabrication of book-objects so far as to reach a level contemporary to the invention of the Duchampian ready-made, as is the case with the cover of Aleksei Kruchenik's *Zaumnaya gniga* (1915) designed by Olga Rozanova, who sewed an actual button atop the silhouette of a head.

In Germany, too, the sound of the human voice is listened to with renewed attention: Raoul Hausmann invents his sound-poetry – and visual poetry, as he exhibited *Off* and *Fmsbw* (1918) as manifestos as well, rising from score-less musical scores – and Kurt Schwitters makes an
impression with his *An Anna Blume* (1919), with his collages and by preparing his *Ursonate*

(1921) that, as the title confirms, aims to capture the origin of this history, its 'primordiality', its very essence.

With the dadaists a restless period of *sui generis* magazines begins, accompanied by other publications, single issues, broadsheets and manifestos difficult to classify according to the usual categories. Dada puts quotation marks around everything, everything assumes a hybrid aspect and unusual form, because the main goal is to shake things up – shake up art itself, and put art, in turn, in quotation marks. Because of this, dada even seems inseparable from its publishing activity, more alive and present in publishing than in the finished 'works' of individual artists: it is more a practice, an atmosphere, than an object or conclusive presence.

The dadaists composed directly with type, in the type shop; playing with the available clichés, they disarranged and jumbled up the rules of page layout and graphic design, they diverted and emptied things of all sense or inject nonsense, mixing and deconstructing. Collage is their favourite means, the form/non-form of their mode of intervention: through collage, everything is put on the same level, everything gains a relationship with everything else, nothing is isolated in its own noble autonomy anymore. In their publications, text and image mix just like in a collage, ushering in an approach that, in this sense, becomes a contagion affecting other fields far outside of dada. Consider a book like Vladimir Mayakovsky and Aleksandr Rodchenko's *Pro Eto* (1923), among the two artists' many collaborations: as both text and image are constructed according to the collage method, their union in the book becomes a sharing – that is, both their springing from the same sole principle and its application to different materials.

Francis Picabia had a prolific period focussing on the book form. He was no poet, but perhaps as a form of therapy, a dadaist therapy, of course! Tense and on the brink of a nervous breakdown as he was at the time, as he cancels out his painter self through a series of 'mechanomorphic' drawings, he also reinvents himself as a poet, a *sui generis* poet. The series of books he produces mix poetry and drawing such that they can no longer really be separated: *La figlia nata senza madre* (The Daughter Born without a Mother, 1918) is a significant title, indicating a relationship without any co-dependence. Picabia's 'poetry' books are what we now call 'artist's books', that is, bona fide works of art. Picabia does not overturn the book's look, but rather its internal form, and as he negates and parodies, he also connects and creates. Perhaps his books would better be exhibited, rather than bound: his poetry is to be looked at just as much as his drawings are to be read.

The truest, most ardent lovers of the book-as-object and the collaboration between writing and image were the surrealists. The unconscious – how shall we say it? – cannot stand the traditional book form, and will not be bound by it: beginning with 'automatic writing', which breaks down all distinctions between prose and poetry in an uninterrupted flood, up to the role – necessarily ambiguous, given their mania for experimentation, but nevertheless important – granted the image. Books – and magazines – were illustrated by painters, but above all the surrealists made books that were already conceived with images as they were written. What is Max Ernst's *Une semaine de bonté* (1924)? Or *La femme 100 têtes* (1929)? 'Novels', as it says on the former's cover? And what are André Breton's *Nadja* (1928) and *L'amour fou* (1937): novels, essays? Or even his manifestos for the movement, like Tristan Tzara's for dada: theory, art criticism, literature?

Marcel Duchamp, for his part, never fails to be inventive even in this field. If, on the one hand, he transforms books and catalogues into 'boxes' – his 1914 box, followed by the *Boite vert* (1934), *Boite en valise* (1936-1941) and *Boite blanc* (1967) – dismembering its pages into leaves, schemas, tables, sundry objects, he also, on the other, creates insistent work on the covers, **57**

exulting the book's object-based aspect and taking it to its radical surrealist turn in *Prière de toucher* (1947), with the cast rubber breasts metamorphosing the book into an erotic object. If this were perhaps the most radical result of the book's metamorphosis into something else, some other object, with a 'symbolic function', as the surrealists themselves defined it, the book also – insofar as it is a particular, peculiar object, a specific medium in and of itself, capable of breaking through the closed specificity of other media – becomes in turn a work of art, with other important developments, particularly after rising styles that share an abstract bent or influence. The book, in other words, is not overturned for what it is, as an object, but rather carries art within – not just hosting, illustrating or explaining it, but embodying it. In this area the book is not just respected as opposed to negated, but is often understood as a tool, a privileged object for putting the particular intentions of all branches of abstraction to the test. These explorations took multiple directions, but we will focus our attention to three in particular.

The first and most significant was the reconsideration of what we now call graphic design, and of its role, which was no longer purely applied, but increasingly independent, to the point of becoming wholly autonomous. With the various abstract art movements, the Bauhaus, neo-plasticism and Russian constructivism, graphic design not only became an autonomous dis-cipline, but a bona fide artistic field in all senses. If, on the one hand, the famous *Bauhaus-bücher* shows the most efficacious use of graphic design as visual communication for both the eye and mind of its reader, on the other hand, many artists also found characteristics in graph-ic design that they then used as a particular material for artistic expression *in toto*. Above all, artists thought about the interaction between word and visual form, with which various au-thors and artists experimented in new ways: words are not just simply used in lieu of geo-metric forms or splotches of colour, but the fact that the eye, as it looks at such things, nec-essarily reads them, allowing for and even requiring a different, unique gaze and comprehension. Theo Van Doesburg's experiments are used for covers, manifestos and other De Stijl graph-ic materials and the *Section d'or*, in which words of various sizes and colours are overlapped or intertwined, forcing the viewer to seek out an integration of sight and reading, or take con-trol of the see-saw motion between one and the other, and their 'pulsation', if not separation. So consider, then, how Kurt Schwitters, intensely involved in graphics on much more than a purely professional level, brings it so deeply into his 'unapplied' art to bring to mind a re-versal of positions, realising collages made entirely of graphic design elements, thus not on-ly turning graphics into an art form, but making art a sort of *ur*-graphics, if such can be said – taking up the same ideas he had applied in the *Ursonate*.

The second direction regards the relationship between word and image – not the image of the word, but an image of something else. This takes the matter to an entirely new, even more interesting level, because it demonstrates how abstraction invented a different use of photography as a substitute for the drawn or painted image, excluded from the latter's po-etics and aesthetics. For the abstract artist, the photographed figure is a found object, *trou-vé*, ready-made, and in this sense is on the same level as rigorously non-figurative forms. The result is a strange sort of collage, constructive instead of explosive, aimed at a synthe-sis instead of a disintegration or differentiation. In certain books of an abstract inclination, photography assumes a decisive role – the role of the visual realm in search of integration with the verbal realm. Take a classic like Vítězslav Nezval's *Abeceda* (1926), where the anal-ogy of bodily positions with the letters of the alphabet becomes a point of departure for an integration that goes far beyond just that, unfolding in complex graphic compositions
58 of the relationship between the photographic image of the body and, one might say, the

graphic image of the letter's 'body', not to mention with the poetic text on the facing page. Lastly, the third direction makes use of other particular aspects of the book form, aspects that easel painting – as it is now being called by those distancing themselves from it, or painting as a unique, fixed image – does not possess and yet continues to seek: movement, narrative, an unfolding over time. The book, with its succession of pages, its collected, whole form, offers the visual artist this additional possibility. Is narrative contrary to the principles of abstraction? Perhaps not, if shown as a discontinuous succession of still image-pages. And what a strange 'story', then, results. Is El Lissitsky's *Story of Two Squares* (1922) really the story of two squares? In what sense? Precisely in the sense that its visual aspect wants to have – one different from the verbal sense. Many books are born in the course of these experimental examples, because artists grow increasingly interested in the book, suspended as it is between being a bona fide medium and, at the same time, a medium quite different from other visual media. In the end, it is overturned like all media, after having cut into the presumed specificity of others, outside its proper bounds, beyond or perhaps even in search of other possible specificities, and reinventions thereof.

In conclusion, we must mention a particular case from the 1930s, before the period of the so-called historic avant-gardes came to a close, before the explosion of World War II divided the century. It does not deal with books, but rather with an issue that has a lot to do with books, according to a recently renewed interpretation. It is the case of John Heartfield and his covers for the magazine *AIZ*. Already famous for their anti-Nazi content, they were then rediscovered from a more formal viewpoint in terms of the 'public sphere', or rather as an art that really, not just in its intentions, speaks to its chosen public – in this case, the proletariat, according to the magazine's basic political position – not just for its contents, but also its form. Here Heartfield is an excellent example in at least two ways: not only because he uses photomontage and other avant-garde techniques in a way its public could comprehend, but also and above all insofar as he produced images with the sole, unique destination of appearing on the cover of the magazine for which they were exclusively realised, finding their fate in that of the publication itself, which most completely actuates the 'technical reproduction' Walter Benjamin is writing about in those same years: an image created to be multiplied, distributed – created for its public destiny, more than public destination.

Today, what could be more relevant – in the era of Internet, digital media, no copyrights – than the obsolescence of the book format?

Carlo Montanaro

Image and Concept

It is hard to believe that Nam June Paik,[1] supreme prophet of video art, had a specific hand in the creation of Peter Jackson's[2] *King Kong*[3] (the most recent remake of the famous 1933 film).[4] And yet it was the Korean artist's curiosity,[5] which by 1970 had become a need, that led him to work with the Japanese electronic engineer Shuya Abe and invent the 'Paik-Abe video synthesizer', allowing a piloted, programmed manipulation of the electronic image. This manipulation, from its initial use in specially designed devices, was gradually transferred to computers that were increasingly powerful as well as increasingly personal[6] – tools that, for many years now and thanks to the increasing reliability of video and graphic programmes, manage to create characters and sets for cinematographers. Such was the case with the latest *King Kong*, where almost nothing is real but everything seems true-to-life, unlike the flashier applications of computerised graphics, which brought three-dimensional animation to the big screen with incredible results.

But at this point it is even harder to believe that just a few years earlier, during the Fluxus movement, Paik conceived of the minimalist cinematographic work par excellence, his *Zen for Film*,[7] which is nothing but the projection of the pure, transparent support of the film strip that – because of mechanical friction, electrostatic energy and superheating related to the dynamics of projection – would gradually but inevitably decay (causing the stains, or 'boogers', that end up digging into the film, cutting lines into the plastic material), becoming a series of indistinct signs that end up, with notoriously Zen timing, in self-destruction.

It is hard to understand Paik's two apparently paradoxical opposites, but it might be easier if we were to reconsider some of the elements in the cryptic yet prophetic *Manifesto della cinematografia futurista*,[8] which as early as 1916 predicted the potential **61**

of the audiovisual realm. Yes, 'audiovisual'. Not just of cinema, plain and simple, but of the audiovisual, or rather a whole made up of signs and sounds, including – oh my god! – video and computer art, which are not born out of thin air, but derive from the evolution and/or transformation of otherwise primitive or antecedent technologies.

Indeed, what could be behind such programmatic elements as "6. Daily exercises for freeing oneself from cinematographed logic", "12. Potential crises within the strategic plans of cinematographed sentiments" or even "13. Linear, sculptural, chromatic etc. equivalents of cinematographed men, women, events, thoughts, music, feelings, weights, scents, noises (with white lines atop black we will create the internal and physical rhythms of a man who discovers his wife is adulterous and stalks her lover, the rhythm of the soul and of the legs)",[9] if not a linguistic and figurative experimentation that only the second time round made an attempt at establishing itself, within dada and surrealist poetics, thanks to cinematographic technology? Because, aside from the lost *Vita futurista*,[10] nothing of a confessionalist bent[11] has been produced in the movement that became a point of redeparture for modern art. Only after the fact, for example, did anyone consider the Ginanni Corradini brothers' (Arnaldo Ginna and Bruno Corra) 'chromatic music' part of a broader cinematographic experimentation. They had conceived of these works as a performance that would take place in a specially designed space, painted completely white, with spectators dressed in a specific 'fashion' (also based on white), who each, little by little, became an integral part of the 'event'. It had not yet been considered that the brothers' use of a hand-painted filmstrip and modified film projector was purely utilitarian, and lacked the fundamental element of cinema – the use of a negative (the original) that necessarily produced copies (the typical seriality of a material destined for commercial purposes).

Thus we come to the true issue underlying all audiovisual history[12]: the technological awareness of the means that permit (or *do not* permit) grammatical and syntactic application. This knowledge is often slyly denied. Let us take the most obvious example: *Retour à la raison*, Man Ray's first film. According to Ray,[13] Tristan Tzara was the one who got him involved, announcing his participation in what would end up being the last major dada event, *Le coeur à barbe*, scheduled for 6 July 1923 at the Michel Theatre in Paris. Diligently, he set to work assembling in a single night pre-made film clips he had realised in collaboration with others, adopting for film a technique already tried out in photography: "On some [celluloid strips] I sprinkled salt and pepper, like a chef preparing a roast; on others I casually tossed pins and pen nibs, then turned the light on for a second or two, just like with the *rayographs*."[14] And presenting it all as utterly casual, almost invoking accidental ruptures in the reel simply projected ("many more of these programmes would have tried the viewers' patience, which was, after all, the dadaists' main objective"[15]), constructed with entirely original framing, realised for the most part without a motion-picture camera. It is too bad Man Ray forgot, as he wrote his splendid autobiography in 1963, that there were also negative-positive passages in the film, as well as 'rayographed' elements. It is also too bad that he did not hesitate to eliminate a few centimetres of film on which "*à tirer 5 fois*" was written (in white on a black ground, therefore 'taken' from elsewhere because it would originally have been written with black ink on transparent film). Since the French term *tirer* is synonymous with 'to print' or 'to make copies of', this simply means that what is being passed off as an extemporaneous improvisation was instead the result of a precise design in the creation of a provocative film that was only apparently determined by chance. And our dear Man Ray, as any good dadaist, in writing about himself chose to immortalise that omitted detail. In order to transgress, one first has to

know; and all the 'creatives' in the 1920s – the period traditionally defined as the 'historic avant-garde' era – who tried their hand using the technology of cinema in hopes of setting the foundations of a new language had rather precise knowledge of the medium. They certainly knew enough to demand, as a bonus, excellent collaborators: indeed, Francis Picabia invited René Chomette (a.k.a. René Clair, who in 1924 was an emerging director) to be co-creator of *Entr'acte*, one of the most important and everlasting products of that period; in 1926 Marcel Duchamp asked his friend Man Ray to help create *Anémic Cinéma*, his sole, fascinating cinematographic work signed Rrose Sélavy. The American photographer Ralph Steiner, no longer seeking abstraction in the manipulation of pure geometric forms (like Hans Richter and others) but directly from reality, won the collaboration of composer Aaron Copland for the accompaniment, in what would turn out to be an amazing montage (even if he was not so convinced . . .), to the reflections of light on water in his H_2O (1929). Abstraction, then, that from the geometric relationships rendered with animated paper cut-outs gradually becomes a rereading of reality where, aside from the aforementioned water, many elements linked to industrialisation can be (with mechanical apparatuses, scaffolds, etc.) found, which the filmstrip – especially the rigorously black-and-white film, the only available at the time – transfigures. They use real images to continue confirming the essence of cinema, which has mastered experimentation in all possible forms, integrating it in all its specificity and denying the possibility of a third approach – that of an autonomous alternative to both painting and film. As Hans Richter wrote: "Easel painting represented a limitation, and in order to surpass this limitation we had to find a 'beginning' and an 'end' that were both progressive. Thus we [Richter and Viking Eggeling] introduced 'rollable' canvases. Thanks to these rolls we unwittingly discovered a dynamic mode of expression, quite different from easel painting."[16] So the idea was to go beyond the mere sign, framed by the darkness of the screen instead of a picture frame, harmoniously linking it to the equally harmonious passage of time. But, going deeper, Richter realised that the real result lay in "[feeling] a new sensation, which condensed all my early artistic experiences into one: the sensation of rhythm. Even today I am still convinced that rhythm – the articulation of units of time – constitutes the ultimate sensation, the one that can provoke all sorts of movement expressed in the art of cinema."[17]

It s no coincidence, then, that Richter, the only one of the 'experimenters' who would continue to alternate the practices of painting and cinema throughout his life, ended up using distinctions, denying the existence of an art that crosses between the two systems of expression, while at the same time exulting the aforementioned essence of cinema, which – simplifying into one specific term the concept underlying the relationship between *rhythm* and *time* – can only be called *montage*.

But montage does not merely represent the harmonic management of time,[18] prefiguring, by replicating the same rules, a mimesis with music. It also represents one of the most important conquests, over the past century, of knowledge, because its correct application goes far beyond the truthful semblance of the images it connects. As Béla Balász wrote: "One of my friends from Moscow was telling me about his new maid's arrival in the city, her first time travelling there from a Siberian *kolchoz*. She was an intelligent girl, and had made the most of her schooling, but due to a series of strange circumstances, she had never seen a film (this was many years ago). Her employers sent her to the cinema, where some popular comedy was being shown. She returned home incredibly pale and surly. 'Did you like it?' they asked. She was still overcome with emotion, and for a few minutes could not ut-

ter a single word. 'It was horrible,' she finally said, indignant. 'I just cannot understand why here in Moscow they allow such monstrosities to be shown.' 'But, what did you see?' her employers replied. 'I saw,' the girl answered, 'men torn to bits: head, feet, hands, a piece here, a piece there, all in different places.' Legend tells of how, at the cinema in Hollywood where Griffith first presented an enormous smiling head 'lopped from the body', the audience was overcome with panic. We can no longer even imagine the complex process of adaptation people's conscience must have gone through to become familiar with such visual associations. It was substantially a question of recomposing in one's own conscience the disjointed images in their unique elements, seen successively over time, giving them unity and continuity; all that without perceiving the complicated procedure necessary to produce such a result. The various moments of an action we see one after the other in film, in reality take place at the same time, and are part of a single action. So here we are, then, in front of a new representative faculty, a new culture developed over an incredibly short span of time. Today we can no longer even imagine how it was possible to learn, over a few short years, the language of images; and recognise the perspectives, metaphors and symbols of images. Over just twenty years a major visual culture has been born."[19]

This means that today – more than fifty years since this little chapter was written by the Hungarian theorist, poet and screenwriter Béla Balász (1884–1949) – it is even more difficult to attempt a meditation on those early years, on the impact the moving image created in the eyes and minds of the first viewers.

The first filmstrips were quite far from the 'visual association' and 'representative faculty' Béla Balász spoke of. It took the first cinematographers months to understand how they could interrupt the continuous flow of the reel's movement, initially resulting in effects with astounding, almost drug-induced appearances (the principle of 'substitution').[20] It took them years to apply the logical consequence of controlling cinematic time in a systematic way, as opposed to the primitive necessities of real time, which forced them to film (or set up filming) an action according to the duration allowed by the length of film available.

Certainly this was the dawn of a new form of representation based on the principles of photography and, like photography, it allowed for the capturing of images automatically in perspective. But both in the first films of the Lumière brothers and in the work of Georges Méliès (in other words, in both primitive 'document' and primitive 'simulation' or 'fiction') it was impossible to identify any metaphor or symbolism beyond those innate to the 'subjects' being filmed.

It had all begun, but it was a continuous, slow, gradual conquest. Artists soon wanted to test the possibilities of 'enlarging' or 'shrinking', zooming in or out – at various moments, of course, in the course of filming (the 'trolley shot' came much later, and zoom was not feasible until the 1960s) – from the subject. It later became possible, via cutting and splicing, not only to reproduce continuous action, composing different fragments realised at different times, but also to modify (both additively and subtractively) the duration of the action itself, without altering its dynamics or meaning. But this already entailed additional unknowns or, better said, the materialisation of 'visual effects' that had previously been unknown or unthinkable. First, it was possible to show juxtaposed drawings or photographs portraying landscapes, objects and people reproduced on differing scales, enlarged or reduced, or even cut and decontextualised from the given reality. Béla Balász's little farmer girl, and later maid, in light of her however minimal level of education, before being faced with cinema cannot *not* have seen a painting, a print or a photograph with someone's portrait – in short, with one of those 'bits' of human being (if not exactly a 'decapitated head',

at least a 'bust sawn in half') that so terrified her when seen on the screen. But, first and foremost, any 'bits' had always remained immobile; so scanning one's eyes from a scene with a 'bit' of figure to one with a 'complete figure', shown next to one another on almost any sort of surface, was directly proportional, in technique and time, to a precise choice made by the observer, not a forced operation. But at the cinema, going from a full-body shot to a close-up is one the most typical directorial choices made by the filmmaker, and the viewer experiences it in an utterly passive way, stuck as he is, sitting in the dark, watching only the lit screen.

So this was a precise decision instantaneously carried out, without allowing the person viewing it any time to rationalise it. This decision is infinitely replicated in the structuring of a cinematic work, and entails a rather concrete plan in shooting, given everything that happens in the fundamental, foundational part of every film when all the clips are numbered and the director assembles (or edits) his work, putting them in order according to more or less chronological and, above all, rhythmic, logical narrative rules: constantly questioning the spatial (type of framing) and temporal (duration) qualities of each clip in relation to what precedes and follows it. These rules have evolved over time, and are perfected precisely when someone has the strength to transgress, negating and/or forever changing them.

Like the famous drop of water cutting through stone, in its first phase (so-called silent film) the audiovisual realm gradually won over everyone who came under its spell. But it is impossible to document (as there is no trace in the collective memory or texts) up to what precise point it contributed to the artistic revolution of the early twentieth century. This impossibility is due to its slow, gradual development and the difficulties of rationalising the mental processes that development triggered; it certainly was not limited to either the cinema and editing booth or to the circle of protagonists who, almost always on an intuitive level, did their best to broaden the possibilities of the medium they were working with and helping to develop. The bases of the revolution lay in a new way of 'seeing'. Because, first of all, the cinematographer's viewer had to learn to decodify a richer visual image, therefore making it more complex to instantaneously recompose those fragments in the mind – fragments that, to be more precise, re-elaborate and deepen the story, if they don't become apparently unnatural in their temporal unfolding. Thus the viewer can accept a continuous change in scale, the movement of amplified details (the 'bits'), and the elision or amplification of time. We then arrive, by 'contextualising the decontextualised' (pardon the play on words), at the next step, which, introducing the idea of visual association, allows the viewer not only to assemble, thanks to montage, images from apparently incongruous sources in a logical way, but even a change in meaning, or the objectification of the subject and the 'subjectification' of the object. Here, too, it was possible – until the advent of cinema – to reproduce natural elements, people and man-made objects: every reproductive faculty (painting, sculpture, etching and engraving, printing, photography, etc.) could only offer a step up in quality from an aesthetic point of view, while at the same time remaining similar to the natural prototype that served as its model. With cinematography, on the other hand, a landscape, an object, beyond their exterior and aesthetic aspects, could become as important as a human expression, glance, gesture or phrase. Becoming, in repeated reproduction, a narrative element, they offer additional qualities to their context, and can thereby assume a more exact conceptual worth. For example: might it be possible that, steeped in the Boccioni-esque climate of futurism, Marcel Duchamp, fascinated as he was by the analysis of movement derived from photography

and cinema (*Nu descendant un escalier n. 2*, 1912), then rapidly arrived at the ready-made (*Roue de bicyclette*, 1913) – in other words, the strictly conceptual – precisely thanks to a logical evolution of thought, however unconscious it might have been?[21] After him, as we said at the very beginning, a precise awareness and conscience rose in everyone experimenting with cinema, who were content with the results and offered new elements for the evolution of the specific language of this medium. This awareness, this knowledge seem less and less determinate in more recent uses of the audiovisual medium, tied as they are to the ease of using digital systems, video cameras and computers.

[1] Seoul 1932–Miami 2006.
[2] Born in Christchurch, New Zealand, in 1961.
[3] Peter Jackson's *King Kong,* Universal Pictures, 2005.
[4] Ernest B. Schoedsack and Merian C. Cooper's *King Kong*, RKO Radio Pictures, 1933.
[5] Prarticularly the deformation of televised images due to the alteration of the TV set's magnetic fields, initially obtained by positionong a strong magnet near the cathode-ray tube.
[6] In the sense of individual management possibilities, when instead, since the 1960s, the computer – beyond its primary military ends – was also used for corporate organisational and economic management, to send men into space and to send out bills and/or commercial invoices.
[7] *Zen for Film* (1962–1964), from twenty (even thirty) to eight minutes.
[8] Signed by F.T. Marinetti, B. Corra, E. Settimelli, A. Ginna, G. Balla and R. Chiti and published in the ninth issue of the *L'Italia futurista* newspaper, Milan, 11 September 1916.
[9] *Manifesto della cinematografia futurista*, Archivio Carlo Montanaro, Venice.
[10] Director and photographer, Arnaldo Ginna; director's assistant, Lucio Venna; script and scenery, Emilio Settimelli (with other futurists); actors, Filippo Tommaso Marinetti, Bruno Corra, Remo Chiti, Giacomo Balla; producer, Italia Futurista, Rome, *visto di censura* permit 12279 dated 14.12.1916, 990 metres.
[11] In reality, there were many signs and signals (cf. G. Lista, *Cinema e fotografia futurista*. Milan: Skira, 2001), above all in the most common cinema, including comic cinema, already midway between the absurd and the demented – enough to provide proof, to anyone writing about it, in the twenty-first *Giornate del cinema muto* festival (a silent film festival) in 2002, entirely dedicated to Italian cinema with the title *L'avanguardia italiana, ovvero un'avanguardia inconsapevole* (The Italian Avant-garde, or, An Unaware Avant-garde).
[12] It must not be forgotten that much of the experimental cinema produced – even in the silent era, and much like with commercial cinema – had precise musical and other references, thanks to the creation of original scores to be played live along with the projection.
[13] M. Ray, *Autoritratto*. Milan: Mazzotta Editore, 1975, p. 212.
[14] Ibid.
[15] Ibid.
[16] "Le tableau du chevalet raprésentait une limite au-delà de la quelle il fallait trouver un «début» et une «fin» par une manière de croissance. C'est ainsi que l'on développa le tableau pour en faire un rouleau. Grâce à ces rouleau, nous avions découvert, sans le vouloir, un mode d'expression dynamique différent de celui de la peinture de chevalet" (Quoted in *Cinéma dadaiste et surrealiste*. Paris: Centre national d'art e de culture Georges Pompidou, 1976, p. 53).
[17] "[. . .] j'éprouvai une sensation nouvelle, qui me fit rejoindre mes toutes premières expériences artistiques: la sensation du rhytme. Je souis ancore aujourd'hui persuadé que le rythme, c'est-à-dire l'articulation d'unités de temps, constitue la sensation par excellence que peut procurer toute expression du mouvement dans l'art du cinéma" (Ibid.).
[18] Andy Warhol, in the 1960s, even managed to negate the need for montage and editing, celebrating the fixed frame, artfully harkening back to cinema's origins and almost hinting at the need for a renaissance.
[19] B. Balász, *Il film, evoluzione ed essenza di un'arte nuova* (Iskusstvo Kino, 1948). Turin: Einaudi, 1952, pp. 40–41.
[20] The first trick, developed in 1896 by Georges Méliès, fundamental to the beginnings of fiction and cinematic language.
[21] So it is no coincidence that, during his time in America, he even played a cameo role in Léonce Perret's film *Lafayette, We Come,* produced by Pathé's American affiliate.

Claudio Marra

The Irresistible Rise of the Photographic

I believe we can initially all agree upon the idea that the impact of media – and in particular the photographic medium – on artistic practices in the twentieth century essentially had two distinct phases, differentiated more by their qualitative presence than for the method and extent of their application. The first wave, the one sparked with such great energy by the historic avant garde, perfectly expressed the sense of being seen from a distance, the sense of genial, advance intuition founded more on certain conceptual hints than on the interpretation of an effective change in lifestyle. In a historical context that had, deep down, already shown some signs of the impact that technological culture would have over the course of the century – but on the surface was not yet affected in a widespread, capillary fashion – artists played the demanding role of those who, for the collective good, assume the responsibility of picking up on energies and tensions that had not yet entered into the mainstream. So the proposed solutions often appeared conditioned by a climate of elite exclusivity, which nevertheless did not impede the development of linguistic forms and categories that would then spread into the media-based applications of the latter half of the century. Even if only in an episodic and often occasional manner, such conceptual models were nevertheless almost entirely present already, and entrusted to the isolated, far-sighted genius of the many [artistic] protagonists of that heroic period.

If, then, it is true that the gap between the two phases is more quantitative than qualitative, one still must not think that the passage between the first and second halves of the twentieth century was strictly a question of historical progression, without any specific significance. To begin with, in general, one must consider that precisely in media-based issues, the quantitative factor is never really an abstract numeric magnitude, but is rather

automatically transformed into a qualitative factor, from the moment that a feeling of expansion and 'massification' are perhaps the first characteristics that distinguish it from related cultural phenomena. But then it is precisely in the specifics of the photographic field that one can grasp some of the main junctures of meaning that are capable of shedding some light on the dynamics linking the presence of media-based technologies in art between the first and second halves of the century. I believe, in particular, we must reflect upon the striking spread and circulation that photography reached in the last three decades of the twentieth century, a veritable dictatorship, one might say, that cannot be simplistically explained, as so many have clumsily tried, solely by making a good case for strictly practical reasons like the ease and economy of the medium and its tools, or, even more generically, by invoking the indisputable rights of primogeniture photography can boast over other media. Certainly, photography is a relatively simple and immediate medium, with a rather long history already behind it, but that is not enough to explain the spread and sympathy it has earned, which show no signs of waivering, and indeed seem only to increase with time.

The real, strong reason for this success, I believe, lies in the fact that, quite rightly, artists have seen photography as the perfect 'noumenic form' of media-based culture – that is, as the tool best capable of condensing, in the purest way, the specific essence of technological aesthetics with respect to manual aesthetics. Givens such as 'objectivity', 'mechanicity' and the almost total absence of *téchne* in execution assert themselves in photography with an absolutely unquestionable clarity and strength. All the parameters that historically pushed artists to substitute manual effort with technology, in photography are taken to the highest possible degree, without hesitation and without any ambiguity whatsoever. Even video, which in comparison would seem to crush photography when it comes to greater [linguistic] contemporaneity, does not seem to enjoy the same level of conceptuality, as it nevertheless entails, between the duration of a shoot and later editing, an undeniably higher degree of manual intervention and ambiguity. Photography does not. Photography is direct sampling in its purest state, absolute and immediate cloning, potentially unpolluted by the human hand and therefore useable as an ideal accomplice for that conceptual tension so strongly invoked by all twentieth-century art. Indirect proof of its supremacy in this sense can be seen in the suspicion it has repeatedly inspired, with regard to both theory and to poetics. How, for example, can anyone forget the serious delay with which, precisely compared to cinema, futurism granted photography any official attention? Almost fifteen years passed between the publication of the respective manifestos – a grave and significant delay that, at least in part, can be explained by people's inability to recognise that the photographic medium has the same capability of linguistic articulation, and therefore same ability for its creator to intervene, that can instead be more easily found in the tools of film.[1] In short, photography seems technologically too radical, and therefore almost excessive in its media-related potential – so far from the logic of manual media that it is even too difficult for an eponymously named modernist movement like futurism to use. In the realm of theory, a field that has repeatedly expressed similar levels of suspicion is semiotics, which tried in every way possible to correct the genetically rooted wrong thinking attributed to photography in the past. First by nurturing the many perplexities regarding its inclusion in the category of indexical signs as proposed by Charles Sanders Peirce, the field's historic founder, and then trying in all possible ways to win back for it the reassuring label 'icon', that is, to group it with those signs that can boast a certain ability to transform the referent via a linguistic manipulation produced by their creator.[2] In short,

what still makes photography scary is what Roland Barthes called its incontrovertible 'clarity', that fatal sense of reality's flagrant nature, which makes it difficult to trace back to a manual aesthetic.[3]

So, photography's presence in the artistic practices of the late twentieth century fundamentally hinges on this central meaning. On the reasons and motives that led the medium to become an inevitable accomplice in the development of a post-manual aesthetic, necessary supporter of the conceptual expansion of sensibility. The presence and incidence of photography, then – but perhaps it would be best to say of *the photographic*,[4] because in effect, even more than the concrete results, more than the produced works, what counted was the spread of a philosophy, a particular way of conceiving a relationship with the real that was developed and instituted by this medium. So we essentially want to say that the question of photography in twentieth-century art – and in particular in the art of the century's final three or four decades – cannot be simplistically reduced to the question of what an image is, nor even to the question of what a work of art is, in the broadest definition. The greatest impact was the one expressed by *the photographic*, by a spirit and logic that in any case pervaded artistic production even when there was a direct absence of photography itself.

If this were not the case – and here we are moving toward a more analytical recognition of the period in question – we would even find it difficult to understand the relationship between photography and pop art. In light of the movement's glaring, overall debt to the entire media-based system, the direct presence of photography in pop art is actually quite limited. Even in the case of Andy Warhol, doubtless the artist most involved in this regard, philologically speaking we would need to admit that the presence of 'pure photography', that is, photography that is not manipulated or modified, is extremely limited. It is quite another matter if, for instance, we refer instead to the principle of *the photographic*, which undeniably shaped and characterised every possible implication of Warholian poetics: from his continuously expressed desire to 'be like a machine', or to 'have a photographic memory',[5] to his recurring use of one of the process's basic principles such as repetition. Paradoxically, then, the photographic spirit emerges even more clearly in cases that are apparently unrelated to photography as it is traditionally understood, as happens, for example, with the zoom-ins and blow-ups of cartoons and objects as Roy Lichtenstein and Claes Oldenburg made them. But we could go even further and find the significant imprint of the photographic in the overall idea of poetics that, at the time, Lucy Lippard attributed to all pop art in defining it as a "more extroverted than introverted"[6] art – an art, that is, necessarily involved with the outside world, and characterised by an explicit, direct relationship to that world. Now, isn't that the exact same photographic identity later outlined with such lucidity by Rosalind Krauss when, comparing it to painting, she goes to the point of indicating its specificity as lying in the act of relating to the subject head-on as imposed by the medium's technical structure?[7] As Krauss perceptively suggested: you can paint a tree in its absence, but you certainly cannot photograph one. Photography, then, is a process of obligatory extroversion, forced by material imposition that you evidently cannot avoid, the very fact of being continually present, which then became an unsettling metaphor for our contemporary culture, the condition of a global supermarket open twenty-four hours a day, as the pop artists had so punctually predicted. Privileging the photographic over photography, it becomes possible to extend our vision even beyond the 1970s, when photography still seems completely absent from the main focus of artistic practice and output. More than absent, I should say separate, since in the ten-

plus years separating the end of World War II from the first signs of the pop movement's arrival, art and photography both seem not to feel the need to get involved in each other's destinies. Both were frenetically focussed: one on the symbolic expression, in the violent and heated strokes of action painting and informal art, of all those vitalistic energies that the war had so painfully cancelled out; the other on retelling, in direct and realistic language, the effective resurgence of life. But if we do not stop at the straightforward comparison of possible formal coincidences – that is, at pointing out actual superficial resemblances that painting and photography could simultaneously show – and again go even further, to look at their intentions and overall poetics, we can see the emergence of provocative ideal coincidences. If, for example, we decide to go with the interpretations the best critics have proposed regarding that pictorial movement, we realise that the accent falls on the desire for a direct, instinctive immersion in the energetic flow of life as made manifest, through the pictorial gesture [through painting], by the informal artists. To use a sort of play on words, following these convincing interpretations, informal art should not be viewed formally, but rather behaviourally – that is, precisely like a hint, a sign of an irrepressible worldly, social calling, an unstoppable desire to rush headlong into the chaos of life in order to sensorially embrace it in all its possible manifestations. No, how can we not see an analogous worldly intention in the type of photography most practised in those same years – what we generically refer to as reportage, in the particular, revised interpretation artists like Robert Frank and William Klein gave it at the time? Today we would call them careless, improper reporters, now that those formulas have found such genial revivals in art and fashion thanks to German artists like Wolfgang Tillmans and Jürgen Teller or the American photographer Robert Richardson. So now, although it remains tied to the figurative approach, this photographic typology now seems absolutely in line with the deeper senses of informal painting. The engrossing metropolitan reportages carried out by Frank and Klein in the 1950s are not at all distant, in spirit and intent, from what their fellow painters were doing at the time, which once again proves the linguistic exchange that, in light of their respective autonomies, constantly brings the photographic and the painterly into a dialectic tension.

But the rise of the photographic grows truly irresistible between the 1960s and 1970s – surprise! – just as the elite experiments of the historic avant-gardes return on a large scale, in 'normalised' form. Drawing a map, or even the most summary outline, of photography's presence in the artistic practices of those years would require much more room than we have here. So we will have to limit ourselves to identifying the categories of the photographic that explicitly contributed to the development of such rich experimentation, which can for the most part be traced back to the triad of 'body, environment, concept', set into action in those extraordinary years.

The first fundamental question has to do with the contribution that the photographic made to the drastic reorganisation of technical and execution-related factors, to the point of producing a veritable phenomenon calling for the 'concealment of the artist', an idea proposed in 1978 by the brilliant Franco Vaccari.[8] In this case Vaccari rightly traces the idea of concealment back to Marcel Duchamp, the grand old man behind that entire experimental wave, and extraordinary prototype of an artist who cancels himself out in the manual realm in order to expand in the conceptual realm. But isn't it perhaps the subterranean presence of the photographic, the incidence of an implicit 'photographability', that Rosalind Krauss repeatedly returns our focus to in her convincing analysis of Duchamp's oeuvre?[9] Duchamp, who

was not a photographer, but absorbs photography's deep spirit, making a metaphor of its high-

ly reduced manual aspect, as well as its unparalleled capacity for exposing the real in an immediate, direct way – just like a ready-made. These are the fundamental categories that, from the experimental laboratories of the early twentieth-century avant-garde, spread like wildfire in the art of the 1970s, fragmenting and redefining themselves in the many directions that artistic practice took in those years.

As regards body/behaviour/action, an even stronger influence the photographic had seems to affect the root of the experiences themselves, ever since the presence of a tool capable of effectively 'maintaining' and 'reproposing' the impact of physicality and the evanescence of a gesture, allows the artist to design and develop operations that would otherwise be inconceivable. So it would be a grave mistake to consider photography a tool that has simply limited itself to documenting what we call, in its entirety, body art. Certainly that function is present, but an even more important contribution is conceptually derived from the awareness that, in the photographic era, the body is no longer limited to a limiting symbolic transposition, as happens in drawing, but can be wholly brought back in 'flesh and blood'. With this in mind, we must recognise the fact that, once the political emergencies of the 1970s were extinguished, all the tension that in the following decades would fuel so-called body culture was conceptually based on the effective possibility of 'maintaining' and 'reproposing' stemming from a tool that, as early as the nineteenth century, was referred to as a 'mirror with a memory' [10] Moving from experiments focussed on the body to those focussed on the environment, the contribution of the photographic remains both fundamental and decisive. Whether it is a matter of recognition- or relation-based perspectives, the art of the 1970s rediscovers the authentic and original identity of media as mediators. So they are no longer tools limited to the material production of the image, but rather effective connecting agents with the outside world, artificial extensions of sensitivity, capable of extending and intensifying our relationship with the environment. Of all the applications unleashed by this media-based/mediative concept, one in particular is worth underlining: the specific possibility of manipulating time (by stopping, cutting, shortening are lengthening it . . .) that the photographic introduces to our relationship with environment. This is an effective, influential intervention in the codified structure of spatio-temporal relationships that allows artists to warp interpretations and points of view, so as to facilitate the full, sensorial recovery of the world, as opposed to the anaesthesia produced by habit and the repetition of old behaviours.

After the body and the environment comes the frontier of concept. Having accepted that the first two phases were already based on a solid conceptual framework, were we to want to examine the particular declinations of conceptual art in itself, we would simply need to close the loop and come full circle regarding the aforementioned Duchampian legacy. Once again, it is not – or at least not only – a question of the actual presence of artistic research carried out with photography, as much as it is a question of the contribution the more general philosophy of the photographic developed in this trend. A conceptual art can evidently develop as soon as the material culture permits. Returning for a moment to Krauss's reading of Duchamp, we must emphasise how his passage from pictorial to conceptual, which culminated in his abandonment of cubism, was attributed not to fortuitous chance or an act of isolated genius, but rather to an accumulation of stimuli that recognise, in the photographic, the founding condition of all conceptual operations: a direct 'intentionment' of the real, uncontaminated by any manual intervention. Certainly the artists who collected this legacy, fifty years later, make use of exactly the same opportunities made possible by the photographic, managing to stabilise a connection between subject and object regard-

less of any possible form of expressive involvement. It is worth recalling how this same cold adoption of the medium at the time caused a lot of misunderstandings for the critics who interpreted this 'low', 'banal' use as a sort of offence to the linguistic dignity of photography, without considering that, on the contrary, precisely the validation of conceptual possibilities constituted a way of opposing the dominant formalism that would otherwise have sucked the medium back toward a more pictorial realm.

Many of the impulses that emerged in the experimental laboratory of the 1970s seeped into the last two decades of the twentieth century as well, but not without undergoing some further 'normalisation' due to the irrepressible escalation of media-based currents throughout culture. This phenomenon even seemed to revive the alluring utopianism cultivated by the historic avant-garde regarding an artistry that was suspended throughout and spread into daily life, or at least deeply contaminated by it. And once again photography is the tool that seems most suited for effectively shuffling the deck, confounding and overlapping the destinies of art, fashion, design, architecture, communication. Photography was what made magazine pages competitive with museum galleries, favouring the free circulation of the same bunch of players from one to the other. It was as if the photographic managed to produce a sort of continuous space, a sole, imposing virtual scenario, capable of exporting the aesthetic beyond the confines of the places institutionally delegated to deal with it, in such a way as to let it circulate more broadly. In the 1980s and 1990s the body/environment/concept triad made a full comeback, but on another level, further articulated in a dimension where the real and the virtual intertwine without any solution for reaching a continuity. It is in the empire of the image that the body manifests itself as an ever more artificial entity, and if just twenty-odd years before the most urgent need seemed to be a need to regain conscience, almost didactically making use of the possibilities offered by the media-based mirror, now, consciousness having been gained, the most compelling desire seems to deal more with a progressive sliding toward a post-organic condition. This perspective is perhaps overly emphasised in references to the current crazes of plastic surgery and cellular manipulation, but in reality it is much more incisive and evident if considered in light of the multiplications of identity so easily allowed by the photographic. So while the big brothers of the first wave of body art were busy looking at the body photographically in order to catalogue its structures and operative conditions, toward the end of the century artists turn the body/photography binomial into the privileged chance to expand into the imaginary, and into a disenchanted experimentation with identity.

Even the relationship with the environment is now geared toward artificial scenarios and, while depersonalising non-places multiply outside the window, the photographic must now reconstruct the spaces in which it wants to operate. Spurred on by new technological frontiers, it even seems possible to glimpse, in the developments of photography, confirmation of that absorbing characteristic that distinguished it right from the start – that is, the possibility of experiencing the real through a shift, a perspective we now find widespread and evident amid the masses in the increasingly common idea of virtual reality. The 'as if' principle that the photographic had always allowed for – albeit not without being considered, by many, a form of colossal linguistic naïveté – now asserted itself as the most innovative and revolutionary feature of the last media-based state.

Far-sightedly foreshadowed by the artists of the historic avant-garde, the regime of the conceptual now totally dominates the horizon of the late twentieth century, in a condition where, paradoxically, precisely this progressive 'indefinition' of the given reality makes its substitu-

tion for the credible virtuality of the photographic ever more necessary.

[1] Remember that the *Manifesto della cinematografia futurista*, signed by F.T. Marinetti, B. Corra, E. Settimelli, A. Ginna, G. Balla and R. Chiti is from 1916, while the *Manifesto della fotografia futurista*, signed by F.T. Marinetti and Tato (pseudonym of Guglielmo Sansoni, an artist from Bologna) is from 1930.

[2] An enormous, recently published study essentially reproposes the same obstinate approach; see P. Basso Fossali and M.G. Dondero, *Semiotica della fotografia*. Rimini: Guaraldi, 2006.

[3] "It is erroneously associated, given its technical origins, with the idea of a dark passage (camera obscura). One should rather say *camera lucida* . . . in fact, from the gaze's point of view, the image's essence appears entirely exterior . . . If photography cannot be furthered and deepened, it is because of its strength as evidence" (R. Barthes, *Camera Lucida: Reflections on Photography*. New York: Hill and Wang, 1982; this citation taken from the Italian edition, Turin: Einaudi, 1980, p. 106).

[4] Speaking for myself, I expressly used the concept of 'the photographic', understood as the 'philosophy of the medium', beginning with the essay "La fotografia come metafora dell'arte contemporanea", in the exhibition catalogue *Private View*. Bolzano: Galleria Civica, 1999. The same concept was then studied by R. Signorini, *L'arte del fotografico*. Pistoia: Editrice C.R.T., 2001.

[5] From an interview with David Shapiro, in *Pop Art. Evoluzione di una generazione*. Milan: Electa, 1980, p. 136.

[6] L. Lippard, *Pop Art*. London: Thames and Hudson, 1966; this citation taken from the Italian edition, Milan: Mazzotta, 1967, p. 29.

[7] R. Krauss, *Teoria e storia della fotografia*. Milan: Mondadori, 1996.

[8] F. Vaccari, *Duchamp e l'occultamento del lavoro*. Modena: Autoedizione, 1978. See also L. Panaro, *L'occultamento dell'autore. La ricerca artistica di Franco Vaccari*. Carpi: Edizioni APM, 2007.

[9] R. Krauss, *Teoria e storia della fotografia*, *Op. cit.*, p. 67 ff.

[10] This expression was coined by Oliver Wendell Holmes, an American who used it in 1861. I strongly recommend Giovanni Fiorentino's evocative reading of Holmes's theories regarding the photographic as a harbinger of 'virtual culture'. Cf. G. Fiorentino (ed.), *Il mondo fatto immagine. Origini fotografiche del virtuale*. Genoa: Costa & Nolan, 1995.

1. Francesco Cangiullo, *Pise*
(Planche de mots en liberté),
1914

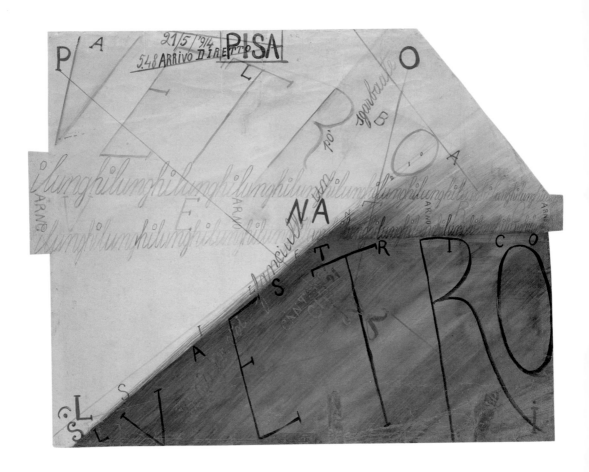

2. Filippo Tommaso Marinetti
The Wireless Imagination and Words in Freedom:
Futurist Manifesto (1913)

3. Photogram from the film *Vita futurista* (1916) with 'interventionist fistfight'

The Futurist Sensibility
My *Technical Manifesto of Futurist Literature*, with which I invented *essential and synthetic lyricism, wireless imagination and words in freedom*, deals exclusively with poetic inspiration.
Philosophy, the exact sciences, politics, journalism, education, business – however much they may seek synthetic forms of expression – will still need to use syntax and punctuation. Even I am obliged, for that matter, to use them myself in order to make myself clear to you. Futurism is grounded in the complete renewal of human sensibility brought about by the great discoveries of science. The people who today make use of the telegraph, the telephone, the phonograph, the train, the bicycle, the motorcycle, the automobile, the ocean liner, the dirigible, the aeroplane, film and cinema and the grand newspaper (the synthesis of a day of life in the world) do not realise that these various means of communication, transportation and information have a decisive influence on their psyches.
An ordinary man can – in a day's time – travel by train from a dead small town of empty squares, where the sun, the dust and the wind amuse themselves in silence, to a great capital city bristling with lights, gestures and street cries. By reading a newspaper, the inhabitant of a mountain village can tremble each day with anxiety, following insurrections in China, the suffragettes of London and New York, Doctor Carrel and the heroic dogsleds of the polar explorers. The timid, sedentary inhabitant of any provincial town can indulge in the intoxication of danger by going to the movies and watching a great hunt in the Congo. He can admire Japanese athletes, Negro boxers, tireless American eccentrics, the most elegant Parisian women, by paying a franc to go to the variety theatre. Then, back in his bourgeois bed, he can enjoy the distant, expensive voice of a Caruso or a Burzio.
Having become commonplace, these opportunities arouse no curiosity in superficial minds, which are as incapable of grasping any novel facts as *the Arabs who looked on with indifference at the first aeroplanes in the sky above Tripoli*.
For the keen observer, however, these facts are important modifiers of our sensibility, because they have caused the following significant phenomena:
1. Acceleration of life to today's swift pace. Physical, intellectual and sentimental balance on the cord of speed stretched between opposing magnetic poles. Multiplied, simultaneous awareness in a single individual;
2. Dread of the old and the known. Love of the new, the unexpected;
3. Dread of quiet living, love of danger and an attitude of everyday heroism;
4. Destruction of a sense of *the Beyond*, and an increased value of the individual whose desire is, to use Bonnot's words, to *vivre sa vie*;
5. The multiplication and unbridling of human desires and ambitions;
6. An exact awareness of everything inaccessible and unrealisable in every single person;
7. Semi-equality of men and women, and a lessening of the disproportion in their social rights;
8. Disdain for love (sentimentality or lust) produced by the greater freedom and erotic ease of women and by the universal exaggeration of female luxury. Let me explain: today's woman loves luxury more than love. A visit to a grand dressmaker's establishment, escorted by a paunchy, gouty banker friend who pays the bills, is a perfect substitute for the most amorous rendezvous with an adored young man. The woman finds all the mystery of love in the selection of an amazing ensemble, the latest model that her friends still do not have. Men do not love women who lack luxury. The lover has lost all his prestige. Love has lost its absolute worth;
9. The passion, art and idealism of *Business*. New financial sensibility;
10. Man multiplied by the machine. New mechanical sense, a fusion of instinct with the efficiency of motors

and conquered forces;

11. The passion, art and idealism of sports. Conception and love of the record;

12. New tourist sensibility bred by ocean liners and grand hotels (annual meetings and synthesis of different peoples). Destruction of distances and the nostalgic feeling of solitude;

13. New sense of the world. I'll explain: one after the other, men will gain a sense of their home, of the neighbourhoods they live in, of their regions, of the continents. Today they are aware of the whole world; they scarcely need to know what their ancestors did, but they must assiduously discover what their contemporaries are doing all over the world. The single man, therefore, must communicate with every people on earth. He must feel himself to be the axis, judge and motor of the explored and unexplored infinite. All this results, for us, in a vast enlargement in a sense of humanity and an urgent need to establish a relationship with all mankind and with our true proportions;

14. A nausea of curved lines, spirals and the tourniquet. A love of the straight line and the tunnel. A dread of slowness, minutiae, analysis and detailed explanations. Love of speed, abbreviation, the summary and the synthesis;

15. Love of depth and essence in every exercise of the spirit.

These are some elements of the new futurist sensibility that has generated our pictorial dynamism, our anti-graceful music in its free, irregular rhythms, our noise-art and our words in freedom.

Words in Freedom
Casting aside all stupid formulae and all the confused verbalisms of the academics, I now declare that *lyricism is the exquisite faculty of intoxicating oneself with life and filling life with the inebriation of our own selves*. The faculty of changing into wine the muddy water of the life that swirls and engulfs us; the ability to colour the world with the unique colours of our changeable selves. Now suppose that a friend of yours gifted with this faculty finds himself in a zone of intense experience (in the midst of revolution, war, shipwreck, earthquake and so forth) and starts right away to tell you his impressions. Do you know what this lyrically poetic, excited friend of yours will instinctively do?

He will begin by brutally destroying the syntax of his speech. He wastes no time in building sentences.

Punctuation and the right adjectives will mean nothing to him. He will despise subtleties and nuances of language. Breathlessly he will assault your nerves with visual, auditory, olfactory sensations, just as they come to him. The rush of steam-emotion will burst the sentence's steam pipe, the valves of punctuation and the adjectival clamp. Fistfuls of essential words in no conventional order. Sole preoccupation of the narrator: to render every vibration of his being. If the mind of this gifted lyrical narrator is also populated by general ideas, he will involuntarily bind up his sensations with the entire universe that he intuitively knows. And in order to render the true worth and dimensions of his lived life, he will cast immense nets of analogy round the globe. In this way he will telegraphically reveal the analogical foundation of life, with the same economical speed that the telegraph imposes on reporters and war correspondents in their swift reportages. This urgent laconism answers not only to the laws of speed that govern us, but also to the centuries-old relationship between poet and audience. Between poet and audience, in fact, the same relationship exists as between two old friends; they can make themselves understood with half a word, a gesture, a glance. So the poet's imagination must weave together distant things *without any connecting strings or conducting wires*, by means of essential words that are absolutely free.

The Wireless Imagination
By the wireless imagination I mean the absolute freedom of images or analogies, expressed with unhampered words and with no connecting strings of syntax or punctuation.

"Up to now writers have been restricted to immediate analogies. For instance, they have compared an animal with a man or with another animal, which is almost the same as a kind of photography. (They have compared, for example, a fox terrier to a very small thoroughbred. Others, more advanced, might compare the same trembling fox terrier to a little Morse-code telegraph machine. I, on the other hand, compare it with gurgling water. In this there is *an increasingly vast gradation of analogies*, there are ever deeper and more solid affinities, however remote.) Analogy is nothing more than the deep love that assembles distant, seemingly

4. Photogram from the film *Journée d'une paire de jambs* (1909) produced by Gaumont

5. Francesco Cangiullo, *Caffeconcerto: alfabeto a sorpresa*, 1919

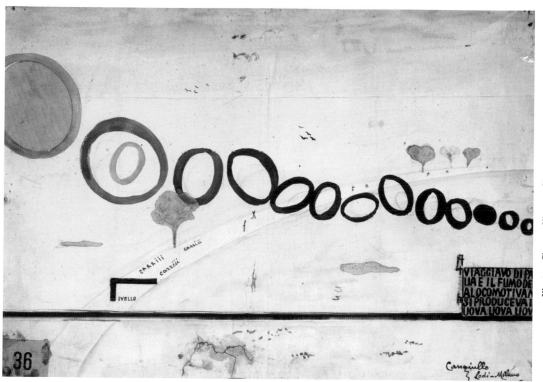

6. Francesco Cangiullo,
Passaggio a livello più uova di Pasqua, 1915

diverse and hostile things. An orchestral style – at once polychromatic, polyphonic and polymorphous – can embrace the life of matter only by means of the most extensive analogies. When, in my *Battle of Tripoli*, I compared a trench bristling with bayonets to an orchestra, a machine gun to a femme fatale, I intuitively introduced a large part of the universe into a short episode of African battle. Images are not flowers to be chosen and picked with parsimony, as Voltaire said; they are the very lifeblood of poetry. Poetry should be an uninterrupted sequence of new images, or it is mere anaemia and greensickness. The broader their affinities, the longer images will keep their power to amaze." (*Manifesto of Futurist Literature*, 11 May 1912)

The wireless imagination and words in freedom will bring us to the essence of material. As we discover new analogies between distant and apparently contrary things, we will endow them with an ever more intimate value. Instead of humanising animals, vegetables and minerals (an outmoded system) we will be able to *animalise, vegetise, mineralise, electrify or liquefy our style*, making it

live on the selfsame life of the material. We will have: Condensed metaphors. —Telegraphic images. —Maximum vibrations. —Nodes of thought. —Fans closed or opened by movement. —Analogical shortcuts. —Colour balances. —Dimensions, weights, measures and the speed of sensations. —The plunge of the essential word into the water of sensibility, minus the concentric circles that the word produces. —Restful moments of intuition. —Movements in two, three, four, five different rhythms. —The analytic, exploratory pylons that sustain the bundle of intuitive strings and wires.

Semaphoric Adjective-isation
Everywhere we tend to suppress the qualifying adjective because it presupposes an arrest in intuition, too minute a definition of the noun. None of this is categorical. I speak of a tendency. We must make use of the adjective as little as possible and in a manner completely different from its use hitherto. One should treat adjectives like railway signals of style, employ them to mark the tempo and any slow-downs or pauses along the way. So, too, with analogies; in such a way, as many as twenty of these

7. Filippo Tommaso Marinetti, *8 anime in una bomba: romanzo esplosivo*, 1919

8. Luciano Folgore, *Ponti sull'oceano: versi liberi (lirismo sintetico) e parole in libertà*, 1915

9. Arturo Martini, *Contemplazioni*, 1918

10. Fortunato Depero, *Depero futurista*, 1927

11. Filippo Tommaso Marinetti, Tullio D'Albisola, *Parole in libertà futuriste: olfattive, tattili, termiche*, 1932

semaphoric adjectives might accumulate.

The Infinitive Verb
Here, too, my pronouncements are not categorical. I maintain, however, that in a violent and dynamic lyricism the infinitive verb might well be indispensable. Round as a wheel – like a wheel adaptable to every car in the train of analogies – it constitutes the very speed of the style. The infinitive in itself denies the existence of the sentence, and prevents the style from slowing and stopping at a definite point. While the infinitive is round and mobile as a wheel, all other moods and tenses of the verb are either triangular, square or oval.

Onomatopoeia and Mathematic Signs
When I said, in my *Technical Manifesto of Futurist Literature*, that we must "spit upon the *Altar of Art* each day", I incited the futurists to liberate lyricism from the solemn atmosphere of compunction and incense one normally calls by the name of Art with a capital *A. Art* with a capital *A* constitutes the clericalism of the creative spirit. I used this approach to incite the futurists to destroy and mock the garlands, the celebratory palm fronds, the aureoles, the exquisite frames, the mantles and stoles, the whole historical wardrobe and the romantic *bric-a-brac* that comprise a large part of all poetry hitherto. I proposed instead a swift, brutal, immediate lyricism – a lyricism that must seem antipoetic to all our predecessors, a telegraphic lyricism with no taste of the book about it but, rather, as much as possible

of the flavour of life. Then came the bold introduction of onomatopoetic harmonies with which to render all the sounds and noises of modern life, even the most cacophonous. Onomatopoeia that vivifies lyricism with crude and brutal elements of reality was used more or less timidly in poetry (from Aristophanes to Pascoli). We futurists initiate the constant, audacious use of onomatopoeia. This should not be systematic. For instance, my *Adrianopoli – Assedio – Orchestra* (Adrianopolis—Siege—Orchestra) and my *Battaglia Peso + Odore* (Battle Weight + Smell) required many onomatopoetic harmonies. Always with the aim of giving the greatest number of vibrations and a deeper synthesis of life, we abolish all stylistic bonds, all the bright buckles with which the traditional poets link images together in their prosody. Instead, we employ very brief or anonymous mathematical and musical signs, and we put indications such as (fast) (faster) (slower) (two-beat time) between parentheses in order to control the speed of the style. These parentheses can even cut into a word or an onomatopoetic harmony . . . One may object that my words in freedom, my wireless imagination, demand special speakers if they are to be understood. Because I am not worried about the understanding of the multitudes, I will reply that the number of futurist public speakers is increasing, and that any admired traditional poem, for that matter, requires a special speaker if it is to be enjoyed.

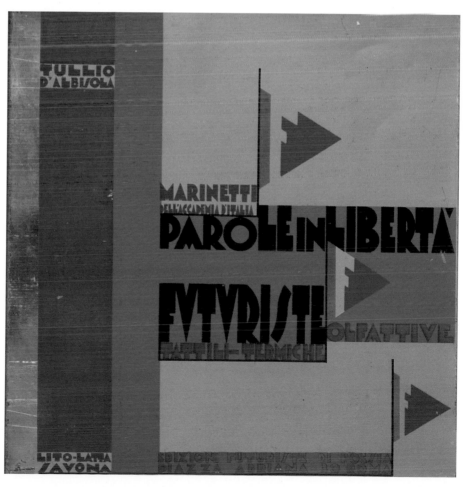

12. Giacomo Balla, *Linea di velocità + forma + rumore*, 1915

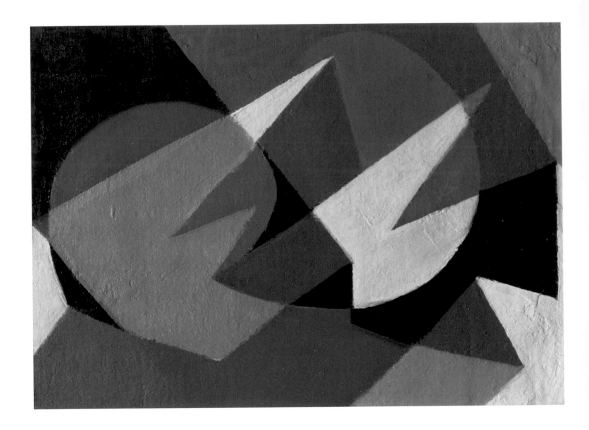

13. Giacomo Balla, Fortunato Depero
Futurist Reconstruction of the Universe (1915)

14. Fortunato Depero, *Pianoforte motorumorista*, 1915

15. Fortunato Depero, *Complesso plastico motorumorista a luminosità colorate e spruzzatori*, 1915

With the *Technical Manifesto of Futurist Painting* and the preface to the catalogue of the futurist exhibition in Paris (signed by Boccioni, Carrà, Russolo, Balla, Severini), with the *Manifesto of Futurist Sculpture* (signed by Boccioni), the *Manifesto of the Painting of Sounds, Noises and Smells* (signed by Carrà), with the volume *Futurist Painting and Sculpture* by Boccioni and Carrà's *Warpainting*, pictorial futurism has succeeded in the course of six years in progressing beyond impressionism and in solidifying it, proposing plastic dynamism and the moulding of the atmosphere, interpenetration of planes and states of mind. The lyrical appreciation of the universe, by means of Marinetti's words in freedom and Russolo's Art of Noises, combines with plastic dynamism to provide a dynamic, simultaneous, plastic and *noise-ist* expression of the universal vibration.

We futurists, Balla and Depero, aim to realise this total fusion in order to reconstruct the universe making it more joyful, in other words, by a complete recreation.

We will give skeleton and flesh to the invisible, the impalpable, the imponderable and the imperceptible. We will find abstract equivalents for every form and element in the universe, and then we will combine them according to the caprice of our inspiration, creating plastic complexes that we will set in motion.

Balla began by studying the speed of automobiles, thus discovering the laws and essential line-forces of speed. After more than twenty exploratory paintings, he understood that the flat plane of the canvas prevented him from reproducing the dynamic volume of speed in depth. Balla felt the need to construct, with strands of wire, cardboard sheets, fabrics, tissue paper, etc., the first dynamic plastic complex.

1. Abstract. —2. Dynamic. Relative movement (cinematographic) + absolute movement. **—3. Extremely transparent.** Because of the speed and volatility of the plastic complex, which must appear and disappear, light and impalpable. **—4. Brightly coloured and extremely luminous** (using internal lights). **—5. Autonomous**, that is, resembling itself alone. **—6. Transformable. —7. Dramatic. —8. Volatile. —9. Odorous. —10. Noise-creating.** Simultaneous plastic noisiness with plastic expression. **—11. Explosive**. Elements appear and disappear simultaneously with a bang. The free-wordsmith Marinetti, when we showed him our first plastic complexes, said enthusiastically: "Before us, art consisted of memory, anguished re-evocation of a lost Object (happiness, love, landscape), and therefore nostalgia, immobility, pain, distance. With futurism art has become action-art, that is, energy of will, optimism, aggression, possession, penetration, joy, brutal reality in art (e.g. onomatopoeia; e.g. *intonarumori* = motors), geometric splendour of forces, forward projection. Art becomes Presence, a new Object, the new reality created with the abstract elements of the universe. The hands of the traditionalist, passéist artist ached and longed for the lost Object; our hands yearned for a new object to create. That is why the new object (the plastic complex) appears miraculously in yours."

The Material Construction of the Plastic Complex
NECESSARY MEANS: Coloured metal wires, cotton, wool, silk, of every thickness. Coloured glass, tissue paper, celluloid, wire netting, every sort of transparent and bright material. Fabrics, mirrors, sheets of metal, coloured tin foil, every sort of gaudy material. Mechanical and electrical devices; musical and noise-making elements, chemically luminous liquids of variable colours; springs, levers, tubes, etc. With these means we will construct:
ROTATIONS
1. Plastic complexes rotating on a pivot (horizontal, vertical, oblique).
2. Plastic complexes rotating on several pivots: a) in the same direction

16. Giacomo Balla, *Linea di velocità + cielo + rumore*, 1913

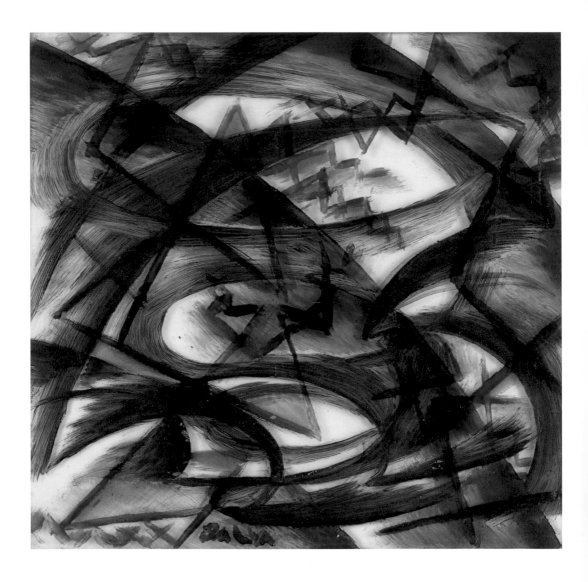

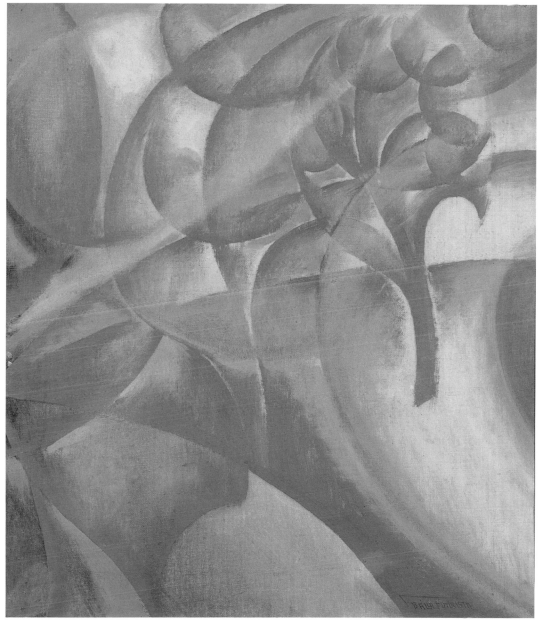

18. Fortunato Depero,
Clavel nella funicolare, 1918

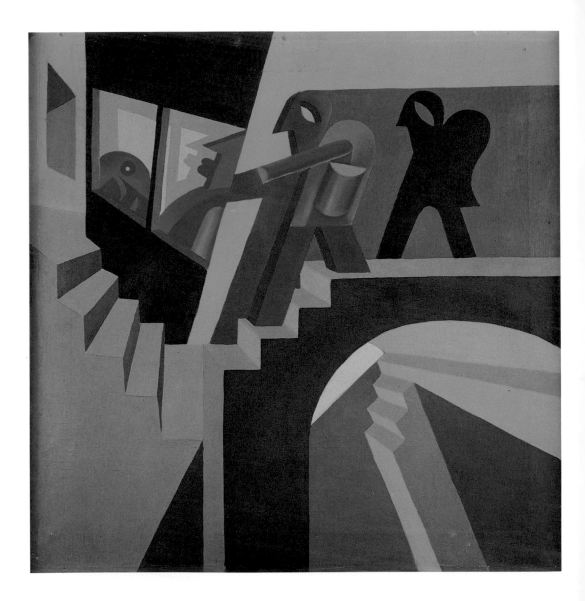

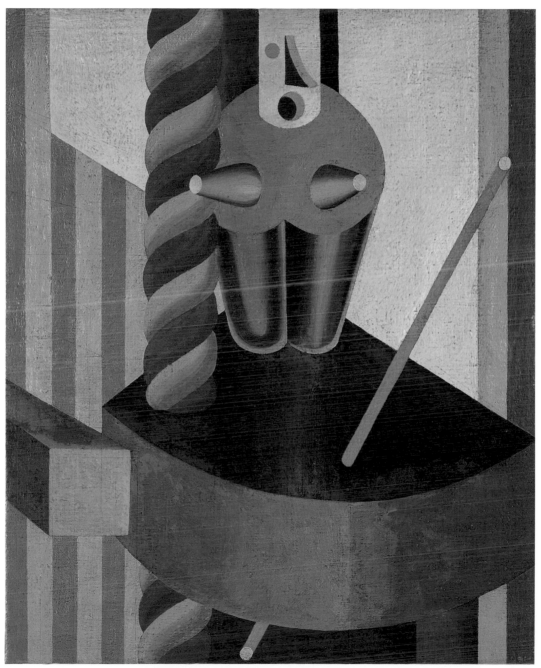

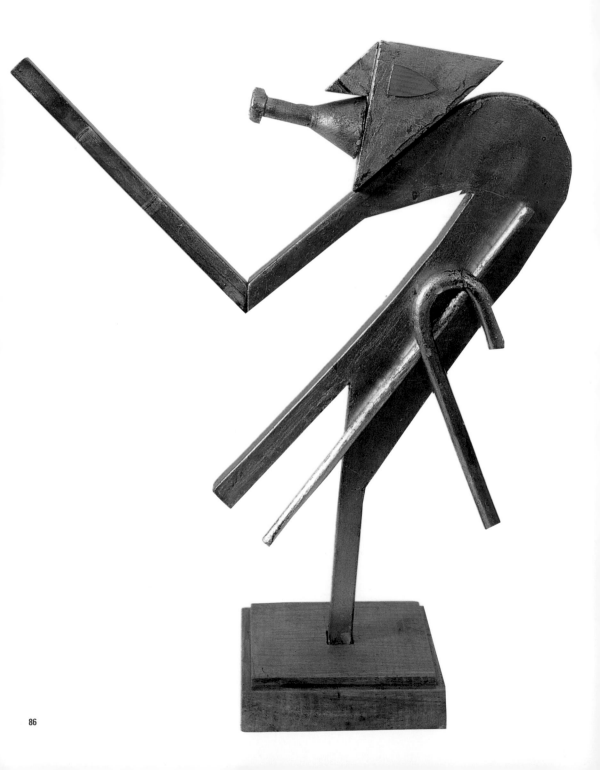

21. Filippo Tommaso Marinetti and Benedetta in the sitting room of the house on Piazza Adriana, Rome, 1932

but with varying speeds; *b)* in *opposite* directions; *c)* in the *same and opposite* directions.

DECOMPOSITIONS

3. *Plastic complexes that break up:* a) into volumes; b) into layers; c) in successive transformations – cones, pyramids, spheres, etc.

4. Plastic complexes that break up, talk, make noises and play music simultaneously.

DECOMPOSITION

TRANSFORMATION } FORM + EXPANSION { ONOMATOPOEIAS, SOUNDS, MIRACULOUS NOISES, MAGIC

5. Plastic complexes that appear and disappear: a) slowly; b) by repeated jerks (in scales); c) with unexpected explosions. Pyrotechnics—Water—Fire—Smoke.

The Discovery—Infinite Systematic Invention

Using complex, constructive, noise-producing abstraction, in short, the futurist style. Every action developed in space, every emotion felt, will represent for us a possible discovery. **EXAMPLES:** Watching an aeroplane swiftly climbing while a band played in the square, we had the idea of **a plastic-motor-noise concert in space and the launching of aerial concerts** above the city. —The need to keep changing our environment, together with sports, led us to the idea of **transformable clothes** (mechanical trimmings, surprises, tricks, disappearance of individuals). —The simultaneity of speed and noises inspired the **roto-plastic noise fountain**. —Tearing up a book and throwing it down into a courtyard resulted in **phono-moto-plastic advertisements** and **pyrotechnic-plastic-abstract contests**. —A spring garden blown by the wind led to the concept of the **magical transformable motor-noise flower**. —Clouds flying in a storm suggested **buildings in the noise-ist transformable style**.

The Futurist Toy

In games and toys, as in all traditionalist, passéist manifestations, there is nothing but grotesque imitation, timidity (little trains, prams, puppets, immobile objects, stupid caricatures of domestic objects), both *anti-gymnastic and monotonous, which can only make a child stupid and depressed*.

With plastic complexes we will construct toys that will accustom the child:

1. *To spontaneously laugh* (by way of absurdly comical tricks);

2. *To maximum elasticity* (without resorting to thrown projectiles, whip cracking, pin pricks, etc.);

3. *To an imaginative impulse* (by using fantastical toys to be studied under a magnifying glass; small boxes to be opened at night, containing pyrotechnic marvels; transforming contraptions, etc.);

4. *To the continual exercise and sharpening of sensitivity* (in the boundless realms of acute, intense and exciting noises, smells and colours);

5. *To physical courage, to fighting and to* **WAR** (with gigantic, dangerous and aggressive toys that will work outdoors).

The futurist toy will be very useful to adults, too, keeping them young, agile, jubilant, spontaneous, ready for anything, untiring, instinctive and intuitive.

The Artificial Landscape

By developing the first synthesis of the speed of an automobile, Balla created the first plastic ensemble (*N. 1*). This revealed an abstract landscape composed of cones, pyramids, polyhedrons and the spiral of mountains, rivers, lights and shadows. Evidently a profound analogy exists between the essential line-forces of speed and the essential line-forces of a landscape. We have reached the deepest essence of the universe and have mastered the elements. We shall thus be able to construct.

The Metallic Animal

Fusion of art + science. Chemistry, physics, continuous and unexpected pyrotechnics all incorporated into a new creature, a creature that will speak, shout and dance automatically. We futurists, Balla and Depero, will construct millions of metallic animals for the greatest war (conflagration of all the creative energies of Europe, Asia, Africa and America, which will undoubtedly follow the current marvellous little human conflagration).

The inventions contained in this manifesto are absolute creations, generated entirely by Italian futurism. No artist in France, Russia, England or Germany anticipated us by inventing anything similar or analogous. Only the Italian genius, which is the most constructive and architectural, could invent the abstract plastic ensemble. With this, futurism has determined its style, which will inevitably be the dominant sensibility for many centuries to come.

22. Anton Giulio Bragaglia
Futurist Photodynamism (1911)

23. Anton Giulio Bragaglia,
Mano in moto, 1911

24. Anton Giulio Bragaglia,
La Gifle, 1912

1.
First of all, we must draw a distinction between dynamism and dynamism. There is effective dynamism, realistic dynamism, the dynamism of objects in evolution, in real motion – which, to be more precise, should be called *movementism* – and then there is the virtual dynamism of static objects, which futurist painting is so interested in Ours - the dynamism focussed on here – is movementism, such that, had we not so strictly noted the interior dynamism of Photodynamics, it would have to have been called *photomovementistics* or *photocinematics*. The *Technical Manifesto of Futurist Painting* inspired me to explore this concept of photodynamics. We want to realise a revolution, in the name of progress, in photography: we want to do so in order to purify it, ennoble it and truly elevate it to an art. And I maintain that, through the means of photographic mechanics, art can be made solely if it surpasses pedestrian photographic reproduction of the immobile or fixed truth in the guise of a snapshot, such that the photographic result – managing to gain the expression and vibration of vividly lived life through

other means, and detaching itself from its own obscene, brutal and statically realistic state – is no longer average, traditional photography, but rather something much more elevated, something we call photodynamic. So, we aim to create the art of photodynamics – as a special art, distinguished by its ultra-modern ends – and, together, we aim to give *movementist* painting and sculpture that solid base so absolutely necessary nowadays: we will scientifically show this later on. Hitherto, with the results we have obtained, it has firmly been proven that photodynamics is not only the *right* sort of creation, but is even *necessary*. The fact that many of these results are still imperfect, or not quite convincing enough, is due to our lack of mechanical means sufficiently suited to capturing and rendering beings and things in their movement.
. . .

20.
Cinematography does not trace the shape of movement, but rather subdivides it – with no rules, with absolute mechanical free will, disintegrating and shattering it without any kind of aesthetic concern for

25. Anton Giulio, Arturo Bragaglia,
Ritratto polifisionomico di Boccioni, 1913

rhythm: it is not within its coldly mechanical power to satisfy such concerns. Cinematography, in any case, never analyses movement, because it shatters it in the frames of the film strip, quite unlike the action of photodynamism, which analyses movement precisely in its details. And it never synthesises movement, either, because it merely reconstructs fragments of reality, already coldly broken up, in the same way the hand of a chronometer deals with time, even though time flows in a continuous and constant stream.

. . .

55.

Indeed, despite contrary assertions, I maintain that, if today photodynamics is not yet an art, it is at least a mechanical means whose results more than possess the essential virtues, and procure emotions identical to those inspired by a work of art. But it is also necessary to consider how – given the fact that photodynamics requires remarkable amounts not only of technique, but also of art, in whosoever wishes to practice it – it is absolutely absurd to think that it could be obtained as with straightforward photography, whose execution requires little more than the simple opening of the lens' aperture in front of an object more or less well lit and well posed. But because photodynamics requires such artistic virtues – and being enriched as it and its results are by innumerable emotional elements, more even than a painted picture often is, and producing infinite vibrations of intellectual pleasure, on a par with the work of art as it has hitherto been defined – it is becoming known as an art or mechanical means whose results possess the essential virtues, and procure emotions identical to those inspired by a work of art, as they tend to become denatured and therefore recall the camera much less. And yet you still cannot believe that movement is obtained on a plate with such ease and facility that even a sucker could successfully manage it; that the idea of portraying movement is not only abstruse, but is even more difficult to portray it in the right way.

26. Anton Giulio Bragaglia, *Figura sulle scale, autoritratto, studio simultaneo di movimento a scatti e strisciante*, 1911

27. Luigi Russolo
The Art of Noises (1913)

Dear Balilla Pratella, great futurist composer,

In Rome, in the Costanzi Theatre, packed to capacity, while I was listening to the orchestral performance of your overwhelming FUTURIST MUSIC, with my futurist friends, Marinetti, Boccioni, Carrà, Balla, Soffici, Papini and Cavacchioli, a new art came into my mind which only you can create, the Art of Noises, the logical consequence of your marvellous innovations.

Ancient life was all silence. In the nineteenth century, with the invention of the machine, Noise was born. Today, Noise triumphs and reigns supreme over the sensibility of men. For many centuries life went by in silence, or at most in muted tones. The strongest noises that interrupted this silence were not intense or prolonged or varied. If we overlook such exceptional movements as earthquakes, hurricanes, storms, avalanches and waterfalls, nature is silent.

In this dearth of *noises*, the first *sounds* that man drew from a pieced reed or stretched string were regarded with amazement as new and marvellous things. Primitive peoples attributed *sound* to the gods; it was considered sacred and reserved for priests, who used it to enrich the mystery of their rites.

And so the concept of sound as a thing in itself was born, distinct and independent of life, and the result was music, a fantastical world superimposed upon the real one, an inviolable and sacred world. It is easy to understand how such a concept of music resulted inevitable in the hindering of its progress by comparison with the other arts. The Greeks themselves, with their musical theories calculated mathematically by Pythagoras, and according to which only a few consonant intervals could be used, limited the field of music considerably, rendering harmony, of which they were unaware, impossible. The Middle Ages, with the development and modification of the Greek tetra-chord system, with the Gregorian chant and popular songs, enriched the art of music, but

continued to consider sound *in its development over time*, a restricted notion, but one which lasted many centuries, and which still can be found in the Flemish counterpointists' most complicated polyphonies.

The *chord* did not exist, the development of the various parts was not subordinate to the chord that these parts put together could produce; the conception of the parts was horizontal, not vertical. The desire, search and taste for a simultaneous union of different sounds – that is, for the *chord* (complex sound) – were gradually made manifest, passing from the consonant, perfect chord with a few passing dissonances to the complex and persistent dissonances that characterise contemporary music.

At first the art of music sought purity, limpidity and sweetness of sound. Then different sounds were amalgamated, with great care, however, to caress the listener's ear with gentle harmonies. Today the musical art, as it becomes continually more complex, strives to amalgamate the most dissonant, strange and harsh sounds. In this way we come ever closer to *noise-sound*. This musical evolution is paralleled by the multiplication of machines, which collaborate with man on every front. Not only in the roaring atmosphere of major cities, but in the country, too, which until yesterday was totally silent, the machine today has created such a variety and rivalry of noises that pure sound, in its exiguity and monotony, no longer arouses any feeling.

To excite and exalt our sensibilities, music developed toward the most complex polyphony and the maximum variety, seeking the most complicated successions of dissonant chords and vaguely preparing the creation of MUSICAL NOISE. This evolution toward 'noise sound' was not possible until now. The ear of an eighteenth-century man could never have endured the discordant intensity of certain chords produced by our orchestras (whose members have trebled in number since then). To our ears, on the other hand, they sound pleasant, since our hearing has already been educated

28. Vernissage of the first
Rumorarmonio, Thiene, 1924

by modern life, so teeming with variegated noises. But our ears are not satisfied merely with this, and demand an abundance of acoustic emotions. On the other hand, musical sound is too limited in its qualitative variety of tones. The most complex orchestras boil down to four or five types of instrument, varying in timber: instruments played by bow or plucking, by blowing into metal or wood and by percussion. And so modern music goes round in this small circle, struggling in vain to create new ranges of tones. This limited circle of pure sounds must be broken, and the infinite variety of noise-sounds conquered. Besides, everyone will acknowledge that all musical sound carries with it a development of sensations that are already familiar and exhausted, and which predispose the listener to boredom in spite of the efforts of all the innovatory musicians. We futurists have deeply loved and enjoyed the harmonies of the great masters. For many years Beethoven and Wagner shook our nerves and hearts. Now we are satiated, and find far more enjoyment in the combination of the noises of trams, backfiring motors, carriages and bawling crowds than in rehearsing, for example, the *Eroica* or the *Pastoral*.

We cannot see that enormous apparatus of force that the modern orchestra represents without feeling the most profound and total disillusion

at the paltry acoustic results. Do you know of any sight more ridiculous than that of twenty men furiously bent on the redoubling the mewing of a violin? All this will naturally make the music-lovers scream, and will perhaps enliven the sleepy atmosphere of concert halls. Let us now, as futurists, enter one of these hospitals for anaemic sounds. There: the first bar brings the boredom of familiarity to your ear and anticipates the boredom of the bar to follow. Let us relish, from bar to bar, two or three varieties of genuine boredom, waiting all the while for the extraordinary sensation that never comes.

Meanwhile a repugnant mixture is concocted from monotonous sensations and the idiotic religious emotion of listeners Buddhistically drunk with repeating for the nth time their more or less snobbish or second-hand ecstasy.

Away! Let us break out since we cannot much longer restrain our desire to create finally a new musical reality, with a generous distribution of resonant slaps in the face, discarding violins, pianos, double basses and plaintive organs. Let us break out!

It is no good objecting that noises are exclusively loud and disagreeable to the ear.

It seems pointless to enumerate all the graceful and delicate noises that afford pleasant sensations.

To convince ourselves of the amazing variety of noises, it is enough to think of the rumble of thunder, the whistle of the wind, the roar of a waterfall, the gurgling of a brook, the rustling of leaves, the clatter of a trotting horse as it draws into the distance, the lurching jolts of a cart on pavement and of the generous, solemn, white breathing of a nocturnal city; of all the noises made by wild and domestic animals, and of all those that can be made by the mouth of man without resorting to speaking or singing.

Let us cross a great modern capital with our ears more alert than our eyes, and we will get enjoyment from distinguishing the eddying of water, air and gas in metal pipes, the grumbling of noises that breathe and pulse with indisputable animality, the palpitation of valves, the coming and going of pistons, the howl of mechanical saws, the jolting of a tram on its rails, the cracking of whips, the flapping of curtains and flags. We enjoy creating mental orchestrations of the crashing down of metal shop blinds, slamming doors, the hubbub and shuffling of crowds, the variety of din, from stations, railways, iron foundries,

spinning wheels, printing works, electric power stations and underground railways.

Nor should the newest noises of modern war be forgotten.

Recently, the poet Marinetti, in a letter from the trenches of Adrianopolis, described to me with marvellous free words the orchestra of a great battle: *"every 5 seconds siege cannons gutting space with a chord* **tam-tuuumb** *mutiny of 500 echoes smashing scattering it to infinity. In the centre of this hateful* **tam-tuuumb** *area 50 square kilometres leaping bursts lacerations fists rapid-fire batteries. Violence ferocity regularity this deep bass scanning the strange shrill frantic crowds of the battle Fury breathless ears eyes nostrils open! load! fire! what a joy to hear to smell completely taratatata of the machine guns screaming a breathless under the stings slaps traak-traak whips pic-pac-pum-tumb weirdness leaps 200 meters range Far far in back of the orchestra pools muddying huffing goaded oxen wagons pluff-plaff horse action flic flac zing zing shaaack laughing whinnies the tiiinkling jiiingling tramping 3 Bulgarian battalions marching croooc-craaac [slowly] Shumi Maritza Karvavcna crooc-craac crys of officers slamming about like brass plates pan here paak there* **buuum** *ching chaak [very fast] cha-cha-cha-cha-chaack down there up around high up look out your head chaack beautiful! Flashing flashing flashing flashing flashing flashing footlight of the forts down there behind that smoke Shukri Pashà communicates by phone with 27 forts*

29. Luigi Russolo, *La Musica*, 1911

in Turkish in German Allo! Ibrahim!! Rudolf! allo! allo! actors parts echoes of prompters scenery of smoke forests applause odour of hay mud dung I no longer feel my frozen feet odour of gun-smoke odour of rot Tympani flutes clarinets everywhere low high birds chirping blessed shadows cheep-cheep-cheep green breezes flocks don-dan-don-dinbèèè Orchestra madmen pommel the performers they terribly beaten playing Great din not erasing clearing up cutting off slighter noises very small scraps of echoes in the theatre area 300 square kilometres Rivers Maritza Tungia stretched out Ròdopi Mountains rearing heights loges boxes 2000 sharpnels waving arms exploding very white handkerchiefs full of gold **Tum-tuumb** 20,000 raised grenades tearing out bursts of very black hair **zang-tumb-zang-tumb-tuumb** the orchestra of the noises of war swelling under a held note of silence in the high sky round golden balloon that observes the shots."

30. Anonymous, Luigi Russolo seated in front of his painting *La Musica* and between two models of *Rumorarmonio*, 1928

We want to attune and regulate this tremendous variety of noises harmonically and rhythmically. To attune noises does not mean to detract from all their irregular movements and vibrations in time and intensity, but rather to give gradation and tone to the most strongly predominant of these vibrations. Noise, in fact can be differentiated from sound only insofar as the vibrations which produce it are confused and irregular, both in time and intensity. Every noise has a tone, and sometimes also a harmony that predominates over the body of its irregular vibrations. Now, it is from this dominating characteristic tone that a practical possibility can be derived for attuning it, that is, to give a certain noise not merely one tone, but a variety of tones, without losing its characteristic tone, by which I mean the one that distinguishes it. In this way any noise obtained by a rotating movement can offer an entire ascending or descending chromatic scale, if the speed of the movement is increased or decreased.

Every event of our life is accompanied by noise. Noise, therefore, is familiar to our ear, and has the power to conjure up life itself. Sound – alien to our life, always musical and a thing unto itself, an occasional but unnecessary element – has become to our ears what an overly familiar face is to our eyes. Noise, however, reaching us in a confused and irregular way from the irregular confusion of our life, never entirely reveals itself to us, and keeps innumerable surprises in reserve. We

are therefore certain that by selecting, coordinating and dominating all noises we will enrich humanity with a new and unexpected sensual pleasure.

Although it is characteristic of noise to bring us brutally back to real life, the art of noise must not limit itself to imitative reproduction. It will achieve its most emotive power in the acoustic enjoyment, in its own right, that the artist's inspiration will extract from combined noises.

Here are the *6 families of noises* of the futurist orchestra we will soon set mechanically in motion:

1. Rumbles, Roars, Explosions, Crashes, Splashes, Booms;
2. Whistles, Hisses, Snorts;
3. Whispers, Murmurs, Mumbles, Grumbles, Gurgles;
4. Screeches, Creaks, Rumbles, Buzzes, Crackles, Scrapes;
5. Noises obtained by percussion on metal, wood, skin, stone, terracotta, etc.;
6. Voices of animals and men: Shouts, Screams, Groans, Shrieks, Howls, Laughter, Wheezing, Sobs.

In this inventory we have encapsulated the most characteristic of the fundamental noises; the others are merely the associations and combinations of these. The rhythmic movements of a noise are infinite: just as with tone there is always a predominant rhythm, but around this numerous other secondary rhythms can be felt.

Conclusions

1. Futurist musicians must continually enlarge and enrich the field of sounds. This corresponds to a need in our sensibility. We notice, in fact, in the composers of genius, a tendency toward the most complicated dissonances. As these move further and further away from pure sound, they almost achieve *sound-noise*. This need and this tendency cannot be satisfied except *by the addition and substitution of noises for sounds*.
2. Futurist musicians must substitute for the limited variety of tones possessed by orchestral instruments today the infinite variety of tones of noises, reproduced with appropriate mechanisms.
3. The musician's sensibility, liberated from facile and traditional Rhythm, must find in noises the means of extension and renewal, given that every noise offers the union of the most diverse rhythms apart from the predominant one.

4. Since every noise contains a predominant general tone in its irregular vibrations it will be easy to obtain in the construction of instruments which imitate them a sufficiently extended variety of tones, semitones and quarter-tones. This variety of tones will not remove the characteristic tone from each noise, but will amplify only its texture or extension.

5. The practical difficulties in constructing these instruments are not serious. Once the mechanical principle that produces the noise has been found, its tone can be changed according to the same general laws of acoustics. If the instrument is to have a rotating movement, for instance, we will increase or decrease the speed, whereas if it is to not have rotating movement the noise-producing parts will vary in size and tautness.

6. The new orchestra will achieve the most complex and novel aural emotions not by incorporating a succession of life-imitating noises, but by manipulating fantastical juxtapositions of these varied tones and rhythms. Therefore an instrument will have to offer the possibility of tone changes and varying degrees of amplification.

7. The variety of noises is infinite. If today, when we have perhaps a thousand different machines, we can distinguish a thousand different noises, tomorrow, as new machines multiply, we will be able to distinguish ten, twenty or thirty thousand different noises, not merely in a simply imitative way, but to combine them according to our imagination.

8. We therefore invite young musicians

of talent to conduct a sustained observation of all noises, in order to understand the various rhythms of which they are composed, their principal and secondary tones. By comparing the various tones of noises with those of sounds, they will be convinced of the extent to which the former exceed the latter. This will afford not only an understanding, but also a taste and passion for noises. After being conquered by futurist eyes our multiplied sensibilities will at last hear with futurist ears. In this way the motors and machines of our industrial cities will one day be consciously attuned, so that every factory will be transformed into an intoxicating orchestra of noises.

Dear Pratella, I submit these statements to your futurist geniality, inviting you to discuss them. I am not a musician, so therefore have no acoustical predilections, nor any works to defend. I am a futurist painter using a much loved art to project my determination to renew everything. And so, bolder than any professional musician could be, unconcerned by my apparent incompetence and convinced that audacity earns all rights and all possibilities, I have been able to initiate the great renewal of music through the Art of Noises.

32. Filippo Tommaso Marinetti, Bruno Corra, Emilio Settimelli, Arnaldo Ginna, Giacomo Balla, Remo Chiti
Futurist Film: Futurist Manifesto (1916)

The book, a completely traditionalist, passéist means of preserving and communicating thought, has long been fated to disappear – just like cathedrals, towers, crenellated walls, museums and the pacifist ideal. The book, static companion of the sedentary, the nostalgic, the neutralist, cannot entertain or exalt the new futurist generations intoxicated with revolutionary and bellicose dynamism. The conflagration is steadily enlivening the European sensibility. Our great hygienic war, which should satisfy *all* our national aspirations, centuples the renewing power of the Italian race. Futurist film, which we are now preparing as a joyful deformation of the universe, an a-logical, fleeting synthesis of life in the world, will become the best school for boys: a school of joy, speed, force, courage and heroism. Futurist film will sharpen and develop sensibilities, will quicken the creative imagination, will give one's intelligence a prodigious sense of simultaneity and omnipresence. Futurist film will thus take part in the general renewal, taking the place of the literary review (invariably pedantic) and the drama (invariably predictable), and killing the book (invariably tedious and oppressive). The necessities of propaganda will force us to publish a book once in a while; but we prefer to express ourselves through film, through great panels of words in freedom and mobile, illuminated signs. With our manifesto *Synthetic Futurist Theatre*, with the victorious tours of the theatre companies of Gualtiero Iumiati, Ettore Berti, Annibale Ninchi, Luigi Zoncada, with two volumes of synthetic futurist Theatre containing eighty theatrical syntheses, we have begun the revolution in the Italian prose theatre. An earlier futurist manifesto had rehabilitated, glorified and perfected *variety theatre*. It is therefore logical for us to take our vivifying energies into a new theatrical zone: *film*.

At first glance film, born just a few years ago, may seem to be futurist already, lacking a past and free from traditions: in fact, by appearing in the guise of theatre without words, it has inherited all the most traditional trappings of literary theatre. Consequently, everything we have said and done about the stage applies to film. Our action is legitimate and necessary, insofar as film up to now *has been, and tends to remain, profoundly* passéist, whereas we see in it the possibility of an eminently futurist art and *the expressive medium most adapted to the complex sensibility of a futurist artist.*

Except for interesting films of travel, hunting, wars and so on, the filmmakers have done no more than inflict on us the most backward looking dramas, great and small. The same scenario whose brevity and variety may make it seem advanced is, in most cases, nothing but the most trite and pious *analysis.*

All the immense *artistic* possibilities of film, therefore, still remain entirely in the future. Film is an autonomous art. Film must therefore never copy the stage. Film, being essentially visual, must above all fulfil the evolution of painting, detach itself from reality, from photography, from the graceful and solemn. It must become antigraceful, deforming, impressionistic, synthetic, dynamic, free-wording.

Film must be freed as an expressive medium in order to make it the ideal instrument of *a new art*, immensely vaster and lighter than all the existing arts. We are convinced that only in this way can one reach that *poly-expressiveness* towards which all the most modern artistic researches are moving. Today, the *futurist filmmaker* creates precisely the *poly expressive symphony* that we announced barely a year ago in our manifesto *Weights, Measures and Prices of Artistic Genius*. The most varied elements will enter into futurist film as expressive means: from the slice of life to the streak of colour, from the conventional line to words in freedom, from chromatic and plastic music to the music of objects. In other words it will be painting, architecture, sculpture, words in freedom, music of colours,

Nineteen Eleven – Nineteen Sixty-two

lines and forms, a jumble of objects and reality thrown together at random. We shall offer new inspirations for the researches of painters, which will tend to break out of the limits of the frame. We shall set in motion the words in freedom that smash the boundaries of literature as they march towards painting, music, noise-art, and throw a marvellous bridge between the word and the real object.

Our films will be:
1. *Cinematic analogies* that use reality directly as one of the two elements of the analogy. Example: if we should want to express the anguished state of one of our protagonists, instead of describing it in its various phases of suffering, we would give an equivalent impression with the sight of a jagged and cavernous mountain.
The mountains, seas, woods, cities, crowds, armies, squadrons, aeroplanes will often be our formidable expressive words: *the universe will be our vocabulary*. Example: we want to give a sensation of strange cheerfulness: we show a chair cover flying comically around an enormous coat stand until they decide to join. We want to give the sensation of anger: we fracture the angry man into a whirlwind of little yellow balls. We want to give the anguish of a hero who has lost his faith and lapsed into a dead neutral scepticism: we show the hero in the act of making an inspired speech to a great crowd; suddenly we bring on Giovanni Giolitti who treasonably stuffs a thick forkful of macaroni into the hero's mouth, drowning his winged words in tomato sauce. We shall add colour to the dialogue by swiftly, simultaneously showing every image that passes through the actors' brains. Example: representing a man who will say to his woman: "You're lovely as a gazelle", we shall show the gazelle. Example: if a character says "I contemplate your fresh and luminous smile as a traveller after a long rough trip contemplates the sea from high atop a mountain", we shall show traveller, sea, mountain.
This is how we shall make our characters as understandable, *as if they were speaking*.
2. *Cinematically filmed poems, speeches and poetry*; we shall make all their component images pass across the screen.
Example: "Canto dell'amore" (Song of Love) by Giosuè Carducci:

"In their German strongholds perched
Like falcons meditating the hunt"

33. Photogram study from the film *Thais* (1916) by Anton Giulio Bragaglia with set design by Prampolini

34. Photograms from the film *Thais* (1916) by Anton Giulio Bragaglia with set design by Prampolini

35. André Deed, *L'uomo meccanico*, 1922

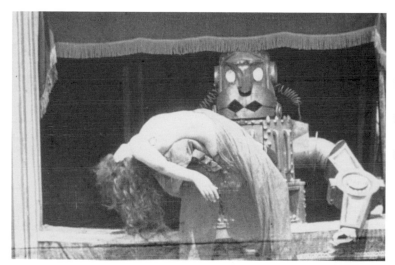

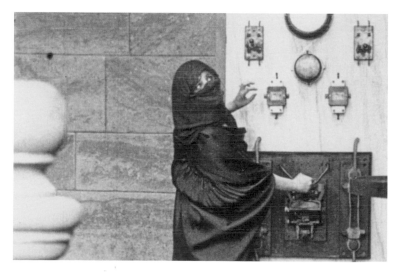

We shall show the strongholds, the falcons in ambush.

"From the churches that raise long marble,
arms to heaven, in prayer to God"
...
"From the convents between villages and towns
crouching darkly to the sound of bells
like cuckoos among far-spaced trees
singing of boredoms and strange joys . . ."
We shall show churches that little by little are changed into imploring women, God beaming down from on high, the convents, the cuckoos and so forth.

Example: "Sogno d'Estate" (Summer's Dream) by Giosuè Carducci:

"Among your ever-sounding strains of battle, Homer, I am conquered by the warm hour: I bow my head in sleep on Scamander's bank, but my heart flees to the Tyrrhenian Sea."
We shall show Carducci wandering amid the tumult of the Achaians, deftly avoiding the galloping horses, paying his respects to Homer, going for a drink with Ajax to the *Red Scamander* Inn and at the third glass of wine his heart – whose palpitations we ought to see – pops out of his jacket like a huge red balloon and flies over the Gulf of Rapallo. This is how we cinematically film the most secret movements of genius.
Thus we shall ridicule the works of the passéist poets, transforming to the great benefit of the public the most nostalgically monotonous weepy poetry into violent, exciting and highly exhilarating spectacles.
3. *Simultaneity* and *interpenetration* of different *cinematographically filmed* times and places. We shall project two or three different visual episodes at the same time, one next to the other.
4. *Cinematic musical investigations* (dissonances, harmonies, symphonies of gestures, events, colours, lines, etc.).
5. *Dramatised states of mind, filmed.*
6. *Daily exercises in freeing ourselves from mere photographed logic.*
7. *Filmed dramas of objects.* (Objects animated, humanised, baffled, dressed up, impassioned, civilised, dancing – objects removed from their normal surroundings and put into an abnormal state that, by contrast, throws into relief their amazing construction and nonhuman life.)
8. *Windows of filmed ideas, events, types, objects, etc.*

9. *Meetings, flirtations, fights and marriages of funny faces, mimicry, etc., filmed.* Example: a big nose silencing a thousand congressional fingers by ringing an ear, while two policemen's moustaches arrest a tooth.
10. *Irreal reconstructions of the human body, filmed.*
11. *Filmed dramas of disproportion* (a thirsty man who pulls out a tiny drinking straw that umbilically lengthens so far as to reach a lake, and dries it up instantly).
12. *Potential dramas and strategic plans of filmed feelings.*
13. Linear, plastic, chromatic equivalences, etc., of men, women, events, thoughts, music, feelings, weights, smells, noises (with white lines on black we shall show the inner, physical rhythm of a husband who catches his adulterous wife *in flagrante* and chases the lover – rhythm of soul and rhythm of legs).
14. *Filmed words in freedom, in movement* (synoptic tables of lyric values – dramas of humanised or animated letters – orthographic dramas – typographical dramas – geometric dramas – numeric sensibility, etc.).
Painting + sculpture + plastic dynamism + words in freedom + composed noises (*intonarumori*) + architecture + synthetic theatre = futurist film.
Thus we decompose and recompose the universe according to our marvellous caprice, to centuple the sheer power of Italian creative genius and its absolute worldwide pre-eminence.

36. Fortunato Depero, cover for *Movie Makers*, 1929

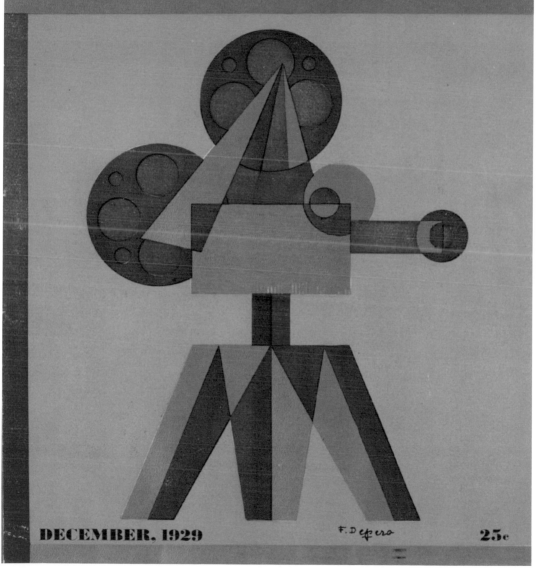

37. Paul Klee, *The Sun
Discovering that the World of
Colours Already Exists,
Complicated Composition*, 1916

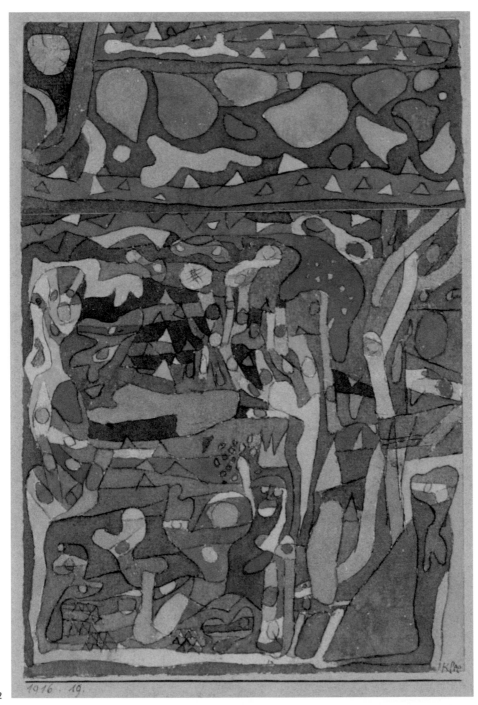

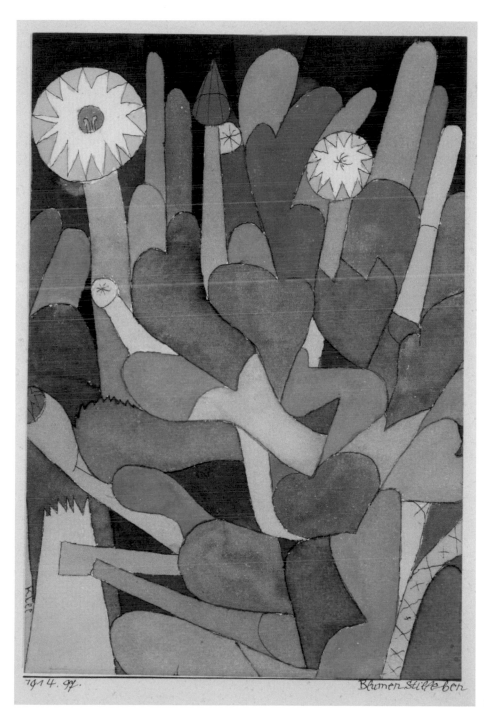

39. Georges Braque
Thoughts on Painting (1917)

1. In art, progress consists not in the extension of, but rather in the awareness of its limits;

2. The limits of the means employed determine the style, generate a new form and stimulate creation;

3. The appeal and strength of children's drawings often derive from the limited means employed to make them. Vice versa, decadent art is a product of the extension of those means;

4. New means, new subjects;

5. The subject is not the object; it is the new unity, the lyricism that comes entirely from the means employed to create the work;

6. The painter thinks in terms of form and colour;

7. The aim is not to *recompose* an anecdotal fact, but rather to *compose* a pictorial fact;

8. Painting is a mode of representation;

9. One must not imitate what he wishes to create;

10. One must not imitate appearance; the appearance is the result;

11. To be a pure imitation, painting must create an abstraction of appearance;

12. Working according to nature means improvising. One must watch out for any all-encompassing formulas, fit for interpreting the other arts as much as reality, and which, instead of creating, would produce only a style or rather a stylisation;

13. The arts that draw their effect from their purity have never been all-encompassing arts. Greek sculpture and its decline taught us that;

14. The senses deform, the mind forms. Work to perfect the mind. There is no certainty except in what the mind conceives;

15. A painter who attempts to make a circle would only make a ring. Perhaps what he sees might satisfy him, but he would still harbour some doubt. The compass will give him back all certainty. The *papiers collés* in my drawings also gave me a sort of certainty;

16. *Trompe-l'oeil* is due to an *anecdotal* event that produces its effect through the simplicity of the facts;

17. The *papiers collés* – and the imitation of wood and other elements of the selfsame nature – that I have used in certain drawings also produce their effect through the simplicity of the facts; this caused people to confound them with *trompe-l'oeil*, which they are, in fact, the extreme opposite of. They, too, are simple facts, but are *created by the mind* and are such that they constitute one of the justifications for a new figuration of space;

18. Nobility comes from the emotion contained;

19. Emotion must not be rendered through emotional trambling. It is not something to be added or to imitate. It is the germ, while the work is its blossoming;

20. I love the rule that corrects emotion.

40. Erik Satie, *Le piège de Méduse. Comédie lyrique en un acte de m. Erik Satie avec musique de danse du mème monsieur, ornée de gravures sur bois par m. Georges Braque*, Paris, 1921

41. Georges Braque, *La Clarinette*, 1913

42. Georges Braque, *Nature morte avec violon*, 1913

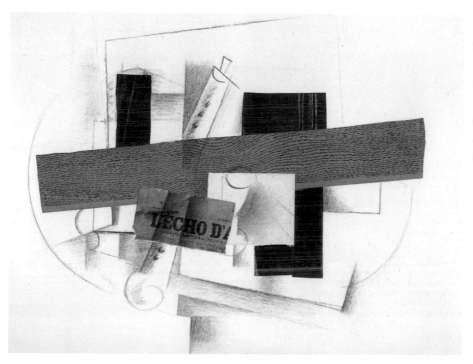

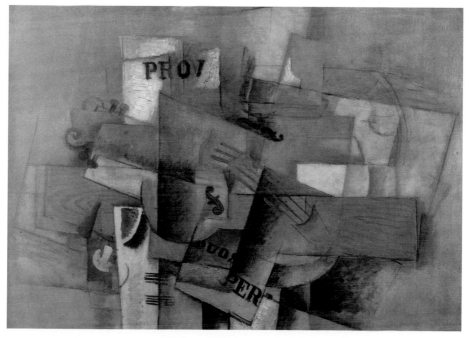

43. Georges Braque, Jean Paulhan, *Les paroles transparentes*, 1955

44. Man Ray, *Georges Braque*, 1922

45. Hesiod, *Théogonie. Eaux-fortes de Georges Braque*, 1955

46. Max Jacob, *Saint Matorel. Illustré d'eaux-fortes par Pablo Picasso*, 1911

47. Joseph Delteil, *Allo! Paris! Avec vingt lithographies par Robert Delaunay*, 1926

48. Pierre Reverdy, *Les Jockeys camouflés. Agrémentés de 5 dessins inédits de Henri Matisse*, 1918

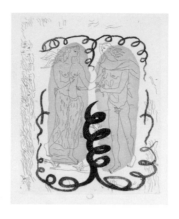

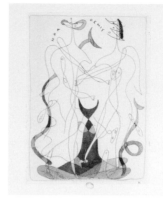

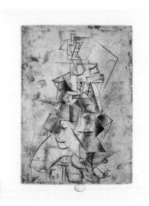

49. Aleksandr Rodchenko
On the Art of Photography (1920–1924)

Photomontage led me to my interest in photography. The first photos were a return to abstraction. Those photos were almost non-objects, and the prevalent aspect was the problem of composition.

We are discovering all the wonders of photography. After being a complementary, imitative art – of etching, painting, tapestry weaving – photography, having found its own road, now begins to flourish and emanate its own true scent. Unknown possibilities open up, creating a subtle, pluri-semantic theme that wins over photomontage . . . Contrasts in perspective. Contrasts in colour. Contrasts in form. The impossible foreshortenings in drawing and painting, foreshortenings of such exaggerated angles, along with the merciless vision of the material's manufacture. Compositions that, through sheer audacity, surpass all artists' imagination. Compositions that are super-charged and overflowing with forms, which make Rubens appear relatively backward.

This revolution in photography means that the captured object, precisely for 'how' it is captured, has an incredibly strong and unexpected effect, thanks to the specific qualities of photography, such that it cannot only compete with painting, but can also show everyone a new, perfected method for discovering the world of science, technology and the everyday existence of modern man. To state it more simply, we must find – we are seeking out and will find – a new aesthetic (have no fear!), the necessary impetus and pathos to express our new social facts and events through photography. For us, a photo of a recently constructed factory is not simply a photo of some building; the new factory in the photo is not a simple fact, but rather an occasion of pride and joy for the Soviet country, and we must learn 'how to capture' all this. We have a duty to experiment. In photography there are old points of view – those of the man on planet earth looking straight ahead of himself, or, as I like to call it, 'the quaint little

bellybutton formulae', the photographic apparatus on one's belly. I implore you – take photographs from any and all angles, just not 'from the bellybutton', until all points of view can come to be appreciated! The points of view most interesting today are those that go 'from up high to down low' and 'from down low to up high', and it is this we must work on. I've no idea who invented them, but I believe they have been round for some time now. I want to consolidate, amplify and grow accustomed to them, and to the modern city, with its skyscrapers, particular factory and workshop constructions, two- and three-storey shop windows, trams, automobiles, bright and large-scale advertisements, transatlantic travel, aeroplanes and everything else that has involuntarily stirred – albeit just slightly, in truth – widespread conceptions of visual perception.

It would seem that the photographic camera is the sole thing capable of representing modern life. But . . . the antediluvian laws governing the visual image placed photography on a level strictly inferior to that of painting, etching and engraving, with their retrograde perspectives. Because of this tradition a sixty-eight storey

50. Aleksandr Rodchenko, *Portrait of Mayakovsky on a Stool*, 1924

51. Aleksandr Rodchenko,
Technology, 1919–1920

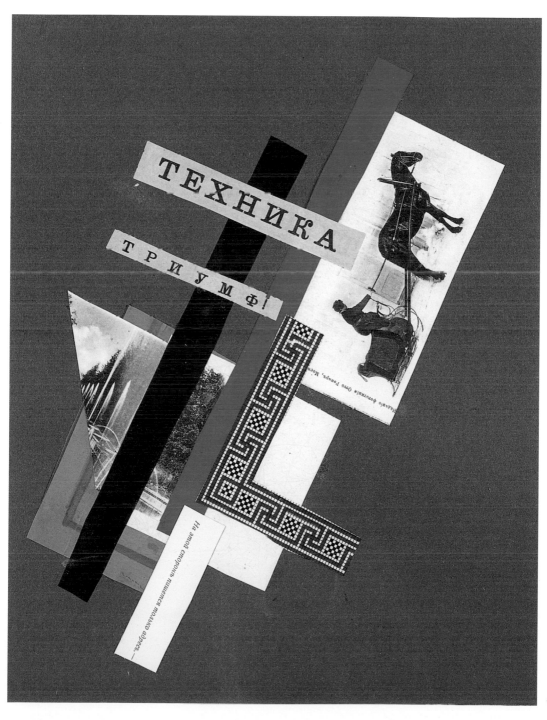

52. Installation meeting for Mayakovsky's comedy *The Bedbug*, 1929. Pictured: Dmitry Shostakovich, Vsevolod Meyerchold, Vladimir Mayakovsky and Aleksandr Rodchenko

American skyscraper is portrayed from the bellybutton – but this bellybutton just happens to find itself on the thirty-fourth floor, so the photographers scramble up to the thirty-fourth floor on the building next door and capture the sixty-eight storey giant. And if there is no building next door, they try to obtain this frontal, projected view through retouching. What good is it to observe a factory if they have decreed that you must look at it from a central point, instead of scrutinising it in detail, from inside, from high to low and low to high?

We must shoot some different photos of a single object from various points and angles, almost analysing it, rather than spying upon it through the keyhole. We mustn't make photographic paintings, but rather must make some 'photomoments' of documentary, rather than artistic, value. In summary: to make people accustomed to looking from new points of view, we must photograph common, familiar, well-known objects from absolutely unusual points of view, giving a complete image of the object.

We know not how to find – or, better yet, not find, but rather see – nature in order to present it in a different way. Essentially, we are simply blind, and only see that which has been transmitted for generations now. Each new vision provokes a revolution. We are accustomed to banality, to a yellow sun, a white moon, a blue sky, etc. We must always make new discoveries. The earliest humans made many more than we do. We must travel more and see new things in order to learn how to see what is right

before our very own eyes.

We do not see what we look at. We do not see the wondrous slices of perspective all round us, and the positioning of objects. We are accustomed to seeing what is familiar, what has been inculcated into our minds; we must discover the visual world. We must revolutionise our visual conceptions. We must tear from our eyes the blindfold called the 'bellybutton point of view'. Take photographs from any and all angles, just not 'from the bellybutton', until all points of view can come to be appreciated. And the points of view most interesting today are those that go from high to low and low to high, with diagonals.

In photography, composition plays an immense role – perhaps the main role. Because it is a young art and still rather closely resembles painting, it has obviously drawn on painting, in terms of composition, both for better and (primarily) for worse. Composition is the way in which something is arranged; the buttons and pockets on a suit, the actors on a stage, things in a room, books on a bookshelf, black and white in photography, etc. In general, it is any conscious order in the positioning of any given thing. Composition in art has led to a necessary composition in life as well. Even a person's day – divided into hours of work, leisure and enjoyment – is a composition. I would divide the representable world into three types of composition: common – everything on the right; uncommon – everything on the left; mystically religious, tranquilising, balanced – everything centred. In general, the right side is

53. Aleksandr Rodchenko, *L'art décoratif et industriel de l'URSS*, 1925

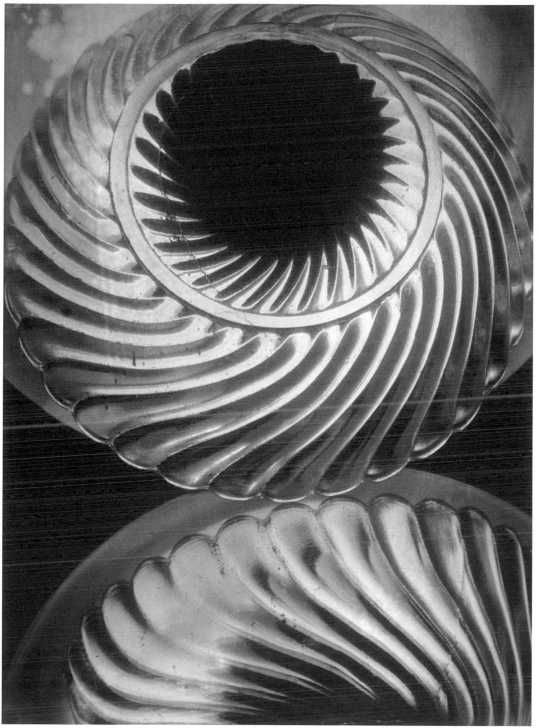

54. Aleksandr Rodchenko, *Glass and Light*, 1928

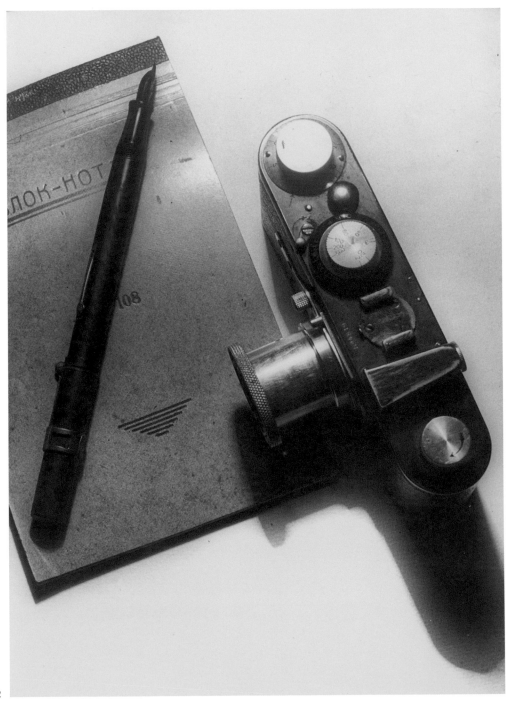

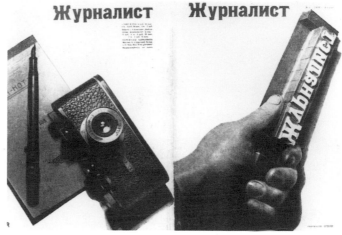

56. Aleksandr Rodchenko,
Portrait of Filmmaker Lev Kuleshov, 1927

57. Aleksandr Rodchenko, cover of the magazine *The Journalist*, no. 4, 1930

always fuller because the right hand is the more active one; it is so normal, by now, that both in paintings and on stages you will always see the right-hand side more loaded down with material. Normally people think of composition as the layout of figures and objects on the surface of a painting. Not exactly; composition is all that, plus the singular structure of each figure: it is also the light, tone and general structure of light and overall tonality, and the entire composition can be composed upon one unique light or one unique tone. For the most part, we shoot horizontal photos. That is due to the fact that in painting, too, there is a vast majority of horizontal paintings. So the old culture still has an influence upon us. And at the same time, this happens above all because we have two eyes, set horizontally, and because in nature horizontal things predominate. The city and technology are vertical.

We absolutely must publish the photos that have had some success in the press, and reflect actual happenings. We must publish these photos and write reviews, with the aim of getting the most well known authors and photographers to participate in this project. It wouldn't hurt to publish four issues each year, dedicated to a single theme – for example: February, the armed forces; June, sports; August, building and construction; October, political revolutionary events. I would also propose that we reserve a page of this magazine for pieces by masters of the field, both old and young.

Photography is a very easy technique. I see, I shoot – there is nothing easier than changing the subject. This implies a lack of independence, a loss of personality. It must find, understand and occupy its proper place. One photographer may possess lyrical qualities; another may be capable of representing harsh reality; yet another may possess irony, humour, etc. And this is what it must find: style, composition, tone, dimensions and even its own genre. We photojournalists always run the risk of losing our personality, because we photograph everything the editors order. We can confront absolutely any subject or theme in an original way, starting from our own capabilities. The disgrace of the photojournalist is for him not to have his own ideas, own thoughts, own objectives. He carries out executive work, never the work of an artist, and never poses any problems to himself until he has shot the photo he was commissioned to shoot. But the photojournalist should also reflect upon an episodic photo and look for personal themes.

What must we photograph? There are exemplary things – how one paves a street, for example – but mud and utterly impracticable streets also exist. Because we haven't any time to contemplate this first, second and third option, we must choose between the better and the worse, but in no circumstances must we choose the middle of the road, because it leads nowhere. We must photograph just as we pave streets, because that will show us what we must fight for.

We must carry out our artistic practice so well, so correctly on the political level that the working class of the entire world can say: this, here, is my avant-garde proletarian art.

58. Varvara Stepanova
Knowledge Possibilities for Art (1920)

*At the time people denied almost
everything / that was part of the
positive sciences.*
Camille Flammarion

The essential and legitimate justification of art's existence is its forward movement, which is both uninterrupted and absolute. Art attempts to penetrate the future, not to return toward the past. This makes the work of art a 'miracle', something incomprehensible, which in turn forces the viewer to either admit this incomprehension or come to understand art. Man cannot live without miracles. By his very nature he lives a complete life only when he creates, discovers, produces experiments. The process of comprehending a miracle – that is, comprehending the incomprehensible – serves to motivate his spiritual activity, be it an activity of thought or work relating to some construction, or the simple organisation of his personal life. The more there is that which is incomprehensible in art, the more art takes effect; the less utilitarian art is, in the strictest sense of the term, and the more utilitarian it is in a metaphorical sense, the more it acts as a creative stimulus.

Materialism mines the roots of idealistic vision (a sufficiently unilateral worldview) but . . . for now, the world exists and man lives – this is the 'miracle', the incomprehensible fact, since we have not resolved the problem, the *why* of human existence. Perhaps later on we will be capable of understanding or revealing our spiritual lives, just as we now understand our material lives. We cannot deny that it exists, simply because we do not yet know it, because we cannot yet explore it.

We cry "down with aesthetics and taste!" In truth, both are sufficiently discredited already, but not everything is finished yet, and the form alone cannot be and is not the sole content of the field of art, since this content has not yet been discovered. The formal is a homage to the materialism of the present time. None of us has ever based his own work on mathematics. I disagree with the idea that in painting, a painter first sets up some tasks for himself and then gets to work. The very first moment – or, more precisely, the impulse to creation – has not yet been discovered, otherwise we would not use the phrase 'spontaneous and emotional creativity'.

If, recently, these words occasionally seem inapplicable to any and all works of art, the reason for that must be sought in the fact that the technique of painting has ventured remarkably ahead, in hopes of paralleling the creative process. In art, tenacious labour is indispensable, but to complete real work straightforward labour is not enough. In this way that incomprehensible element, whose technical perfection presents the possibility of expressing oneself more clearly and precisely, would be excluded.

Precise knowledge does not create the inventor who, by force of his imagination and technical skill, finds the means through which he realises his painting, his invention, the incomprehensible . . . Only after some fact is confirmed is the scientist able to discover the laws that preside over it, or explain it. In work, as with invention and creation, there is only that which is real, and no precise cognition could possibly add anything to it.

In work, miracle – that is, the incomprehensible element – must exist, both in the moment of creation and in its technical execution; its formal execution tends to be equally incomprehensible, much like the first moment of its conception. Today the painter knows no limits to his unbridled desire to take the reigns of pictorial technique.

He penetrates the very essence of painting, and begins to come to know his own art. In truth, with respect to the future, there will only be some primitive attempts, but the serious, conscious relationship he has toward his own work can give us well-founded hope – such hope that many things will be discovered in the not-so-distant future.

59. Aleksandr Rodchenko, Varvara Stepanova, *Buskers*, 1921

60. Varvara Stepanova, book cover design for *Rtny Chomle*, 1919

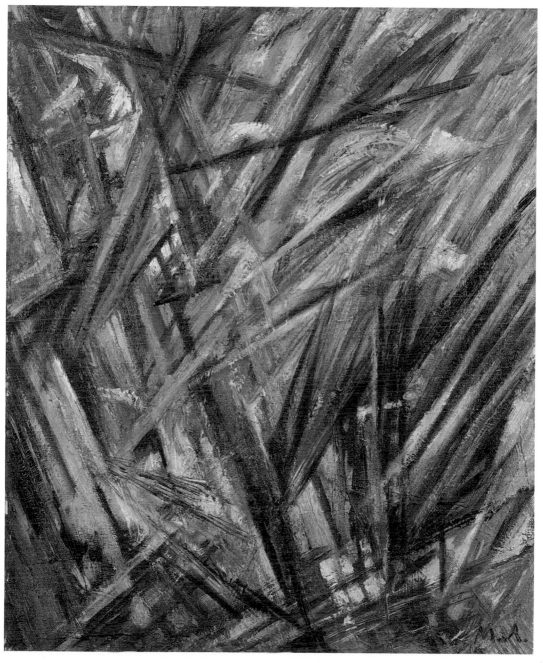

64. Fernand Léger, *L'Horloge*,
1918

I. EXPLANATION

The drawings for *kinetic painting* portray the principal moments of imagined process.

The work will be realised in film. The process consists of dramatic and evolutionary developments in the sphere of pure art (abstract form); as if analogous to the musical processes noted through hearing.

As in music, here, too (in a completely spiritual sense), the plot is produced with pure material, and this pure material reaches a point of tension, a melting point, in the sense that, in lieu of any material confrontation whatsoever, it is: elementary = magical.

II. FIGURED BASS

1. The 'language' (the language of form) in which 'speaking' takes place here is based upon an alphabet shaped by an elementary principle of contemplation: polarity. Polarity, as a principle of universal life = the compositional method of all formal manifestations.

Proportion, rhythm, number, intensity, resonance of the positioning, measurement of time, etc. From an empirical point of view: relationships and contrasts of both small and large antitheses; *spiritually* – relationships and analogies of those things that, in another, exterior sphere, are newly differentiated from one another.

Creative changes, logical equalities and inequalities in the central conception of creation.

2. The major will behind this work and the visible scope of it do not stop at the margins of its drawings. The basic aesthetic principles of this alphabet pave the way for all works of art, because the basic principles, employed in a non-dogmatic way, and in synthesis, are valid not only for the art of painting, but are equally valid for music, language, dance, architecture and the dramatic arts.

This is the line of thinking, the idea of culture as a totality, such that it accumulates and encompasses all creative forces, and is built up from a common root, in infinitely varied forms (not additively, but rather as a synthesis).

III. THE DEFINITION OF 'ART'

A. *Transcendental Definition*

Art = creative human will. As such, it is

66. Photogram from *Symphonie diagonale* (1924) by Viking Eggeling

67. Franz Roh, *Rücken (Back)*,
c. 1922–1928

68. Franz Roh, *Untitled
(Experimental Nude)*,
c. 1922–1928

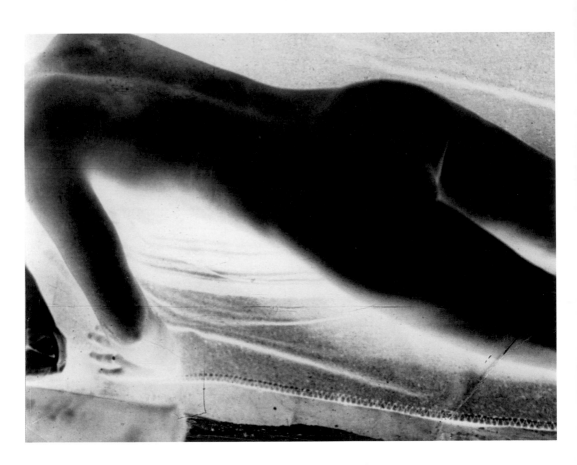

an individual organ, which serves the individual as a way of giving himself a sense of the transcendental world. (Supra-individual: transcendental ambition.) Art serves for the realisation of a superior unity: the idea of a human being belonging to humanity; the perfection of the individual in a superior form of organisation.

'Everything', 'humanity' is the synthesis of single parts (a constructive principle).

To reach this goal is an ethical necessity. Ethics is based on the knowledge and awareness of what we are capable of, in terms of a more perfect existence, and encompasses the categorical imperative of acting according to this consciousness: the necessity of a complete ethics (in contrast to religious or philosophical ethics) according to which we do everything in light of, and from the point of view of, this 'totality'. Synthesis is the creative relationship that exists between the individual and the unit; a logical creative relationship, but not one of a mathematical nature. Polar synthesis: this is identical to a manifold idea, a reference to a reasoned analogy of contrasts.

If human creative forces manage to arrive at a significant comprehension of the idea of a complete 'existence' (insofar as they are capable of any synthesis), then this (polar) synthesis is elevated to transcendence.

This knowledge and awareness is followed by the discipline of creative forces, leading to the unity of all creative human endeavours: culture.

B. Practical Definition

69. Franz Roh, *Untitled (Nude in Winter Garden)*, c. 1922–1928

70. Natalja Goncharova, Aleksandr Rubakin, *Gorod: Stikhi (The City Verses)*, 1920

71. Natalja Goncharova, *Mystical Images of War*, 1914

The most extreme, excessive economy of means; only a truly rigorous discipline of the elements and their most elementary application makes the continuation of construction possible. I repeat: art is not the essential explosion of an individual, but rather the organic language of the individual's most serious meaning. Therefore its foundations must be sufficiently immune to error, made of stone and in this sense 'lapidary' enough to truly be employed as the language of all humanity. We would be mistaken to believe that the value of art depends on the level and quality of single works of art; in truth, art demands that individuals' creative practice totalises the multitude of individual feelings into a single thought or line of thinking. This task requires a whole, integral human being: awareness and intuition must collaborate equally in the solution of single details.

The language of the psyche (that is, Art) flows still and deep, and is less oppressive to the man who inhabits the world of concepts, who has already been corroded by its acids. It is absolutely vital that the verification of all the bases of artistic language, of its *criticism*, be impartial, objective and in no way sentimental.

IV. APPENDIX

Without doubt, creative works of art will soon find recourse in – and make abundant use of – the kinetic, cinematic framework. Cinema and film are the new creative fields for artists' creative work. It therefore becomes ever more essential to specify that the simple, straightforward succession of forms, in and of itself, has no meaning, and that this meaning (taken as a definition) can be found only through art. This new art absolutely needs identical, identifying elements, without which it could still create a game – even a highly seductive game – but one that would never be art; it would never be the language in which man gives meaning to himself.

72. Marcel Duchamp

Dear Stieglitz,

Even a few words, I don't feel like
writing.
You know exactly how I feel about
photography.
I would like to see it make people
despise painting until something else
will make photography unbearable.
There we are.
Affectueusement,

Marcel Duchamp
(New York, 22 May 1922)

73. Man Ray, *Rrose Sélavy*,
1924–1925

74. Marcel Duchamp,
Porte-chapeau, 1917 (1964)

75. Marcel Duchamp, *Obligations
pour la Roulette de Monte-Carlo*,
1924

76. Marcel Duchamp, *Fountain*,
1917 (1964)

77. Marcel Duchamp,
*Porte-bouteilles ou Séchoir
à Bouteilles ou Hérisson*,
1914 (1964)

78. Marcel Duchamp, *Roue de
bicyclette*, 1913 (1964)

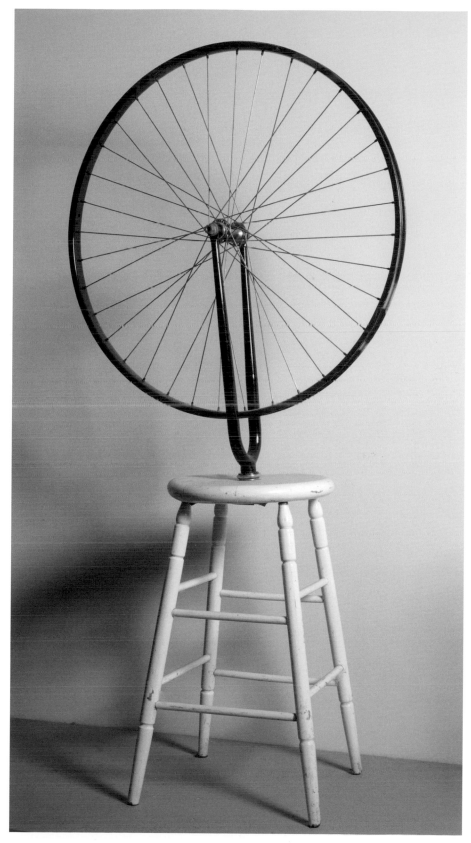

79. Raoul Hausmann
From Talkies to Optophonetics (1923)

. . .

The inventors of what are currently the best talkies are Vogt, Massolle and Engl. Vogt, the idea's creator, took up an old discovery made by Ruhmer, but substituted selenium-celluloid with his new invention, photo-celluloid with a potassium coating. In the new talkies, as in Ruhmer's work, acoustic vibrations are converted into luminous oscillations, which are then fixed onto the filmstrip by way of photography, and reproduced as sound. Now, Vogt, Massolle and Engl's discovery is a real step forward, a noteworthy improvement on Ruhmer's 'photographed music'. The thing Ruhmer never managed to make possible – the correspondence of a filmed action and its complete synchronous translation into music (in opera, etc.) – is now resolved.

The recording of sound and image takes place in the following way: the filmstrip, which is wider than usual, carries the recording of sound on one side of the guiding perforations. While a scene is being filmed, an acoustic device (an auricle of sorts) collects the oscillations, which are then converted into a reinforced electric current through the so-called microphone and conducted to a high-frequency lamp. The luminous oscillations of the light are photographed through a fissure in the film being recorded, on the side closest to the guiding perforations, where some thin, variable horizontal striations can be seen. This film with a combination of sounds and images is developed and copied just like any other film.

. . .

There is yet another basic concept underlying the talkie, identified by Waltz-Meusser. In 1920, in a magazine dealing with precision mechanics, there was a report about a patent that indicated the possibility of developing talkie film utilising relief capacitance. He managed to demonstrate, in practice as well, that the guiding perforations of a normal filmstrip, used for relief capacitance, were capable of producing a musical sound with various pitches, perceptible through variations in capacitance according to speed. Because his means were limited, his research was interrupted and continued as a side activity, working toward the transmutation of words and music through variations in capacitance . . . This route led to the gramophone and the possibility of sound reproduction with the help of a small condenser microphone. The scientific demonstration that clear sound reproduction could be achieved with variations in capacitance even smaller than those required for film

80. Raoul Hausmann, cover for *Der Dada*, no. 1, 1923

81. Raoul Hausmann, cover for *Der Dada*, no. 2, 1919

82. Raoul Hausmann, cover for *Der Dada*, no. 3, 1920

was proven in 1920, with a small antenna equipped with a cylindrical condenser.

But the road leading from talkies to optophonetics is still long and winding. The inventor of the 'antiphone', Plenner, was the first to posit this problem in his article "The Future of Electric Television". He claimed that the ray of light could be forced (through selenium-celluloid) to produce or modify inducted currents, and then a receiver inserted into the line would transform these inducted phenomena into sounds. So what arrives as an image at the receiving station would then result in a sound in the intermediate apparatus; and if at the beginning moving images and visible processes are recorded, they would then conversely be manifest as a succession of sounds. The shape of a square, in acoustic transformation, must provoke a sound quite different from that of a triangle or circle. A cube must sound rather different than a cone or prism. Crystals and stars will begin to speak, but in what language, and with what accents? All this is still sheer supposition, but one day, from the current state of ignorance, knowledge will arise.

130 Now, at the foundation of this concept,

just as at the base of talkies, there lies a naturalism that for us, today, is no longer posed as a real problem. The fact that music, in its ultimate form (even futurist music), no longer corresponds to our consciousness of the world – just as a-kinetic painting no longer corresponds to it – is an incontestable given.

We must therefore find, for both (music and painting), new laws, laws valid for us today, and a new function. We must discover a new, essential way in which the function of form belongs to the intensity of oscillation, to then arrive from the realm of chance at a new, binding norm of form.

87. Tristan Tzara
Photography Upside Down and Inside Out (1922–1923)

As the trajectory of its extremes crosses before the iris, the object no longer projects a poorly reversed image upon the surface. The photographer has invented a new method: he presents space with the image that exceeds it, and the air, with tense hands, head facing forward, captures and keeps it.

An eclipse circles round the partridge, or is it a cigarette case? The photographer turns the spit of his roasting thoughts to the squeaking of the un-oiled moon.

Light varies according to the dizziness of the pupil on the cold paper, according to its weight and the shock it produces. A sliver of a delicate tree makes him foresee metallic layers, open-armed cartwheels. He illuminates the vestibule of his heart with a cloth woven of snowflakes.

And, what interests us most is that all this happens without rhyme or reason, much as a cloud spits its abundant voice.

But let us talk a little about art. Yes, about art. I know this guy who does excellent portraits. The guy is a camera. "But," you'll say, "he doesn't

88. Tristan Tzara, *La deuxième aventure céleste de Monsieur Antipyrine*, 1920

89. Man Ray, *Tristan Tzara and Jean Cocteau*, 1921

have any colour, nor the tremble of a paintbrush." This uncertain quivering was at first just a weakness that, to justify itself, took on the name *sensibility*. Human imperfection, it would seem, has virtues more serious than the exactitude of machines. And as for still lifes?

I'd like to see whether appetizers, desserts and basketfuls of hunted game don't more swiftly attract our appetite. I listen to the hissing of a serpent, of the petrol wells, a torpedo twists up its mouth, in domestic disagreements plates get broken. Why isn't all this portrayed? Because we look to a channel that communicates a particular, moving emotion to those who capture it all, using up neither eyes nor colours. Painters have understood, they've formed a circle, they've discussed it at length and found the laws of decomposition. And laws of construction. And of convolution. And a few laws of intelligence and comprehension, of sales, of reproduction, of dignity and of museum conservation. Others, later, rushed in with illuminating shrieks to say that what the first guys thought was just a bunch of worthless bird poo. As a substitute they proposed their merchandise, an impressionist sketch reduced to a vulgar yet seductive symbol. For a moment I believed their idiotic shouts, but quite soon I realised they were merely tormented by a sterile jealousy. They all ended up packaging English greeting cards. After getting to know Nietzsche and cursing about their lovers, after flaying their friends' cadavers, they declared that a few cute little babies were worth as much as any good oil painting, and that between the two, the one with a higher price tag was indeed superior. Painting with tails like a tuxedo, curly hair, in gilt frames. Here's their marble, here's our servant piss. When everything we call art was quite covered with rheumatic scars, the photographer lit the thousands of candles in his light bulb, and the sensitised paper absorbed the gradients of darkness cut out by some

utilitarian objects. He had invented the strength of a tender, fresh lightning bolt that surpassed all the constellations of our life's little pleasures in importance. The mechanical, precise, unique and correct deformation is thereby fixed, smooth and filtered like a fine head of hair through a comb of light. Is it a spiralling whirlpool of water or the tragic flash of a revolver, an egg, a twinkling arc or a sluice gate of reason, a fine ear with a mineral whistle or a turbine of algebraic formulae? Just as a mirror effortlessly bounces back an image, and an echo returns a voice without asking us why, the beauty of material belongs to no one, since it is a physiochemical product. After the greatest inventions and tempests, all the little tricks of sensibility, knowledge and intelligence are swept out from the pockets of the magic wind with a single swoosh of the broom. The intermediary of luminous values upholds the challenge put forth by the stable boys. The quantity of oats they give each morning and each night to the horses of modern art won't be able to upset the chess game's impassioned course.

90. Tristan Tzara
To Make a Dadaist Poem (1920)

Take a newspaper.
Take a pair of scissors.
Choose an article from this newspaper
that is as long as you plan to make
your poem.
Cut out the article.
Then carefully cut out each of the
words that make up this article and put
them in a bag.
Shake gently.
Then take out the scraps one after the
other in the order in which they came
out of the bag.
Copy conscientiously.
The poem will resemble you.
And here you are, an "infinitely original
writer endowed with an alluring
sensibility, as it lies beyond the
understanding of the vulgar".

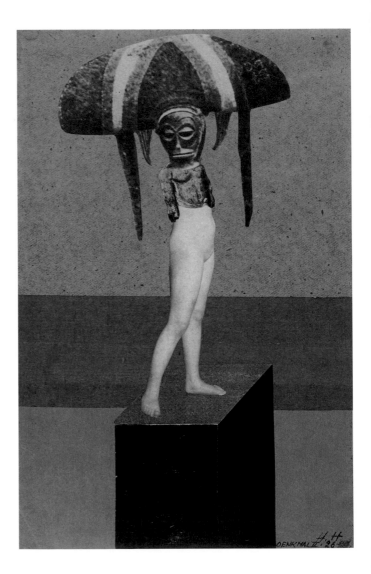

91. Hannah Höch, *Denkmal II,
Eitelkeit,* c. 1926

92. Hannah Höch, *Dompteuse*,
c. 1930–1964

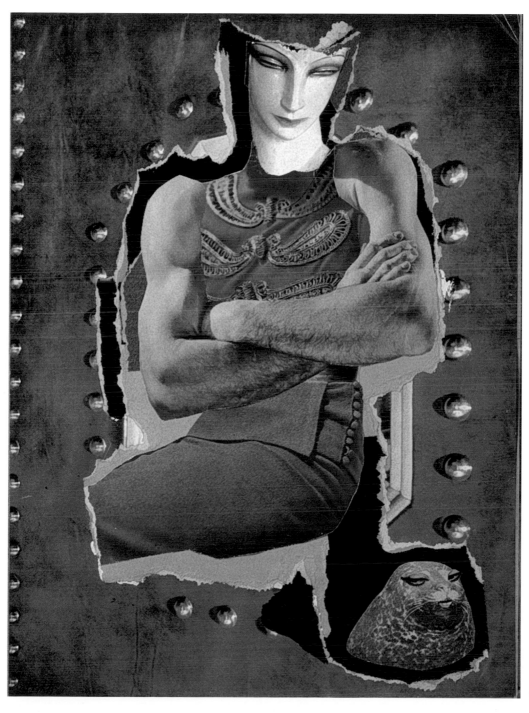

93. John Heartfield, *Der Sinn von Genf*, *AIZ*, no. 48, 1932

94. John Heartfield, *Der Sinn des Hitlergrusses*, *AIZ*, no. 42, 1932

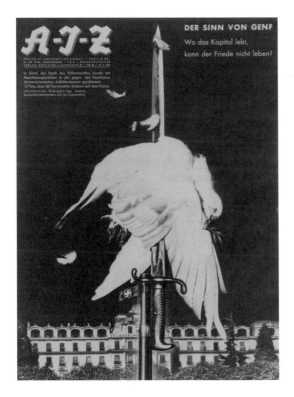

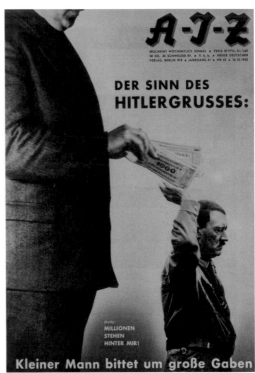

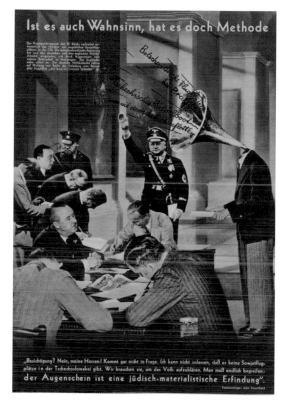

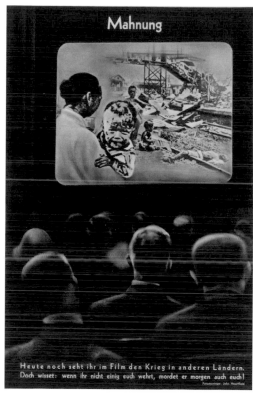

97. Pablo Picasso
Declaration to Marius de Zayas (1923)

I have a hard time understanding the importance given to the word *research* as it relates to modern painting. In my opinion, *searching* means nothing in painting. What counts is *finding*. Nobody is interested in following a man who, with eyes fixed on the ground, spends his life looking for the purse fortune should place on his path. A man who finds something – no matter what it might be, even if his intention were not to search for it – at least arouses our curiosity, if not our admiration.

Among the various sins I have been accused of, none is more false than the one claiming I have, as the principal objective in my work, a spirit of research. When I paint, my objective is to show what I have found, not what I am looking for. In art intentions are insufficient and, as we say in Spain, love is proved by actions, not by reasons. What one does – not what one had the intention of doing – is what counts. We all know that Art is not truth.

Art is a lie that makes us realise truth, at least the truth that is given us to understand. The artist must know how to convince others of the truthfulness of his lies. If, in his work, he only shows that he has searched and re-searched for his own way to lie, he would never accomplish anything. The idea of research has often led painting astray, and made the artist lose himself in extended mental lucubration. Perhaps this has been the principal fault of modern art. The spirit of research has poisoned those who have not fully understood all the positive, conclusive elements in modern art, and has made them attempt to paint the invisible – that is, the unpaintable.

They speak of naturalism in opposition to modern painting. I would like to know if anyone has ever seen a natural work of art. Nature and art, being two distinct things, cannot be the same thing.

With art we express our conception of what nature is not. Velázquez left us his idea of the people of his epoch. Undoubtedly they were different from the way he painted them, but we cannot conceive a Philip IV in any other way than the one Velázquez painted. Rubens also made a portrait of the same king, and in Rubens' portrait he seems quite another person altogether. We believe in the one painted by Velázquez, as he convinces us by his right of might. From the painters of the origins, the primitives, whose work is obviously different from nature, down to those artists who, like David, Ingres and even Bouguereau, believed in painting nature as it is, art has always been art and not nature. And from the point of view of art, there are no concrete or abstract forms – only forms that are more or less convincing lies. Doubtless such lies are necessary to our mental selves, as it is through them that we form our aesthetic conception of life. Cubism is no way different from any other school of painting. The same principles and the same elements are common to all. The fact that, for a long time now, cubism has not been understood, and that even today there are people who cannot see anything in it, means nothing. I do not read English – an English book is a blank book to me. This does not mean that the English language does not exist, so why should I blame anyone but myself if I cannot understand what I know nothing about? I also often hear the word *evolution*; I have repeatedly been asked to explain how a given painting evolved. To me, there is no past or future in art. If a work of art cannot live persistently in the present, it must not be considered at all. The art of the Greeks, the Egyptians, the great painters who lived in other times is not an art of the past; perhaps it is more alive today than it ever was. Art does not evolve by itself, rather people's ideas change, and with them their modes of expression change. When I hear people speak of an artist's evolution, it seems to me that they consider him as standing between two mirrors facing each other and reproducing his image an infinite number of times, and that they contemplate the successive images of

98. Pablo Ricasso, *Mandolin and Clarinet*, 1913

99. Joan Miró, Tristan Tzara,
Parlor seul, Poème, 1950

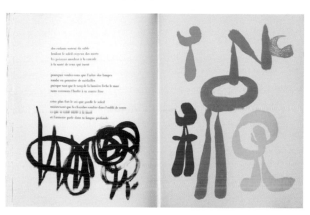

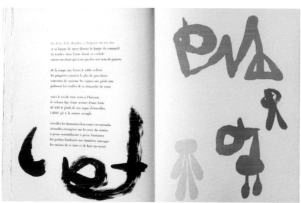

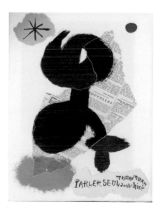

Le chant des Morts

Miracles du sommeil
Les mains liées dans
les ornières
Les pieds au ciel

Figure délayée dans l'eau
Dans le silence
Trop de poids sur la gorge
Trop d'eau dans le bocal
Trop d'ombre renversée
Trop de sang sur la rampe
Il n'est jamais fini
Ce rêve de cristal

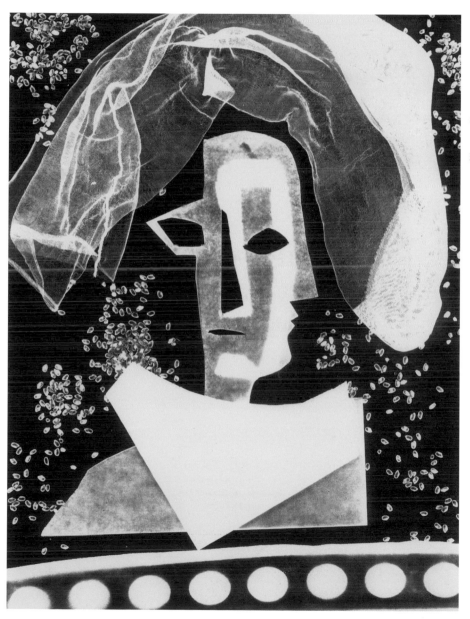

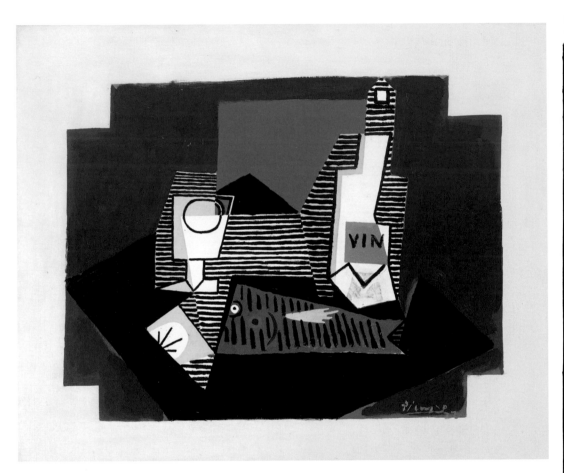

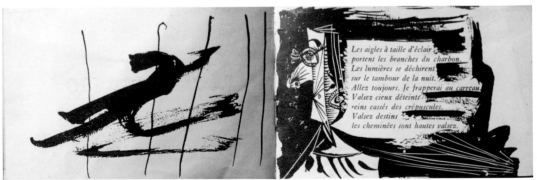

one mirror as his past, and the images of the other mirror as his future, while his real image is taken as his present. They fail to consider that these are all the same images, just on different planes. Variation does not mean evolution. If an artist varies his mode of expression this only means that he has changed his manner of thinking, and that changing could be for the better, or for the worse. The various manners I have used in my art must not be considered an evolution, or steps toward some unknown ideal of painting. All I have ever made was made for the present, with the hope that it will always remain in the present. When I have found something to express, I have done so without thinking of the past or future. I do not believe I have used radically different elements in all these different manners. If the subjects I have wanted to express have suggested different modes of expression, I have never hesitated to adopt them. I have never made trials or experiments. Each time I had something to say, I said it in the manner in which I felt it ought to be said. Different motives inevitably require different methods of expression.

This implies neither evolution nor progress, but rather an adaptation of the idea one wants to express and the means to express that idea.

Transitional arts do not exist. In the chronological history of art, there are periods that are more positive, more complete than others. This means that there are periods in which there are better artists than in others. If the history of art could be graphically represented, like a nurse's chart used to mark her patients' temperature changes, mountain-like silhouettes would be shown, proving that there is no ascendant progress in art, but that it follows certain ups and downs that may occur at any time. The same occurs with the work of an individual artist.

Many think that cubism is an art of transition, an experiment that should lead to further results. Anyone who thinks that way has not understood cubism. Cubism neither seed nor foetus, but rather an art dealing primarily with forms; when a form is realised, it is there to live its own life. Mineral substances, having a geometric structure, are not like that for transitory purposes, but rather to remain what they are, and they will always have their own form. But if we apply the laws of evolution and transformation to art, then we must admit that all art is transitory. On the contrary, art does not enter into such philosophic absolutisms. If cubism is an art of transition, I am certain the only thing that will come of it is another form of cubism.

Mathematics, trigonometry, chemistry, psychoanalysis, music: what *hasn't* been quoted in reference to cubism, in order to offer up an easier interpretation. All that is just pure literature, not to say nonsense, which has only succeeded in blinding people with theories. Cubism has kept itself within the limits and limitations of painting, without ever aiming to go beyond it. Drawing, design and colour are understood and practised in cubism in the spirit and manner in which they are understood and practised in all other schools. Our subjects may be different, as we have introduced objects and forms that were formerly ignored in painting. We have kept our eyes open to our surroundings, as well as our minds. We give form and colour their full individual significance, as far as we can see it; in our subjects, we maintain the joy of discovery, the pleasure of the unexpected; our subject itself must be a source of interest. But why should we be saying what we do when anyone can clearly see it if he wants to?

104. El Lissitskij
The Plastic Configuration of the Electromechanical Exhibit *Victory over the Sun* (1923)

What is presented here is the fragment of a work begun in Moscow in 1920–1921. Here, as in all my works, the objective was not the reformation of what already exists, but rather the creation of a new situation. The grandiose scenes of our cities are observed by no one, because any 'someone' who might do the observing is himself involved in them. All energy is used toward an individual end. Everything is amorphous. All energies must be organised, crystallised, unified and made visible. This is how a work is born, if you can call such a thing a work of art. We, on the other hand, are building the scaffolding for a stage – an open place, accessible from all sides – called the *visual machine*. This stage will offer the play's volumes all possibilities of movement. Therefore its individual pieces will have to be able to be moved, rotated, extended, etc. Various heights will need to rapidly be set, one after the other. The whole thing will be a thin lattice structure, in order not to cover the volumes moved during the play. The volumes themselves are structured according to both desire and necessity. They slide, roll and fluctuate on, inside and above the stage. All parts of the stage and all the volumes are moved through electromechanical forces and devices, and the electromechanical generator is in the hands of a single individual. He configures the representation. His place is at the centre of the stage, in front of the control panels managing all the energy. He directs all movements, sounds and lighting. He turns on the radio-megaphone, and the din of railway stations, the roar of Niagara Falls, the hammering of a rolling mill fills the plaza. In place of the single game elements, the 'configurator' of the show speaks into a telephone, connected to an arc lamp, or with other devices that transform his voice according to the character of each single figure. Electrical phrases light up and turn off. Luminous rays follow the movements of each single element, reflection and portrait through prisms and mirrors. Thus the configurator brings the most elementary process to its maximum intensity. For the first execution of this electromechanical show, I used a modern theatrical piece – one still written for the traditional stage: the futurist opera *Victory over the Sun*, by Aleksey Kruchonykh, inventor of sound poetry and leader of the new Russian poetry movement. The opera debuted in 1913 in St Petersburg. The music was by Matyushin (quarter-tone musician). Malevich painted the decorations (the curtain = black square). The sun, as symbol of the old universal energy, is torn from them by modern man, who creates his own energy source through his technical mastery. This idea of the opera is integrated with a series of simultaneous happenings. Its language is analogical. Some of the sung parts are sound poetry. The opera's text forced me to maintain some of the human anatomy in my figurines. The colours of each single part of these drawings, as in my *Proun* work, are to be considered the equivalents of materials. This means that in the final realisation, the red, yellow and black parts will not be painted these colours, but will be made in the corresponding material – for example, polished copper, opaque iron, etc.

I will leave all further development and application of the ideas and forms shown here to others, and now move on to my next work.

105. El Lissitsky, *Kurt Schwitters*, c. 1924

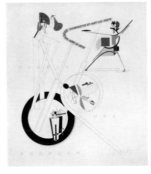

106. El Lissitsky, *Figurines. Die plastische Gestaltung der elek-mechanischen Schau Sieg über die Sonne*, 1923

107. El Lissitsky, *Proun*, c. 1923

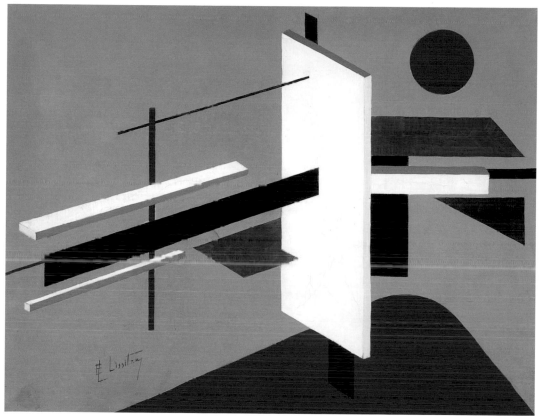

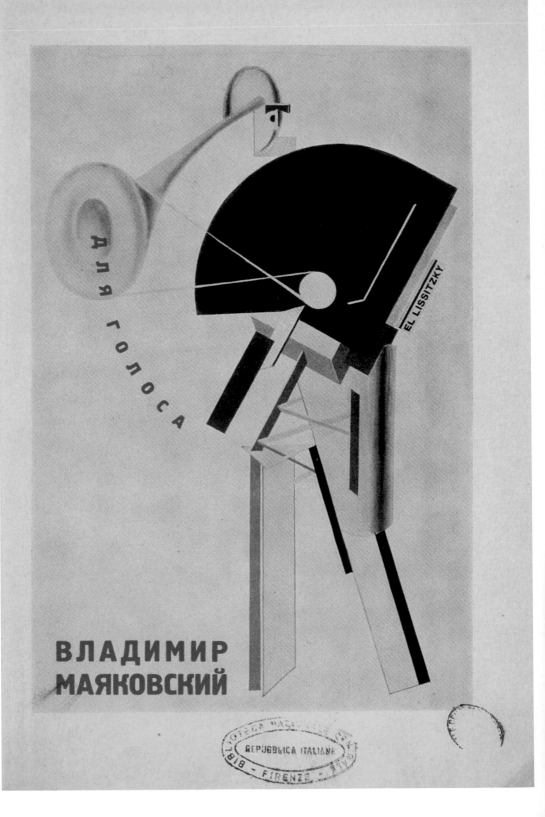

109. El Lissitsky, *Russland.*
*Die Rekonstruktion der Architektur
in der Sowjetunion,* 1930

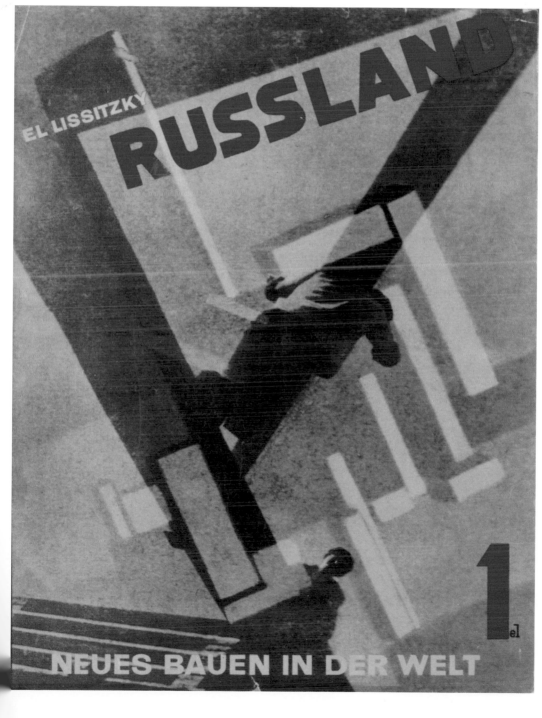

This film aims to be a figurative demonstration, in which determined elementary film-based possibilities are elementarily developed. The appearance and duration of each single form is methodical. Film plays with lighting conditions. Lighting conditions have both qualitative and quantitative characteristics: degrees of luminosity, proportion, etc.

The 'forms' that appear are de facto l i m i t a t i o n s of processes in different dimensions.

, Line serves to limit superficial processes (as surface-limiting materials); the surface serves as a limitation of spatial processes.

Line without a practical width, and surface without any limitation, cannot be represented; hence the widened line (the elongated, extended surface) and the square (as the simplest and most economical form of limitation) and – are subsidiary tools. The true building material is light, its intensity and quantity. The shape of the nature

of light, understood as the possibility of whole perception, is the task of it all. So this film is not, on principle, a film that uses the and the – as a means of composition. It orchestrates and develops them, but is in fact a film where and – appear as subsidiary tools.

The singular sensorial content of surface, etc. – (naturally abstract) 'form' – is avoided. The forms that appear are n o t analogies, nor symbols, nor are they cosmetic. In its unfolding (projection), film provides relations to both the tension and contrast of light. These relations are established between light and dark, large and small, fast and slow, horizontal and vertical, etc.

We have attempted to organise the film in such a way that each single part is in an active state of tension with the other parts and the whole, such that the whole itself remains spiritually mobile.

(1923)

111. Hans Richter,
Rhythmus 21, 1921

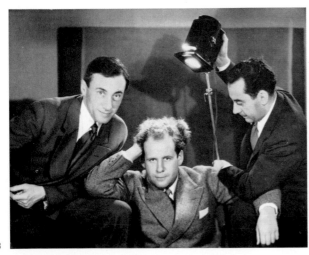

112. Hans Richter, Sergei Eisenstein and Man Ray in Man Ray's studio, Paris, 1929

113. Hans Richter, *Film Study for*
"Preludium"

114. Hans Richter, *Film Study for*
"Preludium"

115. Hans Richter,
Vormittagsspuk, 1926–1927

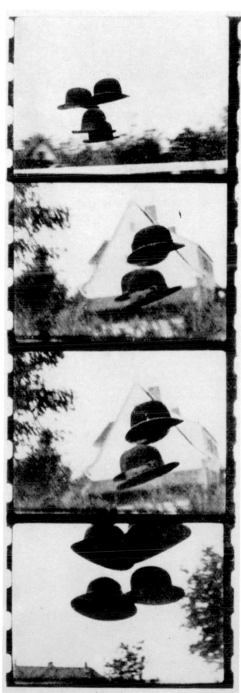

116. Dziga Vertov
Creation of the Kino-Eye (Kinoglaz) (1924)

It all began early on, with the publication of some fantasy novels: *Zheleznaja ruka [The Iron Hand]*, *Vosstanie v Meksike [Revolt in Mexico]*; with a few brief essays: *Ochota na kitov [Whale Hunting]*, *Rybnaja lovlja [Fishing]*; with a few poems: *Masha*; with epigrams and satirical poems: *Purishkevich*, *Devushka s vesnushkami [The Girl with Freckles]*.

A little later all that was transformed into a passion for editing stenographic and phonographic recordings, with a particular interest in the problem and possibility of recording sound, sound documents – in various attempts to fix, through the use of words or letters, the roar of a waterfall, the sounds of a sawmill, etc.

And so one day, in the spring of 1918, I'm exiting a railway station. The puffing and chugging is still in my ears, the noise of the train moves into the distance . . . a curse . . . a kiss . . . an exclamation . . . The laughter, the whistling of the siren, the station bell, the huffing of the locomotive . . . Whispers, calls, adieus . . . As I walk, I think: "There should be an instrument that is not limited to describing these sounds, but rather fixes them, photographs them. Otherwise it will be impossible to coordinate them, impossible to edit them. They flee just as time flees. Perhaps a film camera? To fix what has been seen . . . Organise a universe not yet audible, but visible. Is that the solution?" Just then I happen to meet Michail Kolćov, who offers me a job working in film. And so it began, at no. 7 Maly Gnezdnikovsky Lane, with my work on the magazine *Kinonedelja*. It was little more than a first apprenticeship. It had nothing to do with what I was looking to do. Because the microscope's eye is penetrating enough to reach depths the film camera never will. Because the telescope can reach undiscovered universes, inaccessible to the naked eye. What was I to do with a film camera? What is its role in the offensive I'm launching at the visible world?

I think of the Kino-Eye, the *Kinoglaz*. Early on it was conceived of as a 'rapid eye', but soon the idea expanded: *Kinoglaz* as 'cine-analysis', *Kinoglaz* as a 'theory of intermissions', *Kinoglaz* as an 'on-screen theory of relativity', etc.

I surpassed the standard of 16 photograms per second. Next to rapid recording and animation, recording with a manual camera and many other

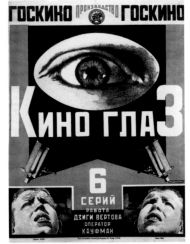

117. Aleksandr Rodchenko, *Poster for Kino–Eye* by Dziga Vertov, 1924

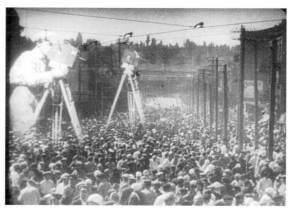

processes became part of my normal practice.

The *Kinoglaz* was understood as 'that which the eye cannot see', the microscope and telescope of time, as the negative of time, as the possibility of seeing without confines or distances, like the remote control for a film camera, like the tele-eye, like x-ray vision, like 'life lived as it happens', etc. etc. All these various definitions intermingled, since *Kinoglaz* implied: *all* cinematographic means, *all* cinematographic inventions, *all* the procedures and methods capable of uncovering and exposing *the truth*. Not *Kinoglaz* for the sake of *Kinoglaz,* but *the truth* thanks to the means and possibilities of *Kinoglaz* – that is, *cinéma vérité*. Not 'life lived as it happens' as such, but in order to show men stripped of their masks and makeup, to capture them with the eye of the film camera right when they are not acting, to read their thoughts, nude before the film camera. *Kinoglaz* as the possibility of rendering the invisible visible, rendering what is dark light, clear that which is hidden, unmasking what is hidden, transforming fiction into reality, making lies the truth. *Kinoglaz* as a fusion of science and newsreels, with the aim of fighting for the communist deciphering of the world, in an attempt to show the truth on screen – *cinéma vérité*.

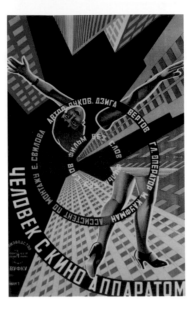

119. Georgi and Vladimir Stenberg, manifesto for the film *Man with a Movie Camera* by Dziga Vertov, 1929

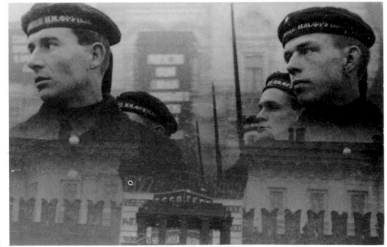

120. Dziga Vertov, *Untitled* (from the film *Ten Days that Shook the World*), 1920

121. Dziga Vertov, *Flugzeug und Lokomotive*, c. 1925

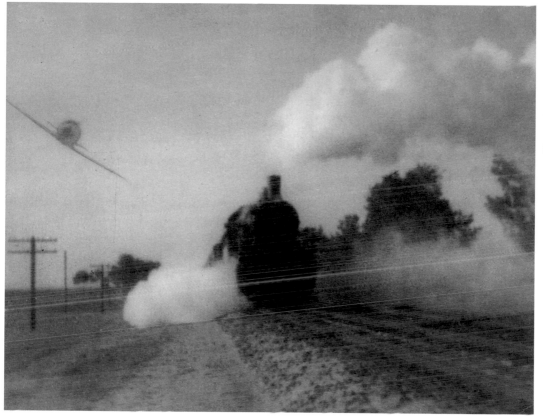

122. Fernand Léger
Ballet mécanique (1924)

Ballet mécanique dates from the period when architects talked about the machine civilisation. There was a new realism in that period that I myself used in my pictures and in this film. This film is above all proof that machines and fragments of them, that ordinary manufactured objects, have plastic possibilities.

There are not only natural elements such as the sky, the trees and the human body; all around us are things man has created that are our new realism. The day that public last accepted a house in a landscape was the beginning. A house is not a natural element, so there is no reason to pause and then set about replacing the noble *subject* with the *object* which is the current plastic problem. In this film, in the midst of the quest for new realism, there are elements of repose, distraction and contrast. The film has been shown several times all over the world. It has unquestionably influenced the development of modern film (in Russia and Germany), the *art of window display* and the development of photographic collections where geometric and mechanical elements are explored.

The fact of giving *movement* to one or several objects can make them plastic. There is also the fact of recognising a plastic event that is beautiful in itself without being obliged to look for what it represents. To prove this, I once set a trap for some people. I filmed a woman's polished fingernail and blew it up a hundred times. I showed it. The surprised audience thought that they recognised a photograph of some planetary surface. I let them go on believing that, and after they had marvelled at this planetary effect and were talking about it, I told them: *"It is the thumbnail of the lady next to me."* They went off feeling angry. I had proved to them that the subject or the object is nothing; it's the effect that counts.

The story of avant-garde films is very simple. It is a direct reaction against the films that have scenarios and stars. They offer *imagination and play* in opposition to the commercial nature of the other kind of films.

That's not all. They are *the painters' and poets' revenge.* In an art such as this one, where *the image must be everything* and where it is sacrificed to a romantic anecdote, the avant-garde films had to defend themselves and prove that *the arts of the imagination*, relegated to being accessories, could, all alone, through their own means, construct films without scenarios by treating *the moving image* as *the leading character.*

Naturally, the creators of these films have never intended to make them available to the public at large for commercial profit. All the same, there is a minority of people in the world who are for us; it is more numerous than one might think, and it prefers quality to quantity.

Whether it is *Ballet mécanique*, somewhat theoretical, or a burlesque fantasy like *Entr'acte* by Francis Picabia and René Clair, the goal is the same: *to avoid the average*, to be free of the *dead weight* that constitutes the other films' reason for being. To break away from the elements that are not purely cinematographic, to let the imagination roam freely despite the risks, to create adventure on the screen as it is created every day in painting and poetry.

Our constraints are self-imposed; little money, little means.

The grasping financier who presides over the big commercial films is disgraceful. When Von Stroheim spends a fortune to make *Greed*, that marvellous and so little known film, so much the better; but 99 percent of the films that are turned out do not warrant these enormous expenditures. Money is *antiart*, an excess of technical means is *antiart.*

Creative Genius is used to living with constraints; it knows all about that, and the greatest works generally spring from poverty.

All artistic decadence arises from overabundance.

To know *how to deal with constraints* in the midst of abundance is a rare talent.

It's difficult to be rich.

123. Fernand Léger, Dudley Murphy, *Ballet mécanique*, 1924

124. Fernand Léger, Blaise
Cendrars, *La fin du mond filmée
par l'Ange*, 1919

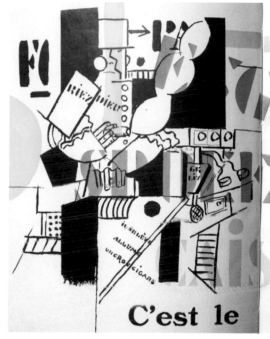

Dieu le père est à son bureau américain.
Il signe hâtivement d'innombrables pa-
piers. Il est en bras de chemise et a un
abat-jour vert sur les yeux. Il se lève,
allume un gros cigare, consulte sa montre,
marche nerveusement dans son cabinet,
va et vient en mâchonnant son cigare. Il
se rassied à son bureau, repousse fiévreu-

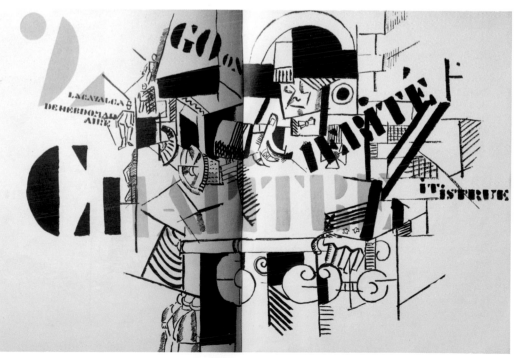

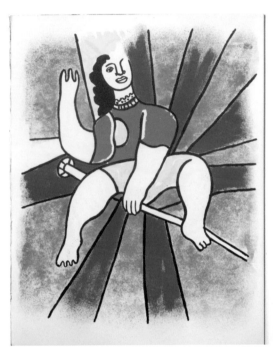

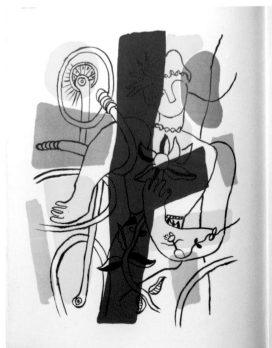

The cinema is in danger of dying from it. In its gilded theatres with its silver stars, it doesn't even take the trouble to think up its own stories; it pirates from the theatre, it copies plays. Then you can imagine for yourself that the recruitment of the human material necessary for these enterprises isn't difficult. Anybody will do. I take a well-known play. I add a well-known star. I mix, I shake gently and I bring out one of those little *Boulevard Paramount* masterpieces that I'm sure you'll find first-rate.

Right now everyone is wondering when the Commercial Cinema is going to collapse. The average theatrical production is less contemptible. It is sustained by a kind of tradition and by the vanity of the actor who, in front of the footlights in flesh and blood, 'gives it everything he's got'. If he is weak one night, the next night he redeems himself.

The cinema is a mechanism that affords *no second chances*.

I am going to say a little about *Ballet Mécanique*. Its story is simple. I made it in 1923 and 1924. At that time I was doing paintings in which the active elements were *objects* freed from all atmosphere, put in new relationships to each other.

Painters had already *destroyed the subject*, as the descriptive scenario was going to be destroyed in avant-garde films.

I thought that through film this neglected *object* would be able to assume its value as well. Beginning there, I worked on this film, I took very ordinary objects that I transferred to the screen by giving them a very deliberate, very calculated mobility and rhythm.

Contrasting objects, slow and rapid passages, rest and intensity – the whole film was constructed on *that*. *I used* the close-up, which is the only cinematographic invention. Fragments of objects were also useful; by isolating a thing you give it a personality. All this work led me to consider the event of objectivity as a very new contemporary value.

The documentaries, the newsreels are filled with these beautiful 'objective facts' that need only to be captured and presented properly.

We are living through *the advent* of the object that is thrust on us in *all those shops that decorate the streets*.

A herd of sheep walking, filmed from above, shown straight on the screen, is like an unknown sea that disorients the spectator.

That is objectivity.

The thighs of fifty girls, rotating in disciplined formation, shown as a close-up – that is beautiful and *that is objectivity*.

Ballet mécanique cost me about 5,000 francs, and the editing gave me a lot of trouble. There are long sequences of repeated movements that had to be cut. I had to watch the smallest details very carefully because of the repetition of images.

For example, in *The Woman Climbing the Stairs*, I wanted to *amaze* the audience first, then make them uneasy and then push the adventure to the point of exasperation. In order to 'time' it properly, I got together a group of workers and people in the neighbourhood, and I studied the effect that was *produced* on them. In eight hours I learned what I wanted to know. *Nearly all of them reacted at about the same time.*

The Woman on the Swing is a *post card* in motion. To get the material for it, I also had complications. It's very hard to rent straw hats, artificial legs and shoes. The shopkeepers took me for a madman or a practical joker.

I had put all my materials in a chest. One morning I noticed that someone had filched all my junk. I had to pay for everything and this time buy other materials.

An epoch alive with exploration, risk, which perhaps is ended now.

It continues through animation, which has limitless possibilities for giving scope to our imagination and humour. It has the last word.

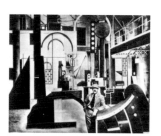

126. Fernand Léger on the set of the laboratory designed for the film *L'Inhumaine* (1923) by Marcel L'Herbier

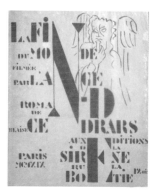

127. Fernand Léger, Blaise Cendrars, *La fin du mond filmée par l'Ange*, 1919

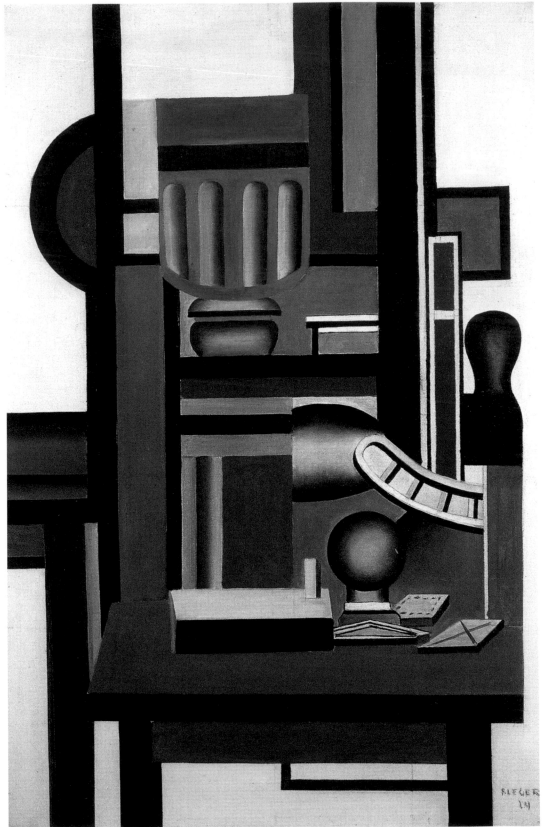

129. Theo Van Doesburg
The Configuration of Time and Light (Film) (1923)

128. Fernand Léger, *Nature morte*, 1924

I

The attempt at freeing film from too strict a connection to its subject has produced interesting innovations in many countries. These attempts at renewal run the gamut, from one extreme to the other. On the one hand there is abstract-graphic work (in motion), and on the other is the suggestive-immediate, in which a discontinuous film is structured upon incoherent naturalistic fragments. In the case of graphic motion picture, the technical film-based aspect is of secondary importance. The so-called score is planned on paper, while the film's various scenes are methodically established, in storyboards and tables. With the latter, the cameraman can program the timing of the compositions in motion. In scene-based film, the scenes are directly projected. Here composition, understood as a balanced sum of its parts, has no importance. In fact, it was avoided, insofar as the film fragments must act in virtue of the recording mode and unexpected contrasts. This is made possible by decomposition and a continuous succession of images. A third attempt at modern film construction is that of purposely deforming the lens and using other deforming processes (for example, putting transparent objects in front of the lens). Deformation serves the aim of distracting attention from the subject and obtaining a resulting whole of more or less abstract forms. I had the opportunity to see these three different techniques at the Théâtre Michel: the first was by Hans Richter, from Berlin; the second was by Charles Sheeler, from New York; and the third was by Man Ray, from Paris. By comparing them I saw that what was lacking in one technique was present in the others; nevertheless, not one of the three artists managed to find a satisfactory solution. In any case, even if the results obtained were not positive, the film-based problematic had still reached an important stage of development. One cannot expect to see such a complex problem already solved over a historic period of time in which we have only just begun to carry out research on the possibilities of these means of expression.

II

After deeper examination of the three aforementioned films, one can safely say that 'drawing and design' are the basis of graphic film (Viking Eggeling and Hans Richter). Graphic film is obtained from a painting, with the intent of adding a new element to the static image: time. A drawing in motion, composed of more or less 'abstract', yet chance, forms. A drawing that changes, develops and is realised over time. This is how I viewed these first trials, developed from a 'static' drawing, like the process of becoming seen in the chance composition of a plane, a bit in the spirit of advertising's trick films. Based on the principles of cubism, an attempt was made to compensate – using film-based techniques – for the lack of dynamics. Though we had yet to master the expressive means of natural materials, we managed, thanks to a laborious process of 're-elaborations', to see the decomposition of form in images. Imagine this process recorded by a film camera, and *voilà*, you have, more or less, graphic film. In graphic film the entire representation (if one can speak of representation) is willed in an aesthetic sense. In the second instance, on the other hand, the film-based process is more technical. The point of departure is the photo-technical process of film itself. The aesthetic aspect is of secondary importance. If we can speak of beauty here, it must be deduced from the recording effects (for example, a panorama of New York, the Eiffel Tower, an aerial view) and from technique (the movement of light). In the third instance, there is a mixture of the other two, in addition to the surprising aesthetic effect of abstract forms.

III

If one wishes to make a figurative film, **159**

the primary, elementary means of film-based figuration must first be identified. Up until now all expressive means (understood in the broadest sense) have been used in a reproductive way, for reproductive ends. Film has become an imitation of theatre and photography. This reproductive method, which belongs to almost every artistic phenomenon, is applied to film as much as it is to the gramophone. Mechanical means of expression are more important for the modern figurative conscience than culture and craftsmanship are for modern painting and plastic arts. The advantage of the latter over mechanical techniques of expression like film, theatre, the gramophone and the telegraph lies substantially in the fact that it only gives a representation. But everything that has emphasised cubism as an expressive technique – that is, the elaboration of materials taken out of their natural contexts (newspaper clippings, glass and tin, etc.) – will in the future completely destroy the artisanal technique of painting. To apply the technique of film figuratively, you must first know the

medium. It was a mistake to think that the field of film was identical to a flat plane, and that therefore any representations had to be two-dimensional. The plane of film has nothing whatsoever to do with the architectural plane, insofar as it is distinguished from the latter by light. This light, not the plane, is the means of expression. The field of light is peripheral, it has X dimensions and is essentially chaotic, given that it is essentially a latent means of expression. The graphic construction of a plane is, therefore, nonsensical. The fact that this construction has a temporal sequence does not distinguish film from two-dimensional drawing and design. The use of the rectangular plane as a means of expression gives the image a crisper determination and a more linear rhythm, but essentially changes nothing. Light and motion are elementary in this new film-based representation. The luminous field is unlimited; the possibilities of figurative expression therefore lie in time and space, as in the modern architectural field. Time and space can make a new

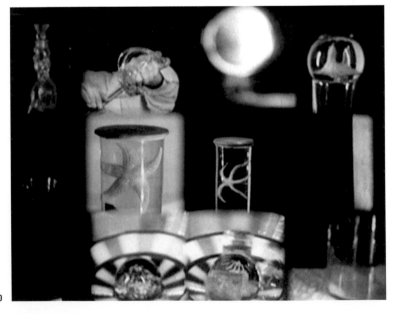

133. Lux Feininger, *Equilibrium*, 1927

134. Lux Feininger, *Saxofon*, 1927

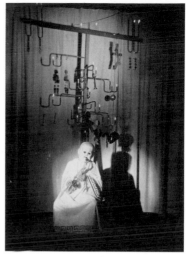

dimension visible, in the case where temporal and spatial moments find equal expression. The revelation of this new dimension constitutes the progress that makes the new film-based figuration important. You can only speak of realisation when a construction develops with the primary elements of film-based technique as its point of departure.

IV

Just as you cannot give a two-dimensional configuration to the plastic arts and architecture, you cannot give such a configuration to film. Our modern conscience is far – both for theosophical and other imaginary reasons (like religious ones) – from denying that the temporal moment is an elementary means of expression Even if the ascetic-protestant *Weltanschauung* wants us to believe that we are physically and spiritually blind to, and therefore incapable of perceiving, the great and indivisible unity of all polarities and the evolution of our intuition pushes us toward the scientific recognition of all that up until now has been vague and veiled. Our conscience has broadened and cleared up to such an extent that, in the blink

of an eye, we see things that previously would have taken years to be understood. The same is true for our awareness of time. We might say that time is the greatest discovery of our age. Thus we are able to express an entirely new dimension in a wholly unlimited way. To arrive at a real expression, we must recognise the temporal moment. Straightforward recognition, not disavowal, leads us to victory over all dominant tendencies – be they of time or space, static or dynamic – of a new portrayal As soon as it has been understood that the field of film is not that of architecture, but of a substance (light) from which and in which a figuration can be constructed (or better yet, is constructed in a techno-filmic way), and done so with the most elementary means, like planes, lines, colour; then the unlimited possibilities of the mechanical apparatus of film to create a new figuration must be recognised. Freed from static and the forces of gravity, film can realise an architecture of light and time that satisfies our modern ideas. The things necessary for its realisation will be outlined in a later chapter, with technical clarifications.

135. Henri Florence, *Lanvin*, 1929

136. Lucia Moholy, *Henri Florence*, 1927

137. Albert Renger-Patzsch, *Lasthaken mit Stahltrosse*, 1924

138. Albert Renger-Patzsch, *Zugfeder*, 1927

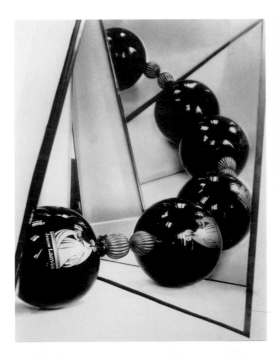

139. André Breton
Secrets of the Magical Surrealist Art. Written Surrealist Composition, or, First and Last Draft (1924)

140. André Breton, *Young Cherry Trees Secured Against Hares*, 1946

Have writing materials brought to you, after you have settled yourself in a place favourable to your spirit's concentration upon itself. Put yourself in the most passive, or most receptive, state you can. Leave behind all thoughts of your genius, your talents and everyone else's talents. Remind yourself over and over that literature is one of the saddest roads that lead to everything. Write quickly, without any preconceived subject, fast enough so that you will not remember what you're writing or be tempted to reread what you have written. The first sentence will come on its own, because with every passing second there is a sentence unknown to our consciousness, a sentence that asks only to be heard. It is somewhat more difficult to form an opinion about the following sentence: without a doubt, it partakes both of our conscious activity and of the other, if you admit that the

fact of having written the first entails a minimum of perception. This should be of little importance, though: to a great extent, this is precisely the most interesting aspect of the surrealist game. The fact remains that punctuation no doubt resists the absolute continuity of the flow we are concerned with, although it may seem as necessary as the arrangement of knots in a vibrating cord. Continue for as long as you wish. Put your trust in the inexhaustible nature of the murmur. If silence threatens to settle in, if you have perhaps made a mistake – a mistake, we might say, of inattention – do not hesitate to break off a line that is too clear. Following the word whose origin seems suspicious to you, place any letter whatsoever, the letter *l* for example, and continue introducing this arbitrariness back by making this letter the first initial of the word to follow.

141. André Breton, *Page-Objet*, 1934

142. Herbert List, *Man and Dog*, 1936

143. Herbert List, *Wax Model–Josephinum*, 1949

144. Herbert List, *Goldfish Bowl, Santorin*, 1937

145. Herbert List, *The Spirit of Lycabettos*, 1937

147. Kazimir Malevich
And Images Triumph on the Screens (1925)

If, as Arvatov says, Eisenstein and Vertov after deep thought consider that one must, in the last resort, destroy all art, including that of production, leaving "naked production-technology"; and if Vertov imagines that what he is making now is not art, then it means that the same mistake has crept into kinetic art as into painting. By the words "Down with art" one should understand art in which instead of non-objectivity, instead of art 'as such', life's ugly mug shows itself. We are talking about the kind of art that wants to make a snout into a rose.

If men of all periods and different social orders have striven to get on the bandwagon of art and to reveal their faces in the form of an artistic image, then, in imitation of them, our contemporary critics direct contemporary artists in the same direction. They consider that since the bourgeois class had itself painted, through the painter's art, with all its everyday rubbish, in canvas or sculpture, or in the theatre, music or poetry, then for some reason today's victorious working class ought also to have its rubbish painted, for if the bourgeois class established itself in art, we, too, should smear ourselves onto canvas and establish ourselves on it in the image and likeness of the bourgeoisie.

It is obviously very interesting for a large number of points then to send art, through the artists, along the same objective route of transforming ugly mugs into images.

Would that our leading critics might lose their habit of seeing in a camel a special animal created by nature to carry Kirghizes, and of seeing in an artist a master with power of a higher order for 'spiritualising' and transforming the *hideous* into the *beautiful*.

In the words of Arvatov, "However much individual intellectuals chatter about the overthrow of all except production art, the working class should take into account the practical consideration that its achievements have not yet reached the stage of complete organisation or single-mindedness in society, and therefore it must provide concrete persuasion i.e. by the means of art" (agit-painting and agit-cinema).

Accordingly art for it is principally a means for agitation, a tool as it were specially created for this purpose, as was the case in early 'peredvizhnichestvo', and as soon as the need for concrete assurance of society disappears, then agitational art will also become unnecessary. In his view, art will pass into production. This point of view also gives the slight hope that imitative easel painting will only vanish if there is the speedy and widespread achievement of single-mindedness amongst proletarian society. Another current point of view holds that the proletariat ought to establish itself in art, in the way that its enemies have done.

According to this point of view the fate of imitative, easel art is postponed indefinitely, for the painterly function of art is carried out on the old, familiar path. Even comrade Arvatov is not against art of the agitational or imitative variety in general including that of 'The Association of Artists of Revolutionary Russia', for agitation and picturesque historical records belong only to the imitative art of the 'Association'. At the same time Arvatov wishes, through the artist, to direct art onto a different path, leading to production – 'Art in production'. From this slogan one could assume that art stems from a technical purpose.

In this way art becomes a trimming to an object's expediency, and completes the forming of what cannot be done by naked technology, for which the forms of objects arise from the purely physical necessity of an organism, but not as such. The technical side of our organism has created fingers of different lengths on our hand, on account not of artistic-formal relations, but of pure utility. Form for form's sake does not exist, nor does form, as such; but if this is so then neither art nor the artist, and, least of all, easel painting, are necessary for the development of

148. Photogram from *Romance sentimentale* (1930) by Sergei Eisenstein and Grigori Aleksandrov

149. Vera Aleksandrova,
Aleksandr Kusikov, *Iskander
Name*, 1922

objects. One has only to alter the order in the slogan 'Art in production' to 'Production in art' and we get a completely different viewpoint which will lead to a large number of 'down withs' in naked technology, and in the whole range of social relations. The bourgeoisie, like all other ruling classes before it, had the artist smear out their images in a fairly primitive way, and likewise had the whole picture of life taken down. The proletariat is translating its domination into reality, and will translate it at the time of great technical improvements in human organs – ears, eyes, legs, arms. One such improvement in the artistic field has been the cinema. It has created new cinema artists, picture producers. Each production is simply called a picture, and a study for the picture has begun to be called a still. Therefore all producers and directors are to a large degree reincarnations of the old painters: they simply have in their hands a new production tool, with which they can unfold a picture *in time* and take a phenomenon in a cinema frame by means of light, as earlier they used to paint little studies by means of light. Every film producer has his peculiarity; this depends on his painter parents and on their compositional upbringing: some have inclinations towards the ancient, the times of Rembrandt,

whilst others adhere to the Barbizon and yet others the impressionist or 'Wanderer' reproduction of phenomena, the setting of which is according to the laws of the above-mentioned trends in art.
Here lies their difference from old technique in which a picture is frozen onto the canvas and acts upon the spectator by bringing into motion the representation that is reflected in the brain. Man thinks about the reasons for an episode and its consequences. Thus nowadays we have new technical improvements in the realm of imitative art of the same character and principles as in the art of former days, which was exploited by ideologists and those aware of social relations.
Eisenstein intends to liquidate easel painting, since he does not understand by this agitation. He ought to strive for the consolidation of agitational easel painting, which he at present approves, deepening the truth of its agitational content by making use of contrast to express the latter. His stills consist of the contents of content; translated into the language of painting this means the style of the Wanderers where painting was of the same content. At that time painters concerned themselves with the face's characteristics, with its various psychological states, 'mood' and they expressed happiness and unhappiness, everyday life, history, various forms of grief, hope and gaiety – instead of revealing painting 'as such' or, in our case, 'the cinema as such'.
But Eisenstein has one advantage over other directors – he has a certain understanding and ability to make use of the law of contrasts, the depth of which should eventually bring him to complete victory over content, through contrasting construction.
Thus, every director strives in his picture to convey not form 'as such' but light 'as such', not painting 'as such' but art 'as such, in general'. He uses light principally as a technical tool for the expression of man's behaviour when surrounded by various circumstances.
Let us take, for example. *No. 8* of this **167**

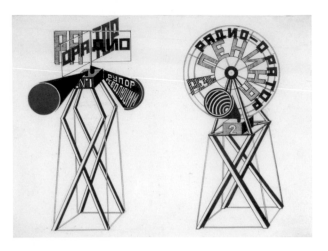

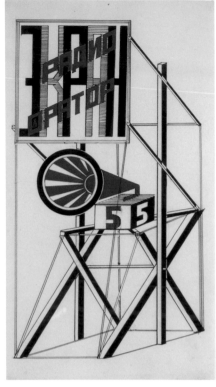

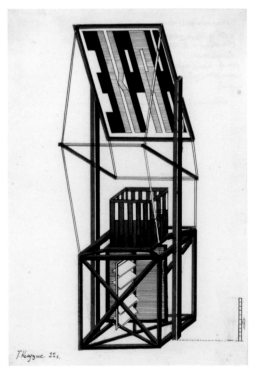

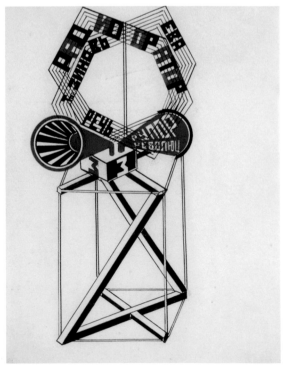

journal and look at the still from *A Black Heart*; not a bad name, incidentally, which tells us that we are still a very long way from realism; a completely mediaeval, mystical name. This study-frame itself is constructed along the lines of the German painters of the '60s. The relations of the heads and figures to each other annul the reality of the spatial and volumetric relations between them. This composition can by no stretch of the imagination be considered modern: in this set-up of contemporary faces in times long past, outside space as we now recognise it, the element of light is used as it was used by the Wanderers of the past. Or, for example, *Cross and Mauser*, a secret sign, discovered one fine day in Boston or Cleveland; the treatment of this still in the style of Repin's time is psychologically also similar to Kasatkin's picture *Who* or Repin's *The Return* (Tretyakov Gallery).

Let us take *1905* – a strike in an undertaker's parlour; a sharp contrast which should in its unexpectedness be opposed to the film which is unrolled like a displacement. In texture this still is totally impressionistic and recalls the times of Renoir, Edouard Manet and Toulouse-Lautrec. In *A.R.K. No. 8*, p. 10, there is a type of peasant who is a complete 'Wanderer' or 'Association' type: earlier we had *The Cranes Are Flying*, now it is *They Are Listening to the Agitator*.

Thus, according to the theories of painting, the cinema is still in the distant past, but the essence of art has, according to its nature, really found itself a new form which is expressed in architecture, the poster, decorations. New art is neither painterly nor imitative. New art is above all architectural, and its true meaning was not understood by the 'left' artists who turned to individual aesthetics and intuitive moods, and created from the debris of photo-montage eclecticism, thus placing a barrier in the path of the developing form of new art 'as such'. This eclectic photo-montage, however, is not, as Arvatov thinks, a replacement of painterly easel painting.

Eisenstein and Vertov are truly first-class artists, with an inclination towards the left, for the first relies on contrast and the second on 'showing the object', as such, but both still have a long way to go to Cézannism, cubism, futurism and non-objective suprematism; the path of their future development can only be determined if one understands

the principle of these schools.

I welcome comrade Arvatov's proposition concerning experimental cinema, for this is the most important problem in the art of the cinema; only by means of this experimental section can we create '*cinematology*' and a special pharmacy without which the cinema will develop catarrh.

Of Vertov's 'pure showing' I would say that one really can show the object 'as such' isolated from any ideological or agitational content. I do not know whether Vertov understands 'pure showing' in this sense, but, if so, it is the correct way of putting the question in art of the left.

In earlier days painters thought and affirmed that there was no painting without ideological content, or no content that did not contain painting. Accordingly, painting depended on the ugly mug of some aristocrat; without this the artist thought that painting would be without basis, smeared, senseless and purposeless. The new painters have understood that it is not a question of an ugly mug but of painting, that painting 'as such' is no less valuable than any other phenomenon.

Vertov in his 'showing of the thing' has already gone half way towards liberating the spectator from things pomaded by ideas, phenomena and objects, and, in showing the thing 'as such', makes the public see things, not pomaded, but real, genuine and independent of ideas; in this way they make an infinitely more powerful and interesting picture than all the images and their various 'contents'.

In cubism art liberated itself from ideological content and began to build its own form. It had for many years served an ideological mistress, had cleaned and powdered her, rouged her cheeks and lips, and pencilled her eyebrows. Today it has given this up in favour of its own culture. The cinema is for the time being also a chambermaid who must free herself and understand, as the cubist painters understood, that painting can exist without image and without everyday life and without the image of ideas. Then the cinema will start to think about its culture 'as such'.

Eisenstein paid attention to the law of contrast, which makes his *cinema-productions interesting*, but he should bear in mind that his *contrasts can create a setting* from which the idea gains importance, but in that case contrasts as such lose their special acuteness and do not reveal contrast as such. If he comprehends the law of

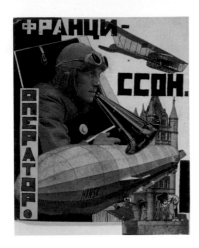

154. Piotr Stepanovich
Galadshev, *Operater Franzisson*,
c. 1925

155. Karel Teige, *Stavba a
bàsen*, 1927

contrasts, and it can only be
comprehended through cubism which
is the *only school concerned with the
laws of contrast,* then he will attain the
summit on which the new art of future
culture stands.

Hitherto it has been considered that
new art in general and cubism in
particular is a falsification of art: an
outstanding analysis by our Western
critics, like the analysis of Krylov's
monkey who just could not get the
idea of putting her spectacles on her
nose instead of her tail, and therefore
decided to smash them as useless.
Our contemporary critics, too, have
resolved to show the worthlessness of
new art in general and to warn the
proletariat of the appearance of an
incomprehensible useless
phenomenon in art, called cubism,
futurism or suprematism.

This monkey's habit of considering
every idea to be a single aim and
conformity of everything to its own
image, has since time immemorial
forced art to orientate itself towards the
priest or pharaoh, as an expedient
image and as the container of great
ideas. The artist has been brought up
with this method and considers that
man's ugly mug is the aim in which the
artistic image in the idea exists, and that
this mug and all its everyday rubbish
and the commotion of the bazaar – that
this is the essence of his life.
Moreover they began to prove to him
that he is born with all this commotion,
and that all the interrelations of *these
ugly mugs comprise the society* of
which he is a *member;* accordingly he
ought to resemble it and his entire art
should consist of representing *this
commotion.* This is what he
understood, and, as a result, stands in
the waiting rooms of life's *deputy
chiefs* in order to engrave their image,
containing as it does an 'idea'; or else
he traverses *the globe* and smears
onto canvas the flattened, *sacred*
everyday life.
*Likewise cinema producers have not
escaped this grip of tradition, and
images triumph on the screens.*

karel теige

sтavba a báseň

edice olymp
svazek
7-8

praha
1927

. . .

Photography

Ever since photography was invented, despite its incredibly broad diffusion, nothing essentially new has been discovered, in terms of technique and theory. With the exception of Roentgen-ray photography (x-rays), all the innovations introduced to date have been based on the concept of artistic reproduction that dates back to Daguerre's time (around 1830): the reproduction (copying) of nature conforming to the rules of perspective. Since then every single period, characterised by a particular pictorial style, has witnessed the birth of an imitative photographic style, derived from contemporary trends in painting. People are discovering new tools, new methods of working that profoundly transform their daily working habits. Nevertheless, such innovations often aren't adequately applied, and are held back by old habits: the new function gets hidden in traditional forms. The creative possibilities of the new process sometimes come to the surface, slowly, out of these old forms, old tools and creative fields that then become the subject of a euphoric blossoming when innovation, after its preparatory phase, finally makes some headway. For example, FUTURIST (static) painting posed the problem of simultaneity in movement, the representation of impulse-time, a precise problem that would later inevitably lead to its self-destruction. This happened in an era when film, although it was already quite widely known, was still far from being understood. Analogously, CONSTRUCTIVIST PAINTING, on a higher level, paved the way for the development of compositions of reflected light, which today already exists in an embryonic stage. The same can be said – with a fair amount of prudence – of a few painters who work with representative-objective means (the neo-classicists and *Neue Sachlichkeit*, or New Objectivity painters), pioneers of a new form of optical-representative composition, which will soon use strictly TECHNO-MECHANICAL MEANS, beginning with the fact that these same works contain elements that are tied to tradition, or are even reactionary. In the past it was totally overlooked that, in photography, the basic element of the photographic process consists of the light-sensitivity of a chemically treated surface (glass, metal, paper, celluloid, etc.). This surface was always and only considered in light of the perspectival laws of the camera obscura, in such a way as to fix (reproduce) the characteristics of single objects, and reflect or absorb light; but not even the potential offered in these combinations was sufficiently and consciously put to use. An effective awakening in our awareness of these possibilities would have made it possible to *make visible*, through the photographic camera, things that the human eye is incapable of capturing or perceiving. In other words, *the photographic camera can perfect and integrate our optical instrument: the eye*. On a scientifically experimental level, these principles have already been applied: for example, in the study of movement (steps, jumps, galloping), and in zoological, botanical and mineralogical forms (enlargements, microscopic photographs) and also in other fields of scientific research.

Still, these attempts remain isolated, and their INTERCONNECTIONS have never been studied in depth. To date we have made use of the film camera's capabilities in a merely secondary sense. This fact is made clear even in so-called wrong, mistaken photographs – shots taken from above, below and the side – which often disconcert viewers, who believe they are pictures taken by chance.

The secret of their effect lies in the fact that the photographic camera reproduces only the optical image, and therefore also the distortions, deformations and optical perspectives, whereas our eye, thanks to our intellectual and associative experience, completes and integrates these optical phenomena in space, translating them

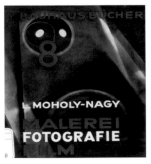

157. Laszló Moholy-Nagy, *Malerei, fotografie, film*, 1927

158. László Moholy-Nagy,
Komposition A 17, 1927

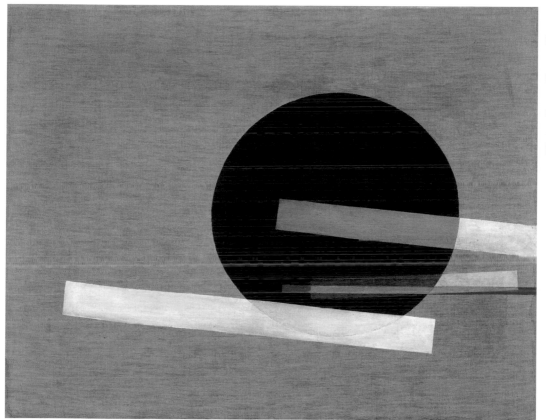

into a CONCEPTUAL IMAGE. This is why the camera is the most trustworthy tool for nearing objective sight. Even before arriving at a possible subjective position, everyone will be forced to see what is optically true, that which explains itself, the objective. In this way, the concept of imaginative, pictorial association – which has lived on for centuries now and is imposed upon our vision by the great masters of painting – will be eliminated. In this sense, a century of photography and two decades of film have enriched us enormously. One might DECLARE THAT WE SEE THE WORLD WITH COMPLETELY DIFFERENT EYES. But, regardless, the results obtained thus far are little more than an encyclopaedic visual loan. But this is not enough. We want to PRODUCE in a planned manner, because the creation of *new relationships* is important for life itself.

. . .

The Problems of Modern Film
The Current Situation
Over the last few years the general principle that all artistic creations must be adapted to the technical possibilities of the means through which they are realised – at least in theory, if not always in practice – has come to be accepted.
Even filmmakers, like other artists, have attempted to apply this principle to their art over the past decade. Regardless, film today is still overwhelmingly dominated by the concepts of traditional painting, and currently, on a practical level, in all film production there are very few elements that can prove the fact that the film's essential medium is *light*, as opposed to colour. Additionally, modern film has limited itself exclusively to projecting a sequence of 'static scenes' onto the screen, and it seems as though no one has understood yet that a mobile projection in space actually constitutes the form best suited to this medium. The same conservative principle is followed for acoustically amplified film – talkies – in which the schema first chosen as a model is still meticulously copied. Even today theoretical attempts at individuating the peculiar, independent forms of this technique are extremely rare.

. . .

The Meaning and Future of the Film Studio
In our politically and economically troubled, unstable times, film as a

recording of events and facts, or reportage, has become an education and propagandist medium of primary importance. Despite that, it is essential to remember that – like all other means of expression – film, with its characteristic elements of light, motion and psychological montage, also exercises a strictly biological allure, independent of any and all social factors (abstract films, for example). Because of this, the film studio will continue to play an important role for future cinematographic production, insofar as it will offer the environment best suited for duly controlling this allure. I do not, naturally, deny the fact that these films will in some sense remain definitively tied to a determined period – indeed, I am convinced that this nexus must be sought out, above and beyond the factor of time, and according to the measure in which it is rooted in the subconscious and constitutes one of the most effective means for the ideological preparation of our future society.
The studio where light is managed and modelled will not evidently be an imitation of today's cinematographic studio. In this studio no attempt will be made at transforming plywood into a forest, or Jupiter lamps into the sun, but work will instead be carried out beginning with the basic elements of the chosen medium, and will tend toward the development of its intrinsic characteristics. The cinematographic architect will naturally have to conform to this orientation: regardless of its acoustic function, the scenographic backdrop of the future will be conceived of as a mechanism for the production of light and shadow (trellis, lattice and skeletal constructions) and as a grouping of planes by which light will be absorbed and reflected in different ways (walls built for the organised distribution of light). Photography without a camera, the so-called photogram, provides us with the key for light's morphosis. Its vast range of colours – between the two extreme poles of white and black, with innumerable nuances and shades of grey (and in the future, certainly colours, too) – is incredibly important for film, and the same can be said of double exposures and overlapping different images. Only a non-imitative studio will make us capable of creating such forms of light and making the most of possibilities that to date remain unimaginable. But the morphosis of light is not film's only problem; problems related to motion and sound require equally urgent

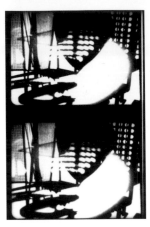

159. Photograms from *Lichtspiel: Schwarz-Weiss-Grau* (1930) by László Moholy-Nagy

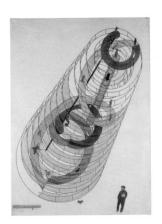

160. László Moholy-Nagy, *Konstruktives kinetisches System*, 1922–1928

161. Laszló Moholy-Nagy,
Komposition, c. 1920–1923

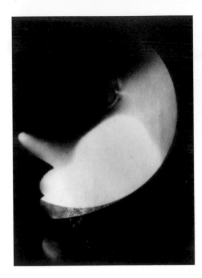

resolution. And that's not all. Film presents a series of aspects and characteristics of a photographic nature, and others tied to its educational function (for example the problem of finding adequate means for expressing the new concept of space-time).

The Creative Use of Movement
Given that our practical experience dates back only a few decades, we do not yet have any real tradition for the use and control of movement in film. Even its basic principles have yet to be established, and because of this, movement is managed in a rather primitive way in the majority of films. Our eyes are not yet trained to receive a certain number of simultaneous sequences. Quite often the multiplicity of phases in a system of inter-correlated movements – although it may be controlled in the best way conceivable – would produce an impression of chaos, rather than an organic unit, in us as in viewers. This is why experiments of this sort, even if they can be important on an aesthetic level, will for some time yet hold no more than a purely technical or pedagogical interest. While many of its aspects may be questionable, to date Russian editing constitutes the only real progress made in this field. The simultaneous projection of a series of complementary films has not yet been attempted.

Reflections on the Talkie
Talkies constitute one of the most important inventions of our time. This innovation will fuel not only the individual's visual and acoustic capacities, but will also improve the awakening of our conscience and new realisations. Nevertheless, the type of talkie I allude to here has nothing to do with the presentation of the usual dramatic dialogue and sound sequences, nor will its function be to provide a recorded documentation of reality in sound. It will carry out that particular function, but such a function will be analogous to the photomontage and editing in silent film. Only with great difficulty will sound be able to enrich the results obtained with silent film, if it is in fact limited to underlining or pointing out only an optical montage that is an end in and of itself. The results that have already been obtained on an optical level with a given medium certainly do not become more convincing when associated with those obtained through some other medium. Only the coordinated use of two interdependent components within the framework of an indivisible whole can be translated into a qualitative enrichment, and lead to a completely new expressive medium. This is also the only field fit for newsreels and film reportage with a sound component.
. . .

164. Man Ray, *Poème optique*, 1924

165. Francis Picabia
Entr'acte (1924)

Entr'acte is a film I wrote the screenplay for, but that matters little. Its realisation was rather complicated, my collaborator René Clair worked remarkably hard, and in the end I had the intense pleasure of seeing exactly what I had envisioned.

Entr'acte is an intermezzo at the cinema, an interlude between evocations, an intermission from the idea of mercantilism. The film we've grown accustomed to, like theatre, conjures up in my mind a rather representative story: one of my friends once bought a magnificent monkey "who resembled him like a brother", which means it had major personality. Returning home, he shut it into a room to see what it would do as soon as it was alone; he waits a minute and then goes to put his eye to the keyhole and sees . . . sees, on the other side of the door, the monkey's eye looking right back at him! I've no comment to add, since you'll have understood it all anyway. All our best screenwriters are just a bunch of monkeys peeping through the keyhole. Entr'acte is the lock – the lock with no key, where gestures and characters' actions move freely. There is a hearse that should serve as an advertisement for pharmaceuticals. "He died because he didn't use Nader Serum – or Boding-Didi." The hearse is towed by a camel. Why? I don't know. The people accompanying it eat crowns because they are made of bread and everyone is hungry; why are they hungry? There is a ballerina seen from below; why? I'd always like to see ballerinas from below. The hearse passes through Magic City, and before stopping at the cemetery death rides the roller coaster; why? I still know nothing, but it seems natural to me, and so on and so forth. At the end the hearse flips over, Life was stepping too quickly, only a paralytic managed to follow the funeral. The casket falls, and falls open, a conjurer in a splendid costume steps out, covered in medals, and with a wave of his magic wand he makes the paralytic and others who caught up with them vanish, and he makes himself vanish, perhaps finding it too taxing to be dead . . . And the public exits the cinema theatre saying that Francis Picabia probably doesn't give a damn about anything.

166-167. René Clair, Entr'acte, 1924

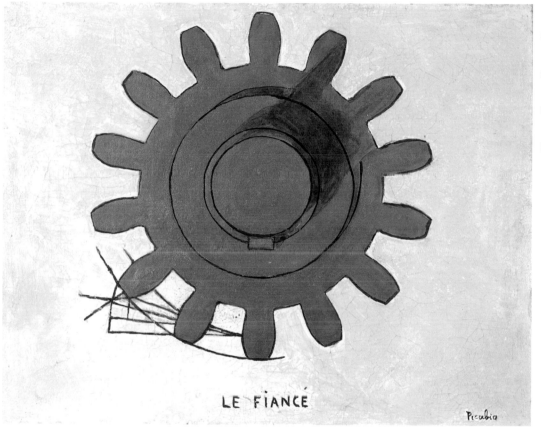

LE FIANCÉ

Picabia

169. Man Ray, *Cadeau*,
1921/1974

170. Man Ray, *Indestructible
object*, 1923/1964

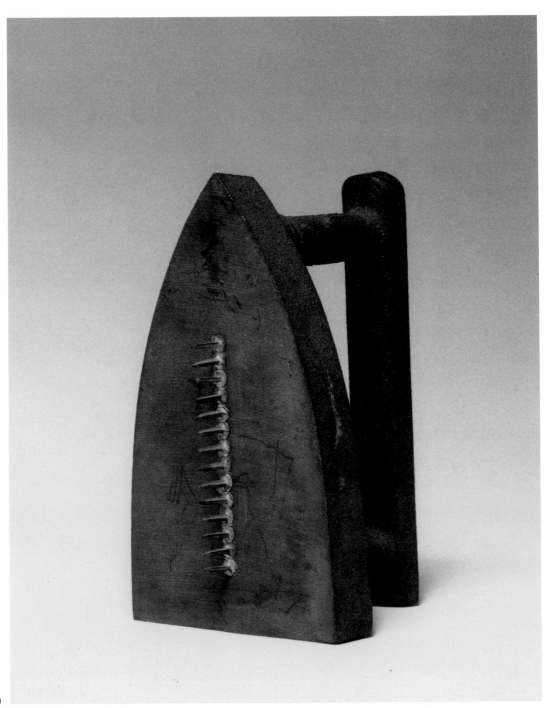

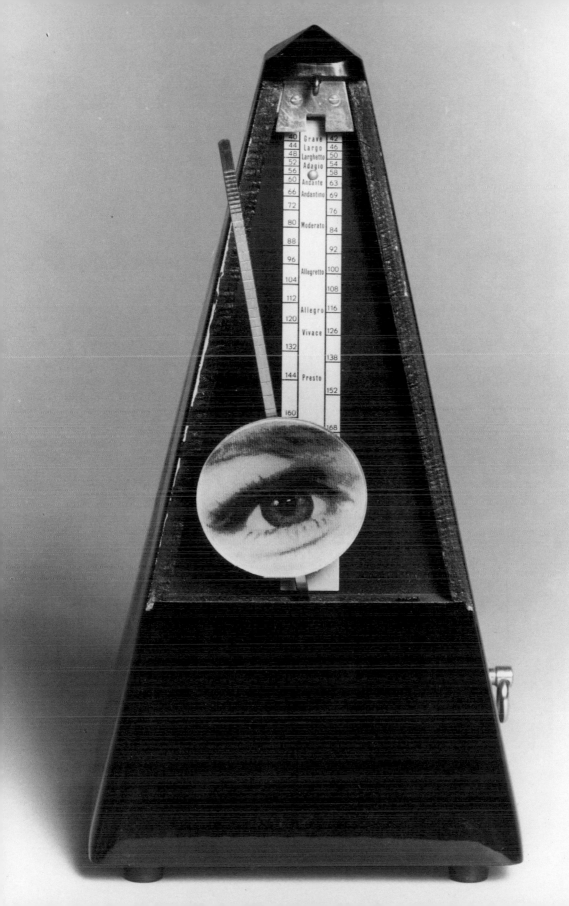

171. Man Ray, *Untitled*, 1922

172. Man Ray, *Untitled*, 1927

173. Man Ray, *Untitled*, 1923

174. Man Ray, *Meret Oppenheim à la presse chez Louise Marcoussis*, 1933

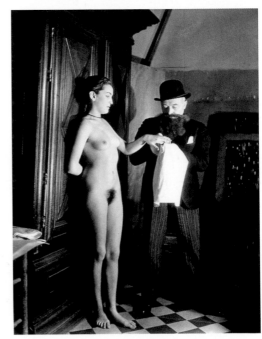

175. Man Ray
Emak Bakia (1927)

176. Man Ray, *Solarization. Self-portrait*, 1934

177. Man Ray, *Emak Bakia*, 1926–1970

A series of fragments, a cinepoem with a certain optical sequence, makes up a whole that still remains a fragment. Just as one can much better appreciate the abstract beauty in a fragment of a classic work than in its entirety, so this film tries to indicate the essentials in contemporary cinematography. It is not an 'abstract' film or a story-teller; its reasons for being are its inventions of light-forms and movements, while the more objective parts interrupt the monotony of abstract inventions or serve as punctuation. Anyone who can sit through an hour's projection of a film in which sixty percent of the action passes in and out of doorways and in inaudible conversations, is asked to give twenty minutes of attention to a more or less logical sequence of ideas without any pretence of revolutionising the film industry.

To those who would still question 'the reason for this extravagance' one can simply reply by translating the title *Emak Bakia*, an old Basque expression that means 'don't bother me'.

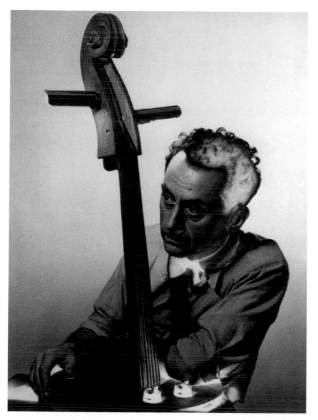

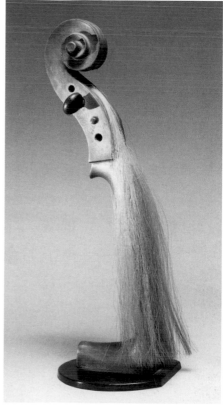

178. Man Ray, *Meret Oppenheim chez Louise Marcoussis*, 1933 179. Man Ray, *Max Ernst*, 1935

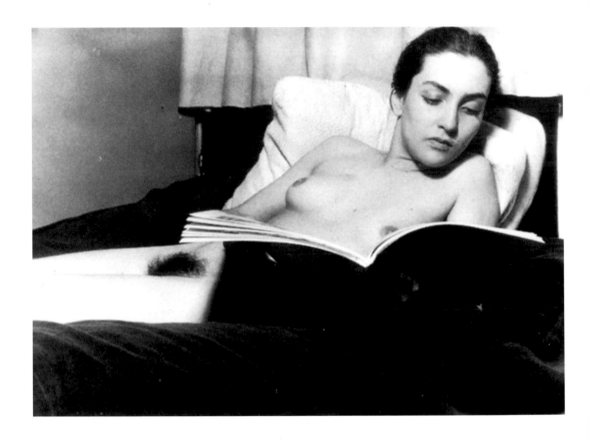

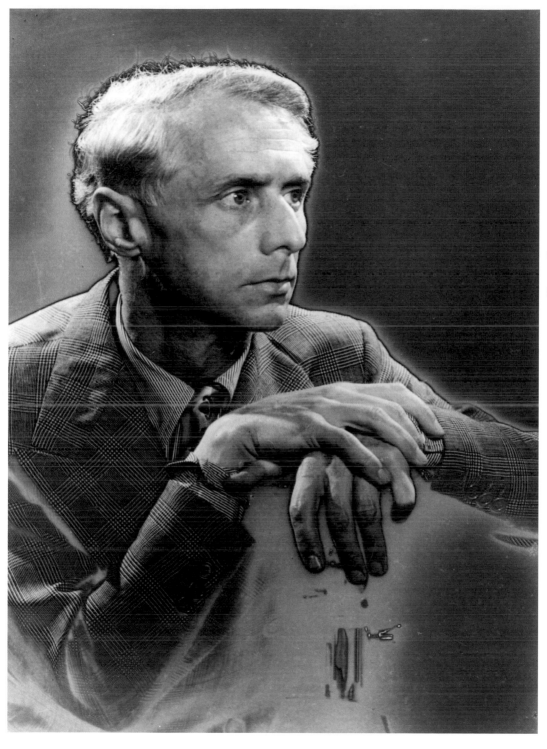

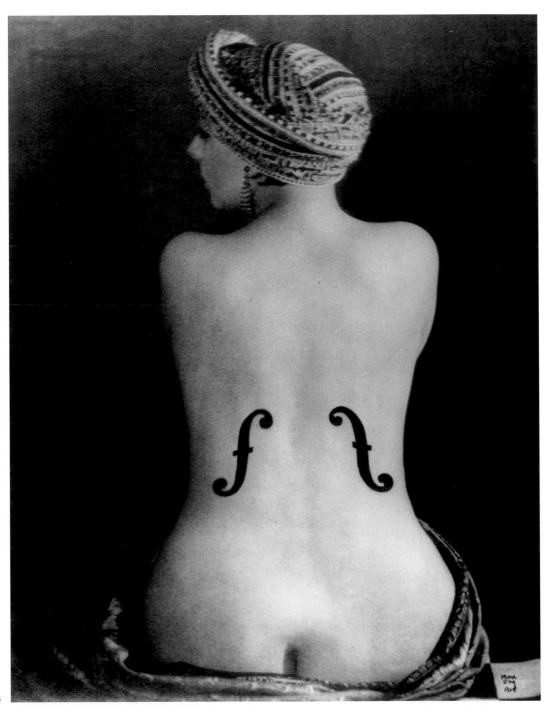

182. Salvador Dalì
Film-Art, Anti-Artistic Film (1927)

To Luis Buñuel, filmmaker,

Beware, many birds are about to take flight. You don't have to go far to hunt the bird of cinema, and the bird of photography; it is everywhere, at every angle, in the least suspected corner. Still, the bird of cinema is such a subtle and perfect mimic that it remains invisible in its flights through naked objectivity. Therefore, finding it is a matter requiring high poetic inspiration. There is no hunt more spiritual than the hunt of this bird whose presence we cannot even perceive.

Just as there is no hunt less bloody or more bleeding, which is also almost a game – the bird is caught, locked into the camera obscura and once again freed by the crystal of a lens, devoid of aniline and with chloroformed wings. If we listen, we can hear the black and white music of these birds' various speeds, as they come out of the projector's electric milky way.

So it will be sweet to finally perceive how the most vertiginous flights are a succession of quiet states and the most inspired wing-beats in a continuum of anaesthetising calms; for with every new light, a new anaesthetic.

The light of cinema is both very spiritual and very physical. Cinema captures unusual beings and objects, plus the invisible and heterogeneous apparitions of ectoplasms. Each cinematic image is the capturing of an incontestable spirituality. The tree, the street, the rugby game at the cinema are transubstantiated in a shocking way; a sweet and boundless dizziness, a vertigo leads us to specific sensual transmutations. The tree, the street, the game can be slowly savoured with a straw, like a milkshake. The quivering movement of the wind in its light gown can be captured in a small aluminium container, like mercury. The bird of cinema is a bell, the bird of cinema is also the air of a fan.

Greater imagination and fantasy are needed to shoot at a tree full of invisible birds than at another in which they have been set up, already dolled up like cubist birds; that said, the bird of cinema, transparent and delicate, dies instantly under any sort of ornament, under the hand of any painter.

The anti-artistic filmmaker shoots at a brick wall and hunts inopportune and authentic cubist birds. The artistic filmmaker shoots at false cubist birds and hunts down a useless brick. The anti-artistic filmmaker ignores art; he films in a pure way, obeying solely the technical imperatives of his device and the instinct – infantile and quite happy – of his own sporting philosophy. The anti-artistic filmmaker limits himself to psychological, primary, constant, standardised emotions and thereby looks toward the suppression of anecdote. When monotony sets in, and when monotony repeats itself, when he already knows what will happen, well then he begins to try out the unexpected joy of technical and expressive diversity. The anti-artistic director reaches action and constant signs. Face shaven; the thin and cutting moustache of the villain; a car chase and a shoot-out, etc. Pipe, jar or preserves, guitar, grappa, little bottle of rum, musical score, etc. The artistic director, corrupted by the intolerable absorption of literature and with a ridiculous desire to be original, tends toward a maximum complexity in psychological and expressive conflicts, and middles them up with the vastest and most varied assortment of recourses, often recourses that lie outside the realm of cinema – all things that, surely, lead directly to an anecdotal approach, with airs of transcendentalism but, deep down, of a perfect innocence and puerility.

The anonymous anti-artistic director films a white pastry shop, some random room, comforting as anodyne and as simple, the locomotive's sentry box, the policeman's star badge, a kiss in a taxi. At the film projection, we come to learn that an entire world of fairytales, of unimaginable poetry has been filmed.

Fritz Lang sets up a grandiose spectacle: architects, engineers, hybrids of very powerful projectors, a

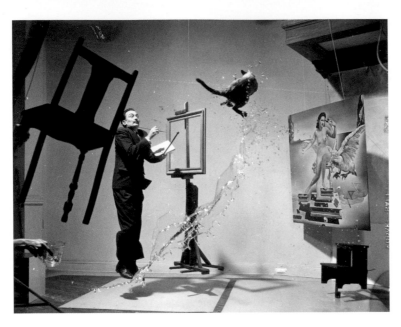

186. Philippe Halsman, *Dalì Atomics (variant)*, 1948

grandiose Dantesque staging, grandiose proportions in which the crowds, the lights and the machines buzz about . . . with all the most wretched theatricality of history painting. Whether a Moreno Carbonero paints the medieval period or a skyscraper, they're not the same thing. In this way, cinema becomes an expressive tool of the most gratuitous and vulgarly anecdotal sort; its pure, newborn palpitation is horrendously infected by all the germs of artistic putrefaction.

Beware also of the innocent concept of grandiosity. Michelangelo, with the *Last Judgement*, is no greater than Vermeer of Delft with his *Dentellière* at the Louvre, not by one square inch. Taking into account its physical, plastic dimensions, Vermeer's *Dentellière*, compared to the Sistine Chapel, could qualify as grandiose. A piece of sugar on the lens, when on screen, can become larger than the most gigantic building.

Cinema, thanks to its technical richness, can provide us the concrete, emotionally moving sight of the most grandiose and sublime spectacles, a privilege until now exclusive to the human imagination, claims the artistic director. In this way, film becomes the simple illustration of what the genial artist envisions. Anti-artistic film, on the other hand, far as it is from any grandiose concept of the sublime, shows us not the illustrative emotion of artistic delirium, but rather the entirely new poetic emotion of all the most humble and instantaneous facts, those impossible to imagine or foresee

before the advent of cinema, born of the miraculous spirit off the final capture of the bird-film. The artistic director requires innumerable and strange circumstances to realise his works; he needs, for example, to go thousands of years into the future to film cosmic emotion (still illustrative), the solemn rhythm of a monstrous workers' strike filing between immense locked-down buildings. For us, it would be much more moving to see the rhythm of the agile yet slow ascension of absinthe up a sugar cube. And we will never cease to feel a cosmic emotion because of the humble and simple physics of this drama. Rather, the pulverised scintilla of the little nickel needle of a phonograph upon the saccharinated mica spiritually enraptures our pupils, more than the tender, distant and feeble pulsation of the constellations. It is widely known that the great Greek tragic playwrights wrote one right in the wake of another, with many recurrences of the same themes. The public didn't go to feel emotion by seeing some unexpected event; it looked to find its own delight and emotion watching the unfolding of expected, well-known events.

In the same way, anti-artistic cinema creates a whole world of very distinctive and differentiated emotions and typified images that are unique, completely defined and clear to the common conceptions of the thousands of people who make up the broad public following film. In addition, each creation is a homogeneous organic one, the result of anonymous

187. Photogram from *L'Âge d'or* (1930) by Luis Buñuel and Salvador Dalì

188. Salvador Dalì, design for the film *Destino* by Walt Disney, 1946

189. Salvador Dalì, *White Telephone with Ruins*, design for the film *Destino* by Walt Disney, 1946

contributions and refinement obtained on the road to standardisation. The mask of evil, his gestures, his mode of dress – and when he is knocking at the door of refined, dramatic and visual emotion, and everything is being improved and becomes better with each new film, we reach perfection through an increasingly narcotic process similar to the outfitting of aeroplanes for war. Artistic cinema, on the other hand, was unable to establish any kind of universal emotion; each new film, however, has contributed to the maximum, absolute dissociation, and most uncontrolled disorganisation.

Oh! Fritz Lang! You are looking for scenes ever more grandiose and exorbitant in your spectacles; never coarse, your imagination can create the fly walking among the hairs of an arm coming out of a rolled-up sleeve – quick and quiet, with legs equipped with a sensory apparatus and on the verge of flying away, to describe the clear and icy cycle of each morning, one cannot imagine a more vivid calligraphy.

The best attempts of artistic films – it is worth mentioning those of Man Ray and Fernand Léger – start on the basis of an inexplicable error: pure emotion without plucked-out eyes (the film by Man Ray is understood only later) should not be sought through forms of invention. The world of cinema and painting are very different; more precisely, the possibilities of photography and cinema lie in the unlimited creativity that stems from the same things.

In the other achievements of film, more or less artistic, come the first signs of fatigue, boredom and sadness, because their artistic feeling has suffered only anti-artistic films, and in particular comic films, producing increasingly perfect films, where the emotion is more immediate and intensely fun. Anti-artistic film is the cheerful, clear, sunny production of sensuality asleep through most of the fury of shots of that anti-opiate known as bare objectivity.

I mean silent, deaf, dumb, blind film, because the best film is the one you can see with your eyes closed.

190. Max Ernst, *Deux oiseaux,* 1926

193. Herbert Bayer
Typography and Commercial Graphic Art (1928)

194. Photograph by a student in Peterhans's course. Work from a portfolio, 1929

The efforts of the Bauhaus (to bring together under the shared goal of 'architecture' the sectors of functional design, after having investigated its elements) extend to advertising as well. In this field, too, economic, social, ethical and formal issues arise. Today, as a consequence of competition, advertising has become essential. It is also . . . a cultural expression and economic factor, and is therefore a peculiarity of our time. At the Bauhaus in Weimar an artistic print shop served in the production of graphic works in etching and engraving, lithography and woodcut. When the set up of the workshops at the new Bauhaus building in Dessau began, we could only think of equipping a technical, more automated print shop That is how a little print shop for book production arose, as a teaching workshop. In fulfilling print orders students practised typesetting by hand, printing and graphic page layout. There were therefore no trendy aestheticisms with regard to 'consumer graphics', but rather the work was inspired by the awareness of its end use and with the goal of making the most of the typographic materials, which up until then had been caught up in antiquated tradition. The elementary typographic programme, first outlined by the constructivists, without doubt pointed out substantially new paths for the conception of typographic work. First of all, it led to a construction based on the qualities of the material on hand, and to develop from that a form bound to the composition technique used. The appeal to clarity, precision, sharpness and abstraction of form (in printing as well) found fertile terrain above all in Germany, perhaps because the use of visually simple forms and primary colours is close to the general opinion, convinced of advertising's primitive character. The need to avoid confusion is an important request, but only one of many. A superficial imitation nevertheless wrongly conveys or obscures the real meaning, which is the functional use of the elements: so there followed a rapid

acceptance of only the most extrinsic aspects. An example of the spread of the 'Bauhaus style' is offered by the register of orders placed at a printer in Frankfurt: approximately fifty percent of all their annual orders requested the 'Bauhaus style'. Large type sizes and heavy hyphens, decorations and imitations of nature through typographic materials were all used to the point of abuse. But in that way we only came right back to where we had begun. Nevertheless, the experiences that came with these developments were most valuable. Considering what goes on in the field of advertising, in places where graphics are given fewer concessions (in America, for example), I came upon the idea that the right path lie not In using a decorative-speculative treatment, nor in using an 'elementary' typography based on an aspect of advertising . . . The term 'advertising graphics' doesn't only imply a design that shows good artistic taste; a truly concrete treatment can be spoken of only when, through the external appearance, one manages to demonstrate the deeper causes, or rather when the essential elements of the task are recognised both before and during the advertisement's design. Functional advertising graphics should be inspired above all by the laws of psychology and physiology. Today advertising is treated almost exclusively on the sentimental level. That, however, doesn't allow us to evaluate the results with any certainty, nor to take aim with any precision . . . These considerations are what instigated a course in advertising founded on a broader base. Typography must be considered a part of this course . . .

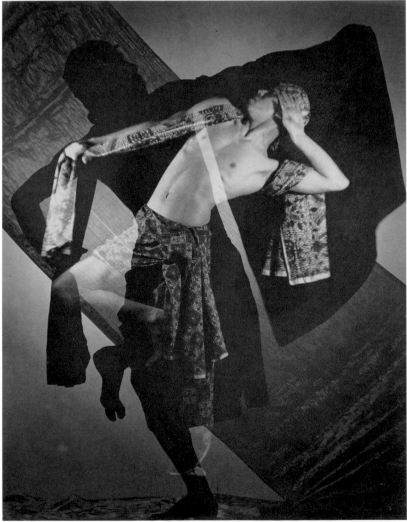

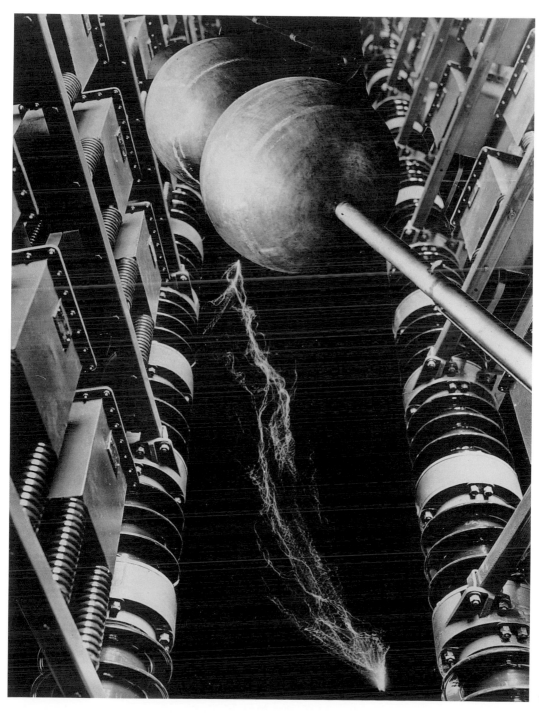

198. Filippo Tommaso Marinetti, Tato
Futurist Photography (1930)

The photography of a landscape, a person or a group of people made with a certain harmony, in minute detail and in a style that makes viewers exclaim "It looks like a paining!" is, for us, a completely passé idea.

After photodynamism – or the photography of movement, created by Anton Giulio Bragaglia in collaboration with his brother Arturo – which I presented in 1912 at the Sala Pichetti in Rome, and which was then imitated by avant-garde photographers worldwide, we must now realise these new photographic possibilities:

1. The drama of immobile and mobile objects; and the dramatic mixture of immobile and mobile objects;
2. The drama of shadows cast by contrasting objects and isolated from the selfsame objects;
3. The drama of objects humanised petrified crystallised or vegetised through camouflage and special lighting;
4. The spectralisation of some parts of the human or animal body, isolated or a-logically reconfigured;
5. The fusion of aerial marine and terrestrial perspectives;
6. The fusion of views seen from the bottom up and the top down;
7. The immobile and mobile inclinations of objects or human and animal bodies;
8. The mobile or immobile suspension of objects and their resting in the balance;
9. The dramatic disproportions of mobile and immobile objects;
10. The amorous or violent interpenetrations of mobile and immobile objects;
11. The transparent and semitransparent overlapping of people and concrete objects and their semiabstract phantasms in the simultaneity of memory and dream;
12. The overwhelming enlargement of a miniscule, almost invisible thing turned into a landscape;
13. The tragic or satirical interpretation of life through the symbolism of camouflaged objects;
14. The composition of absolutely extraterrestrial, astral or mediumistic landscapes through thickness, elasticity, turbid depth, limpid transparency, algebraic or geometric values with nothing human or vegetal or geological about them;
15. The organic composition of a person's various states of mind through the intensified expression of the most typical parts of the body;
16. The photographic art of camouflaged objects, bent on developing the art of war camouflage, which serves the purpose of eluding aerial observers.

All this research has the sole goal of making the photographic science increasingly overlap with and encroach upon pure art, and automatically favouring development in the fields of physics, chemistry and war.

199. Tato, *Aero self-portrait*, 1930

200. Fortunato Depero, *Dinamo futurista*, no.1, 1933

201. Fortunato Depero, *Emporium*, no. 39b, 1927

202. Mario Bellusi, *Traffico moderno nell'antica Roma*, 1930 203. Mario Castagneri, *Le mani di Depero: chiarezza e volontà*, 1930

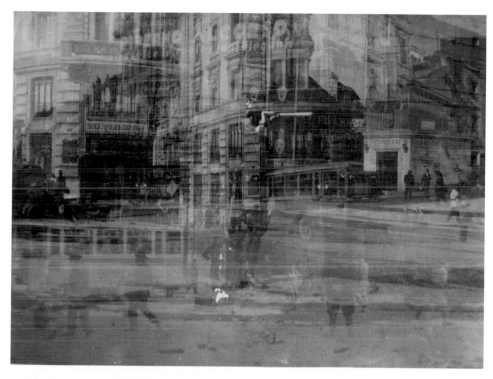

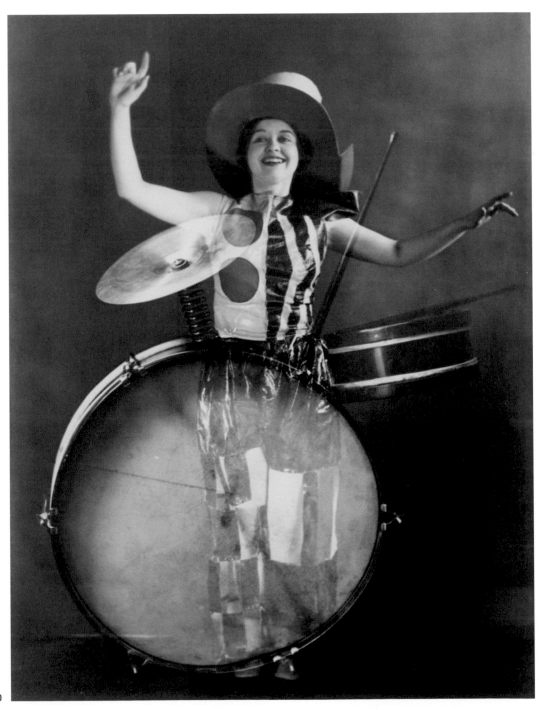

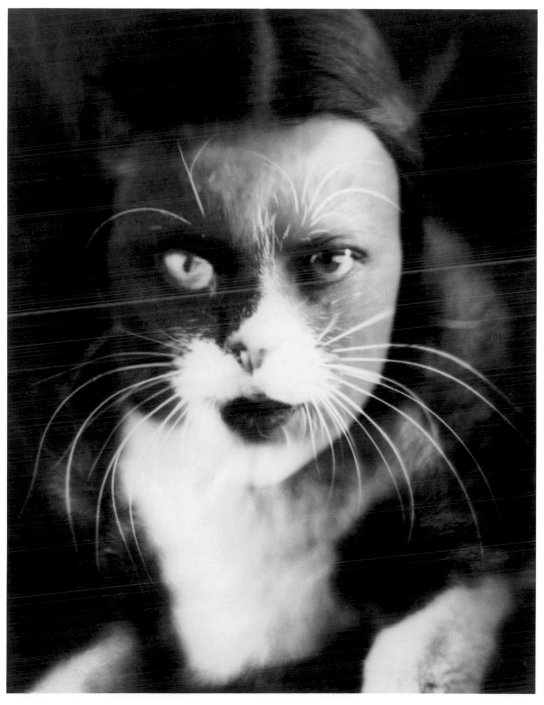

Any analysis of technology's significance in filmmaking must begin by ascertaining the unequivocal nature of the concept of 'film'. In fact, the function technology plays out in film would be quite different if the things we designate by the term 'film' were fundamentally different from one another.

Such a fundamental difference exists *de facto*, and therefore must be decisively underlined, because any confusion of the dividing lines becomes a disadvantage for both sides involved. A division of genres based on the examples we have at hand is certainly quite difficult to demonstrate, because they all exist one next to the other, intersect in many ways and are all apparently fused into one another. Nevertheless, some sort of dividing line is necessary from a theoretical point of view, and for the aim of conducting an analysis; there are, then, two fundamental meanings: film as a means of entertainment and film as art.

Countering the principle division of the concept of film into 'entertainment' and 'art', one could think of a long series of legitimate objections. Above all the question: why can't a form of entertainment be art? Or: why must art not also be entertainment? No one questions the validity of these objections. No one could hope anything better for film than that it be an art that entertains while fully

207. Advertisement photogram for *Berlin: Symphony of a Great City* (1927) by Walter Ruttmann

maintaining its artistry intact. That sort of chemical bond would naturally be the best thing. But in reality such a bond appears only in very rare, highly exceptional cases, and above all it is not systematically pursued, but is rather often substituted by an amalgam that is neither black nor white, and in its indistinct state produces an impression of various colours, which have no other aim than to attract a buyer.

Film's development consequently proceeds not along a culturally autonomous line, but simply moves along behind the wagon of technical progress. Technology is, for such development, the *deus ex machina*, who always has to intervene yet again when the efficacy of its last innovation begins to wear down.

Despite film's dependent relationship to technical progress, to date no real productive principle has been formulated for an approach to work that is shared by and useful to both film and technology. Strangely, film never entrusts to technology the tasks it should resolve. Technology proceeds along its course, in an almost completely autonomous fashion, and only once in a while, only to a certain degree, does it bestow its gifts upon cinema. It is clear that this system is highly unproductive, and can be explained only in light of the tender age – indeed, the turbulent youth – of the cinematographic industry, which has not given the medium the time to lay solid foundations for each key point of its edifice.

What is most surprising in this industry – if we draw a parallel to other industries and other branches of production – is the complete absence of any laboratory. The laboratory, this original and most important cell in the development of any productive field, can be found nowhere in the cinematographic industry, nor in any form that could really be taken seriously. And yet precisely such a laboratory would be the most propitious terrain in which film could develop and grow stronger, starting with itself and without needing to

increasingly depend on external factors. It is therefore worth studying more closely the possibilities of creating such a film-based laboratory. This laboratory's task would not be to make any attempt at bettering and broadening the scope of film's equipment. That is the task of the technical industries, and film should pay it not the slightest heed. But a framework for experimentation and research should be created, in which the development possibilities of film as an expressive medium could be put to the test in all aspects. A meeting point should rise up where the desires of filmmakers and the suggestions of technology can converge, such that the creative artist could say to technology: "I have *this* and *that* in mind, I cannot realise it with the current equipment, could you supply me the necessary means?" And vice versa, technology could say to the artist: "I could build *such and such*, would you know how to put it to use?" Such an active melting pot for the artist's desires and technology's suggestions would above all have to bring about the positive, enormously important result of allowing talent and skill to become manifest.

Explanation of My Archetypical Sonata (1932)

The sonata is composed of four movements – an introduction, a finale and a cadence in the fourth movement. The first movement is a rondo with four main themes, which in this version of the sonata are particularly marked. The rhythm is strong and weak, concise and vast, etc. I don't wish to explain the subtle variations and composition of the themes. I will only note that, in the first movement, the textual repetitions of themes already varied before the addition of each new variation, the explosive beginning of the first theme, the pure lyricism of *Jüü-Kaa* when sung, the rigorously military rhythm of the third theme, which, compared with the fourth, so trembling and meekly tender, sound decisively virile, and finally the accusatory finale of the first movement – *tää?* – with a question mark. The second part is only half composed, and the fact that it is sung can be seen in the text's annotations. The largo is metallic and incorruptible, sentiment and all that is sensitive are wholly lacking. You can see in *Rin, zekete bee beee* and *ennze* an echoing of the first movement. You can also see, in the introduction, the long *Oo* as a harbinger of the long largo. The third movement is a bona fide scherzo. You can see the rapid succession of three themes: *lanke trr gll, pe pe pe pe pe* and *Ooka*, all quite different from one another, and from that stems the character of the scherzo and its bizarre form. *Lanke trr gll* is a constant, and returns in a capriciously cadenced form. In *rrmmmp* and *rrrnnff* there is a recollection of the *rummpff tillfftoo* of the first movement. Yet it is no longer meekly tender, and has become brief and imperious, decidedly virile. Nor does the *Rrumpftillftoo* in the third movement sound so tender any more. The sounds of *Ziiuu lenn trll* and *lümp tümpff trill* imitate the principal theme *lanke trr gll*. The *ziiuu iiuu* in the trio closely recalls the *ziiuu ennze* of the first part, but here it is highly sustained, drawn out and more solemn. The scherzo is substantially differentiated from all other three movements, in which the long *bee* is extraordinarily important. In the scherzo not a single

bee is repeated. The fourth movement is the most rigorous and structurally rich. All four themes are once again precisely indicated in the text. The block from *Grimm* to *Qo bee* is exactly repeated. A long elaboration filled with surprises then follows, and finally the block reappears, but with a shift in the succession of themes. The transitional theme *Oo bee* faintly recalls the second movement. The long, rapid fourth movement puts the lungs of the person reciting it to the test, above all because the infinite repetitions, in order not to sound monotonous, often require an elevation in the voice's volume and pitch. Finally I would like to point out the intentional reverse progression in the alphabet song, ending with *a*. You hear it, and tensely await the *a*. But the song is painfully interrupted, twice, on the *bee*. The *bee* sounds pained. There follows, with a calming effect, the resolution with *a* in the third alphabet. But now, finally, the alphabet follows once again, a third and fourth time, and oh-so painfully ends on *beeee?* That is how I avoided the facile banality of sending the solution straight to the end, which is, after all, indispensable. The cadence then becomes *ad libitum*, and each speaker can compose a cadence however he sees fit, taking it from other parts of the sonata or inventing it. I only suggested a possibility for any potential speakers who might not have much imagination. I myself recite it each time with a different cadence; because I perform the rest from memory, the cadence becomes particularly vital, and makes for a great contrast with the fixed sonata.

Note to My Ursonate
The alphabetic letters employed must be pronounced in German. A single vowel is brief, and two of the same are not doubled, but rather long. But if two of the same vowel were to be pronounced as a double, then the word is broken at that point. So, the pronunciations are *a* as in *schaps, aa* as in *schlaf, a a* is a double, *a* is brief, etc. *Au* is pronounced as in *haus*. Consonants are silent. For consonants to become heard, they must be

210. Man Ray, *Kurt Schwitters*, 1936

211. Kurt Schwitters, *An Anna Blume–Die Sonate in Urlauten (1919-1932)*, 1958

followed by a vowel that gives them their tone – for example: *b, be, bö, bee*. *B p d t g k z* written consecutively must be pronounced isolated from one another, so: *b b b* is like three single *b*. *F h l j m n r s w ch sch* written consecutively must not be pronounced isolated from one another, but rather drawn out. *Rrr* sound longer than *r*. The letters *c q v x y* fall. The *z* is kept for reasons of comfort. Capitals serve only to indicate separation, regrouping, to better point out any periods, to lead a line, etc. *A* is pronounced like *a*. A red underline could be used to indicate *forte* and black for *piano*. So a large red line would indicate *fortissimo*, a thinner one *forte*, a thin black line *piano*, a thick black one *pianissimo*. Any letter that is not underlined is *mezzoforte*. Musical script similar to that of the notes

4/4	Oo			
	1			
	bee bee	bee bee	bee	
	4	4	8	3/8
	(with a low voice, uniformly)			
	Oo			
	1			
	zee zee	zee zee	zee	
	4	4	8	3/8

becomes possible if the rhythm is cadenced, for example. This could be a different way, no so clear, of writing the second phrase. In the free rhythm section, bars could be used, even just to trigger the imagination. All the numbers serve only to identify the rhythmic tempos. Numbers, signs and

anything in parentheses are not to be read; the letters to be used, to summarise the whole thing one last time, are: *a ä au e ei eu i o ö u ü b d f g h k l m n p r s sch ch w z*. The vowels are: *a e i o u ei eu au ä ö ü*. If the *r* is to be pronounced isolated from other letters, the use of the following writing style is recommended: *Rr Rr Rr Rr Rr Rr*. The same thing goes for *Schsch Schsch, LeLeLeLeLe*, etc. In the free rhythm section, pauses and punctuation marks are used for the tongue, and in the fixed rhythm section bars or indications of beats are made through a corresponding division in the print; the *n* are equally long intervals, but with no punctuation marks. Therefore *, . ; ! ? :* must be read solely as timbres. Naturally in the written form only a somewhat obscure indication is given with respect to the recited sonata. As with any musical notation, many interpretations are possible – just as imagination is key for each reading, if you want to read it exactly. The reader must seriously work, if he really wants to learn to read. Working requires a greater sensitivity of the reader than the effort required merely to pose questions or distractedly criticise the piece. Only he who has understood everything has the right to criticise. More than read, the sonata must be listened to. Because of this, I myself freely recite my sonata in public. But because it isn't possible to organise performance evenings everywhere, I intend to record it. The average duration of the sonata's recitation is thirty-five minutes.

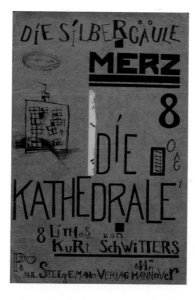

212a. Kurt Schwitters,
Die Kathedrale. 8 Lithos, 1920
212b. Kurt Schwitters,
Mz 180 Figurine, 1921

213. Filippo Tommaso Marinetti, Pino Masnata
La Radia. A Futurist Manifesto (1933)

Futurism has radically transformed literature with words in freedom aereopoetry and the swift simultaneous *parolibero* style it has emptied the theatre of boredom through surprising a-logical synthesis and the dramas of immmensified objects plastic arts with anti-realism plastic dynamism and aeropainting it has created the geometric splendour of a dynamic architecture that lyrically and without decorativisms uses the new building materials abstract cinematography and abstract photography.

In its second national Congress futurism decided upon the following points to be got over

Getting over love for women "with a more intense love for women to counter the erotic-sentimental deviations of many foreign avant-gardes whose artistic expressions have failed and fallen into fragmentaryism and nihilism"

Getting over patriotism "with a more fervid patriotism thereby transformed into an authentic religion of the homeland and an admonishment that Semites identify themselves with other countries if they don't want to disappear"

Getting over the machine "by identifying man with the machine itself destined to free him from hard muscular labour and to immensify his spirit"

Getting over Sant'Elia architecture Sant'Elia "today reigns victorious with an architecture even more explosive with lyrical colour and a found originality"

Getting over painting "with a more experience aeropainting and a tactile polymaterial plastic art"

Getting over earth "with the intuition of the means contrived for realising a trip to the moon"

Getting over death "with a metalisation of the human body and a capturing of life spirit as machine force"

Getting over war and revolution "with a pocket-sized ten- or twenty-year artistic-literary war and revolution in the guise of indispensable little revolts"

Getting over chemistry "with a perfected nutritional chemistry of free vitamins and calories for everyone"

We now possess a television with fifty thousand points for each large image on the large screen Awaiting the invention of tele-tactilism tele-perfume and tele-taste we futurists are perfecting the radiophony destined to centuplify the creative genius of the Italian race abolish the nostalgic old torment of distances and impose everywhere words in freedom as its logical and natural mode of self-expression

214. Fortunato Depero, *Autoritratto con smorfia, 11 novembre 1915*, 1915

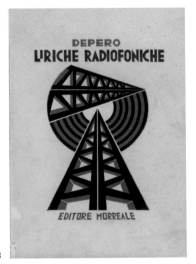

215. Fortunato Depero, *Liriche radiofoniche*, Morreale, Milan, 1934

216. Pino Masnata, *Tavole parolibere*, Edizioni Futuriste di Poesia, Rome, 1932

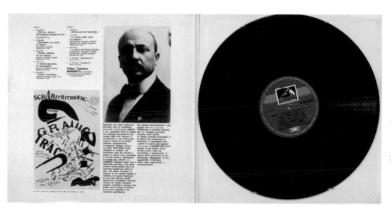

La radia, the name we futurists have given to the magnificent manifestations of the radio, is STILL TODAY a) realist b) closed within a scene c) made ever more stupid by most that instead of developing into originality and variety has arrived at a disgusting languid negro monotony d) an overly-timid imitation of avant-garde writers of the futurist synthetic theatre and words in freedom

Alfred Goldsmith of Radio City in New York said "Marinetti has come up with the idea of electric theatre. Quite different in their conception, the two theatres have a point in common in the fact that in order to be realised they cannot do without a unifying work, and an exertion of intelligence on the audience's part. Electric theatre will require a stretch of the imagination, first in the actors, then in the audience."

Even the French Belgian German theorists and actors of avant-garde radio dramas (Paul Reboux Theo Freischmann Jacques Rece Alex Surchaap Tristan Bernard F.W. Bischoff Victor Heinz Fuchs Friedrich Wolf Mendelssohn etc) praise and imitate synthetic futurist theatre and words in freedom yet almost all of them are still obsessed with realism which no matter how fast it might be must still be got over

La radia must not be:

1. theatre, because radio has killed the theatre already defeated by sound drama

2. cinema, because cinema is dying: a) from rancid sentimentalism of subject matter; b) from realism that involves even certain simultaneous syntheses; c) from infinite technical complications; d) from fatal banalising collaborationism; e) from reflected brilliance inferior to the self-emitted brilliance of radio-television

3. books, because the book which is guilty of having made humanity myopic implies something heavy strangled stifled fossilised and frozen (only the great free-word tableaux shall live, the only poetry that needs to be seen)

La radia abolishes:

1. the space and stage necessary to theatre including futurist synthetic theatre (action unfolding on a fixed and constant stage) and to cinema (actions unfolding on very rapid variable simultaneous and always realistic stages)
2. time
3. unity of action
4. dramatic theatrical character
5. the audience as self-appointed judging mass systematically hostile and servile always against the new always retrograde

La radia will be:

1. Freedom from all point of contact with literary and artistic tradition. Any attempt to link la radia with tradition is grotesque
2. A new Art that begins where theatre cinema and narrative end

209

218. Alberto Montacchini,
Musical alchemy: the soloist,
1930

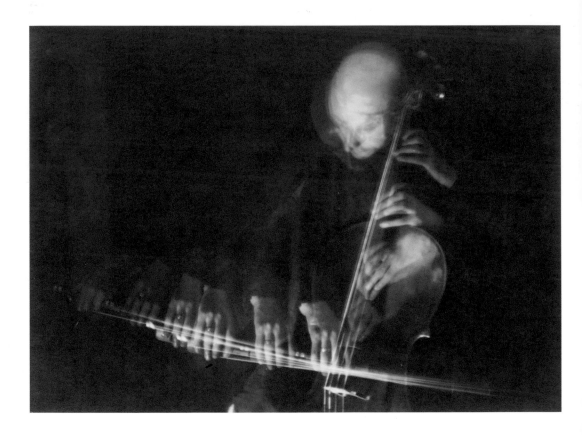

219. Maggiorino Gramaglia,
Spettralizzazione dell'io, 1931

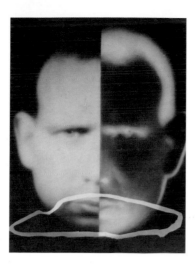

3. The immensification of space. No longer visible and frameable the stage becomes universal and cosmic

4. The reception amplification and transfiguration of vibrations emitted by living beings living or dead spirits dramas of wordless noise-states

5. The reception amplification and transfiguration of vibrations emitted by matter. Just as today we listen to the song of the forest and the sea so tomorrow shall we be seduced by the vibrations of a diamond or a flower

6. A pure organism of radiophonic sensations

7. An art without time or space without yesterday or tomorrow. The possibility of receiving broadcast stations situated in various time zones and the lack of light will destroy the hours of the day and night. The reception and amplification of the light and the voices of the past with thermoionic valves will destroy time

8. The synthesis of infinite simultaneous actions

9. Human universal and cosmic art as voice with a true psychology-spirituality of the sounds of the voice and of silence

10. The characteristic life of every noise and the infinite variety of concrete/abstract and real/dreamt through the agency of a people of noises

11. Battles of noises and various distance – that is, spatial drama joined with temporal drama

12. Words in freedom. The word has gradually developed into a collaborator of mime and gesture. The word must be recharged with all its power hence an essential and totalitarian word which in futurist theory is called word-atmosphere. Words in freedom children of the aesthetics of machines contain an orchestra of noises and noise-chords (realistic and abstract) which alone can aid the coloured and plastic word in the lightning-fast representation of what is not seen. If he does not wish to resort to words in freedom the radiast must express himself in that freeword style which is already widespread in avant-garde novels and newspapers that typically swift quick synthetic simultaneous freeword style

13. Isolated word repetitions of verbs in the infinitive

14. Essential art

15. Music that is gastronomic, amorous, gymnastic and so forth

16. The use of noises sounds chords harmonies musical or noisiest simultaneities of silence, all with their graduations of harshness, crescendo and decrescendo, which will become strange brushes for painting delimiting and colouring the infinite darkness of *la radia* by giving, in short, squareness roundness

17. The utilisation of interference between stations and of the birth and evanescence of the sounds

18. The delimitation and geometric construction of silence

19. The utilisation of the various resonances of voice or sound in order to give a sense of the size of the place in which the voice is uttered. Characterisation as the silent, semi-silent atmosphere that surrounds and colours a given voice sound or noise

20. The elimination of the concept or the illusion of an audience that has always – even for books – had a deforming or damaging influence

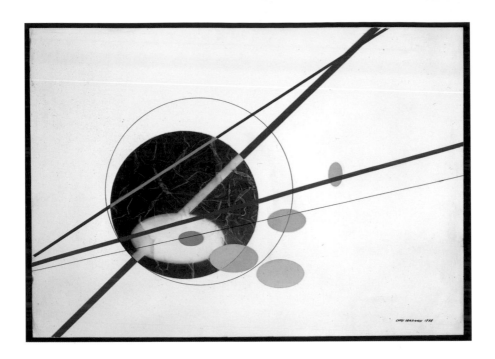

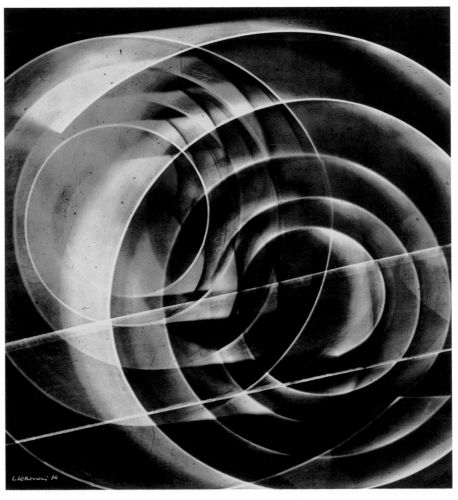

222. Luigi Veronesi
Photograms and Photographs (1978)

220. Luigi Veronesi, *Composizione*, 1938

221. Luigi Veronesi, *Fotogramma 26*, 1936

"The photogram – that is, the luminous image obtained without a photographic camera – is the secret of photography. In the photogram, the unique character of the photographic procedure is revealed, and allows us to fix images of light and shadow on a sensitised surface without the help of any apparatus. The photogram opens new doors to an as yet completely unknown visual language, governed by its own laws. In the struggle to arrive at a new way of seeing things, the photogram is a wholly dematerialised weapon." This is the definition the great artist and photographic theorist Laszlò Moholy-Nagy published in 1936 in the magazine *Telehor*; a better definition cannot be found. The photogram, then, is not a real photograph, although it is the very essence of photography, but is rather just a recording of an object's form, its capacity for transmitting light and the shadows that are created when it is lit. It has an incredibly simple technical basis: the object rests on a photosensitised surface, such that when lit, it allows this surface to record transparencies, thicknesses, shadows, lights and reflections in an extremely rich array of fascinating variations and expressive possibilities. The image thus obtained is never a real 'document', nor the description or representation of an object, but is rather the transformation of the image of this object into a pure relationship between light and shadow. In 1929 Franz Roh wrote in *Foto Auge* (Photo Eye): "les rayons modèlent l'objet d'une façon tellement différente que son corps disparaît plus que comme une lueur et une abstraction d'un monde étrange". Indeed, the photogram was discovered when a ray of light, for the first time, encountered a 'thing' in its path and cast a shadow. Later on – much later – people managed to fix light and shadow upon sensitised surfaces. Absurdly, we could even say that because human skin is photosensitive, the light outline of a bathing suit on a body tanned by the sun constitutes an example of a negative photogram. In the vast majority of cases, the photogram falls under the heading of 'metaphysical' or 'abstract' that has so influenced and conditioned a large part of modern art. And it is both noteworthy and significant that the first few people to experiment with this discipline, in the years between the two World Wars, were primarily painters: Man Ray, Moholy-Nagy, El Lissitsky, Rodchenko and Veronesi. This is not the place to discuss the validity of the artistic movements these painter/photographers belonged to: just being aware of their existence and weight – which, in the evolution of artistic thought, has doubtless been noteworthy – we can say that, thanks to their work, the photogram can now be considered one of the primary manifestations of new aesthetic directions. In the photogram, objects rediscover their primordial expression; we can then see them above and beyond their real form, in images that we normally cannot see and yet are real, and instantaneously shift with the movement of even the slightest glimmer of light.

223. Luigi Veronesi, *I numeri*, 1944

224. Luigi Veronesi, *I colori*, 1945

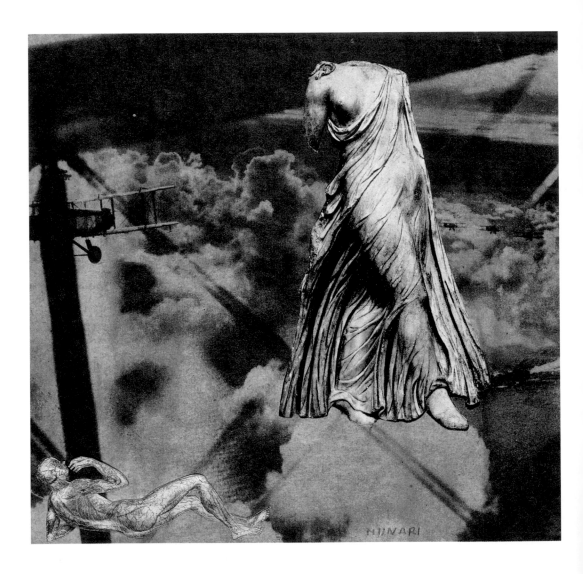

226. Bruno Munari,
Negativo–positivo, 1950–1977

227. Mimmo Rotella, *Cool*, 1956

Manifesto of Epistaltism (Phonetic Poetry, 1949)

Alfa

1. Epistaltic language (the language of phonetic poetry), situated as it is at the end of the abstract tradition of glosseme-based expression, melds the inherent formal valences of language with all the tonal and harmonic possibilities;

2. The term 'epistaltic' was chosen for purely formal reasons: any reference to its possible past, present and future semantic suggestions is purely coincidental. It seemed to us that the term 'epistaltic' connected rhythmic and melodic elements of a rare evocative power within itself;

3. The inclusion of 'sound effects' taken from real life in epistaltic compositions corresponds to the use of polymaterial art in sculpture, and to collage in painting;

4. Epistaltic language means to invent all the words, untying them from their utilitarian value to turn them into rockets for countering the decrepit edifices of syntax and vocabulary;

5. The word is above all sound: the dividing wall between music and poetry – which are essentially the same thing – must be torn down;

6. The true essence of the word lies in musicality, and therefore in sound;

7. In this reduction to its most minimal terms, the word rediscovers its autonomy and evocative nature;

8. The human voice must not be limited to the monotony of articulated language;

9. It is an inexhaustible source of natural musical instruments;

10. Epistaltic language is the only valid poetry-based language of our times.

229. Mimmo Rotella during a performance of phonetic poetry, c. 1956

230. Marcel Duchamp, *La mariée mise a nu par ses celibataires, meme*, 1934

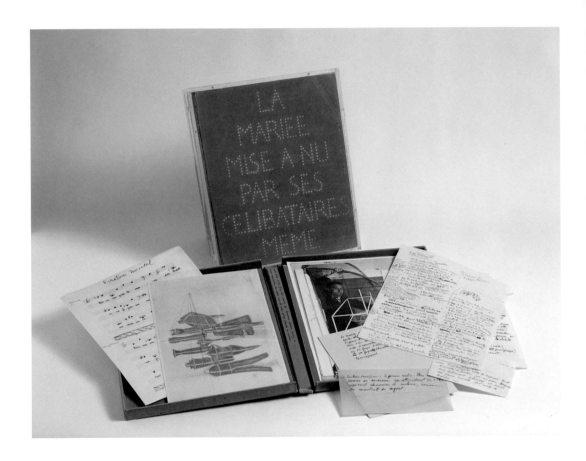

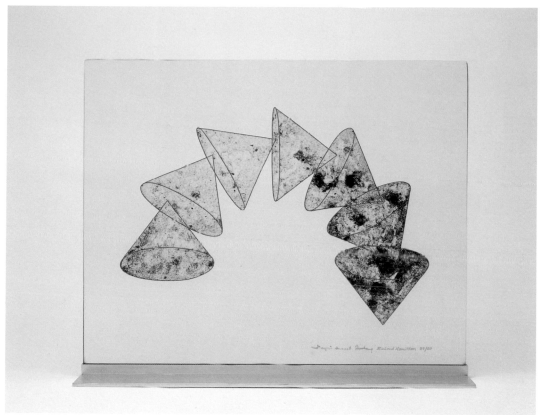

232. Marcel Duchamp,
Rotoreliefs, 1935

233. Marcel Duchamp,
Rotorelief, 1935

234. Man Ray, *Duchamp*, 1921

235. Marcel Duchamp, cover for
Minotaure, no. 6, 1935

236. Marcel Duchamp,
S. M. S., 2 April 1968, 1968

237. Marcel Duchamp,
*The Creative Act: A Paper
Presented to the Convention of
the American Federation of Arts at
Houston, Texas, April 1957*, 1967

238-239. Marcel Duchamp,
Anémic Cinéma, 1926

240. Ambrosini, Burri, Crippa, Deluigi, De Toffoli, Donati, Dova, Fontana, Giancarozzi, Guidi, Joppolo, La Regina, Milani, Morucchio, Peverelli, Tancredi, Vianello
Manifesto of Spatial Movement for Television (1952)

We spatialists broadcast, for the first time worldwide, by television, our new form of art, based on the concepts of space, seen from a two-fold point of view:

first, that of the spaces that were once considered mysterious and by now well known and explored, and therefore used by us as a plastic material;

second, that of the cosmos's still unknown spaces, which we want to confront like givens, with intuition and mystery, the typical givens of art as divination.

Television is, for us, the medium we were waiting for in order to bring together our concepts. We are glad that this spatial manifestation of ours is broadcast from Italy, and is destined to renew the fields of art.

It is true that art is eternal, but it was always linked to mystery, while we want art to be freed from it, such that through space it might last a millennium – even in a minute-long broadcast.

Our artistic expressions infinitely multiply, in infinite dimensions, the horizon lines: they seek out an aesthetic in which a painting is no longer a painting, sculpture is no longer sculpture, wherein the written page leaves behind its typographic form.

We spatialists feel ourselves to be the artists of today, as the conquests of technology already act in service of the art we profess.

241. Lucio Fontana, *Concetto spaziale*, 1966

242. Lucio Fontana, *Concetto spaziale*, 1951

243. Jean Dubuffet
Musical Experiences (1961)

Toward the end of 1960, round about Christmas time, a friend of mine, the Danish painter Asger Jorn, invited me to play a little improvisational music with him. I bought a Grundig TK35 tape recorder to capture the spirit of our gatherings, and the first recording of our sessions, done on 27 December, was entitled *Nez cassé* (Broken Nose). Many more soon followed, as we were both so enthralled by these musical experiences that our improvisations became quite frequent over the following months. Asger Jorn had some experience with the violin and the trumpet; I had scant familiarity with the piano, which I had practised at length in my youth. But the sort of music we had in mind hardly required any virtuoso technique, as we intended to use our instruments to create some unconventional effects. In addition to a pretty poor piano, we started off with a violin, a cello, a trumpet, a recorder, a Saharan flute, a guitar and a tambourine. We gradually added all sorts of other instruments, some quite outdated (old-fashioned flutes, a hurdy gurdy), some exotic (of Asian, African or Tzigane origin), some more common (such as the oboe, saxophone, bassoon, xylophone, zither) and some from the folk tradition (such as the cabrette and the bombarde) – in short, we used whatever we discovered as we went along. We had great help from the musician Alain Vian, who has a shop on Rue Grégoire-de-Tours in Paris selling strange and rare collector's instruments; he not only took part once or twice in our little concerts, but also managed to find, and sometimes even make, suitable instruments for us. At the time, neither Asger Jorn nor myself knew much about the works of contemporary composers, and we weren't even familiar with the protagonists of serialism, dodecaphony, electronic music and concrete music. Indeed, I only learned these terms recently. My own musical experience was limited to my fairly cursory study of classical music on the piano, which I played a lot as a child and teenager, and gave up around the age of twenty. Later, when I was thirty-five, I took up the

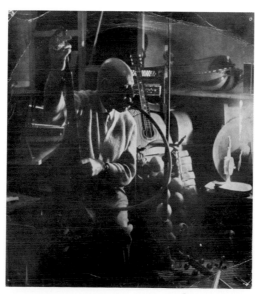

244. Jean Dubuffet, *La fleur de barbe*, 1961

245. Jean Dubuffet, *La fleur de barbe*, back of the LP sleeve, 1961

accordion and its traditional music (with merely moderate success); I went back to playing the piano for a year when I was about forty, in order to play music by Duke Ellington, interspersed with improvisations on the harmonium. In the following period I developed a strong aversion to European music, and only enjoyed listening to Near Eastern and Oriental music (I had become fond of the former during my trips to the Sahara). As for the tape recorder, I naturally had no experience whatsoever. Only later did I come to see that my recordings, made with amateur equipment, left a lot to be desired in comparison to those done by professionals. Strangely enough, though, I am not convinced that the latter really are superior. Similarly, I often prefer photographs taken by poorly equipped amateurs over those of specialists. In my subsequent dealings with technicians, I felt that the downside to certain benefits of the care they took in setting up their equipment had an inhibiting effect; even if the resulting recordings were crisp, clear and free of all flaws and hiccups, they weren't necessarily any more evocative. I believe that all artistic realms could benefit from using simpler techniques. I also believe in getting down to basics, and I am all for rugged and unaffected charms in place of frills and fancy pretence. There is yet another, more important reason for this attitude. We think a good recording provides precise and distinct sound which seems to be coming from a close source; in our daily lives, however, our hearing is subjected to all sorts of other sounds which, more often than not, are unclear, muddled, far from pure, distant and only partially audible. To ignore them is to create a specious artform, solely concerned with a single category of sounds that, when it comes down to it, are rather uncommon in everyday life. I had set out to produce music based not on a selection of sounds, but on sounds that can be heard anywhere, on any day – especially those one hears without really being aware of them. My rudimentary equipment was better suited to this than the most sophisticated machines. Having decided to collect and use whatever kinds of sounds I came across, no matter what category they belonged to, the sometimes unexpected sounds my tape recorder played back to me were at least as interesting (and sometimes more) than those I

had actually intended to tape. When the surprises were in my opinion uninteresting, I erased or destroyed them, but sometimes they were incredibly good. I transformed a room in my home into a music studio, and in between my gatherings with Asger Jorn I became a one-man band, playing each of my fifty-odd instruments in turn. Thanks to my tape recorder, I was able to play each part successively on the same tape, and have the machine play everything back simultaneously. I went about it methodically, step by step, recording over the bad sections and using scissors and sticky tape to cut, splice and put everything together again. Such a method entails a lot of trial and error: because it was impossible, when playing a new part, to hear what I had already recorded, it was very tricky to synchronise everything and, struggling to get precisely what I had in mind, I often had to start over and over again. Nevertheless, the fact that it was so difficult to keep things under control, not to mention that I had to trust to luck, meant that the risks of failure were offset by the added possibility of unexpected surprises. I later added a second tape recorder, which enabled me to transfer material from one machine to the other, to play while listening to what had already been recorded and to make as many changes as I liked without spoiling the initial recording when new elements proved disappointing.

The first tape produced in these circumstances is rather unusual as it is a poem, "La fleur de barbe", which is recited, chanted and vaguely sung by several voices (which are, in fact, all my voice), all mixed together with occasional instrumental accompaniment. The later recordings are the result of two divergent approaches I vacillated between, which are probably both apparent in at least a few of the pieces. The first was an attempt to produce music with a very human touch – in other words, music that expressed people's moods and motives as well as the sounds, the general din and the sound-based backdrop of our daily lives, the noises we are so closely connected to and, though we aren't aware of it, have probably endeared themselves to us – those we would be hard put to do without. There is an osmosis between this permanent music that carries us along and the music we ourselves express; they come together to form the specific

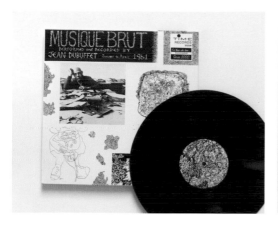

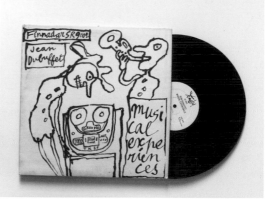

246. Jean Dubuffet, *Musique Brut*, 1961

247. Jean Dubuffet, *Musical Experiences* (1963), 1973

music that can be considered a human being. Deep down, I like to think of this music as *music we make*, in contrast to another, quite different music that strongly stimulates my thoughts – the sort I call *music we listen to*. The latter is completely foreign to us and our natural tendencies; it is not at all human, and could lead us to hear (or imagine) sounds that would be produced by the natural elements if left independent of human intervention. They would be as strange as what we might hear if we were to put our ear to some portal leading to an entire world quite different from ours, or if we were to suddenly develop a new form of hearing, through which we would become aware of a strange tumult our other senses had been unable to pick up, one that might come from elements which were supposedly involved in silent action, like humus decomposing, grass growing or minerals in transformation. I should point out that in both these musical categories, and even when I blend them into one (pay no heed if this seems illogical), there is a clear preference for highly composite sounds that seem to be made up of a great number of voices, calling to mind distant murmurs, communities, hustle and bustle and centres of activity. I also have a preference for music without variation, a music not structured according to a particular system, but unchanging – almost formless – as though the pieces had no beginning and no end, but were simply extracts taken haphazardly from an incessant, ever-flowing musical score. I must admit, I find this idea quite pleasing.

I am, however, also well aware of the gap between my intentions and the real results. The experiments now available in a small collection of records should be considered outlines for a programme which, if it were to be finalised, would require a lot of improvements, such as enhanced recording techniques and better use of each instrument. It may also be necessary to modify the instruments, or even make better suited ones. In the meantime, there is still a lot of room for experiment with what is currently available. With any instrument you come across, you can get a great variety of sound effects, such that it may not be worth the trouble of looking for others. Instrumental technique and a thorough knowledge of how to make the most of each instrument are now obviously, sorely lacking; I am also well aware that they would be of great use to me.

It may be, however, that this would cause us to lose the benefit of the unexpected windfalls that can result from improvising on an instrument one doesn't know how to use. That said, it must be added that the tracks on this record were not intended as polished, completed works, but rather as the initial experiments of someone venturing into what is, for him, a largely unfamiliar territory – and musicians are kindly requested to receive them as just that.

248. Yves Klein, *Monochrome*, 1957

250. Yves Klein, *Le saut dans le vide*, 1960

My Position in the Battle between Line and Colour (1958)
The art of painting consists, I feel, in bringing a sense of freedom back to matter's primordial state. An ordinary painting, as it is generally understood, is like a prison window whose lines, contours, forms and composition are all determined by the bars. Such lines turn our mortality, our emotional life, our reason and even our spirituality into a material. They are our psychological boundaries, our historic past, our upbringing, our skeletal framework; they are our weaknesses and desires, our faculties and contrivances.
Colour, on the other hand, has a natural, human dimension; it draws on a cosmic sensibility. The painter's sensibility is unencumbered by mysterious nooks and dark crannies. Contrary to what the line would like us to believe, colour is like dampness in the air; its is sensibility turned into matter – matter in its primordial state.
I can no longer approve of 'legible' painting; my eyes are made not to read a painting, but to see it. Painting is COLOUR, and it's no coincidence that Van Gogh said, "I long to be freed from I know not what prison." I believe he unconsciously suffered from seeing colour cut by line, with all the implications that entailed.

Colours alone inhabit space, whereas the line does nothing but travel through it, furrow it. The line travels through infinity, whereas colour is infinity. Through colour I feel a total identification with space; I feel truly free.
On the occasion of my second show in Paris at Colette Allendy in 1956, I exhibited a selection of PROPOSALS of various colours and formats. What I expected from the public at large was that 'minute of truth' Pierre Restany spoke of in his text written at the time of the show. I took the liberty of making a clean slate of everything I viewed as a layer of external impurities, and sought to reach that level of contemplation in which colour becomes full, pure sensibility. Unfortunately, the reception that work met with revealed the fact that many viewers, slave to their usual habits of seeing, were much more sensitive to the relations the PROPOSALS might have among one another, and set off in search of decorative and architectural elements with a multicoloured motif. That pushed me to go farther in my research, and in 1957 to install – this time in Milan at the Apollinaire Gallery – a show dedicated to what I dared call my 'blue period' (indeed, for over a year I had dedicated all my efforts to a search for the most perfect expression of blue). The show

251. Yves Klein, *Yves Klein chef d'orchestre à Gelsenkirchen*, 1959

included ten dark ultramarine paintings, all rigorously identical in tone, value, proportion and size. The impassioned controversies that resulted, and the deep emotion it inspired in good-willed people, those ready to leave behind the hardening of old conceptions and codified rules, added an accent to the importance of the phenomenon. Despite all the errors, the naïveté and the utopia I live in, I am happy to explore a problem of such significant timeliness. We must think – and I am not exaggerating – of the fact that we are now living in the atomic age, in which everything that is material and physical can disappear from one day to the next in order to make room for the most abstract things imaginable. I believe that for the painter there is a sensitive, coloured material that is intangible. This leads me to think that colour itself, in its physical aspect, could limit and impede my efforts aimed at the creation of sensitive artistic states. To arrive at Delacroix's famous 'indefinable' – to the very essence of painting – I have devoted myself to 'specialising' in space, which is my own rather extreme way of dealing with colour. It is no longer a question of 'seeing' colour, but rather of 'perceiving' it. Lately, the mark on colour has led me, against my own wishes, to search out, little by little, the realisation of the material through a support (that of the viewer – of the translator) and I decided to put an end to the conflict; now my paintings are invisible, and these are the works I would like to exhibit – in a clear, positive way – in my next show in Paris at Iris Clert.

"Yves Peintures" (1955)
After having gone through various periods, my research led me to paint uniform, monochromatic pictures. I therefore paint the canvases by covering them with one or more layers of one single colour after having treated the support and made use of many technical procedures. No designs or variations appear, there is only the UNIFORM colour. In a certain sense the dominant element invades the entire picture. In this way I attempt to individualise the colour, because I have come to believe that an entire world exists within each single colour, and I express these worlds. My paintings still represent an absolute idea of unity within a perfect serenity; abstract idea expressed in an abstract way, which has set me square in the ranks of the abstract painters. I want to immediately point out that the abstract painters, on the other hand, think of it differently, and will reproach me for, among other things, refusing to set up relationships between colours. I maintain that the colour 'yellow', for example, is already in and of itself sufficient for creating an atmosphere and climate 'beyond the conceivable'; additionally, the nuances of yellow are infinite, and this allows it to be interpreted in countless ways. For me, every nuance of a colour is a sort of individual – a being that belongs to the same race as the base colour, but has its own character and soul. There are shades that are sweet, bad, violent, majestic, vulgar, calm, etc.
Deep down, each shade of each colour is a real 'presence', a living being, an active force that is born and dies after having lived a sort of life drama of colour.

252. Yves Klein, *Yves Klein réalisant FC 1*, 1961

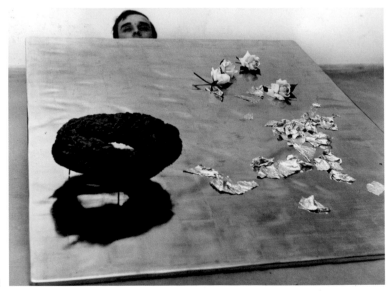

253. Yves Klein, *Yves Klein et Ci-gît l'Espace*, 1960

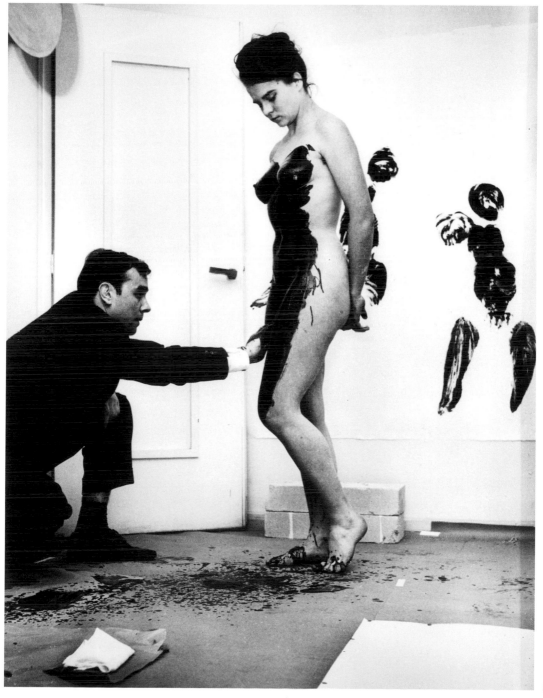

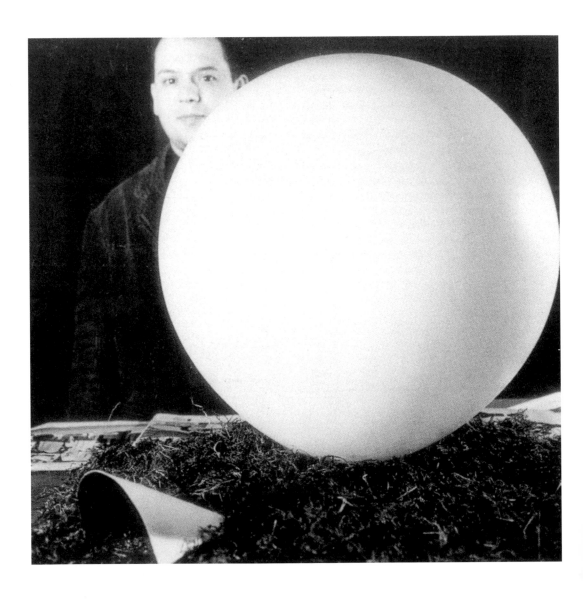

Some Realisations—Some Experiments—Some Projects (1962)

257. Piero Manzoni, *Azimuth*, 1960

My first *achromi* (achromes) were from 1957, in canvas soaked in kaolin and glue; in 1959 the raster of achromes consisted of machine-sewn marks. In 1960 I made some in cotton balls, styrofoam, I experimented with phosphorescents, and others were soaked in cobalt chloride that changed colour with variations in the weather. In 1961 I continued with others, in straw and plastic and with a series of pictures, invariably white, in little balls of cotton padding, and then hairy ones, like clouds of natural and synthetic fibres. I also made a sculpture of rabbit skin. In 1959 I prepared a series of forty-five *corpi d'aria* (bodies of air, pneumatic sculptures) with a maximum diameter of 80 centimetres (height, with a base of 120 centimetres). In that same period I designed a group of 'bodies of air' for a park; they were also spherical, and had a diameter of approximately 2.5 metres: through the use of an air compressor, they pulsate with a very slow, unsynchronised, breath-like rhythm (they were experimental samples, with small wrapping cases, made in 1959). Based on the same principle I also proposed, as an architectural project, a pneumatically pulsating ceiling and walls. For yet another park I thought of creating a little forest of pneumatic cylinders stretched out like stelae, which would have vibrated when pushed by the wind (in the same project some extremely high steel stelae, also through the wind's effect, would have produced sound). For an outdoor project (in 1959–1960), I conceived of a sculpture with autonomous movements. This mechanical animal would be independent, because it would get nourishment from nature (collar energy); at night it would stop and curl itself up; by day it would move about, emitting sounds, rays and antennae to look for energy and avoid obstacles; it might even be given the ability to reproduce. In 1960 I realised an older project – my first sculpture in space: a sphere supported and suspended by a jet of air. Based on the same principle I then worked on some spherical *corpi di luce assoluti* (absolute bodies of light) that,

sustained by the opportunely positioned jet of air, circled like a vortex about themselves, creating a virtual volume. In early 1959 I made my first lines, first quite short, then increasingly long (19.11 metres, 33.63 metres, 1,000 metres, etc.): the longest one I've made thus far is 7,200 metres long (1960, in Herning, Denmark). All these lines are enclosed in sealed containers.

I would also like to draw a white line tracing along the entire Greenwich Meridian. In 1960, over the course of two events (in Copenhagen and Milan) I dedicated some hard-boiled eggs to art, imprinting them with my fingerprints: the public could have direct contact with these works, swallowing up an entire exhibition in seventy minutes.

Since 1960 I have sold imprints of my thumbs, both left and right.

In 1959 I thought about putting some live people on exhibit (I instead thought of enclosing and preserving some dead people in transparent plastic blocks): in 1961 I began to sign people, in order to put them on exhibit I gave each of these works a certificate of authenticity. In January 1961 I built the first *base magica* (magic base): any person, any object that was on it was a work of art, for as long as it stayed there. I built a second one in Copenhagen. In the third, which was large scale, made of iron and placed in a park in Herning (Denmark, 1962) some earth sits atop it: it is the *base del mondo* (world base). In May 1961 I produced and packaged ninety tins of *merda d'artista* (artist's shit, 30 grams each) naturally preserved (Made in Italy). In a preceding project I had also intended to produce vials of *sangue d'artista* (artist's blood). From 1958 to 1960 I prepared a series of *tavole d'accertamento* (assessment tables), of which eight were published as lithographs, collected in files (geographic maps, alphabets, fingerprints . . .). In terms of music, in 1961 I composed two *afonie* (aphonies): the Herning aphony (orchestra and public); and the Milan aphony (heartbeat and breath). Currently [1962] I am working on the study for an electronically controlled labyrinth, which will perhaps be used in psychological tests and brainwashing.

258. Piero Manzoni, *Achrome*, c. 1960

259. Piero Manzoni, *Achrome*, 1962

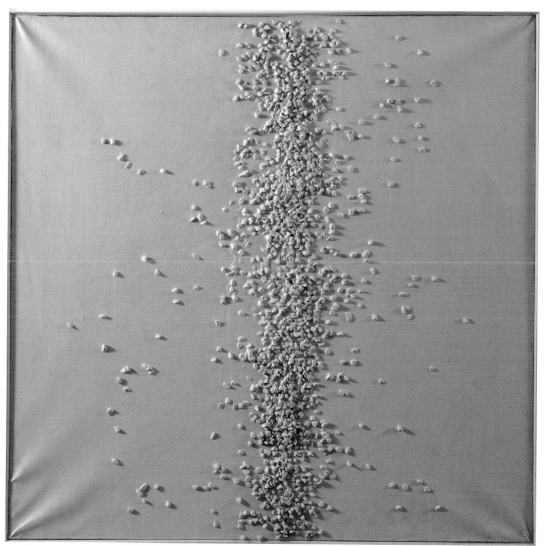

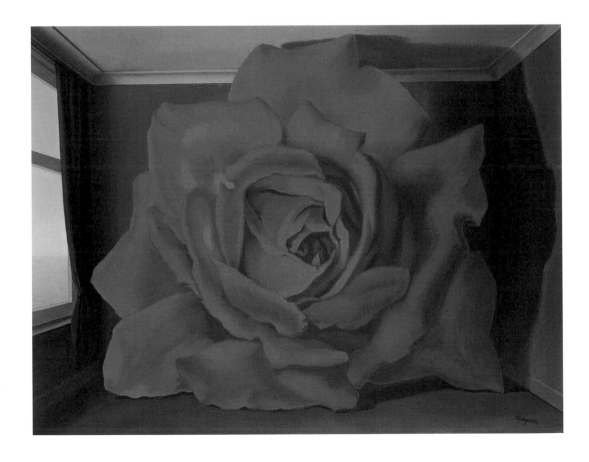

261. François Truffaut
The Cinema According to Alfred Hitchcock (1967)

FRANÇOIS TRUFFAUT: It's 1944, and you are going back to Hollywood to direct *Spellbound*
. . .

ALFRED HITCHCOCK: When we got to the dream sequences, I was determined to break with the traditional way of handling dreams through a blurred and hazy screen. I asked Selznick if he could get Dalì to work with us and he agreed, though I think he didn't really understand my reasons for wanting Dalì. He probably thought I wanted his collaboration for publicity purposes. The real reason was that I wanted to convey the dreams with great visual sharpness and clarity, sharper than the film itself. I wanted Dalì because of the architectural sharpness of his work

– De Chirico is quite similar – the long shadows, the seemingly infinite distances, the lines converging in perspective . . . formless faces. But Dalì had some strange ideas; he wanted a statue to crack like a shell falling apart, with ants crawling all over it, and underneath there would be Ingrid Bergman, covered by the ants! It just wasn't possible. I was worried because the producers didn't want to spend too much. I would have liked to film Dalì's dreams outside, such that everything would be bathed in sunlight and the outlines would become terribly sharp, but they wouldn't let me, so I had to film the dream sequence inside the film studio.

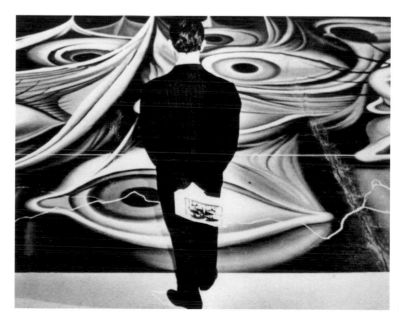

262. Salvador Dalì in front of one of the sets of *Spellbound*, by Alfred Hitchcock, 1945

263. Philippe Halsman, *"Mad Isolde"
– Tony Hollingsworth*, 1945

264. Philippe Halsman, *Alfred
Hitchcock*, 1963

265. Philippe Halsman, *Tippi
Hedrem from the film* The Birds
by Hitchcock, 1949

From Film Projector

To MP3 Player

266. *Gaumont* 35 mm film projector, with hand crank and magic lantern
France, 1903

Cinema is an invention with no future.
(Phrase attributed to Auguste Lumière, co-inventor of cinema with his brother Louis, 1895)

My invention is unsellable. It could perhaps be commercialised as a scientific curiosity for a limited amount of time, but it holds no other commercial value.
(Auguste Lumière, 1895)

The first ticketed showing was held 28 December 1896, at the Grand Café on the Boulevard des Capucines in Paris. For the audience that evening, the cinema was a technological marvel, but among the public there were also some journalists, one of whom commented that the spectacle was incredibly true to life. Another wrote: "This is one of the most extraordinary moments in the history of all humanity!"

Cinematographic images are seen not through a viewing lens, but are instead viewed as projected images – in other words, in the manner of the magic lantern, on a large screen . . . But one remains astonished, amazed when the device begins to move and the images begin to come to life. Full, tangible life unfolds before one's eyes . . . Cinema brings us, through its current growing perfection, the hope of some future miracle – one which even the brilliant imaginations of fairytale inventors could never have imagined.

(*Berliner Lokal-Anzeiger*, 29 April 1896)

I did not invent cinema, but I was the one to make it an industry.
(Charles Pathé)

Your invention, Monsieur Lumière, is our grammar, our language, our *raison d'être*. Before realising the third dimension, you had already granted the human spirit an eye that allowed us, through the simultaneity and suppression of all notions of time and space, to intuit the fourth dimension.
(Abel Gance)

Few young men of twenty-five justify the prophecy that their names will live for ages, but if all the dreams of electrical scientists come true, Guglielmo Marconi will have bound himself with immortality by an unbreakable link.
It seemed as though the acme of human possibility had been reached when Sir Charles Wheatstone showed our grandfathers how to talk over wires, but Signor Marconi has made child's play of ordinary telegraphy.
He has shown us how to throw electricity into space and pick it up across the sea. No achievement of science since the world began is comparable with this. Signor

Marconi is twenty-five; what he may do if he lives to be seventy only daring imaginations can dream. He is one of the world's priceless assets.
He is an Italian, of course, but it is something to be proud of that his mother was an English woman, and that his system has been perfected in England. A year or two ago a little group of men were interesting themselves in a curious apparatus which had been set up on the top of the General Post Office in London. There was no display of flags, no blowing of trumpets, not a millionth-part of the noise that would have been made

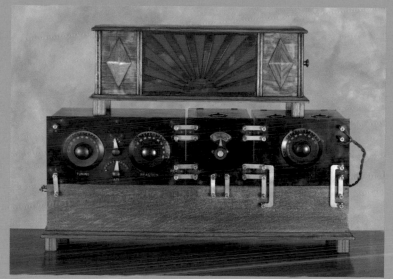

267. *Marconi* radio receiver called 'Il treno' (The Train) Patented 1906, 1912, 1918 Marconi Wireless Telegraph of Canada

by a telegram from the German Emperor. They were conducting the first experiments in wireless telegraphy, under the guidance of a youth of twenty-one. Experiments all over Europe have followed, and men talk today of wiring without wires across oceans and over deserts. It is a fascinating dream, one of the things that men have called impossible; but impossible is a word Signor Marconi cannot spell.
(*The King*, 22 December 1900)*

Nobel Prize awarded to Guglielmo Marconi in Recognition of His Contribution to the Development of Wireless Telegraphy
. . . Although high power stations are now used for communicating across the Atlantic, and messages can be sent by day as well as by night, there still exist short periods of daily occurrence, during which transmission from England to America, or vice versa, is difficult. Thus in the morning and evening, when in consequence of the difference in longitude, daylight or darkness extends only part of the way across the ocean, the received signals are weak and sometimes cease altogether. It would almost appear as if electric waves in passing from dark space to illuminated space, and vice versa, were reflected in such a manner as to be deviated from their normal path. It is probable that these difficulties would not be experienced in telegraphing over equal distances north and south, on about the same meridian, as in this case the passage from daylight to darkness would occur almost simultaneously over the whole distance between the two points. Another curious result, on which hundreds of observations continued for years leave no further doubt, is that regularly, for short periods, at sunrise and sunset, and occasionally at other times, a shorter wave can be detected across the Atlantic in preference to the longer wave normally employed . . . **241**

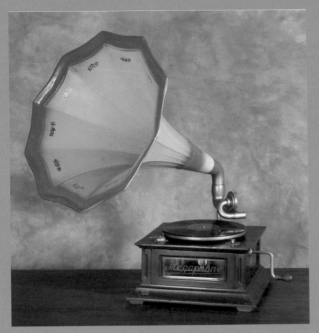

With regard to the utility of wireless telegraphy there is no doubt that its use has become a necessity for the safety of shipping, all the principal liners and warships being already equipped, its extension to less important ships being only a matter of time, in view of the assistance it has provided in cases of danger.

Its application is also increasing as a means of communicating between outlying islands, and also for the ordinary purposes of telegraphic communication between villages and towns, especially in the colonies and in newly developed countries.

. . . Whatever may be its present shortcomings and defects, there can be no doubt that wireless telegraphy – even over great distances – has come to stay, and will not only stay, but continue to advance. If it should become possible to transmit waves right round the world, it may be found that the electrical energy travelling round all parts of the globe may be made to concentrate at the antipodes of the sending station. In this way it may some day be possible for messages to be sent to such distant lands by means of a very small amount of electrical energy, and therefore at a correspondingly small expense.

(From the speech given in acceptance of the Nobel Prize, Stockholm, 11 December 1909, in *Scritti di Marconi*, Rome: Reale Accademia d'Italia, 1941)

It is unthinkable that the so-called wireless music box would have commercial value. Who would ever pay to hear a message not sent to a specific individual?

(Colleagues of David Sarnoff, radio pioneer and director of the Radio Corporation of America [RCA] and the National Broadcasting Corporation [NBC], and the first man worldwide to broadcast via radio news of the Titanic sinking, April 1912)*

In the issue of *Scientific American* published 17 November 1877 Thomas Alva Edison announced the sensational invention capable of "making words infinitely repeatable through automatic recordings".

The principal utility of the phonograph is that it enables one to write letters and dictate texts, and it was constructed for precisely that.

(Emile Berliner, in *North American Review*, June 1878)*

As much as the phonograph may appear, quite rightly, marvellous, it nevertheless still has not proved applicable to any truly useful and practical ends. To date, this device can be counted among those curious inventions of primarily scientific interest.

(Thomas Alva Edison, in *Scientific American*, 22 December 1878)*

The phonograph is not of any commercial value.

(Thomas Alva Edison, 1880)*

With the help of the gramophone a man's life can be summarised in twenty minutes on disc. Five minutes of baby talk, five minutes of joyful shouts of the boy, five minutes of the grown man's thoughts and the remaining time for the last weak observations made on his deathbed. This sonorous image will be remembered forever. One can even make as many copies of my discs as one likes, and singers, orators and famous actors will be able to guarantee themselves a good income through the sales of their 'phonetic autographs'.
(Emile Berliner in a presentation at the Franklin Institute, 16 May 1888)*

It is a vibrating diaphragm that alters the current of an electrified magnet. These variations in current, transmitted to the other end of the line, imprint analogous vibrations on the receiving diaphragm, reproducing speech.
(Antonio Meucci, 1857)

269. *Autelco* telephone in solid walnut wood,
Italy, 1910s–1920s

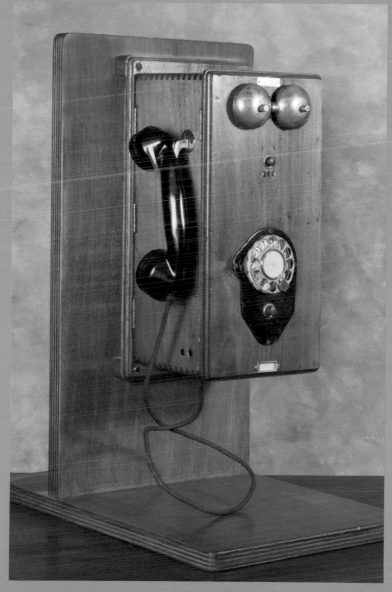

All telegraphic devices produce signals that require an expert's translation, and therefore such instruments are of extremely limited application, but the telephone speaks, and for this reason it can be used for almost any task in which language is used.
(Alexander Graham Bell, 1876)*

The newly invented telephone is a device with which one may communicate by voice over long distances, and thus can substitute the telegraph; its handling is quite simple. A double, complete apparatus consists of two Telephones, which serve for speaking and receiving answers. It has no need of a battery, as the electricity is developed by induction. Each device, constructed by the same factory that supplies them to the Telegraphic Direction of the German Empire, costs, with twenty metres of double line, 32 Lira. Each additional metre of line costs 30 cents. Sole warehouse in Milan, at the branch office of the EMPORIO FRANCO-ITALIANO, C. Finzi and Co., on Via S. Margherita 15, Casa Gonzales. Upon receipt of a postal order for 32 Lira it can be shipped everywhere, well packaged and with related instructions (carriage responsibility of the customer).
(Commercial announcement in *Il Sole*, 3–4 January 1878)

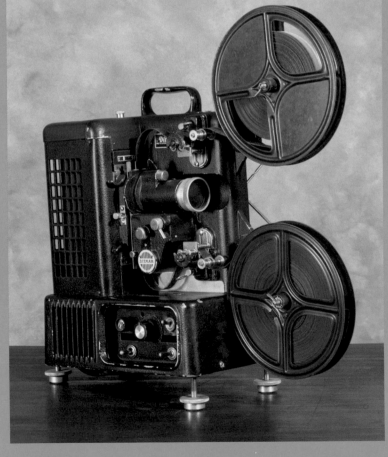

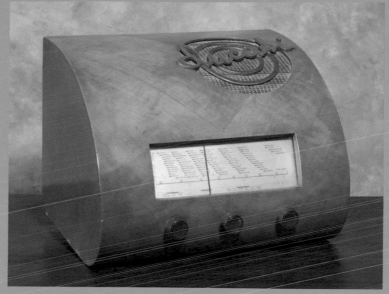

273. *Melodinamic* microphone mod. 75A, France, 1940s

Modern history has proven beyond all doubt that one of the main factors of civilisation and progress in the world is the facility with which people who live far apart can communicate with one another.
(Guglielmo Marconi, 20 December 1901)

I maintain that cinema is destined to revolutionise our scholastic system, and that in a few short years it will – for the most part, if not completely – replace the use of textbooks.
(Thomas Alva Edison, 1922)*

Talkies will never replace silent film.
(Thomas Alva Edison)*

I believed that Armstrong had invented some sort of filter for eliminating the electrical discharge of our AM radio. I didn't think it would trigger a revolution – introducing an entirely new industry capable of competing with RCA.
(David Sarnoff, president of RCA, regarding Edwin Howard Armstrong's invention of FM radio frequency modulation)*

We were in the salon. My guest did not have a radio device, but his maid had one in her possession and brought it to us shortly after eleven. It might seem strange that in 1939, in a well-to-do household, there still wasn't a radio, and that instead the maid had one for herself. But it isn't strange, because in some circles radio had not yet been accepted, it was considered a diversion for the masses, and cultured, intelligent people had the duty of not listening.
(Harold Nicholson)*

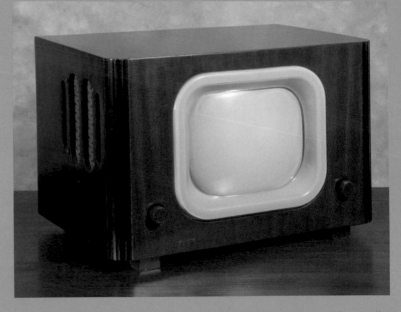

While television may be theoretically feasible, commercially and financially
I consider it an impossibility.
(Lee De Forest, radio pioneer, 1926)*

The many wonders of the current century, parallel to the development
of the airplane and other inventions, led to the acceptance of similar
achievements, as if they were part of the daily routine of the innovative era
we live in. The electrical transmission of light enabled the imagination to
rise up into unexplored realms, and the practical test television was put
to didn't disappoint expectations. Shows can be carried out in distant cities
and be broadcast for individual enjoyment thousands of kilometres away.
Conversations can be had between one side of the ocean and the other and
the speakers can see one another as clearly as if they were in the same
room. The distances of sound and sight will be cancelled out, and the
world will grow incredibly small in order to satisfy the needs of
communication.
(*The Indianapolis Star*, Saturday, 9 April 1927)*

In 1928 John Logie Baird convinced a London surgeon to loan him
an eyeball recently removed from the head of a young man and said:
"As soon as I received the eye, I rushed to the laboratory by taxicab.
Within a few minutes I had set the eye into the apparatus. I then turned
on the energy switch and the waves that carry television were transmitted
from the antenna. Through the television the essential image passed
through the eye, within an hour and a half after the operation. The
following day the sensitivity of the eye's optic nerve was gone. Its optics
were dead. I was unsatisfied with the old-fashioned celluloid and selenium
lenses. I had the sensation that television required something more refined.
The most sensitive optical substance known to man is the human optic
nerve . . . I had to wait a long time to obtain the eye, since those of minors
often aren't removed by surgeons . . . Nothing was obtained from the
experiment. It was a cruel waste of time."
In 1929 Vladimir Zworykin demonstrated the working Iconoscope
(camera tube) and the Kinescope (a cathode ray tube – the first modern
television tube):

"I hate what they've done to my child . . . I would never let my own
children watch it."
"Yesterday, for the first time, I understood the miracle of television – it
was a day that marked the dawn of a new era."
(*The Daily Express of Saturday*, 2 February 1935)*

Television won't last for more than six months on the market. People will
soon get tired of staring at a plywood box every night.
(Darryl F. Zanuck, American film and television producer, former
President of 20th Century Fox)*

Television won't last. It's just a flash in the pan.
(Mary Sommerville, educational radio broadcasting pioneer, 1948)*

The progressive development of humanity depends on invention.
Inventions are the most important result of the creative faculties of the
human mind. The final goal of these faculties is the complete rule of the
mind over the material world, attaining the possibility of channelling the
forces of nature so as to satisfy human need.
(Nikola Tesla, Serbian physicist, inventor, electrical engineer and mechanic)

From Film Projector To MP3 Player

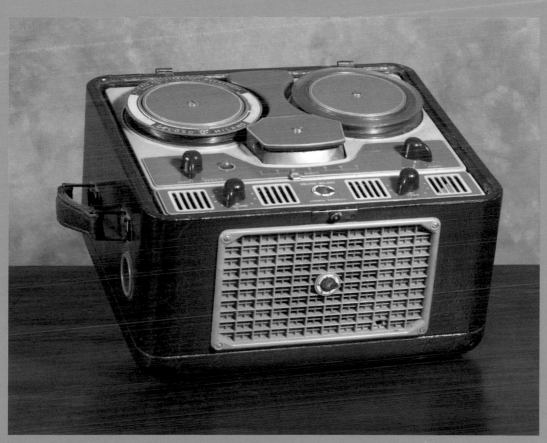

It remains to be seen, however, to what degree the future will truly belong to talkies. We mustn't forget that the talkie will lose its international quality, and will always be limited to works of smaller dimension, since great films can only be absorbed by a global market.
(*Berliner Börsenzeitung*, 18 September 1922)

The demand exceeded the supply, and we struggled to keep up with the orders. It was at the height of development, on a national level as well . . . The portable 45 EP record player remains unforgettable. People carried it everywhere, and anywhere you went throughout Italy you would see them. Today, after the advent of the CD, they've become veritable works of art.
(Franco Del Re, former warehouse manager for Lesa, 14 January 2004, in *Varese News*, speaking about the economic boom of the 1960s)

276. Bell & Howell 16 mm spring-loaded movie camera, USA, 1940s–1950s

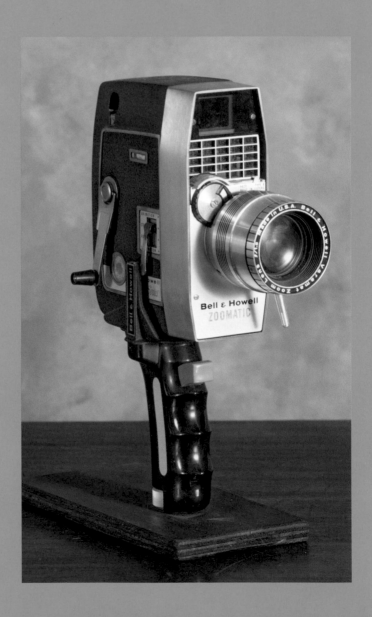

My whole life has been spent trying to teach people that intense concentration for hour after hour can bring out in people resources they didn't know they had.
(Edwin Herbert Land)

You always start with a fantasy. Part of the fantasy technique is to visualise something as perfect. Then with the experiments you work back from the fantasy to reality, hacking away at the components.
(Edwin Herbert Land)

One of my main purposes was to have a camera that's part of you, that's always with you.
(Edwin Herbert Land)*

277. Philips 45 rpm EP portable record player, 1960s

278. *SIP* telephone called the 'Bigrigio' (two-tone grey) Italy, 1960s

279. *Polaroid* camera mod. 420, USA, 1960s

The telegraph, the telephone, radio and above all the computer have made it such that anyone, in any part of the world, is now able to be within earshot. Unfortunately, the price we pay is a loss of privacy.
(Steven Levy, American journalist)*

People want to talk to other people – not a house, or an office, or a car. Given a choice, people will demand the freedom to communicate wherever they are, unfrettered by the infamous copper wire. It is that freedom we sought to vividly demonstrate in 1973.
(Martin Cooper, inventor of the mobile telephone)

To BBC News Online's question of whether or not he thought his invention would become so popular, used by millions of people worldwide, Martin Cooper replied: "I have to confess that that would have been a stretch at the time and in 1983 those first phones cost $ 3,500, which is the equivalent of $ 7,000 today. But we did envision that some day the phone would be so small that you could hang it on your ear or even have it embedded under your skin."

Houston, Tranquility Base here. The Eagle has landed . . . That's one small step for [a] man, one giant leap for mankind.
(Neil Armstrong, 21 July 1969, as he took the fist steps on the moon, in contact with earth via radio and television)

We will probably see two computers on every desktop even before we have two cars in every garage.
(Evening edition of the *New York Journal*, 1965)*

280. Ultravox *Quadrifoglio* radio receiver,
Italy, 1970s

281. *Vodafone* mobile car phone,
Finland, 1970s

282. *JVC* television with 10"
round screen, USA, 1970s

Up until a little while ago, theoretical mathematicians considered a problem solved if there was a known method, or algorithm, for solving it; the process of executing the algorithm was only of secondary importance. Still, there is quite a difference between knowing something can be done and doing it. This attitude of indifference is rapidly changing, thanks to progress in computer technologies. Now it is important to find solution methods that are practical in terms of calculation.
(Enrico Pompieri, 1974)

In Great Britain satellite TV will be a flop.
(Michael Tray, head of the London Broadcast Research Unit, interviewed by the *Sunday Times*, 1 December 1988)*

The model of centralised television, with a large antenna broadcasting to millions of viewers, grew dusty over time. TV is now over half a century old. Satellite dishes and cable TV have come along. Then VHS and DVD, increasingly affordable: people buy videos and watch them whenever they want. Certainly there are still a lot of people who watch TV, but they're decreasing, and spread over many channels . . . TV, which is rapidly ageing, is in trouble. Even the word itself sounds old, today people talk more and more about video. Go online, to Google Video, YouTube, Revver, VideoSift. Watch amateur videoblogs, or vlogs: nobody talks about having a 'TV blog'. All these sites are more than happy to distribute video clips, and nobody aspired to imitate television, nobody dreams of becoming a boring old TV channel.
(Michael Bruce Sterling, *Il meglio della TV? Sono gli spot* [The best of TV is in the advertisements] in *XL Magazine*, March 2007)*

There are few men whose insights and professional accomplishments have changed the world. Jack Kilby was one of these men. His invention of the monolithic integrated circuit – the microchip – which took place forty-five years ago at Texas Instruments, laid the conceptual and technical foundation for the entire field of modern microelectronics. His discovery made sophisticated, high-speed computers possible, as well as the semiconductors with high-capacity memory that now characterise the Information Age.
(Texas Instruments, in remembrance of Jack Kilby, who in 1958 invented the integrated circuit)

From Film Projector To MP3 Player

283. *Commodore* keyboard, England, 1970s

With iPod, Apple has invented a whole new category of digital music player that lets you put your entire music collection in your pocket and listen to it wherever you go.
(Steve Jobs, Apple Computer)*

First and foremost, the product was elegantly designed in classic Apple fashion. They did product design from the outside in. It was very thoughtful layering and nesting of the components mechanically. There's not a lot of unused volume inside [the iPod].
(David Carey, President of Portelligent)*

*Translated from the Italian

284. *Irradio* miniature colour television with LCD screen, import, 1970s–1980s

285. Imported CD player, 1990s

286. *Apple iPod nano* MP3 player

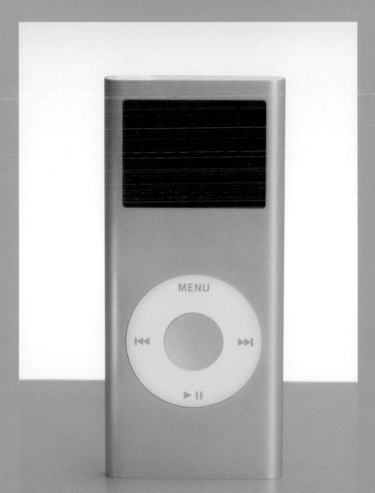

Nineteen Sixty-three

Two Thousand Five

Making Good Use of the Banal

Pop art, no less than neo-dada, is now a living part of twentieth-century art, just as expressionism, cubism, metaphysical art, futurism, dada, surrealism and abstract art are, with all the limitations and ambiguities that such definitions – the so-called *-isms* – entail. Like no other modern artist, including the futurists and dadaists, the pop artist willingly let himself get swept up into the urban world dominated by mass-produced products and the mass media, beginning with the creative fervour of the early 1970s. Then, in art – though not only in art (also in culture, ideology and politics) – things took an impetuous turn. Around 1968, urban art and its culture went through a sort of eclipse, a violent protest that began from within, both from the heart of the city itself and from its geographic edges, those marginal fringes that had still managed to avoid the despotic pressure of an urban world that tolerated neither competition nor other autonomies. It is no coincidence that it was precisely in 1968 that pop art felt the final heartbeats of its creative vein: having ceased to be the driving core, worn down yet substantially homogeneous, it ended up in the uninterrupted evolution of individual artists.

If for some decades now 'the city' has been New York, which has become the capital of the Western empire, toward the end of the 1970s the suburban uprising against it – be it real or metaphoric – was also a political insurrection of sorts. But in its impatience and absoluteness, this revolt fit less easily into traditional ideological schemas, be they American radicalism or European Marxism, than into the schemas of the avant-garde. The youth-led uprising increasingly became a clamorous event, precisely because of its spread throughout the complex and totalising movement known as the avant-garde; an event extreme enough to signal its end – the end of the avant-garde itself.

The very same avant-garde that never intended to close itself off 257

into the autonomous, splendid, yet inseparable bubble of art, and instead had always aimed to transform itself into a way of life, believed that the disorder of 1968 could be the right occasion for self-realisation, the right chance to move into reality and completely transform it. So, aiming at self-realisation, the avant-garde 're-actualised' itself, bringing renewed vigour to the radical languages that had always been a part of it, such as gesture and behaviour. It equated politics with exercises in evasion and insurrection, and therefore played in politics; not so much planning, but rather investing in one's desires, in utopia, in the power of imagination, in the transformation of the world – those were the objectives and straightforward slogans. Nevertheless actual fact, the dry outcome, speaks of defeat. And this defeat had the power to drag the avant-garde along with it. The political proof, the concrete confirmation of the impossibility of its realisation, definitively put the avant-garde in checkmate, drawing its long history to a close.

Even pop art and its immediate predecessor, neo-dada, were part of the avant-garde, but at a time that we now know was its final days: that period, equally inappropriately, called the second avant-garde or neo–avant-garde, with respect to the historic avant-garde of the first three decades of the twentieth century. The neo-dada and pop art movements were not at all some overheated, radical avant-garde, but rather a fairly cold avant-garde, one that stored its thoughts in the fridge. So it is a late avant-garde, and has the repetitive, self-conscious characteristics of all such revivals. In the pendulous oscillation that moved the entire avant-garde – between the poles of the pathetic and the cynical, of planned designs and disenchanted protest, of a future-oriented outlook and the adoption of a rather flat present – artists like Roy Lichtenstein, Jim Dine and Andy Warhol felt at ease only in the latter. Pop art was a lucid, often cynical and almost always highly observant avant-garde, very involved in the present moment. If in 1968 the avant-garde, in its last pathetic political sortie, again took on a utopian, futuristic extremism, these were also precisely the elements that pop art and neo-dada, like most of the final phases of the avant-garde, had already long rid themselves of.

In pop art there was a full awakening to this new situation, which nevertheless remained an alarming discovery for painters and sculptors: in the urban world, the artist ceased long ago to hold a monopoly on the production of the world's figurative 'image-imaginary', a monopoly it had held since the very advent of art up until yesterday. If the artist quit producing images, there still would not be any lack of the imaginary in an epoch equipped with both photography and television and which is nevertheless pushing cinema into becoming a niche for film fans. Consider, for reverse proof, a medieval period without the activity of sculptors, painters and miniaturists. The world – or, more concretely, the artist's visual field, like that of the common man – is already full, saturated with images, just as its practical, daily existence is conditioned by the imposing presence of mass-produced objects. Extending the consequences of a similar situation, neo-dada and pop artists not only rush into it head on, but set art square into the media circuit with a resoluteness unequalled by any other modern artists, neither futurists nor dadaists, who had also looked at industrial techniques for image production.

Today we can consider pop art in particular, more than neo-dada, the creation of a system that is grafted – under, over or perhaps collaterally or in parallel? – onto the central system of mass media, via the fundamental process of citation. Thus, between the artistic and mass-media systems, a perfect identity has established itself, at once iconographic, technically formal and communicative – not just with the adoption of banal, everyday images and the similarly formative, impersonalised, rigorous and mechanical processes of the industrial media, but also by pushing a similar parallelism into circulation, using the same quantitative standards with which the mass media so widely distribute multiplied images and products. Ex-

panding into distribution and imitating the redundancy of technological communication, the pop art parallelism with the mass media has become total, all-enveloping.

So if pop art constitutes a sort of collateral system with regard to the central system of the mass media, of what value is it? Clearly, this parallelism creates the distance between the artistic image and the sector of reality it was extracted from – the sector it intends to be a precise 'cognitive/appropriative' model for.

There is a line of thinking that runs throughout modernity and is expressed in the conviction that the citizen has lost a part of his experience – and this could be the most salient characteristic of the modern age – due to the increasingly rapid processes of 'massification' and standardisation. A similar process, making experience automatic and therefore impeding any direct action – as Walter Benjamin noted – marks the start of a vertiginous decline in experience itself. An early probing of this new human condition can be found in a story penned by a symptomatically American writer. I refer to Edgar Allan Poe and his famous tale *The Purloined Letter*, wherein he shows that, by setting the letter in its most familiar surroundings – on a desktop shelf – it becomes invisible, to the point of even escaping the attentive inspection of a group of specialised policemen.

Thus, in the general 'disposable' culture, these last modern painters create a brusque interruption, a stasis, and, one could almost say, invent an aesthetic 'consumption' of the objective given. A pause in the speedy circulation of products allows the artist to work – to enact an operation that substantially assumes two specific forms, albeit in a rich variety of individual declinations. First, for neo-dada artists like Robert Rauschenberg, Jasper Johns and even Jim Dine, this artistic 'consumption' takes the form of a loan of concretely taking any old object or a disparate group of objects – and therefore a manipulation, a montage, collage and mixture interspersed with varied doses of painting. In Rauschenberg the violent brushstroke serves to grasp and hang onto the sordid, worn-out fragments of the world; in Johns the thin, subtle brushstroke instead serves to domesticate the world's givens, its common objects – a broom, a spoon, a thermometer – put on exhibit within the frame of the canvas. The type of manipulation recalls the technique of bricolage Claude Lévi-Strauss brought our attention to in his anthropological studies; that is, the reuse, in a new 'project', of objects or parts of objects that originally had a different function and then fell into disuse: for example, the use of an old wooden door as a tabletop. Thus the work of even the most sophisticated late-modern artist ends up looking like the work of a member of any subsistence-based society: an ancient farmer, or even primitive man. But there is also a modern technique worth mentioning here: the secondary technique of 'recycling', recovering and reusing discarded materials and objects.

In pop art, on the other hand, this artistic 'consumption' consists of selecting one of the many images or objects already in circulation and then remaking it, refiguring it or reconstructing it in a way apparently faithful to the pre-existing object but in reality also intervening with a series of rejections and minimal changes, beginning with an evident change in scale: a massive increase in scale, 'gigantism' with respect to the original starting point, remains one of the most evident characteristics of pop art. The image initially chosen could be the detail of a comic in Lichtenstein, a photo in Warhol, an advertising image in Rosenquist or a cultural image – like the famous snapshot of the futurist group – in Schifano, a utilitarian object like a sewing machine or toaster in Oldenburg who, alongside Segal, is one of the most representative pop sculptors.

Art – with a similar set-up, and especially with the pop artists – does not only come into relation with the mass media, but rather decisively penetrates into the mass media system with

a breadth that cannot be found in any other modern movement: certainly not in cubism, but not even in futurism or historic dada, which also looked at industrial production techniques and their considerable results. What is 'collage' – which remains one of the largest and most revolutionary inventions of modernism and which, from cubism and above all Picasso, spread like wildfire throughout the twentieth century in ever more complex, denser and quantitative forms – if not a way to incorporate fragments of the real world into the work of art? So from this borrowing of clips and fragments of objects, which remained the foundation of the neo-dadaists' work, we move on to the pop artists' quoting of pre-existing images, with a continuation of the same approach.

If this is the reality, what value or meaning can pop images or objects have as the results of a mere methodical redoing or supposedly deeper investigation – acts that remain as elementary as any imitation? In short, what sense does it make to instigate a secondary, parasitic, even redundant system? Why build a double of something that is already more than well known, a double we invariably associate with a suspect uselessness, even impotence? With this series of questions we come to the central issue of aesthetic order in pop art.

At this point semiology, the science of signs – a cold, analytical and dispassionate critical method, distant from the prejudices of any ideology whatsoever – can lend us a hand in answering these questions. It is also significant that semiology reached the height of its popularity in the same period as pop art rose to success.

With specific regard to the mass media they were separated, extracted and quoted from, the images and objects chosen by pop artists take on the value of a sample or, more precisely, a 'paradigmatic' example, in the sense of an exemplar representative of the entire series. Samples allow artists to carry out a work of impartial investigation, a critical analysis with a very close eye, linguistic reconstruction, casting light on the meaning of the image or thing under examination, with the same quotient of experience they entail. In this way, at the end of the pop artist's procedural work – that is, a punctual remake – the 'paradigmatic' exemplar is presented as the image or object reconstructed, interpreted, made 'invisible', in such a way as to make evident what was merely latent in the original model. So although it remains that same model, it comes to represent an addition of sense, intelligence, experience. Let us examine and exemplify this process in the actual works of three quintessential pop artists: Lichtenstein, Warhol and Oldenburg. The heroine Lichtenstein borrowed from a comic strip becomes 'paradigmatic' in comparison with all the comic-strip characters she is a part of. Warhol's star does in comparison with Marilyn Monroe or Liz Taylor, the faces made mythic by the cinema and newspapers. Oldenburg's typewriter does in comparison with that indispensable, mechanical tool found in every middle-class American home. At the completion of these artists' remakes, the paradigm is promoted to the level of exemplary model. Oldenburg, through his ingenious manual reconstructions, manages to condense into a remade plastic object all the infantile and regressive dreams and desires consumer culture, in its opulence and apparent ease, continues to repress. Lichtenstein, in his pantographic enlargement of cartoon characters, uniquely sheds new light on the value of form at the expense of narrative, the efficacious visual quotient such characters an values contain, the residue of a high stylistic tradition dating back to art nouveau and Georges Seurat: all elements only found in potential form in the communication processes filtered through popular images. Finally, Warhol, doing quite the opposite of Lichtenstein, emphasises a series of other values that also inform mass communication: the emptying and degradation of content; the consumption of the image, its definitive 'death'. According to the artist himself: "I realised that whatever it is I was doing had to be death". And you could add that today, between television and cinema, death

as a main subject has never been so popular. The centrality that sight has gained, with respect to all our other senses, has ended up identifying things solely by their mobile and artificial surface, their visible skin. The phenomenon we classify under the term 'look' began to spread precisely with pop art.

All these artists – basically artists operating in the Western world, on both sides of the Atlantic – act, with dramatic lucidity, on one crucial fact: art's loss of centrality. Deep down, a similar awareness gnawed the conscience from within throughout the modern period: Charles Baudelaire had already pronounced, with pained sarcasm, that the modern poet had lost his 'halo'. The scene where this symbolic loss took place was a deafeningly trafficked Parisian street. Nonetheless, modern artists have always tried to regain their centrality with regard to the social world, to recrown themselves with their halos, strolling the contrary streets of rational planning, revolution and 'cursedness', struggling to reconquer, in this last instance, a lost centrality through negative practices, revolt – tragic testimony pushed to the limits of self-destruction and death. From Vincent Van Gogh to Jackson Pollock – to a painter in the generation that just preceded the neo-dadaists and pop artists, to the generation of their direct forebears.

On the contrary, among the artists who came later there is a broad awareness – an open-mindedness many pop artists pushed to the brink of cynicism – that art now occupies a marginal, peripheral place within a modernity that has reached its definitive completion. And that is the same spot it continues to occupy today, for those of us who come 'after the modern age', after the sunset of modernity. Aesthetically, art is reduced to ornament, to a leisure-time activity that requires only a distracted attention and passing glance. Socially, it is a sign of promotion, a 'luxury object', more sought-after the higher its market estimates are. The noteworthy economic value modern paintings and sculptures have reached – including those by the aforementioned neo-dada and pop artists – do not allow art to exit the ghetto it is now confined to; a highly advertise, gilt ghetto, but a ghetto nonetheless, a lovingly protected reservation.

So the theory advanced by Jean Baudrillard becomes understandable: basing his statement on pop art and Warhol's 'paradigmatic' figure, he speaks of art's 'disappearance'. As for ourselves, without trying to soften his necessary radicalism, we are speaking of its concealment, its 'invisibility'. Art, by exhibiting itself and being exhibited, has made itself invisible. We have returned, as you may have noticed, to the apparently paradoxical hypothesis Edgar Allan Poe asserted in *The Purloined Letter*, back at the very beginning of a now defunct modernity.

Making Good Use of the Banal

Ugo Volli

The Screen – 'General Equivalent' of Contemporary Art

I.

A widespread, general theory regarding the meaning of art – or at least contemporary art, understood as such from the moment it ceased to be based on the criterion of value or mastery – argues that its meaning lies in the 'linguistic experimentation' art carries out as its specific mission. 'The tradition of the new' at the base of twentieth-century art is a brilliant emblem of this idea, and is also interesting to think about given the oxymoronic tension that supports it. If we make an effort to go beyond the conventional wisdom of the past century – now so deeply rooted that it almost seems an evident truth, calling for neither demonstration nor discussion – we have to admit, for two main reasons, that this is a clearly inadequate theory, if not downright false.

The first reason is that languages – real ones – are never experimentally tested out or designed, but are spoken without intent and without solid goal, almost naturally. They change only slowly and through collective dynamics, according to a method Ferdinand de Saussure defined as unconscious. So there never really has been a real *linguistic* experimentation: the various artificial languages occasionally designed to be 'perfect', which Umberto Eco wrote an excellent book on more than a decade ago,[1] have never been spoken by anyone, and are not true languages. Similarly, the strange 'idiomettes'[2] (private languages) are not true languages, as someone tried to define – with yet another oxymoron – works of art, which instead "always repeat the same thing", as Plato said in the *Phaedrus*: in fact, among the few universally accepted modern philosophical truths we can certainly include Ludwig Wittgenstein's assertion that "there are no private languages".

The second reason is that experimentation, understood in the strictest sense, be it 'linguistic' or not, must nevertheless arrive at an experimental result; that is, it has to confirm certain hypothe-

ses and refute others. But that clearly does not happen in the field of art, which for at least a century now has not been able to stop 'experimenting' – meaning constantly changing its rules and forms – on penalty of being condemned as overly academic, so it is therefore incapable of hoarding earlier 'experiments' if not as paths already taken and therefore to be avoided at all costs. Concomitant to this absence of experimental results is the highly limited degree of transference from the expressive modes of contemporary art to common languages, be it music, sculpture, video etc., which also makes the metaphor of the 'avant-garde' profoundly inadequate in this case.

We can continue to sensible talk about 'experimentation' only if we distance the word from its programmatic scientific reference and bring it closer to its deeper Indo-European origin, whereby the root *PER* means experience, attempt, danger, mishap: the condition of one who, more or less voluntarily, subjects himself to the uncertainties of fate in hopes of survival. How much this tangential condition of 'extreme' wandering necessarily has to do with art's path is not anything to discuss here; having hinted at the idea will suffice.

Precisely in light of this tangential wandering, we must also admit that the twentieth century (in which, it seems, we continue to be held prisoner, at least from this point of view) was characterised in the realm of art by processes of formal (as opposed to 'linguistic') variation (as opposed to 'experimentation'). This almost Brownian variation – made up of frenetic 'false moves', à la Wenders, around points of attraction that, in turn, move according to a slow, almost unwitting drift – certainly recalls fashion and trends more than the scientific processes of accumulating knowledge. And with fashion and trend it certainly shares the change in rhythm that occurred at the dawn of the twentieth century: a vertiginous increase of speed in (false) movement and the acquisition of a programmatic character, obligated by such a change, even more sped up and made even more casual and 'false' in the last three decades of the century.

II.

Another widespread commonplace is the idea that artistic variation occurs on two main levels, which correspond to the major theoretical opposition between messages' expression and their content. In art there would naturally be a predominance of work on the signifier – that is, of the exploration of new expressive syntaxes and forms. But in different artistic sectors and trends – like the broad affiliation of pop art and the other, equally broad, art that stems from political involvement – one naturally finds an often ironic and paradoxical work on content, realised, for example, by reversing advertisement messages, or, more generally, reusing the grammatical and lexical meanings of commercial communication with new meanings. Both levels, then, are subject to a process of variation.

But there is a third level of variation, more significant as much as it is actually occurring in our society, independently of art's 'experimental' task, and subject to a real and autonomous movement: our means of communication. Basically, the major cultural contents of our society that are represented in artistic work have substantially remained the same for at least a century (the bourgeois values of success, the social values of equality and freedom, the psychoanalytical themes of the unconscious and the erotic, the aspiration to realise full identity and its cosmic overcoming, plus a few others). On the other hand, we must also admit that even general forms and grammar have changed little over the past century, or thereabouts, that separates us from the contemporary success of mass communication, the cultural industry and historic avant-gardes, which in the early decades of

the twentieth century established the major rules of the game, its forms and genres – in

short, syntactic limits within which all communication (artistic and otherwise) still operates. What has, on the other hand, changed quite greatly – in a process that has a rhythm of continuous acceleration, more like rapids, than the catastrophic flow of cascades – are the means of communication. An essential summary: photography and the telegraph in the 1840s; the telephone and phonograph in the 1860s; film and radio on the cusp of the 1900s; cinematic colour and sound and television thirty years later; and then the computer, little by little growing lighter and more portable; followed by Internet and mobile phones. Those were the main developments that deeply changed our contemporary ways of communicating, perceiving and even thinking, if not the form and content of thoughts.

For art, this change had a twofold effect: on the one hand, it led to a decrease in its social roles, like portraiture and illustration, now delegated to new media that were both more economic and considered more exact, insofar as they were at least partially 'automatic' (photography, cinema, video etc.). On the other hand, it led to the exploration of new tools and techniques (photographic, xerographic, cinematographic, informational, video etc.). Over the past century all means of communication, as well as their technical supports (like, for example, electric lighting or audio reproduction, but also newsprint, which was already an information carrier), have little by little become 'new media'[3] and therefore possible supports for artistic work and objects of experimentation (this time, yes: often authentic experimentation, with rules that can be generalised beyond the single, unique work of art).

The vast majority of these objects soon fell into the banality of daily life, losing the aura of novelty that had made them interesting candidates for artistic operation; or they evolved into proper languages, quite distinct from traditional visual arts. The second option was the clear destiny, for example, of photography and cinema; the first was instead the clear destiny of photocopies, printing and newspaper. One sole object, on the other hand, underwent its own uninterrupted development, significantly enough to have kept it from both aforementioned destinies. This support, extraordinary enough to remain new over a century and a half after its first appearance – a sort of 'meta-medium', that is, a media-based function embodied in incredibly diverse techniques and materials – is the screen.

III.

The word *screen*[4] has Germanic roots: the Lombard word *skirmjan* meant 'to defend', from which comes the Italian *scherma* (the sport of fencing), the German *Schirm* (umbrella) and *Schrank* (wardrobe cabinet), the English *screen* and also the Italian *schermo*, which already appeared in Dante in the sense of a defence or barrier. It took on no other meanings until the mid-eighteenth century (for example, in Niccolò Tommaseo's impressively large dictionary, the twenty-volume *Dizionario della lingua italiana* published in 1865, it was only defined as a 'shelter, defence').

This is one instance where language correctly represents reality: the screen, in the way we understand it, did not emerge until the invention of projections – that is, with cinema and its immediate antecedents (the so-called magic lanterns, for example). The terms for a defensive barrier, a physical element of separation, became incongruously attributed to any and all immaterial supports for communication made purely of luminous material.

Right from the start the screen really was utterly new with respect to the old materials of art. So it is not an object, but rather a function: in the first phase, a screen could be just about anything – a wall, a bed sheet, a sheet of paper – as long as it was sufficiently flat, smooth and light-coloured. Even objects that were usually painted on, old supports like canvas and walls, could readily become screens if still virgin.

Secondly, though this is actually the fundamental point, unlike the old supports, a screen saves not a single trace of the artistic manipulation it has been subjected to: it is not a surface for inscribing (given that the principal characteristic of inscription is its permanence, the 'dif/ference' Jacques Derrida referred to), but is rather a support for projecting, literally a target for images, *variable* during its use, but precisely because of that also inert and *insignificant* (literally, a non-sign) when not in use. These are facts that we all know quite well from our daily lives, even if we normally do not give them much thought. But just over a century ago, screens constituted an important break in the history of communication, even if there was no lack of precedents with rewritable supports: the sand Archimedes drew on, which the Roman soldier's foot so fatally muddled; chalkboards; scraped and rewritten palimpsests; the wax tablets carrying Greek and Roman letters. The difference lies in the screen's sheer distribution, its visual richness, the speed and ease with which the image changes, which is in turn the basis for its fundamental communicative innovation (and, in particular, its artistic use): the representation of the process of becoming and, above all, of movement. As we have said (and as Ruggero Pierantoni masterfully proved[5]), movement was one of the constant problems of working with images and art in particular, from its Neolithic origins right up to the present day. Until the invention of moving projections and the screen, the realistic (isochronous) solutions to this problem were by force 'homomaterial' (theatre and dance, in which human actions and time are represented by the real presence of bodies in motion) or immaterial (music, which exists in time but not space); the figurative arts still proposed 'heteromaterial', but not isochronous, solutions alongside forced symbolic solutions (the various techniques of multiplying images along the before/after axis, signs of motion and movement in drawing, etc.).

The screen profoundly changes these limits. It is isochronous like music, but exists in space, and above all allows for the creation of narrative or abstract virtual spaces thanks to the many techniques of representation accumulated over many millennia of figurative culture. It even facilitates the creation of new techniques thanks to its own technical characteristics and the technical characteristics of the apparatuses that provide it with projections (for example, the various film editing techniques). The screen is the perfect base for a natural representation of change, above all because it is itself constantly changing, up until the extremes wherein it is turned on or off.

The screen has a history. From a passive, mute, black-and-white object devoid of technical content (if not of an opportune reflexivity), it becomes a speaking, then coloured object (both innovations of the cinema). In the 1920s its name and function begin to expand, to include images that cannot be seen in daily life, such as the entire human body (*schermografia*, or 'screenography', was the first Italian term for the image of a body made transparent by X-ray): this was the very start of a rich generation of artificial images typically projected onto screens, *visions of the invisible* (CAT and PET images,[6] as well as falsely coloured astronomical images, etc.). A century and a half after its invention the screen was radically transformed with the advent of television, becoming an active receiver. The projection becomes invisible, hidden within the cathode-ray tube, and above all is now directed from a faraway place it is synchronised with, which is the key premise for the presupposition of a reality so characteristic of television (as 'direct effect'). First the screen was a place of a representation that was, at least potentially, particularly realistic and engaging, capable of strongly realistic effects – like the early myth regarding cinema and the screen, when the Lumière brothers' first viewers believed the on-screen train was really coming out toward them – but this realism was rapidly assimilated as a medium specially adapted to fiction. Therefore, it was framed

by our conditioned suspense of disbelief – insofar as it belongs to an order of reality quite different from our own, from the representational realm – that we assign to the narrative, representative and shown worlds.

The television screen, on the other hand, even in its very name, outright states that it shows things that *really* are happening elsewhere, and coordinated for a causal chain. From a mere crack in the wall separating reality from fantasy, oneiric recorder and metaphysical shuttle between possible worlds, the screen became a 'window on the world' – the real world. This way of functioning did not change, even as the TV screen rapidly gained the ability to show 'fictional' worlds, simultaneously with the invention of the video camera. In this way the screen manages to 'remediate'[7] all the other preceding media. This is also characteristic of the screen – its distinguishing capacity for 'general representation'.

The next stop is the computer screen, which is no longer the receiver of a remote transmitter, but rather makes locally produced images and texts visible (even if its receiver capacity swiftly returns thanks to the Web). In this case, the most characteristic aspect it its interaction with the viewer (generally reduced to one, from the family that typically watched the TV screen together and the hundreds of people cinema screens were set up for). Here there is an interaction *between* people *through* the screen, which reiterates and improves upon the old telephone, plus there is the person's interaction *with* the screen. The clearest case is through the mouse, a real object that is only apparently physically coordinated (in reality thanks to a numeric calculation) to a fictional object like its arrow, which seems capable of acting upon the screen's images, activating, 'dragging' and perusing them. But the interfaces between viewer and screen are even more varied, from the keyboard to the joystick, all the way to the direct contact of touch screens. The screens of arcade videogames, ticket machines, ATMs and other public devices function according to the same principle, counting increasingly upon the third technological change – the luminous workings of the screen itself, from cathode-ray tubes to liquid crystal displays.

And hence we have arrived at the immense proliferation of screens in contemporary daily life: watches and clocks, mobile phones, automobile dashboards and the controls of all sorts of electronic devices, the televisions, computers, monitors and luminous 'chalkboards' that surround us. We continually interact with these objects – neutral but rewritable, reactive and interactive, intelligent or passive, capable of supporting any type of communication or entertainment – the concrete spaces of the virtual realm. It was inevitable that artists would eventually deal with them as well. This is not the place to attempt even the most summary inventory of such operations, which transversely develop between genres: installation and cinema, video art and film clips, performance and interactive events.

But, in conclusion, it is worth proposing a final concept here: the screen – in its radiant neutrality, its own very insignificance that, as such, is capable of becoming a support for any communicative meaning and genre, and even in the structural precarity of its signification – is a metaphor. Actually, it is much more than a metaphor – it is a fundamental regulating principle of contemporary culture, and therefore also of that culture's art.

The communicative inflation connected to the precarity of messages, rapid consumption, the prevalence of spectacle and therefore of strong, fast perceptual stimulation (the phenomenon Sergei Eisenstein called the 'editing attraction', or 'montage of attractions'), the progressive difficulty in passing from the practical level to the formal level, and the level of actual works (it is no coincidence that Hannah Arendt, in her *Vita Activa*, described our time as characterised by cyclical, almost biological 'labour' as opposed to the ambition of the [artistic] 'work' to remain and defy time; and for the most part there aren't *works* in media like

radio, television and Internet, while even cinema is progressively giving up all creative ambition in its works) – all these general characteristics of our time and our art are symbolised by the screen, if not invoked by its characteristics: a virtually universal space, insignificant in and of itself, brilliant, which comes to life only as it is becoming, and does not remain, itself. The screen is an abstract surface facilitating control and manipulation, one we play with and one we are watched by. It is a place of allure, seduction, appearance, illusory depth. It is the abstract 'general equivalent' of communication, just as for Karl Marx money was a general equivalent of value, and therefore work. The screen is a space circumscribed by a frame, which in turn circumscribes our entire world – and our art, too.

[1] U. Eco, *The Search for the Perfect Language*. London: Fontana Press, 1997; this citation taken from the Italian edition, *La ricerca della lingua perfetta*. Bari-Rome: Laterza, 1993.

[2] Translator's note: the author uses the term 'idioletti', a diminutive of *idioma*, idiom.

[3] This was the fundamental hypothesis in L. Manovich, *The Language of New Media*. Cambridge, Mass.: MIT Press, 2001; this citation taken from the Italian edition, *Il linguaggio dei nuovi media*. Milan: Edizioni Olivares, 2002.

[4] Translator's note: 'screen' is *schermo* in Italian, which is slightly closer to the German root.

[5] R. Pierantoni, *Forma Fluens*. Turin: Bollati Boringhieri, 1986.

[6] Translator's note: CAT and PET stand for 'computed axial tomography' and 'positron emission tomography', respectively.

[7] Regarding the concept of remediation, see J.D. Bolter and R. Grousin, *Remediation*. Cambridge, Mass.: MIT Press, 2000; this citation taken from the Italian edition, Milan: Guerini e Associati, 2005.

Giovanni Maria Accame **Connecting Pages**

Between the late 1950s and early 1960s, after the lengthy season of informal art (*art informel*) in Europe and abstract expressionism in America – which had focussed on existential probing and sought an affirmation of pure existence in the declensions of gesture and material – clear signs of a major shift in the nature of art and artistic experience began to emerge. In many respects, the unfinished beginnings of the historic avant-garde were revived and taken to their most extreme and implicit consequences. In particular, the assumption of linguistic models geared to a communications-based society and 'technologised' relationships, as well as their formal and reproductive structures, led art to venture beyond the specificity of the artistic language. For art, this new connection to the world – to the systems of information and the multimedia relationships the world itself creates as it unfolds – results in a non-hierarchical artistic practice. From that moment on, objects are processes and every medium is an extension, an occasion, something valid in and of itself, as well as beyond itself.

The mass media burst into artwork as material, concept and system. The work of art becomes a density of circuits in which physicality and technology are closely intertwined. The resulting transformations, accumulations and reductions allow for both a real presence in the world and a slippage into another realm. The set of signs begins to define itself; made up of corporality and technology, hot and cold media – according to Marshall McLuhan's famous theory – where the multiform and the uniform are always an expression of the complexity that is the truest essence of the contemporary. One characteristic of artistic practice from the 1960s on is to create and follow connections between things that were previously separate. The work of art comes to reflect a polycentric, multidimensional world. "There is no longer *one* order. There is order in the universe, but there isn't one sole order."[1]

Among the various articulations of work in these new media, there is one distinguished by its originality in several contemporary tendencies. It not only finds a medium in the page itself and its progression in book form, but also a source of ideas and sensations, where its media-based aspects thicken and fluidise. The book as a work of art is created through a compression of language's specifics, the cancelling-out of all confines between media and what comes into, or out of, the page. In the book format we find words as ideas and as objects, a total absence and overflowing, the most radical conceptualism and the physicality of direct action. In, with and outside the pages, the artist makes the book an action, created either physically or conceptually, but always aiming to break all the media boundaries it both forms and transforms.

Because of this total intellectual freedom, I do not think it useful to repeat the genre's entire history here; rather, through a few of the countless examples crowding this area of artistic practice, I aim to retrace the mechanism of an idea. This idea radically crosses over many media and, as such, cannot be compressed into an object or category, but as *a concept* it is in continuous expansion.

Germano Celant rightly emphasised the influence that, from the 1960s on, books like John Cage's *Silence* have had on artists. "Silence can only be described with words. That's what inspired my idea of the book understood as a piece of music . . ."[2] Cage worked from *inside* music, and in the book found the ideal format for describing silence, its perception and its function as container of all life's pauses and sounds. The concepts of silence and indeterminism derive from Eastern culture, and here it is useful to recall that the 'form of formlessness', the 'emptiness of form' and how 'being is generated from non-being', are all fundamentally Taoist conceptions that then deeply penetrated Western artistic culture. The idea that emptiness and nothingness are the origin of every phenomenon, and necessary for being's formation – but also that absence is a presence and experience in and of itself, and acts as a powerful stimulus for some artists who then remain captivated by it and intuit the great potential of mixing it in to all that was taking place between Europe and America.

John Cage and Yves Klein, from the 1950s on, were among those artists; the proliferation of – and reactions to – their work were numerous. To what Klein defined as his "adventure into the immaterial, into the void",[3] Piero Manzoni replied with determination and coherence in his reduction of things to the concrete. In his 1962 book of one hundred white pages – and even more in the later *Piero Manzoni: The Life and the Work*, edited by Jes Petersen – in addition to the absence of signs and words, Manzoni dissolves the paper support, ably substituting it with transparent plastic sheets. Hence the book pushes its own sense of self-determined meaning to its extreme, subtracting words and images; transparency's consistency becomes the presence of many absences.

Klein, on the other hand, prints his own newspaper, titled *Dimanche*, transferring the transcendent tensions of his poetics into the most emblematic form of mass communication. Dated 27 November 1960, *Le journal d'un seul jour* is laid out like a normal newspaper. On the first page a photograph of his famous leap into the void, under the headline *Un homme dans l'espace!* jumps out at the reader; next to it is an article about the *Théâtre du vide*. On the remaining pages various texts and a few images deal not so much with the artist's works as with his increasingly broad theories about life. On the last page, down low, four photocopied judo moves remind us that Klein was a black belt. He also included some photographs taken the day of the newspaper's release documenting it on the newsstand alongside other dailies, and even a reader with *Dimanche* in his hands[4] as proof that the 'creativity of the void'[5] and

all radical concepts based on subtraction and the absolute, found, in mass media, a window

on the world that led to fundamental aspects of this whole artistic realm.

If aesthetic action becomes a thing, a fact, an event,[6] and the reproductive logic of the medium creates new, crossover connections for the work of art – connections that override all hierarchies and genre barriers – it must also be said that the characteristics of the book and serialised communication are rerouted by the artist toward a more discordant, divergent reading, rectified with respect to the usual uses of such technology. This shift introduces a pivotal difference for artists and books, as they always operate outside of any rules, even if they make use of all rules.

When an artist's work assumes characteristics that are utterly similar to the average commercial product, the way in which it is put to use is what alters the meaning of the work itself. In 1962 Ed Ruscha realised the first in a series of books, then published in 1963 under the title *Twentysix Gasoline Stations.* This volume contains twenty-six black and white photographs of petrol stations in various states of the USA. There are no accompanying texts, no theorisations, just bare-bones captions noting the brand of petrol and geographic location – nothing more. The importance of what Ruscha is doing is substantial; it is no coincidence that many artist's book specialists cite that volume as the start of it all. Ruscha does not manipulate the photographs in any way; he prints them on plain paper and, as with the later books in that series, he takes a documentary approach. Documentation of the ordinary, the quotidian: from filling stations to car parks, pools to buildings; the central idea is to make the normality of everyday things, their artistic insignificance and a simple printed form of documentation coincide with the art system. Regardless of its affinities to pop art, such as the selection of familiar subjects, Ruscha's undertaking sharply departs from the alterations Lichtenstein, Warhol and Oldenburg carry out in the structure or exhibition of a given image. In *Twentysix Gasoline Stations* and the following books, the artist's work presents itself with a wilfully neutral tone, without any artifice, and the book's meaning is entrusted not to its aesthetic characteristics, but rather to the universality of the relationship between a medium chosen in advance and the anomalous intentionality of the artist. Ruscha therefore acts on a plane quite different from the majority of artists, even conceptual artists. He is among the very few to have created an absolute equivalence between the use of a current, 'mediatised' language and its meaning as a work of art.

In a 1978 interview, just a few months before his death, Harold Rosenberg observed that art "has become a field outside of any field".[7] That happened the moment that art, interpreting the world, *became* the world, and assumed all its media-based tools and devices. So art left its own field not in order to occupy some other field, but rather to spend some time in a nomadic, fluctuating identity, bound to the uncertainty of its own ability to be identified. As soon as Daniel Spoerri published a little book – in 1962, in Paris – titled *Topographie anecdotée du hasard* using the printed page to bring the world of objects into contact with memory, he created a communicational mix that had never been seen before. The book describes the eighty objects arrayed on his hotel room table at a given time on a certain day and, with the exception of a drawing mapping out the object's positions, the book consists entirely of text. The text unfolds on two levels: meticulous description and memory-based associations. The list and personal remembrances are differentiated typographically. The drawing has a determinant function: it does not portray the objects, but outlines their perimeter and position. It thereby becomes a device hinting that the word-based descriptions can be related to a spatial organisation, and further allows the mapping of the objects to float within the space of memory. Spoerri's book, unlike Ruscha's, relies not upon the immobility of the image, but rather upon the movement of things, their coagulation and dissolution.

This is one reason the book format, returning and reformulating itself over the years, became a favourite of the Fluxus group, as can be seen in the work of Robert Filliou introductions by Dick Higgins in the 1966 publications by Something Else Press. Spoerri himself even participated in the festivals organised by Fluxus – a movement that played a central role in establishing a very widespread, variegated multimedia approach in that period. The entire dada legacy was put to use in the creative ferment of the 1960s, where the concepts of non-art, chance and indetermination manifest themselves in a mutual grafting of happening and books, music and video, with the declared intent of creating an incessant, absorbing flux and flow between art and life.

One book in complete harmony with the Fluxus sensibilities, understandings and intentions – aimed toward creating a transgressive, diagonal crossover art shaped by the direct contact with the events of everyday life – is the edition titled *Moi, Ben je signe*, 'cyclostyled'[8] by Ben Vautier in 1962. Paper normally used for wrapping food is here used as a support for autobiographical annotations, project ideas and designs and various declarations, as well as a wine label, a vinyl disc, a postcard etc., all directly glued to the paper. These pages are not bound, and carry the warning that the edition is neither numbered nor signed – supporting an ideal of free circulation, an alternative to the economic system of art, which was so present in the intent of the first artists who made books, although the book format was soon inexorably sucked back into the world of collecting, subject to the rules of the market.

Andy Warhol's Index (Book) is the result of a different experience, focussed on the density of information and redundancy of images and references. This book, from 1967, reflects the atmosphere of the Factory, the creative laboratory Warhol founded, where life and work merged in the production of artworks. In this sense, *Index (Book)* ventures beyond the usual features of pop objects, precisely because it reveals a broader cultural and existential climate. Behind the cover, printed on aluminium foil, are a series of texts and black and white photographs, with a harsh contrast in light and layout that transforms with each page, thereby heightening the images' impact. The images were taken from his films, and range from various provocative scenes of life in the Factory to scenes of an isolated beauty. This intertwining of lived, 'mediatised' daily life are overlapped with three-dimensional pop-up inserts. An aeroplane, a disc by Lou Reed, a jar of Hunt's Tomato Paste, a medieval castle etc., accentuate the paradoxical connection of messages, indifferent to fact and event, immersed in effects and impressions.

Books as works of art do not contain the history of things, facts, events and ideas, but are in and of themselves things, facts, events and ideas. The serial, impersonalised procedures of minimal art, the linguistic definition of concepts freed from the phenomena-based implications of conceptual art, see the book as a container particularly suited to its contents. The book's clear convergence with the modular, procedural aspects of minimalism is understandable, as the book itself is modularly constructed object. But its nature as a forum for theoretical, analytical, project-oriented work – and certainly its ability to make even the most abstract developments of conceptual thought materialise – is what makes it such a coherent, efficacious medium for these movements. Sol LeWitt repeatedly proved the consonance between the space of the page and his way of thinking about art. For example, his *Four Basic Kinds of Straight Lines and All Their Combinations in Fifteen Parts* and *49 Three-Part Variations Using Three Different Kinds of Cubes*, both from 1969, confirm the importance he attributed to the moment of ideation, and how the originating idea is, for him, already a work of art. His statement that "the idea becomes the machine that makes art"[9] is well known and extensively quot-

ed, but does not have the automatism and mechanical nature that many have detected in it

when isolated from a much more complex text. The intelligence and appeal of LeWitt's formulations lie in the fact that they go beyond the limits of the words and drawings in which they appear. To recognise a conceptual definition as *art* does not mean to negate that property in an object derived from that same definition. Contrary to the most radical conceptualism, LeWitt's effective and original position was precisely the fact that he considered art both a concept's delineation and an object's self-definition, distinguished by their essence, presence and perception.

The similarities and differences between minimal art and conceptual art were almost symbolically announced in a 1968 book by Andre, Barry, Huebler, Kosuth, LeWitt, Morris and Weiner. They used a Xerox machine to create sequences of personal pages. In the most intransigent conceptual thinking, the minimalists' act of emptying physical objects of all artistic, expressive character leads to the very absence of the object. Here we are obliged to mention Lawrence Weiner's *Statements*, the 1968 book that signalled his desire to present written declarations as works of art. The passage from general considerations to detailed ones, work proposals that can be realised or not, by the artist or by others, intentions and statements – everything assumes the bearing of a mental process begun by Weiner but absolutely open to any and every possible interpretation or development.

Art as a reflection upon the nature of art – be it carried out in an exclusively linguistic fashion or in broader ways, allowing for the inclusion of other forms of communication – widens and reinforces the book's many functions. Even Joseph Kosuth's investigations, crucial to conceptualism, are for the most part built on pronouncements that make writing itself the connective essence of the works. Contained in a book, inserted in a newspaper, hung up as a poster, made into an object through the use of neon or spread out as an installation, art theory becomes art practice. The most active and proactive forum for conceptual work and the debate surrounding it was the magazine *Art-Language*, first published in 1969. Its role as a research laboratory and means of distribution for conceptualism remains fundamental, and it is still useful for contemporary reflections on art.

Regarding the relationship between artists and books, conceptual radicalism was a serious immersion into non-production, a step that, inhibiting body- and object-based expression, opened up a universe of possible worlds. Later returns to body- and object-based work were not conceived as revivals, but rather as new perceptions. The intertwining of conceptual practices that are not exclusively self-referential, but make allusions to or have comparisons in the world of phenomena, proves this fact, and distinguishes these artists and their books. On Kawara and Christian Boltanski, with different methods, both create records and reconstructions of their personal lives. Giulio Paolini, with *Ciò che non ha limiti e per sua stessa natura non ammette limitazioni di sorta* (That Which Has No Limits and by Its Very Nature Admits No Limitations Whatsoever), published in 1968, expands the names of real people into a sign- and alphabet-based abstraction, hence they become indecipherable to anyone who is not familiar with them. Identities remain suspended in the rarefied space of the page; the names remain empty. Organic coherence and abstraction are highly present in *Fibonacci 1202. Mario Merz 1970*. Fibonacci's mathematical ideas are effectively tied to generative aspects of nature, and Merz pushes their dynamic, spiralling forms beyond the page's margins, turning numbers into signs of life.

Mind and nature confirm one another's existence and mutually make use of one another in a multidimensional artistic practice. Niele Toroni, with his 'impronte di pennello n. 50' (brush imprints, no. 50), crosses the pages of a book, transforming a repeated gesture into a concept. Even painting finds an 'extra-territoriality', a foreignness of sorts that allows it to be- 273

come a medium outside all rules. Buren, Cucchi, Gastini, Griffa, Kiefer, Knoebel, Paladino, Tremlett et al. have shown how the book can become a continually evolving theatre of possibilities.

If art's identity lies in its diversity and otherness, just as its language lies in its plurality, it can also be said that the immersion of natural and artificial phenomena – the fact of art being material and digital – into an indistinct state expands its perspective, simultaneously reducing its consistency and efficacy. In an a-centric, multimedia world, art can easily lose itself and accept an ornamental fate, or become an aesthetic action that connects ideation to knowledge, specialised language to real existence, where the artist's work is a thing, a fact, an event – and forms the future.

[1] E. Morin, *Il metodo*. Milan: Feltrinelli, 1983.

[2] G. Celant, "Book as Artwork 1960/1970", *Data*, 1, September 1971, quoted in Ibid., *Off Media. Nuove tecniche artistiche: video, disco, libro*. Bari: Dedalo Libri, 1977.

[3] Y. Klein, *Il mistero ostentato*, texts edited by G. Martano. Turin: Martano Editore, 1971.

[4] This photographic documentatin is also included in the catalogue *Yves Klein*, J.Y. Mock (ed.), Paris: Centre Pompidou, 1983 and *Yves Klein*, B. Corà and G. Perlein (eds.), Prato: Museo Pecci, 2001.

[5] Y. Klein, *Il mistero ostentato, Op. cit.*

[6] Translator's note: several times in this essay the author refers to art and aesthetic practice as *un fatto*. This term has an ambiguity in Italian that cannot be rendered in one sole English term, as it is both a noun (a *fact* or *event*) and a past participle (of *to make* or *to do*), hence I have rendered it as 'a thing, a fact, an event' in English, as all of these manifold meanings apply.

[7] H. Rosenberg, *L'arte è un modo speciale di pensare*. Turin: Umberto Allemandi, 2000.

[8] Translator's note: the author uses the term *ciclostilata*, literally 'cyclostyled', by extension referring to the production of multiple copies.

[9] S. LeWitt, "Paragraphs on Conceptual Art", *Artforum*, 10, June 1967.

Marco Senaldi

Tele-aesthetics: Between Television and Art

The 'Televisual'[1]

If film is the 'twentieth-century eye'[2] and if, extending the metaphor, the Web could be considered the 'twenty-first-century mind', as it embodies the concept of a network of minds, what organ in this allegorical anatomy would correspond to television? TV cannot also embody the twenty-first century eye, because the function of structuring, training, surprising and even perverting the eye and its gaze has already been fully satisfied by film. Everything that to a greater or lesser extent is connected to the gaze – the role of who wields it and who is its subject, the position and forms of looking, even looking without seeing (as is the case in Guy Debord's white film, *Hurlements en faveur de Sade*, 1952) – has basically been explored in film, though film is nevertheless profoundly distinct from the typical media-based aspects of television.

Television, which is often confused with the television set (that is, the final terminus that receives it) and video (that is, the technological medium it uses), is a bona fide communicative system equipped with a specificity that cannot be attributed to any other medium. In part because of its relative newness, and in part because of the difficulty of more deeply developing a television-based language, TV is, among all contemporary media, the one that critics and artists have most grudgingly granted an aesthetic status – the one that has least been considered an art form and, therefore, has been least used for artistic ends.[3]

If photography, after the initial opposition of artists and intellectuals (from Charles Baudelaire to Jean-Auguste-Dominique Ingres), beginning with the historic avant-gardes, gained – at least in part – the statute of art, as most of film did, the same cannot be said of television. That very issue has never even come up with television, and no one really views it as an 'experimental' area that could be artistically interesting or useful. Besides, TV loses any

relevance and can be used artistically only as a *television set*, as object or medium, as a mass commercial good, a consumer good mainly to be used through sampling, not as an autonomous form of expression. From this point of view it likely behoves us to make some distinctions that, right now, most criticism tends to avoid – like the distinction between television (as a phenomenon) and a television set (as an object), in relation to the work of Nam June Paik. Paik's work, unanimously considered pioneering in the field of video art, is essentially based on the objective and object-based possibilities of the TV set, and should be considered (without detracting an iota from its value) essentially a *pictorial and sculptural oeuvre*. Even when Paik leans toward performance (as in his first shows, for example *Exposition of Music – Electronic Television*, 1963) or interaction (*Participation TV*, 1963, and *Video Commune*, 1970), he treats the televisual medium in a utopian way, not for what it is, but precisely for what it *is not* (it is not interactive, it does not have an aesthetic, etc.) and as such he is not interested in using it as it has historically appeared; in other words, Paik's work falls under the genre of artwork that *would not* be taken into consideration when speaking of TV's aesthetic influence.

Still, in addition to the fact that some important remarks have been made about certain aspects of televisual communication, from Umberto Eco's *Opera aperta* (1962) to Jean Gimpel's *Contro l'arte e gli artisti* (1968), it is fairly evident that – more than some presumed linguistic autonomy TV supposedly has – there has been, and is, a general influence (social, cultural, educational and aesthetic, not to mention others) of the *televisual* as a system of social mediation. Generally speaking, we can say that the *televisual* constitutes an entire expressive form that could be considered the *soul* of the twentieth century, and therefore – in part consciously, and in part not – it has influenced the development of contemporary arts in a way that is still incredibly tangible today.

Double Inversion

What, then, are the characteristics of the *televisual*? The first lies in its specific feature as *communicative 'inverter'*. In fact, TV has been the victim of an enormous ambiguity, since it has traditionally been viewed (obviously ever Marshall McLuhan's time, ca. 1964) as a medium, that is, as a communicative (or, worse yet, technical) channel that intervenes between transmission and reception; a view that is in turn based on the classic rules of communication as described by Claude Shannon and Warren Weaver. Inexplicable and paradoxical phenomena such as allure, emulation and viewer interaction have made it clear that such rules are not only limited (they circumscribe the medium's role to that of a 'neutral' communicative conduit), but also profoundly ideological (they hide the communicative impact on the reciprocal positions of transmitter and receiver).

Here we must return, vice versa, to the famous definition Jacques Lacan gives of the communicative process; according to him, in a communication "the transmitter receives from the receiver its own message, in inverted form".[4] In other words, for Lacan communicating does not at all mean 'broadcasting' a message from a transmitter to a receiver via a transmission channel, but rather 'communicating means *receiving back from the receiver* our own *selfsame* message *in an inverted form*, that is, its *true* form'. 'Receiving back from the receiver' means that the message is not some specific content, but 'the very act of sending a message, whose addressees, in the final analysis, are ourselves'; 'our own *selfsame* message *in an inverted form*' means that the *true* meaning of communication must be frustrated, captured and launched back to us 'reversed' in order to be fully grasped (the other, the receiver, is nothing more than a mirror, or better yet, the impersonal monitor that witnesses

and replicates this same 'communicative' process). One could think that such a model is typical, above all for the forms of neo-television like reality shows, in which viewers 're-ceive back' from the medium their own content (their real life) in inverse form (spectacu-lar). In reality, this model has rightfully belonged to television since before its inception, as Orson Welles's famous radio broadcasts from *The War of the Worlds* attest, anticipating the involvement that is now typically *televisual*. What American citizens heard delivered on the radio that 30 October 1938 was substantially their own unease with the global situation, reversed in a science-fiction that they took as 'authentic' (with quite well known conse-quences). This 'boomerang' communicative model (which for Lacan takes place in all com-munication between subjects) is then assumed as the fundamental form of TV/televisual communication.

The key artistic example of this type of inversion is seen in Bruce Nauman's *Live-Taped Video Corridor* (1968–1970). It is a corridor the viewer can enter into; as Nauman explains it: "On another support, there's a video camera installed high up, above the corridor en-trance. The video camera has a wide-angle lens. When you enter into the corridor, the video camera is behind and above you. Little by little as you approach the monitor, your own image – or the image of yourself seen from behind – you are getting farther from the video camera; so that on the monitor you're getting farther from yourself, and the closer you try to get, the farther you get from the video camera, and therefore from yourself. It's a com-pletely bizarre situation."[5] This installation triggers many types of reflection. First of all, it is a work where videotaping comes into play, and this is already, in and of itself, an im-portant innovation on the level of using non-traditional media languages. This is even more relevant if you consider that the video is not used to realise a narrative or pictorial effect (as happened in cinematic filming and, in general, in video art), but simply to tape any users who happen by, who thereby become the consumers and consummators of an aesthetic process they themselves triggered. *Video Corridor* sets our habitual way of relating to the TV/televisual medium into crisis: in place of a peaceful, domestic relationship between mon-itor and spectator, Nauman introduces a movement dictated by the desire to see better, but governed by a taping the spectator (at least at first) is unaware of, and which results in the disconcerting experience of seeing yourself taped and 'not recognising yourself' in the video image. It is almost a visual and experimental paraphrasing of the Lacanian idea of communication.

The Beauty of Live Broadcast

From this first feature of inversion (or, better yet, of obversion) comes a second feature, al-ready indicated by Eco – the 'flow', *live* broadcast. Broadcasting events in real time, live, in such a way as to make us ocular witnesses (even if through the media) of an event, is a ma-jor point dividing TV from film, because the TV is no longer just the gaze, the eye, the tool of the gaze, a partial object endowed with a unique sense. Rather, television, insofar as it is a spatio-temporal gathering of events, is a sort of 'common sense' in the Aristotelian sense of the term, a *sixth sense* that cannot be reduced or compared to the other five, because it is not tactile like sculpture, aural like radio, visual like film and so forth, but encompasses them all. It is a relational vector, with a two-fold meaning in the relationship between the various sens-es and the relationship between who produces and receives the sense.

So it is true, then, that TV is not film, because it is a flow, and with live broadcast it allows us to perceive feelings, the soul of the world, but also implies that TV *is not* just a mass medi-um that objectively informs the subjects; it is not a window on the world (which is instead a 277

prerogative of film), but instead *is* a window on man, a window open on the interior, not the exterior, and therefore a space of self-reflexive communication. TV/the televisual is, then, this universal 'soul' that inverts the 'communication of events' into the 'event of communication'. In this same regard, we must also observe that in all likelihood the first person to have noticed this event structure was Martin Heidegger, in his *Die Zeit des Weltbildnis* (translated as *The Age of the World Picture*), a text that should certainly be snatched and distinguished from his nostalgic, backward-looking, decadent thinking and be fully reread in light of its contemporaneity.

In the same years that Heidegger was giving his lectures (1938), people began to talk about television and the 'globalisation of the event' becomes reversed in the 'world's becoming an event'. Heidegger also speaks about this in his *Der Ursprung der Kunstwerkes* (translated as *The Origin of the Work of Art*), and it is extraordinary that he connects this process of the world becoming image to the work of art that must 'become an event'. When Heidegger says all that, he is not simply referring to the performative event – a concert or theatrical piece (which are in any case more 'immersive' than a painting or sculpture) – but he refers instead to the work of art as an event, that is, to the *actualitas* of the *ens actus*, the unfolding of the present.[6]

It is also no coincidence that Heidegger brought, as proof of the world's process of becoming image, 'the representation – through a simple radiophonic knob – of distant worlds in their everyday states', the very same year as Welles's notorious production. In 1936, it is worth noting, the first television broadcasts began, with encouragement from Adolf Hitler, and in the same year the first experimental television station in the USA came into being, while in England the BBC launched its daily news broadcast on 2 November. The last futurist manifesto, *La radia*, was penned a few years earlier, in 1933; it foresaw the advent of television understood as "a new art that takes off where theatre, film and literature left off", in which it will be impossible to 'frame' the scene's space, thus becoming "universal and cosmic . . . an art without time nor space, with no yesterday and no tomorrow", made by a group of noises captured by transmitters spread round the globe, where even the "interferences between stations" and silence will be part of the total work of art thus created.

It is interesting that just a few years later, in 1948, this idea, which pertains specifically to the TV/televisual real, was explored chiefly by the spatialists with the *Secondo manifesto spaziale* (Second Spatial Manifesto), in which they assert that the spatialists will broadcast "on radiotelevision, artistic expressions of a new sort". Later on, with the *Manifesto del movimento spaziale per la televisione* (Manifesto of Spatial Movement for the Television, 17 May 1952, signed by A.G. Ambrosini, A. Burri, R. Crippa, M. Deluigi, De Toffoli, Donati, G. Dova, L. Fontana, Giancarozzi, V. Guidi, B. Joppolo, La Regina, M. Milani, B. Morucchio, C. Peverelli, Tancredi and V. Vianello), they clarify this concept of space – no longer understood as the space of artistic dynamics, exhibition space, architectural space, but rather as *space* in the cosmic-modern sense of the term, like the space of outer-space voyages, space of radiations, of tele-transmissions (and distant broadcasts) and, therefore, of its televisual aether. In this sense the spatialist manifesto is pure genius, because it grasps onto the televisual as a concept that changes space-time far beyond Einstein's innovation, giving the curvature of the communicative event to both space and time; and that is precisely the type of space the spatialists intend to work with. In fact, some manage to do so – Lucio Fontana, for example, who that same year produced some broadcasts for RAI[7] (these have since been lost) that were intended to be seen as 'television-based works of art' broadcast live on national TV. This approach can also be found during that same period in John Cage's *Radio*

Music (1952), which is practically an ecstatic whirling around various radio channels by simply turning the knob: a 'piece' that cannot simply be 'listened to' and is impossible to record because each time it is performed anew within the space of radio waves. From this perspective it becomes clear that TV is greatly indebted to radio, and that what one of the world's most acclaimed video artists said is true – according to Bill Viola – that while film derives from photography and has a completely different genealogy, "video and TV have more to do with radio".[8]

This notion of live broadcast, of a continuous *flow*, is never lost, and we encounter it once again in the ideas of German gallerist Gerry Schum, who in 1968 invented the famous *Fernsehgalerie* (the television gallery) and imagined that TV reproduction would change not only the gallery's statute, but also that of the artists themselves, who would then be able to work on video pieces and survive thanks to the proceeds from the rights of such works, as was already happening in the musical field. So for Schum, it was as if music, for example with Cage, had paved the way that would then be followed by visual artists with television. Naturally, this is not what happened, but perhaps now we can say that Schum's utopia was not wholly impossible, and that this idea of copyright, in some way, could also be a part of drawing up a more feasible future for certain types of artists, albeit in light of subtracting the work of art from its technical 'irreproducibility'. Perhaps today this battle is more open than ever before.[9] The theme of live broadcast crops up in many other interesting experiments, like Allan Kaprow's *Hello* (1969) with him greeting himself from one television station to another in a sort of interaction, a happening, played out in the media-based field; and also, in a much more aggressive, brutal way, but extraordinarily strong as a work, Chris Burden's famous *TV Hijack* performance, in which the artist, invited to a TV talk show, takes his interviewer hostage, transforming the broadcast into a bona fide artistic intervention (1978).[10]

And anyway, Welles's *The War of the Worlds* already had the same structure as a live television news broadcast about Martians landing, and took the form of a media-based performance. This characteristic of TV/the televisual continues to return, in artistic relapses and spin-offs. One example, among others, is the fact that in the in the seventies (specifically, 1972) what was perhaps the first real taping of an event broadcast live on national TV – John Wojtowicz's bank hold-up, which for hours on end kept America riveted to the small screen (Italy experienced the same thing in 1981 with the Vermicino case). Also interesting to note is that the American bank robbery was first made into a film, Sidney Lumet's *Dog Day Afternoon* (1975) and then, almost twenty-five years later, the same event inspired a video art piece, Pierre Huyghe's *The Third Memory* (1999). Even if Huyghe frees himself from the use of live broadcast, he cannot fully get away from the idea: indeed, the 'third memory' of the title is linked to the fact that the robbery had already become something else – the subject of a 'media event'. Once again, the concept of live TV broadcast reached its apotheosis with the classic example of September 11, 2001. Not only did the event itself, the attack on the World Trade Center immediately become a live broadcast that had the entire world glued to this wholly media-based event; what is less known is that the same event immediately produced an artistic operation. The work in question is due to the artistic practice of Wolfgang Stehle, who was having a one-man show at an important New York gallery at the time. The piece involved the live taping of the Manhattan skyline. The taping was fed by a few fixed webcams that sent images back to the gallery, where they were projected in large format on the walls, creating a sort of live landscape-event. The idea took up the style of several websites that globally broadcast live tapings at famous locations. While these web-cams clearly have their preferred location on the Internet, the concept of live broadcast that inspired them 279

evidently comes from the field of television. And it just so happened that Stehle's web-cams 'by chance' taped the attack on the towers. By chance because they were not specifically aimed at or intended for the Twin Towers, but rather took in all of the New York horizon; yet it was not entirely by chance, because, after all, they were like several eyes, wide-open to anything that could have happened – from the most minor event (birds flying by, a white-capped wave in the bay, the city street lamps turning on and off), and instead ended up capturing an event as catastrophic as September 11.[11] Along this same vein we can also cite, for example, the work of Carlo Zanni, who created made-up landscapes whose outlines (the profile of mountains, colour of the sky etc.) are brought to life according to the live fluctuations of economic transactions on eBay (*eBay Landscape*, 2004). So the fact that live broadcast has an artistic value is undeniable. In fact, it has a first-rate, highly important aesthetic value, not only in the sense Umberto Eco theorised about in the 1960s, for involving the viewer, but as a new cultural, space-time[12] dimension of a work of art. Here the opening intuitions of the *Manifesto del movimento spaziale per la televisione* – that is, the idea that "for us, television is the medium we were waiting for to unite all our concepts . . . [A] spatial manifestation, destined to renew the fields of art . . ."[13] – went on to marry the truth of media-based events. Such events, however, paint a rather less tranquil picture, more unsettling, in which media events are catastrophic, but at the same time that catastrophe provides quality, content, depth and breadth to their vague, purely formal look – it provides a Kantian transcendental quality, a Heideggerian proposition according to which the work of art is the occurrence, the *eventum* of presence.

Interpassivity

Next to this feature of the event another feature emerges which determines not only television's structure and aesthetic, but can also be transferred to artistic practice: *interpassivity*. In other words, while film allows us to remain aware of our role as viewer – that is, we know that the spectacle is active and productive, while we are substantially passive (and we've grown increasingly so thanks to the "institutional modes of representation"[14]) – with regard to the new media people often speak of *interactivity*, implying that communicative content and structure are determined or affected by the user, and the user therefore does not limit himself to passively consuming these media, but actually proposes them, makes them circulate, determines them and, to some degree, 'activates' them. Television, on the other hand, being between these two poles, could be described (taking Slavoj Zizek's suggestion[15]) as yet another pole – that of a *doubly passive* interaction. Why a doubly passive interaction? Because TV is, in a certain sense, the opposite of interactivity: its contents are proposed by the spectacular pole, but often imply the viewer's presence within that pole, a sub-species or cross-section of the public in the TV studio, like, for example, in the talk show format. On the other hand, the public that stays at home, thanks to the presence of the public in the studio that in some way implicates and involves them, feels exonerated, so to speak, from actively participating in the event. So while in film the viewer's passivity is compensated for by a sort of activity, an involvement, their act of taking a conscious position leading to discussions, interventions, reflections, indignations, censures etc., and on the Web the user's activity is necessary for the medium's very existence, all this, in the TV system, is infinitely postponed, in a sort of passivity squared – passivity raised to the second power. TV and the televisual are places of pure consumption, which on the one hand implies a production of media-based objects that have already been consumed, and never have a feeling of total newness, because (as we have already said) television can only rarely play a role of authentic experimentation; on the other

hand, these products are consumed by a public that is itself already 'consumed', ready to chew something predigested that does not entail any subjective interpolation, any real responsibility. The TV/televisual medium, then, in this sense, perfectly embodies the condition of spectacle, as was already clear to Guy Debord and the situationists. The society of spectacle is not a society that 'creates spectacle' in the ancient sense of the word, in the sense of the ancient Roman world's 'spectacularity', or spectacle in the sixteenth- and seventeenth-century public executions; it is instead a 'spectacularity' in which spectacle is something routine, passive in its very nature, something that must not provoke any reaction, and if anything it must inure viewers. It is a way of making all forms of exception passive, and it is the normal condition of contemporary society made passive by these subjects; in this sense it is a redoubled passivity.

With interpassivity the site of spectacle is seen as a place of subjective destitution, debasement, reduced symbolism, lightened subjects, such that spectacle no longer counters a non spectacle, a real work day, but is rather a delayed day off, indefinitely prolonged, it is spectacle as non-spectacle. As one example of interpassivity Slavoj Zizek invokes the prerecorded laugh track heard on many TV series; through them the viewer is relieved of the 'hard work' of laughing, of really being entertained and having fun, because the laugh is already programmed into the passivity of the spectacle itself, it is a foreseen reaction that 'passivises' itself.[16] In my state of interpassivity I am so passive that someone else 'does it for me', and that someone else is no longer an Other in the institutional or symbolic sense, but it is someone else with a different character – a spectral other who makes me passive, the spectre of the other person who has fun in place of me having fun. So in what sense, then, do we see an artistic spinoff, an artistic fallout of all that? In two different ways. On the one hand, television is considered an unacceptable medium for art because it does not leave room for experimentation and is therefore an essentially dangerous place, a place we must essential defend ourselves from. This is the reaction that emerges above all in the 1950s and 1960s, years of protest and the situationist analysis of the society of spectacle so effectively pointed out in works like the oeuvre of Wolf Vostell, who takes a TV set and buries it or shoots into and destroys one (TV Burying, 1963). All these actions against the TV set are actions against television, in which the artist takes the viewer's terminus (the object, the TV set) of this system of interpassivity and reacts to it with an activity that, unable as he is to directly strike the heart of this system that does not even seem to exist (physically), strikes only the distant end of one of its branches. On the other hand, there were attempts at domesticating it, like Joseph Beuys's famous performance Filz TV (1970), in which he covered a TV set with felt, a material that, read according to his poetics, indicates something that heals, calms, tames (in this sense another performance also gained him major fame, I Like America and America Likes Me, in which he went up against the quintessential wild North American animal, the coyote, and tried to tame it by dressing it in a felt cape of sorts). Here the wild animal, fruit of culture as opposed to fruit of nature, is called television – a ferocious beast that we must somehow turn off, or tranquilise by unplugging it. This reaction, obviously, would be unthinkable with regard to film: we could never even conceive of a 'Filz Film', because, if anything, film was used by the historic avantgarde as an active alternative medium, while here the artistic reaction is a full-on frontal attack. Even the situationist critiques of television, their creation of counter-spectacular situations in daily life, are clearly reactions aimed at avoiding the dominant interpassivity of the televisual spectacle.

Conversely, others have thought that this form of interpassivity is, deep down, a typical form of contemporary aesthetic enjoyment. The most visible case of this is Andy Warhol and his

Andy Warhol's TV (1980–1987). Warhol's TV must be carefully considered, because it is an utterly unique instance in the relationship between art and television. In fact, it is the first and (at least so far) only case where an artist does not limit himself to entering into television as a character, outright refusing the system altogether, or even assaulting the TV set as the concrete embodiment of a visible power dominating all humankind. In the Warholian view, it is not a question of appearing or disappearing from TV images, but rather a matter of seizing the system's reigns from within, of *making* television as an artist. Warhol's film, if you think about it, is a very TV-oriented, televisual type of film – quite detached – which sets the very notion of cinematic enjoyment into crisis. And Warhol's statement that "film does more than theatre can . . . and I think that television will do more than film", is already quite famous.[17] Warhol manages to put his expectation that it will do 'even better' into practice at the end of his long artistic career precisely with *Andy Warhol's TV*, which is essentially a talk show from which Warhol himself is symbolically absent. This work is clearly a riff on the concept of interpassivity, because it is the classic talk show in which nothing happens – actually, Warhol's original title for it was *Nothing Special* – in which the exceptional aspect of the work of art becomes that 'nothing special' that is television itself, this nothing we do not notice but which dominates our lives.[18]

This Warholian legacy had little following, but something happened. Here we must cite at least three examples: Christian Jankowski and his work *Telemistica*, presented at the 1999 Venice Biennale; Matthieu Laurette and his participation in several TV competitions (*El gran truque*, 2000); and Francesco Vezzoli, with his 'ready-made TV show' *Comizi di non amore*, 2005. Jankowski's work simply consists of the artist consulting a TV-based fortune-telling card reader regarding his future success as an artist; this creates a sort of masked form of interactivity, because in fact the spectacle does not give any answers, but rather throws them right back, and indefinitely procrastinates just like the fortune teller, tossing the questions back to the enquirer in the form he wants to hear. So this work was created as a reflection on the realm of the useless interrogation so typical of the TV/televisual era. Laurette's work is also an attempt at overthrowing the system of spectacle as manifest in prize competitions with a 'no-prize competition', distorting the end goal of the competition and exposing it for what it is; indeed, the end goal of prize competitions seems to be the goal of inspiring an imaginary desire to win when instead you lose, more than anything else. Therefore in Laurette's work losing is an a priori fact, as you go from a superior prize to an inferior prize, down to no prize at all, in a reversed escalation.

Vezzoli, on the other hand, must be discussed separately, because his piece *Comizi di non amore*[19] presents itself as a sample taken from TV, but is not a bona fide ready-made, because these 'comizi', these interviews, do not exist as such: it is not a real programme that gets broadcast, but is invented anew, based on the classic TV format model exhibited here as a work of art. But can a simple talk show really become a work of art? Warhol taught us it could, but with Vezzoli it just so happens that the same product is brought back in another context, an artistic context. This leaking out from the original context avoids a real confrontation with its opposite, which even here is assumed only long-distance. The opposite – the televisual – is imported into the exhibition space and once there takes on a different identity, that of the work of art. As it has not yet been broadcast, this talk show still has not undergone the trial by fire its opposite context would have provided, and therefore remains a nice little trial run, an almost calligraphic exercise of copying, a bona fide remake, but perhaps is not yet capable of being a real critique, from within, of the very system of TV and televisual communication.[20]

[1] Translator's note: this is a play on words. The author's original term is *televisivo*, which generally indicates something 'related to television', but according to its roots (*tele-* and *–visivo*) more literally means 'tele-visual'. He uses it with intentionally ambiguity throughout this essay, and I have left 'TV/televisual' or 'the televisual' to maintain the term's multifaceted nature.

[2] As Francesco Casetti claims (for the term 'l'occhio del Novecento', cf. F. Casetti, *L'occhio del Novecento. Cinema, esperienza, modernità*. Milan: Bompiani, 2005), referring to Michael Baxandall's 'period eye' metaphor about perspective (and painting in general) as the 'fifteenth-century eye'.

[3] "Many people think that TV isn't the best forum for innovative artistic practice." Cf. J. Decter (ed.), *Tele(visions)*, exhibition catalogue. Vienna: Kunsthalle Wien, 2002.

[4] J. Lacan, "Funzione e campo della parola e del linguaggio in psicoanalisi" (1953), *Lacan*, 1, 1974, p. 291.

[5] B. Nauman, *Image/Texte 1966-96*. Pairs: Centre Pompidou, 1997, p. 102

[6] Cf. M. Senaldi, *Enjoy! Il godimento estetico*. Rome: Meltemi, 2003.

[7] Translator's note: RAI stands for 'Radiotelevisione Italiana', the national radio and television company.

[8] B. Viola, *Reasons for Knocking at an Empty House: Writings 1973–1994*. Cambridge, Mass.: MIT Press, 1995.

[9] It is significant that, after the failure and closing of the *Fernsehgalerie*, Schum opened a *Videogallery* with the intent of distributing artist's videos in numbered, signed editions – a clear compromise with respect to the productive utopia of its early years. Cf. D. Daniels, *Vom Readymade zum Cyberspace*. Ostfildern-Ruit: Hatje Cantz, 2003.

[10] While it is true that the episode in which Burden set *TV Hijack* underway was not immediately transmitted live, his 'terrorist' action nevertheless directly struck the interviewer during taping, thereby reversing the common notion that recorded and live transmissions are radically different: even recorded work falls under the category of 'media event', and in the moment of broadcast it is, in a sense, live.

[11] Regarding this work, cf. M. Senaldi, "Il Ground Zero del godimento", in A. Moresco and D. Voltolini (eds.), *Scrivere sul fronte occidentale*. Milan: Feltrinelli, 2002.

[12] Translator's note: the author uses the term *spazio-tempo-culturale*.

[13] Cited in G. Celant, *Off Media Nuove tecniche artistiche: video, disco, libro*. Bari: Dedalo Libri, 1977.

[14] N. Burch, *Le lucarne de l'infini. Naissance du cinéma*. Paris: Nathan, 1999.

[15] Cf. S. Žižek, *The Plague of Fantasies*. London–New York: Verso, 1997.

[16] Ibid.

[17] Warhol 1967, in Aprà, Ungari 1978.

[18] Incredibly, the artistic relevance of Warhol's TV is only now beginning to gain attention (it was shown as a work of art in 2006 at Hauser & Wirth, London). For a close reading of it, cf. F. Carmagnola and M. Senaldi, *Synopsis*. Rome: Meltemi, 2005. See J.G. Hanhardt, "Andy Warhol's Video and Television", in A. D'Offay (ed.), *Warhol's World. Photography & Television*, exhibition catalogue. London, 2006, for an analysis of Warhol's absence from the screen and his capacity to make very different types of people interact – such as a director or artist with a politician or emerging actor. Such interactions show the society of spectacle's 'interpassion' (as opposed to interaction) with itself, and this is the only possible way Warhol could create action within the general 'interpassivity' (as opposed to interactivity) of TV.

[19] Translator's note: this is a reference to the 1963 work by Pasolini, *Comizi d'amore*, also titled *Love Meetings* or *Assembly of Love*, a series of interviews about love.

[20] Additional bibliography: J. Baudrillard, "Videosfera e soggetto frattale", in *Videoculture di fine secolo*. Naples: Liguori, 1989; S. Bordini, *Videoarte e arte*. Rome: Lithos, 1995; D. Daniels and R. Frieling (eds.), *Media Art Action. The 1960s and 1970s in Germany*. Vienna-New York: Springer, 1997; G. Debord, *La société du spectacle*. Paris: Champ Libre, 1971; A. D'Offay (ed.), *Warhol's World. Photography & Television*, exhibition catalogue. London, 2006; U. Eco, *Opera aperta*. Milan: Bompiani, 1962; J. Gimpel, *Contre l'art et les artistes*. Paris: Editions du Seuil, 1968; M. Heidegger, *Holzwege*. Frankfurt am Main: Klostermann, 1950; W. Herzogenrath (ed.), *TV-Kultur: Das Fernsehen in der Kunst seit 1879*. Amsterdam-Dresden: Verlag der Kunst, 1997; M. McLuhan, *Understanding Media*. New York: Ginko, 1964; M. Senaldi, "Sorvegliare e sedurre", in A. Sigismondi and L. Bonfante (eds.), *Grande Fratello. Il fascino indiscreto del quotidiano*. Milan: Ricerca e Sviluppo Mediaset, 2000; M. Senaldi and A. Piotti, *Lo Spirito e gli Ultracorpi*. Milan: Franco Angeli, 1999; R. Silverstone, *Televisione e vita quotidiana*, ed. G. Mazzoleni. Bologna. Il Mulino, 2000.

Les cousins: Film and Artistic Avant-gardes

I.

"Film is a bearer of movement. / Film updates literature. / Film demolishes aesthetics. / Film is audacious. / Film is an athlete. / Film is the spread of ideas. / But film is ill. Capitalism has thrown a fistful of gold in its face. Capable entrepreneurs take it out for a stroll down the lane, holding it by the hand."[1]

In Vladimir Mayakovsky's famous 1922 text *Film and Film*, a montage of verses and political declarations, the fundamentally contradictory nature of the relationship between film and twentieth-century avant-gardes – both before and, in a somewhat different form, after World War II – becomes clear.

This contrast, between the revolutionary potential of film as art and language and the conformist monotony imposed on it by the economic system as spectacle and pastime, is visible throughout futurism (especially in Italy) and the reflections of many other exponents of the artistic avant-gardes in the period between the two World Wars. We find it in Marxists like Dziga Vertov and Mayakovsky himself: how could you miss the echo of the contrast between the freeing potential of the 'productive forces' and the stubborn resistance of the 'modes of production' to the social and cultural transformations that innovation brings with it? But we could also, and even earlier (in 1916), have found that echo in another political context, one rather different from the Italian futurist scene: "Up until today the cinematographer has been – and even now continues to remain – profoundly focussed on the past, while we see in film the possibility of a pre-eminently futurist art, and this means of expression is most fitting for the multiform sensibilities of the futurist artist."[2]

This same contrast later inspired the breakaway of Joris Ivens, who, after having directed an (extraordinary) documentary commissioned

by a large firm and titled *Philips Radio* (1930), systematically refused any commissions that were not politically in keeping with his line of thinking, and coherently accepted his place at the margins of film distribution circles. Or also the choices made by director Walter Ruttmann, who, after making documentaries as historically important as *Berlin: Die Symphonie der Großstadt* (1927), dedicated himself for several years to secluded research on *ars acustica*, the sound montages in which the filmstrip is used purely as a support for recording and editing voices and sounds, leaving the film-story form behind. Over the following years the opposition between film as a possible art form and film as an industry enslaved by money and banality grew to become part of a widespread feeling, above all among European intellectuals, and led to recurring idealised celebrations of the heroic cineastes and their wars against the ruthless commercialism of the large film producers.

Mayakovsky himself, however, had introduced a new nuance to the debate in 1923, complicating the issue: *"The oppressed will pull themselves up. / The oppressed themselves / with broom in hand / will cover / the many miles round the globe. / So anyway, / Mishka, / turn the crank. / Battle! Hello! / Universal sensation. / The last little thing. / Charlot with wings. / Airplane Charlot?"*[3]

What is the 'airplane Charlot' mentioned in these verses? Is it the pet of capitalism he had written of a year before, the backward-looking residue of Filippo Tommaso Marinetti destined to be swept away by the aesthetic and/or political revolution of the future? But then why does the poet (and prophet of the future) make such an effort to separate himself from Marinetti, while remaining fascinated by the projector's crank, turning it almost as if he could not, despite his best attempt, detach himself from it? Or is his comic and pathetic tramp, timeless and ultramodern, the sign of a radical novelty, an already revolutionary art? But then how do we explain his good fortune in a field so blinded by money and capitalism? For Mayakovsky, one thing alone is certain: film is a contagious force[4] that no one manages not to love, despite any discrimination between film as industrial spectacle and film as an art form ripe for discovery.

In truth, as soon as it appeared, film always occupied – in the twentieth-century system of arts – a position that was at once exemplary and equivocal. For the avant-gardes of painting, music, sculpture and installation, it was not only a morally and aesthetically contradictory creature, but an art that was simultaneously both near and different: it was the paradigm of a new, possible path for all arts, as well as a creative process that seemed irreparably distant, separate from all others.

Film as Paradigm

Film was (it is hard to deny, at least since stars like D.W. Griffith and Charlie Chaplin arose) a new art, unforeseen and astonishing, that came not from the conscious planning of a single person or group, not from the creative act of a poet or painter, but came about *ex machina*, from the very strength of the surrounding mechanisms: a new art whose 'modes of production' most artists, when not outright battling them, simply did not trust; yet this contagion inevitably caught up with even them, viewers among all the other viewers. "The image comes to light" wrote Maxim Gorky, underlining the fact that it was an authentic, aesthetically dense revelation, even just in regard to the surprise its invention inspired. It was an art that perhaps did not even need artists, given the strength of the cinematic mechanism itself.

Ever since then, every media-based revolution has generated – at least in some artistic circles – the hope for a new revelation, the hope that even fresher, more innovative, more contagious arts (or at least potentials for expression) would 'come to light'. That revelation came, in the 1930s, in the form of radio. This comes to mind in the tentative title Rudolf Arnheim gave to

his book, *Radio Seeks Its Form*[5]: the medium was invented, even if it had not yet found an adequately artistic expression. Musicians and dramaturges could perhaps midwife that form, but the medium would ultimately have to find it for itself. In those same years Bertolt Brecht conceived of a similar dream: the dream of a radio that, "born before the need for it was even felt", and therefore forcefully subjugated to artistic forms inherited from the past, would be freed on both aesthetic and political levels.[6] Unlike film, however, plans for a radio-based 'aural art' remained unrealised.

After World War II, the wonder of a new art born *ex machina* was announced several more times as media's many realms seemed to proliferate, propelled by some internal force: the prophets of concrete music and electronic sound appointed themselves the 'obstetricians' and exalters of the aesthetic potential in the 'large computing machines', well before the microcomputer became a banal ubiquity. Then, toward the end of the 1960s, came the advent of mass-produced videotape recorders, which swept through the world like a shock wave, beginning with some early works by Andy Warhol, who did not use video as such, but anticipated its characteristics, became closely linked with performance art and led up to the video work done by Nam June Paik, Bill Viola and many others. And again, with the dawn of the information age, personal computers and the Internet, an ephemeral utopia took hold, with its artificial reality and 'enhanced' – if not wholly virtual – perception.

Each time the heightened expectations recall that first revelation: the marvel of a new art, a new language born almost as if they spontaneously germinated in a place generally thought to be leagues away from the world of artistic production – in engineering laboratories – and that, despite any backward-looking tendencies, manage to contaminate the collective sensibility, spreading the contagion to the culture at large. Each time, the announcements were premature and disappointing, and expectations had to be lowered: new media seem to refuse artistic form and shun their artistic potential, as happened with television and radio even earlier – or they lend themselves only to marginal artistic uses, an interminable experimentation that runs parallel to more socially widespread uses without ever really bringing them into question. Now that the twentieth century has come to a close, it is time to recognise that none of these art plans ever had a 'Tramp'. Still, the recurring reappearance of hope after so many disappointments proves that the revelation of film has left a lasting mark on the aesthetic sensibility of an entire century, and perhaps beyond.

Film as Other

What sort of art was it that theorist Ricciotto Canudo called 'the seventh art?'[7] It was industry – in a world where the word art has assumed its modern meaning, implying a division between the beautiful and the useful as a result of the separation of industry from the artisan tradition. It is a collective product ("a painter works with the brush, a writer with the pen, the film director with an army" as Orson Welles said, though he was long esteemed as the tenth muse's genius creator par excellence) that can only be viewed as the product of one single creator if considered with a major slant, in a century where the art system so highly exulted the subject's figure and gesture. With a few marginal exceptions, it is a story, in a century where classic narrative is systematically suspected of deceit. With respect to the work of avant-garde painters and musicians, it represents a profoundly different reality, in terms of living and working conditions as well as planning and design conditions. It, too, could have its avant-gardes – in Russia as in Germany – but its novelty did not solely lie in the avant-garde's work, and often remained outside them: it was from this, not from the incredibly vital experiments of someone like Eisenstein or Vertov, that Mayakovsky struggled to detach **287**

himself; he saw the arrival of freedom in the 'Tramp'. Film is an art that seems to require, in order to be appreciated as such, criteria quite different from all the other arts.

A Redeemed World
Then there is another aspect that almost no one wittingly touches on but which should never be forgotten. In Siegfried Kracauer's original book plans for a title then published in Italy as *Film. Ritorno alla realtà fisica* (Film: The Return to Physical Reality),[8] he spoke not of return, but of 'redemption'. While Walter Benjamin saw in 'redeemed humanity' the true possible subject of history and, at the same time, free expression, Kracauer was interested in the redemption not of the subject, but of objects, including the men's and women's very corporeity. In film he saw the appearance of a language capable of penetrating and charging them with meaning, freeing them from the human gaze insofar as it subtracted them from the standardised, canonical gaze of pictorial and verbal conventions and unbound them from the lazy habits of the eye itself.

This is an aspect of film whose absence would prevent us from fully understanding the allure the medium has had throughout the century for successive generations of artists who have never made film: a way of looking capable of recuperating precisely those objects the eye of once figurative arts was straying far from, ending up at least as distant as they did from academic representations.

For several decades, from film's beginning up to the 1950s, the medium's inherent contradictions (well summarised by Francesco Casetti)[9] seemed both rich and remote to the avant-gardes of other arts. For a long time, film presented itself to those avant-gardes like a close yet unfamiliar relative, or a distant blood relation: like cousins, to hearken back to the title of a suggestive, innovative film by Claude Chabrol (1958).

II.
The nouvelle vague was likely a decisive moment of passage in the relationship between film and the avant-gardes. In order to understand this, within the larger history of twentieth-century taste and aesthetic experimentation, we must closely consider an event that split the country in two: the advent of television, a medium that appeared not with the marvellous (in the broadest sense of the term) characteristics of film, but rather came in the simultaneously reassuring and scarcely fascinating guise of banality – and similarly enveloped the moving image and editing, close-ups and the sound/sight dialectic in banality. With television, film lost part of the ambiguity it was so accused of by the futurists: with respect to the flow that Chaplin had far-sightedly called an indifferent and omnivorous conveyor belt, film began to show its text-based nature, that of a work subject to its own rules, but also capable of holding up over time.

At the end of the 1950s, the shock inspired by TV's appearance (a shock whose social significance Joshua Meyrowitz has shown better than anyone)[10] began to be metabolised and exorcised by a phenomenon so surprisingly global that it remains a historic mystery. This was the simultaneous birth of a 'young film' scene in many countries, with common features that cannot be explained merely by exchanges or relationships (which, if they existed, they would in any case have been limited and uncertain): from young Polish film to New American Cinema; from the vivid and rapidly suppressed ferment of the young Andrei Tarkovsky, Vasily Shukshin and others in Russia to Britain's Free Cinema; and from the most innovative period of Italian film to the French nouvelle vague, which represented the most programmatic

expression of those years and became the main point of reference on an international level.

Perhaps it is no exaggeration to call the nouvelle vague the last of the twentieth-century's historic avant-gardes: the last group of artists to theorise together and put into practice, in a radical way, the unexplored expressive possibilities they saw in the medium itself, challenging the mainstream not from a marginal position, but from a viewpoint that, at least potentially, held the majority. Nouvelle vague film did not limit itself to recasting the narrative standards of television, but recognised and metabolised, as we already said, the deepest innovations of the medium. The interminability of its narration shows this, as does its ability to mimetically represent the banal and decisive reality of everyday life, which does not necessarily have the same immediately perceptible meaning as the subjects of classic narrative tradition (where if you see a noose it is because someone will definitely end up hanged by it). Nouvelle vague film, while it did launch a new language, also reread the history of the entire medium from its own point of view: that was the project that from then on became the lifelong work of Jean-Luc Godard.[11] This is another mark of a project that is not at all marginal, and perhaps even held the hegemony.

From the 1970s on, film and the other arts grow closer again, both objectively and subjectively. 'Objectively' because in the new film/television dichotomy the former returns to nineteenth-century artistic tradition as much as the latter seems to be a foreign, almost alien, even overwhelming reality. 'Subjectively' because in Godard or Rivette other artists can recognise a figure that is certainly more familiar than a Lang or Chaplin, or perhaps even Eisenstein could ever have been. Also because, at least early on, during the filmmakers' political phase, while it aimed to explore the 'tradition of the new' hidden within film's past, it ended up applying the same, ultimately reassuring model of artistic subjectivity to film, making the director the creator par excellence. And anyway, the decision of a poet like Pier Paolo Pasolini to 'switch' to film, bringing his poetics to this other medium, is yet another sign of a convergence that would characterise all arts from then on.

In Europe this convergence found its outlet in an event that was not artistic in the strictest sense of the term, but certainly had major aesthetic significance: the revolution of 1968 which, with the impassioned participation of painters and directors, musicians and theatre workers, seemed – at least for a moment – to be the realisation of that dream of the total work of art, the idea of a *Gesamtkunstwerk* we have held ever since Richard Wagner coined the term, and also appeared to be a way to overcome the self-referentiality and futility that are always waiting in ambush in the arts, and radically change life.

On the other hand, it is also noteworthy that, at the time, artistic-political action did not appear in the guise of exploration or rich productivity, as had happened in another phase of fusion between a search for the new and revolutionary mobilisation: the Soviet 1920s. On the contrary, renunciation reigned supreme for a few weeks or years: painters became simple illustrators; poets squished their creative vein into prose-like verses, in imitation of contemporary voices of demonstration; French directors produce ciné-tracts, veritable leaflets made up entirely of (still) photography; and directors like Marco Bellocchio leave behind all their visual knowledge to create 'useful images'. It was as if the convergence of all arts lined up to achieve full self-realisation, on a sort of shared 'zero degree' level from which they could venture off anew, following a new relationship between the artist and society.

This experience was prolonged, for a good part of the 1970s, in the discovery of video, used both by political movements and directors like Jean-Luc Godard, musicians like Brian Eno and performance artists, up until the creation of an essentially unique piece – Alberto Grifi and Massimo Sarchielli's *Anna* (1975) – which, in the basic desperation that characterises it, is both film and video, fiction and real life.

In many writings from those years, the enthusiasm felt for video had accents similar to those that welcomed the invention of film: it was the dream of a medium as widespread and accepted as television yet as expressive as film, capable of recording reality without any strings attached, and therefore able to go beyond the surface, like a double of 'normal' perception that, as a doppelganger, shows us things through new eyes. It was the ideal medium for somehow giving greater duration to arts that, at this point, sought their own core in gesture and event, and no longer brought about works, but rather facts and acts. It became the most useful language for the productions of artists who had difficulty indicating which of the many arts they practised.

Nevertheless, born as it was at the convergence of film and the world we conventionally continue to call 'art', video perhaps marked the end. Ever since, film seems to have taken a different route – with its own experimentations carried out by a minority of filmmakers and its own indefeasible narrative vocation – once again positioning itself as a paradigm, with an inevitably different language than all the other arts.

[1] V. Mayakovsky, *Cinema e cinema*. Viterbo: Stampa Alternativa, 2006. To date there is no English translation of this text; here I have translated the title as *Film and Film*.
[2] F.T. Marinetti, B. Corra, E. Settimelli, A. Ginna, G. Balla and R. Chiti, "Manifesto della cinematografia futurista" (1916), in C. Salaris, *Storia del futurismo. Libri, giornali, manifesti*. Rome: Editori Riuniti, 1992.
[3] V. Mayakovsky, "Cinecontagio", in *Cinema e cinema, Op. cit.*
[4] Translator's note: the author points out that the composition quoted here is titled *Cinecontagio*, or 'Cinecontagion', remarking on film's contagious quality.
[5] Cf. R. Arnheim, *La radio cerca la sua forma*. Milan: Hoepli, 1937. See also R. Arnheim, *Radio*. New York: Arno Press, 1971.
[6] Cf. B. Brecht, "Teoria della radio", in *Scritti sulla letteratura e sull'arte*. Turin: Einaudi, 1973.
[7] R. Canudo, "Trionfo del cinematografo" (1908), in G. Grignaffini, *Sapere e teorie del cinema. Il periodo del muto*. Bologna: Clueb, 1989.
[8] Cf. S. Kracauer, *Film. Ritorno alla realtà fisica*. Milan: Il Saggiatore, 1962. This was published in English as *Nature of Film: The Redemption of Physical Reality*. London: D. Dobson, 1961.
[9] Cf. F. Casetti, *L'occhio del Novecento. Cinema, esperienza, modernità*. Milan: Bompiani, 2005.
[10] Cf. J. Meyrowitz, *No Sense of Place: The Impact of Electronic Media on Social Behavior*. New York: Oxford University Press, 1986.
[11] Cf. J.L. Godard, *Histoire(s) du cinéma: introduction à une véritable histoire du cinéma la seule la vraie*. Paris: Gallimard-Gaumont, 1998.

Andrea Branzi

The City Is a Computer Every Twenty Square Metres: Toward a Non-figurative Architecture

The relationship between design culture (industrial design and above all architecture) and the new media has not yet come of age. Up until now, this relationship has limited itself to a tool-like use of electronic means; that is, to the mere formal representation of design, and – in the case of multimedia communication design – to a collaboration according to the organisation and expressivity of the various information-based sites.

I consider this type of relationship wholly inadequate and retrograde with respect to the issues the design world faces at the dawn of the twenty-first century. Retrograde because this illustrative relationship to the computer occurs in the context of a tradition that confirms the exclusively figurative role of contemporary architecture: architecture understood as an activity aimed at creating buildings we might establish a visual relationship to, in a city that continues to be based upon solid foundations and enclosed by a well-defined perimeter.

The development of 'digital architecture' over the past twenty years has, in fact, focussed on the possibility of representing highly complex forms (like fractals) that have facilitated a return to the baroque, based upon a recurring misunderstanding in the form of a naive certainty that there must perforce be an immediate formal resemblance between the physiognomic (or technological) characteristics of a given period and the very shape of its architecture. Therefore, as 'machine civilisation' calls for a correspondent architecture, similar to a motor; as the 'speed age' calls for a correspondent aerodynamic architecture; this 'media-based civilisation' calls for a correspondent architecture made up of dynamic fragments, and so forth.

Hence a neo-naturalistic architecture developed at the beginning of the twenty-first century, one that simulates a formal continuity with natural phenomena to the point of almost absorbing, in its 291

own organic forms, their currents, energies and high complexity, and almost corresponds (in a metaphorical way) to the currents, energies and high complexity of contemporary society. So electronic technology, the profound forms of nature (fractals) and the amorphous, dynamic reality of contemporary society should be mirrored by an architecture that simulates, despite its structural rigidity, the complex formal codes of all those phenomena. It is a question of formulating a theorem according to which *technology*, *nature* and *history* would all have identifying points in architectural form.

And electronics, in current design culture, is not viewed as a technology that brings with it a new general epistemology; rather, it is only viewed as a producer of graphic services that – unlike older modes of representation – enable the description of complex organisms. In other words, contemporary architecture continues to view itself (and represent itself) as a formal code, a system for building capable of giving itself some exposure.

In still defining itself as a compositional and building-based discipline, it proves the mechanical root of its foundations, which refer to a technology based on the movement of bodies and displacement of volumes. It remains a discipline made up of money and formal metaphor; a formal discipline set within an urban terrain still designed and viewed as the material motor of human relations, which would be shaped by the layout of streets and plazas resembling a closed hydraulic system where people's physical bodies circulate.

The existence of a society that establishes intense interpersonal relationships through telematics – at a distance, independent of the city's physical form – is a reality that contemporary architecture still has not internalised.

This stance excludes architecture from the general transformations taking place within the city and in the vast majority of contemporary culture and economics. The city is no longer a *visible landscape,* and has instead become an *experiential territory* where the identity of places is not constituted by their buildings, but rather by the cognitive experiences that those places make possible: the information, products, services and people you can encounter there. Today the city has become an immaterial, abstract reality, a 'semiosphere' evolving within the empty shells of architecture. So the city is therefore a concave space, like an unlimited market of genomic exchanges and relational economies produced by widespread work and mass entrepreneurship.

Today architecture begins to pay for its historic delay with respect to all the other twentieth-century cultures (painting, music, literature) that courageously faced up to their own epistemological crises, venturing beyond the traditional confines of their own disciplines, confronting abstraction as the first and most evident sign marking the fall of old figurative functional codes in order to regenerate themselves by internalising their own codes. Modern architecture never faced up to this epochal watershed and continued to represent itself as the confirmation of its own institutional role.

The interior spaces of the city no longer have a clearly defined function, but can change their end uses through the simple substitution of their computer software. The struggle to optimally and definitively resolve a structure's functional issues (schools, hospitals, industry, housing) is now completely skipped over: people live in laboratories, teach in factories, trade in workshops, hold exhibits in gasholders. Under the apparent continuity of the urban landscape, everything has changed and continues to change. The city (like the computer) is an immaterial system in constant change; a 'functionoid' that adapts to multiple changes in use. The Athens Charter, drawn up in the 1930s to provide for a modern city organised into specialised areas through zoning codes (organised round functions such as

residential, work, leisure and an historic centre designation), was substituted by a homo-

geneous and flexible *texture* that accommodates all possible activities. The city has become a computer every twenty square metres.

This level of urban abstraction – a computerised, air-conditioned territory crossed by immaterial currents of information and relational experiences – has thrown the characteristic processes of formalisation in historic architecture, based on closed perimeters and systems of spatial identity, into a profound crisis. The contemporary metropolis has transformed into enzymatic territories where place has a low degree of identity and weak functional specialisation.

The urban scene is overrun by the movements of the multitudes (for the first time the global population has passed the six-billion mark) who express their own creativity like coloured molecules that, in addition to commodity-based scenarios and commercial messages, create an iridescent filter that steals the show from buildings and their frail puzzle-like games. Urban liquefaction floods interior spaces, blurs perimeters and fogs over differences, creating a sort of general semiosphere that evades design's control: a plankton made up of mutating microsignals that nourish millions of icons but do not ever really produce a 'new temple'.

The most evident symptom of this historic delay lies in contemporary architecture's writing systems – traditional geometric systems that express all a building's functional and formal rigidity. While the avant-gardes of over one hundred years ago radically renewed the ways poetry was written and read (i.e. the futurists), opening it up to the city's rhythms – and contemporary music adapted its old staff to new sounds, transforming it into a planar system or rhythms and signs to be interpreted (Karlheinz Stockhausen, Sylvano Bussotti, Luciano Berio, György Ligeti and many others) – architecture remained stuck with the idea of itself as a pure constructive building practice that largely excluded variants and more creative interpretations.

It is widely known that Wasily Kandinsky's first abstract paintings were musical scores and profoundly influenced Arnold Schönberg, sending him in the direction of atonality and clearing the limits of harmonic law. None of this happened in early twentieth-century architecture, which viewed the advent of 'industrial culture' merely as a chance to seek out new monuments, similar to factories and their machinery.

Architecture had to wait until the advent of the radical movement in the 1960s to carry out the first attempts at a new writing for the urban system. It took the efforts of Bernard Tschumi at the Parc de la Villette in Paris to finally track down digital experimentation that corresponded not to figurative criteria, but rather to a different way of designing a terrain.

Design culture still has not felt the impact of the deep transformations electronic culture is introducing into the very concept of space. Even the practices of contemporary design still suffer from their own formal limits, and have not managed to confront the decline in objects that information-based webs are progressively effecting; it is a slow yet profound mutation that modifies the philosophical bases of contemporary object design.

The authoritative Zingarelli dictionary defines an object as "all that the subject perceives as different from itself; the external world, as opposed to the thinking, knowing subject". This definition brings us back to the concept of an object as a presence that is different not only from the person looking at it, but also from its surrounding context. So it refers to the object as a presence that has no organic exchange or structural continuity with the surrounding space, but instead possesses an autonomous *raison d'être* and motive for functioning.

The object is, then, by its very nature recognisable within and separable from its context; whether it is mobile or immobile, the it is always set into a different space that then surrounds it, defines its confines and, consequentially, defines its identity.

The golden age of objects that was the twentieth century – that is, the century of mechanics

(in the sense of a technology and philosophy of the world) – always produced strong, concentrated objects, visible parts of a visible modernity (linguistics) that operated by violent contrast, in search of definitive solutions to old and new problems with devices (motors, archetypes of the machine age) aimed at fulfilling predetermined, clearly defined functions. If today we still think of the object – be it a design object or architectural object – we see something similar to a carter embellished with a few holes and buttons, which functions by producing noises and vibrations and asserts its uniqueness, originality and specialisation with respect to a context that does not possess the same exact degree of design. We think of an object that represents itself and responds to the dogma of the unified form/function relationship. Classic modernity produced an entire constellation of objects – of exceptions, of perfect functions, of recognisable signs. It was a constellation intense and vital enough to create a veritable 'object revolution', in the sense that objects became the true model of all that was postmodern, made up entirely of exceptions, discontinuities and autonomies. Toward the end of the twentieth century the world became a highly complex material system, no longer represented by the architectural metropolis, but rather by the object-based universe – that is, the dusty system of disconnected molecules gone crazy that, as a whole, represented the evolution of modernity outside modernity, beyond all rationalism, functionalism, common sense and even the urban realm.

The 'system of objects' even became the functional model for philosophy ('weak thought') and politics ('permanent reformism') following the collapse of general connective systems, made up of grand narratives and ideologies that left a dispersed series of fragments and tendons that no longer share any precise connection and describe a path or investigation that wanders about, searching within itself for its own *raison d'être*.

The 'system of objects' ended up coinciding with the 'system of products', that is, those tautological market presences that have not any shared direction and are animated solely by the energy of competition and pure expressive innovation. Even architecture, in the last decade of the twentieth century, began to become a system of products – objects made to be looked at from outside, that only live in polemical contrast to their urban context and function like the supports of a brand, a logo, an entrepreneurial undertaking.

Why, then, do we speak of a decline in objects? Because the objects that surround us in the electronic age have lost most of the full autonomy that characterised them throughout the twentieth century. Each of these objects lives as a link in the Web, as part of an information-based system that runs throughout the city, making its old function-based separations fluid. The information-based object (the computer, the palm-pilot, the mobile phone) has definitively broken off the relationship between form and function that nourished the compact identity of the modern object: it no longer has *a* function, but has *many* functions – as many as the needs of each single user.

The decline of the object as a separate, recognisable identity, unifying motor of the world's innovation, began at the very moment our metropolis ceased to be an uninterrupted succession of architectures in order to become a genetic system of human relations, information, services and immaterial trades, where objects (large and small) are crossed and filled by the uninterrupted currents of invisible energy, which produces an evolving plankton that envelops objects, blurs their contours and perimeters and transforms them into instrumental parts of our new relational economy.

So in this 'genetic metropolis' specialised organisms and the old function-based typologies fall into decline as a new system emerges – an undefined system of opportunities, availabilities, spaces not clearly determined from a productive point of view – where objects are like

jellyfish in the ocean, and float about, transparent and opaque, part animal and part plant, transported by invisible currents, opening a new poetic and spiritual dimension in this new environment.

Contemporary design changes its statutes, and is no longer called upon to create single objects, but rather dynamic strategies for innovation. We are gradually passing from *product design* to *buzz design*, from the unique act to the cluster of projects, produced by a weak and widespread system of market – and societal – creativity. So the object is beginning a fascinating transformation in a nebulous, dynamic reality located in the enzymatic territory that now constitutes the contemporary city, where everything can be changed, connected and renewed much like the cycling of the seasons.

It has no precise direction and, therefore no longer has stable, recognisable confines.

Francesco Bernardelli **From Film to Video Art**

Two Histories – Two Traditions
On one side there is film, with a long history and tradition, a recog-
nised genealogy, a continuous, self-generating evolution and an en-
tirety of forms, figures and conventions that have made it the most
successful medium for mass communication and public attention
throughout the twentieth century – not to mention an instrument
of incredible richness and grandeur that result in unequalled vi-
sual and aesthetic work. On the other side is a grouping of often
blurry images, at first rather unstable, ephemeral, in black and
white, then more and more coloured, certainly not given such im-
mediate, rapt public attention early on, but which over the years
– four entire decades now – have rapidly gained ever greater space
among our habits as viewers with broad, expanded visions, and
experiences that almost approach the level of physical sensation.
For a long time technological limits and conditions came between
the horizons of film and video-vision, such that, in the experience
of one with relation to the other, peculiarities and differences stood
out, set before the vertiginous vision of a vast panorama and the
sensation of being before a luminescent box. These were obviously
differences not only of scale, detail and depth of field, but also and
above all in intensity of gaze and perception, and of how the im-
ages themselves organise and structure themselves in a complet-
ed linguistic discourse.
In both such visual experiences it is essential not to forget – ac-
cording to traditional historic interpretation – which role had the
capacity to capture movement. As is well known, the etymology
of the term *cinema* (and *cinematographer*) derives from the ancient
Greek term *kínesis*, or movement, which united with *gráphein* (to
write) signifies the possibility of writing movement, a transcription,
a transfer or mathematical translation from one field to another,
in an accepted meaning that brings with it a transformative idea, 297

while the term *video*, deriving from the Latin for 'I see' (and therefore in strong connection with the subjective centrality of the visual process), underlines how the production of images, which by their very nature are not permanent, stable (but rather just the result of magnetic waves), is almost conditioned, linked to that impermanence, that transitory nature that is a property of the dynamics of perception.

At the time this new practice emerged, there were many reflections and echoes that adopted different tools for reading and comprehending while approaching and investigating the video experience, which was essentially something 'other' with respect not only to the contemplation of painting and sculpture, but also the cinematic, film-based realm. The (material, institutional) spaces and contexts had already changed a great deal, but above all the approach had. Even more than in the earliest period of the 'light' documentaries of British *Free Cinema*, Jean Rouch's *Cinéma vérité* or North American *Direct Cinema*, represented *in primis* by the expansion of film to 16mm and Super-8 formats – with the auxiliary aid of audio taping made possible by portable Nagra recorders (between the 1950s and early 1960s), first with the pioneering Portapak, then followed by other models and brands – not to mention by the spread of videotape recording technologies (VTR), even in all its variety and different formats. These instruments soon brought forth the awareness of being able to enter into surrounding reality in a more rapid, direct way. Marshall McLuhan (as early as 1961, with *Inside the Five Sense Sensorium*) had already interpreted the presence and role of video- and television-based technology as a synergetic composition of forces that could be considered a media-based exteriorisation of the human sensorial apparatus. In fact, it was quite clear, and people were well aware that not only sight and sound were involved in the relationship with this new electronic medium, but rather an entirely new synaesthetic vision, one that could comprehend a tangibility that derived from its new visual and sculptural form. In a word: multisensory.

Video's Presence and Success
Certainly video, for years on end, suffered limits, indubitable conditions, that partially contributed to creating this nevertheless unique allure, often so immediate and brutal as to appear disorienting, perhaps even repulsive. But at the same time, in light of the close relationship to the world of television, with the technical possibilities of 'direct', 'live', 'real time' broadcasting (an extraordinary detail that still inspires everyone to experiment with video, to come into contact with it and experience it in a sort of eternal, fluid, continuous present), the most relevant element soon became defined in the multiform, liquid current of contours and forms similarly visualised, and capable of standing out ever more starkly because of its often unheard-of self-referentiality, from a closed, concentration-camp universe.

Over the course of a few decades, artistic practice with video (but also '*in video*') expanded its own characteristics in such a pervasive way that it surpassed by far the expectations that had begun to form. Born 'poor', video, a declared anti-illusory medium, unlucky relative denied almost all the means that the world of radio- and television-based broadcasts had in abundance, knew how to make virtue out of necessity and reappropriated all those basic means that constituted a language – elementary yet nevertheless of primary, first-born potency.

It is useful to keep in mind how, since the earliest experiments by Wolf Vostell and Nam June Paik (above all the *13 Distorted TV Sets* of March 1963 at the Galerie Parnass, in Wuppertal, and all the 'manipulations' that would follow), a very strong component of absolute technical and linguistic reinvention emerges, close not only to an overturning or reversal, but even

the violence of/toward the medium itself. Television sets directly altered by the use of mag-

nets (opportunely set into action and reaction against the cathode-ray tubes of the television set) indicate a clear direction toward which a lot of the 'electronic' experience would be modelled or, even better, moulded upon. Not a mere historic detail, but an integral part not only of an aesthetics of vision but, rather, an ethics of transformation and radical reinvention, the video practice (as it had been carried out since the beginning) manifests itself in all its undeniably strong and visionary nature, adopting work modes and strategies that were radically 'other' with respect to the forms, linguistic categories and constitutive fabric of film (above all if understood through its history and relation to narrative genres and traditions, rarely brought into question).

Various theorists and expounders of video work have recognised how it essentially manages to condense highly different and strong instances within itself (methodological, political, conceptual instances) that set themselves in an original position with respect, above all, to the arts that precede it.

In fact, video can carry out a series of exercises and transformations between the abstract and the experimental, relationships of forms and relations between sounds and their visualisation: just think of the early days of Gary Hill or researchers/experimenters like Steina and Woody Vasulka (famous founders of The Kitchen in New York, as well as indefatigable researchers over the years, with the help of technicians, programming engineers and information technology specialists). Video also investigated the communicative relationships between the social and the personal, as well as the ways in which one might visualise or stage them: here the fundamental examples are Peter Campus and Dan Graham's intuitions and projects in the early 1970s.

Video became famous above all when it entered into a close relationship with the needs of its maker's search for personal identity (in gender, feminist and others senses . . .). A sufficient example is the idea of a vast volume of works produced in the highly performative field: early Vito Acconci or many other artists, such as Eleanor Antin, Joan Jonas, Hannah Wilke and Valie Export. But, as expected, it also assumes valences of rapid and circumstantial timeliness as a means of political critique, capable of quickly intervening within the folds and contradictions of society: there are various examples of this, from the works of video collectives (born in the United Sates – Raindance Corporation, Ant Farm, Downtown Community TV – but which soon developed in many other countries, like England, Italy and Germany) up to figures like Ira Schneider, Doug Hall and Antonio Muntadas.

Discourse on Film

It is additionally true that, right in the heart of the vast film-based genealogy (over a century of works), the practice of research and the avant-gardes, beginning with the so-called historic avant-gardes, nourished itself through constant exchanges with other fields of visual art: indeed, it is impossible to forget how figures like Fernand Léger, Hans Richter, Laszló Moholy-Nagy, Marcel Duchamp, Francis Picabia and even Salvador Dalì (in his collaborations with Luis Buñuel) had – right from the start and in direction very different from one another – nudged their film practice into reaction with eccentric and completely autonomous needs, aiming to re-envision and even push the medium of film to a new level. The very fact that visual artists modelled film tools to their own personal requirements, diverging from the canons and dictates of the burgeoning film industry (whether it was a matter of opening their eyes to the strengths of the object-based world – and their reciprocal relationship – or needs aimed toward an ever bolder abstraction, or toward an exploration of perceptive processes, or even a series of provocations aimed at liberating the unconscious forces of the imagination), pre-

cisely the modes explored and consolidated in those few short years (the 1920s) and over the following decades influenced the industry, which rapidly assumed its 'dream factory' status. The United States film scene, the first and main model of an industrial-scale production machine exported internationally, used those techniques and practices that, at almost the same time, had influenced every other blossoming 'vision factory' and (consequently) their film industry, from Europe to India, from Egypt to Japan, enlightening examples of means and methods assumed on a global scale. In short, a vast, variegated yet still well researched tendency to work with illusion and illusory techniques.

In the field of film-based visions some strong needs and desires come about, aimed at a constant expansion and redefinition of visual experience and its dynamics when interacting with the most complex perceptive processes. In such a vast area of research there was no want of contacts, migrations, spillage of techniques and modes of working between the restricted occasions for investigation offered by the historic avant-gardes and the vastest scenes of industrial film production, but certainly there did come to be a lack of occasions for a reciprocal recognition and adequate awareness. An age-old objective difficulty, the sporadic possibilities for circulation and direct experience in experimental film, therefore unfortunately handed avant-garde film (more often and more gladly) over to the display cases of historical archives and the occasional rediscovery made by specialised film festivals.

The fundamental legacy of film-based work by the historic avant-gardes, however, progressively enters into an underground dialogue with the later postwar filmmakers, through personal affinities and solitary approaches, in a crossing of destinies, of human and work trajectories that are not always immediately very legible. A large part of the *New American Cinema* – above all in its most inventive, unpredictable, visionary fringes (Joseph Cornell, Kenneth Anger, Stan Brakhage, Bruce Conner, Marie Menken, Jack Smith, Andy Warhol and James Broughton) – opted for historical reference points, different each time and more often than not obliquely present, almost like an unconscious memory, which represent a riverbed, a reservoir of personal references that are often written in code, indirect.

This vast avant-garde period – which here we have synthesised through an evocation of experimental North American film, but which also knows and crosses through larger and not always so recognised geographic areas – is worth consideration because of its implicit tendency to overstep its own dimensions of implementation and use, its limitations, in a constant tension that at the time was described by Gene Youngblood as *Expanded Cinema*. In recent years, the right light is once again beginning to be cast on a season that, unfortunately rather quickly, produced a whole series of works that were no longer limited to the visual realm, but were articulated through a genuine spatial and temporal expansion through new technical and formal procedures. A novel, unexplored concept of duration, an attention never before granted to the processes and procedural aspects of vision, a recourse to multi-vision formats through the use of several synchronised projectors and the overlapping of various disciplines under the appearance of film projection, gave the go-ahead to an enlargement not only of working contexts and experimentation, but also and above all the opportunity to make full use of the medium, in light of constant review and reformulation of the viewer's position with regard to vision (or, better yet, a full and complete multi-sensory experience). Beyond the specific examples adopted at the time and mentioned by Youngblood, it is precisely in this adhesion and working approach that we see, in my opinion, film's unexplored and revolutionary potential.

If one can speak of an intertwined progress of visual experience, which developed precisely in the mid-1960s, the key point that must be understood remains firm: the completely un-

precedented attention, born around the primacy of the process-related results over the purely aesthetic results (of minimalist, conceptual and body art), appears as the foundational material of a major period of audiovisual research by creating anti-illusory devices, real 'viewing machines' focused, at the same time, on the expansion of techno-linguistic mechanisms and the process of making such formulas more explicit.

Already the anticipatory work of Peter Kubelka, Tony Conrad with *The Flicker* (1966), Michael Snow and figures such as Paul Sharits, Hollis Frampton, Anthony McCall, Peter Gidal and the Whitney Brothers – with the emerging 'electronic' arts applied to animation – brings with it a careful and refined reflection on the means and tempos used to define the perceptual experience put into action (and its implied self-reflexive aspects). Key figures like Sharits (with his move from 'miniaturistic' Fluxus films to the vast works of the 1970s on the observer's subjective perception) or the protean Snow (who debuted as a painter, sculptor and musician and has gone on to develop a systematic exploration of every constituent element of the film camera, and even working in video) or Frampton (with an emphasis on the materiality of the film strip, its visual structure and procedural and structural composition related to its time-based development), in his ongoing work with the development of new viewing devices and mechanisms (in relation to the space both of vision, internal to the image, and the viewer's perception, external to the image), act as valid points of passage that foreshadowed more recent forms of contemporary art in sensorial installations.

From the many at hand I will take two examples – one internal, the other external to the projector. The most extreme case is that of Michael Snow, who, toward the late 1960s, in collaboration with a Canadian engineer, developed the model of a mechanical arm that enabled the camera to move and rotate freely in all directions (360 degrees) and at a speed of rotation and movement completely controlled by the artist. This technical-mechanical device was tested and used in the tour de force film *La région centrale* (1971), a three-hour long, continuous panorama of unpredictable movement. Or, even more strongly, McCall's *solid light films*, real sculptures of 'solid light' that are at the same time strongly cinematic and ineffably sculptural, and recalibrate the relationship between public space and the object (that is, the solid geometric figure designed with projected light) by immersing the observer in an active process that brings the interaction between movement, duration and participation into the forefront, since the public is free to visit, move around and move within the projection of light in the exhibition space.

Working with the formal and material structure of film (and on the medium itself: the film strip) – making the medium's self-reflexive capabilities clear and quite declared, as well as proving the expansion of film's possibilities – these filmmakers/artists created results that were still in line with the film tradition, while at the same time transcending the medium's previous results, breaking away from the technical and rhetorical apparatus that constituted those traditions.

Although in most cases the anticipatory work of these figures has suffered some, and become blurred in the public's memory, in more recent times it has gradually been rediscovered and appreciated in several exhibitions and festivals (primarily in the United States, England and Germany). The most recent of these (*Mindframes*, Zentrum für Kunst und Medientechnologie, Karlsruhe) showed, with ample evidence, that during a period when specific studies about media art on the university level were not yet developed, a courageous initiator named Gerald O'Grady, initially a professor of English Literature and tireless organiser of conferences on the role and future of video and television, founded the department of Media Studies at the State University of New York at Buffalo, in 1973. A wide arc of media arts was consid- **301**

ered and addressed by that program and the recent exhibitions – from photography, slide shows, music, performance on film and video to work on film and film installations, video and the first video environments, as well as the emerging computer graphics and the first interactive art installations.

This rich and vast field began to be explored and taught as early as the 1970s and 1980s by avant-garde structuralist filmmakers like Tony Conrad, Hollis Frampton, Paul Sharits, documentary filmmaker James Blue, video artists like Woody and Steina Vasulka, as well as Peter Weibel. Through the close and detailed study of the transformation in the role of electronic media in contemporary society (primarily television and video) and their unprecedented participatory possibilities with regard to political and artistic projects, a great utopian impulse emerged, which at the same time has a concrete vision, and looked toward creating a democratic and progressive use of new technologies. Research carried out through various 'visual machines' (photography, film, video) focused on the new technological possibilities with respect to the limits inherent in traditional vision, working toward an increasingly free vision, detached from the limiting characteristics of the human eye.

From Yesterday to Today

In recent times – and more specifically by the 1990s – major emphasis was given to the possibility implicit in the new (albeit heavily stylised) narrative forms, which made the video, in its updated variant of video installation, a dynamic media-based reinvention where narrative practices and techniques have combined different elements from specific areas and artistic disciplines and allowed them to react.

There was also a major push – apparently more 'representative' and 'narrative', using reappropriation and deconstructivist procedures (sampling etc.) or mimetic-realistic procedures clearly influenced by film – which became visible in the work of internationally successful, albeit highly different, artists such as Eija-Liisa Ahtila, Stan Douglas, Rodney Graham, Isaac Julien, Sam Taylor Wood, Knut Åsdam, Pierre Huyghe, Doug Aitken, Anri Sala, de Rijke/de Rooij, Christian Jankowski, Francesco Vezzoli and Catherine Sullivan.

And so the catalogue of visual, representative and communication-based options developed in recent years had no difficulty being read as an 'allusive' approach (Peter Weibel), where work with specific types (of figures, characters, situations), and also languages (narration and illusion, anti-illusion and anti-narration), brings to the foreground an explicit need to develop a reflection on the manner in which images engage tensions with movement and time (and their intertwined perception), through visions capable of condensing multiple layers of time (past, present and future). This is often created by emphasising details, as well as slowing and extending temporal images (and their potential). In this sense, each new, more sophisticated technology seems to emphasise and underline the push toward the emerging, often static image.

All this leads to research aimed at incorporating the public's capabilities of reading and enjoyment (increasingly understood in an ever broader sense), in order to transform some potential criticisms of audiovisual work into a different, broader sort of involvement (even physical, emotional involvement) and a renewed conception of work's critical reinvestment, now understood in the sense of everyday politics. This 'aesthetic of the given', something already known and shared by a large part of the public and users, not only (and not so much) informs the underlying ideology, but rather reflects on the forms of creation/construction of the work itself, through its theoretical structure, but also in the more concrete relationship

302 'exposed' and 'put on exhibit' with the public.

From the dematerialisation of the conceptual period – or the extreme attempt at 'essential-ising' the discourse active in the design and development of a work – we rapidly moved on to a period of ever-faster digital reproduction that, for its implicit ease, has overturned the very idea of conceptual originality, uniqueness (and ownership) of the work. From this a re-newed need to create relationships with the viewer has emerged, as well as the need to cre-ate a type of communication that – far from the role of playful provocation, and rather clos-er to the role-play more typical of film – can lead the viewer to an emancipation from his role as the purely aesthetic, pleased user and transform him into a more active and conscious ob-server/user. Right in the here and now – more precisely in the effort left to each individual user, and more generally in the broader preparation of certain conditions and certain visual mechanisms – aesthetics are prone to become more specifically political.

'Who We Are When We Go to the Movies'
Strengthened by at least a couple decades of research on the semiotic contexts and places of film consumption (and, in a metaphorical sense, also on the specifics of the black box) and, therefore, also the exhibition of film and videotape, in an inclusive, 'expanded' view, you can start finding out what, and how many, debts a large part of video installation art has devel-oped, more or less consciously, with respect to the various strategies and practices of the many types of display implemented since precinematic, prefilm days.

The punctual description and explanation of how several similarities with the methods of stag-ing already instituted in nineteenth-century fairs, dioramas, amusement parks, commercial *pas-sages* and galleries, planetary and science museums and major technical and universal expo-sitions (continued even in recent years) – the entire, vast scenario of techniques and archi-tectures – has prefigured and brought on a variety of experiences that are not just visual, but rather sensory, and place major emphasis on the uniqueness of the viewer's contact (eye or body contact) and his 'positioning'.

Research carried out in this direction by scholars such as Ina Rae Ark, or on the emergence of a cinema that is 'in exhibition' or 'on exhibition', as well as on Jean-Claude Royoux's in-terpretive line of thought, have focused attention on what type of traces lie at the base of the work developed (on an increasingly thin dividing line) by refined artists like Pierre Huyghe, Dominique Gonzalez-Foerster, Philippe Parreno, Pierre Bismuth, Tacita Dean, Melik Ohan-ian, Christelle Lheureux, Olivier Bardin – figures that, in just a decade's time, have not only renewed film and video research on a metanarrative level, but also with regard to the forms/modes of relating to display strategies and the public, through a renewed awareness of how each new technology implies greater freedom and opportunity for virtual movement and selection and display methods, up to the involvement of distribution.

A substantial ability to go beyond the distinctions of form/format (film projection, loops, in-stallations, videos and publications, posters etc.) has allowed concerned artists to constantly call into question not only the audiovisual medium, but also a creative practice that in their case is loaded with resonance, exchanges, reciprocal influences and tributes, to arrive at the idea of completely redefining artistic nature (a kind of post-production), practice and 'pa-ternity' (or authorship).

In this regard, we must quickly mention the project-cycle *No Ghost Just a Shell*. It was begun in 1999 by Philippe Parreno and Pierre Huyghe, with the acquisition of a female character named Annlee and her original image from a Japanese company (called Kworks) in the flour-ishing *manga* (comic book) and *anime* (animated films) industry. Running for a number of years, Annlee was offered to a number of artists commissioned by the initiators to use her in

the development of their ideas and stories. The various resulting video animations with Annlee become the 'chapters in a story of a sign', something that has a 'life' within the context of the practice of each artist involved, but at the same time also in the wider shared project. The so-called 'life-extending measures' of this virtual figure bring in a whole series of issues, ranging from considerations on the nature of commercial products returned to their context of exchange and gift, and the factors associated with the supposed conditions of artistic autonomy typical of contemporary creation, to reflections on those conditions. The conclusion of the entire project underwent a final moment of celebration (with a lot of fireworks in Miami) when it was revealed that Annlee would receive a final contract that transfers the copyright and rights of use. In this sense, the project was raised and released from the obligation of circulation through the economic and artistic exploitation connected to its original nature. The particular role of audiovisual devices seems to have developed around the issue of the relationship between time (seen, lived, perceived time) and subjective experience. The concepts of duration, temporal flow and experience intersect in the varied practices of the individual user (a spectator quite unlike the filmmaker or cinematographer). The many differences between film and the installed video-film device are manifest in the special spatial and social conditions, which then carry out dynamics that are very different from straightforward reception and reaction.

What exactly we mean, then, when we talk about the new frontiers of audiovisual devices is not so easy to define. Years ago some useful (and evocative) definitions such as 'exhibition cinema', 'spatialisation of duration', 'spaces of imagination' (or 'spaces of the possible') and even 'plans for an escape' were proposed. However, it is necessary to add that, precisely because of the extreme sensitivity related to the exhibition contexts and interaction with the public (in being able to approach, experience and understand the work), similar projects reached a high degree of articulation and functionality, reshaped step by step, each time, starting from the exhibition's original place and context.

New Horizons: A New Working Paradigm
In a recent large exhibition in Miami, Christine Van Assche, the first curator in a museum of contemporary art in Europe to deal specifically with video, drawing up a history of video, presented the changes and developments of four decades into five sections/areas: 'Imaginative Television', 'The Search for Identity' (which relates to the essence and structure of television), 'From Videotape to Installation', 'Post-Cinema' and 'Contemporary Perspectives' (on issues concerning the artist's statute, the role of spectator/viewer and the relationship between fiction and documentary). As seen above, the interpretation given to audiovisual media in their manifestation and affirmation over the course of the twentieth century was characterised by the constant tension between illusionistic and anti-illusionistic trends, which in recent times have resulted, as Peter Weibel has noted, in allusive forms.

But I believe it is necessary to try and identify areas of recent artistic practice through the moving image and by considering the artist's role, which – continually renewed on the basis of models as pioneering as the experiments of Billy Klüver and EAT (9 *Evenings: Art, Theatre, and Engineering*, originally presented in 1966 at the 25th Street Armory, New York) – are now emerging in the exchanges between the various responsibilities of scientific research at the crossroads between art and IT engineering.

Through such practices, artistic interest moves toward new processes and ways of working, where the creation of new forms of active participation, rather than the mere completion of finite works in and of themselves, means that you explore and deal with the changes in lan-

guage media precisely beginning with the transformations that have taken place in the field of film as well as digital productions. Finally, new anthropological and philosophical scenarios take shape, where the digital camera can increasingly interact with a wealth of knowledge and the potential of the unconscious, dematerialising and reshaping the relationship with reality, and even transforming the realm of contemporary subjectivity.

Even in the realm of the film- (or video-) essay – beginning with a few anticipatory figures who turned initial studies in film and film editing into an opportunity to address larger issues, as well as study the very means of recording in relationship to society and the subject explored, up to younger artists – the desire to distinguish video from film begins, literally, to no longer make any sense: artists/essayists like Jean-Luc Godard, Chris Marker, Harun Farocki, Hito Steyerl, Ursula Biemann, Deimantas Narkevicius and Jem Cohen, through a constant and uninhibited ability to slide from one medium to another and vice versa, have shaken free of the limits and influences imposed by a desire to continue thinking in categories of belonging and technical distinction, while their hybrid research eludes any form of a priori categorisation, to delve into the unresolved knots of contemporary critical consciousness.

In recent times (the last decade, to be more precise) the transformations that took place in the production and processing of moving images through digital means (i.e. the broader process of digitising the information in any field, including cinema) have literally upset and overturned every hierarchy and productive idea. This vast and growing process of modelling (which ascribes each process of recording and transcription to a sequence numeric data, in a growing horizon of bits accumulated and stored for any and all possible future uses) obviously does not just come out of nowhere.

As we know, every form of writing and transcription, physical or mechanical cataloguing, is the basis of the possibility of thinking and of thought itself. These increasingly large binary signs that lie behind the creation of records, archives and databases are the very basis of our relationship with the pictures (and their possible manipulation), and represent a point of transition toward the imagination and representation of a 'virtual' sphere that acquires an ever greater space and importance within our 'infosphere' (the vast range of communications media present at all levels of our information-based society).

At present, the (electronic) sum of these data – in the form of images, be they moving or static, pure or manipulated, as sound or text or communicative signs – allows for them to be available on media that are no longer materially differentiated, but rather in bits, pure information, that can be used in many continuous reconfigurations (and subsequent interrelations and productions of meaning). These new relationships among images, between images, take place (if one can say it like this) through formulas of digitisation, in order that they may be easily modified, rerecorded, multiplied, archived and retrieved (as many times as you want/see fit . . .). In this sense, working alongside a growing detachment from the world of things, it is something that runs the risk of becoming a mere reference and index, surpassed by the many implementations given by virtual reality.

The advent of digital technology has therefore become a medium, or rather the generating process, of a multimedia idea truly expanded, precisely in light of the evolution of electronic phenomena. Crossing multiple languages (the visual arts, video, cinema, to electronic music, sound art, dance and performance), digital media have allowed and even encouraged a more continuous intersection of these phenomena, making a hybridisation and creation of new languages possible, encouraging a redefinition of the nature of the artistic statute and of artistic languages. The crux of the issue remains to be addressed, and is tied to the real possibilities implicit in the very nature of the many digital media: are they a vast and undiffer-

entiated technological innovation, or rather an authentic and profound structural transformation capable of involving and transforming the modes and possibilities of imagination and action in human thought?

Now, following the high hopes (and equally large disappointments) of the 1960s and 1970s, it is interesting to note how many deeply rooted ideas, however close or indebted they were to forms of political radicalism, have found a space for revision and renewed life in an ever wider sphere of production and circulation of media and artistic content: what is now called 'community electronic media' and the entirety of productions made by activists of alternative forms of DIY ('do-it-yourself') culture. This creates a veritable barter economy (an economy of exchange and of the gift) not only of information but of data, technical resources, skills and technology that have rapidly developed thanks to a variety of factors, not least technical architecture and network usage (Web/Internet) and digital media, going beyond the usual concerns of individual intellectual property. The extraordinary speed and extent of the spread of open-source systems on a global scale is only the most immediate sign of a revolution now fully underway. The current hi-tech economy of exchange is based on a huge (and growing) range of information, (im)material data, programmes (Linux and Apache, to name the most famous) that allowed to freely circulate and be exchanged by e-mail, shared lists, news groups, on-line broadcasts and special sites. All this has not waged war or entered into competition with the existing market economy, but it has shown, and continues to demonstrate, how the two models can coexist in forms that are symbiotic, readaptable and always different. Unlike most 'cyber-elite' supporters of neo-liberalism (the theoreticians who preach their vision of a closed, protective and restrictive potential electronics and interactivity on the web), a strong and substantial number of theorists and practitioners saw – in the latest wave of major technological innovations with everyone's reach – the importance and ability to counter, and put into crisis, these underlying views and ideology. The Web/Internet must be considered the most extraordinary field of experience for the emergence of a whole series of spontaneous, dynamic and flexible virtual communities, which are defined much less with relation to exchanges in the market than with regard to fairly new uses, methods and social conventions – with the aim of enlarging and sharing all benefits. It is precisely in this vast scenario, in my opinion, that the future of electronic arts will find ever more extensive applications, and the many multiform incarnations of artistic practice will discover applications not yet imagined, where more and more freedom of technology and imagination will proceed side by side.

Carlo Antonelli

The Sonic Youth of the Last Century

Histories and Geographies

Partial, invisible, perhaps literally unheard; nevertheless, there is a history. Reconstructed over and over, it is the rather 'Milano-centric' history that, from the futurist experiments of Luigi Russolo's *intonarumori*, run right up to the postwar period – to 1955 when, also in Milan, the RAI Studio di fonologia (Phonology Studios) were founded (following the lead of the Parisian *Groupe de Recherche de Musique Concrète* and the *Westdeutscher Rundfunk* studio in Cologne). It was there that the collaboration between Bruno Maderna and Luciano Berio upheld Italian pride, perhaps for the last time, with supreme results and an opening of international exchange that viewed Italy as a magical crossroads of new sonorities. All this – let us not forget – while entirely different waves were beginning to roll in a part of the musical galaxy that would soon be defined as *rock*. This is perhaps an apparently banal observation: the research of the Studio di fonologia began with an unheard-of generosity toward other disciplines. The early years saw visits by Umberto Eco and his collaboration in *Thema. Omaggio a Joyce* (Theme: Homage to Joyce, 1958) by Luciano Berio, but also the bizarre passing through of John Cage who, in Milan of all places, created his remarkable *Fontana Mix* (1958).

So, in hopes of being rigorous and moderately enlightened, one hypothesis for a sonic history with possible reverberations in the present day could begin right here. From Cage to Fluxus, from the breakdown of disciplinary barriers – with the explosion of the new avant-gardes – to the appearance of happenings and behaviour as the central motor for various ways of twisting the arts . . . You could object that in reality even the less undisciplined, more rigorous movements created works that, in one way or another, 'played pieces': the groups making kinetic and programmed work, for example. Perhaps the real problem emerges when you focus 307

on the category of 'sound art'. Let us try to completely abstract this. It is quite likely that an awareness of the use of sound as expressive material sanctions this difference. We cannot help but note, however, that – both for Fluxus artists, in their happenings as in their sculptures (from Wolf Vostell to Nam June Paik, to cite those who worked with video) and, to take a random example, for Jean Tinguely – sound was an essential component of a work of art. So . . . looking more attentively, the audio component – beginning in the 1950s as a 'programmed' presence, a structuring component and an evident 'absence' – is certainly there. And everywhere. And so? And how can we say anything with regard to music (that, minimal as it was, mere *noise* or disturbed sound, would lead us down a whole new path)? The music of La Monte Young, Steve Reich and Terry Riley; the music of Andy Warhol and the Velvet Underground, for example, or even John Lennon/Yoko Ono, Mike Kelley and Tony Oursler's group Destroy All Monsters or, later on, Sonic Youth. Or, returning to the discussion of video and rethinking the issue (in historiographic terms) the art/new technologies/research relationship, we could retrace the routes of the many types of music that accompanied Nam June Paik's work (from Kraftwerk to Cage and pop), Bill Viola's work (like Paik, also with a background in music), Laurie Anderson's work and Tony Oursler's work, to then explode into the 1990s going every which way, with forerunners like Mike Kelley, Doug Aitken and Cameron Jamie (all Californians . . . of a different mould), as undeniably formidable presences.
In short, in terms of histories and reconstructions, anything is possible. And perhaps, here, they are not even that necessary. So let us try taking a different tack.

Counterhistories and Countergeographies
So when did we really begin to see shows that explicitly posed the question of the ear's autonomy (and/or the autonomy of music, let us not forget) in art? Probably, just to put it out there, there are three collectives we could take into consideration. All three took sound as a central subject for reflection. Before chronicling them, let us just list them: the *Sonic Boom* show at London's Hayward Gallery in 2000, *Frequencies [Hz] Audio-visual Spaces* at the Schirn Kunsthalle in Frankfurt am Main in 2002 and *Sonic Process: Une nouvelle géographie des sons* at the Centre Pompidou in Paris, also in 2002 (with an initial stop at the Museu d'Art Contemporani in Barcelona, in not-so-chance coincidence with the international *Sónar/advanced sounds* festival). A few elements immediately emerged: temporal proximity and, in the case of *Sonic Process*, 'spatial' proximity with the event that, toward the end of the twentieth century, changed perception as a collective phenomenon – electronic or advanced music, which immediately followed the phenomenon of rave culture (which rose to popularity in the latter half of the 1980s), and defined a generation of music consumers or, more generally, cultural consumers as a 'postrave' or 'intelligent dance music–oriented' audience.
But beyond (for now) the definitions of various publics it is important to observe, perhaps, that those shows – although they occurred in 2000 – essentially brought the final decade of the previous century to a (solidly sealed) close; that century that had seen electronic music explode onto the scene and be swiftly ordained before irremediably falling into decline. New means of production (digital media), frightful acceleration (in all senses) of access to music sources (the Web), possibilities of image manipulation (live mixing through software) as well as, naturally, sound manipulation (the evolution of turntable culture as opposed to CD mixers): things – for those who make them – change. And radically. And surrounding this phenomenon, without going into detail regarding genre distinctions, an itinerant creative community obsessed by coolness immediately gathers. This community consumes and amplifies

fashions, styles and representations, designates new capitals (Barcelona, Berlin, Helsinki, Vi-

enna, but also Glasgow, Rennes, Hyères) and makes an excellent (but, let us tell it like it is: little more than sub-cultural) magazine like *The Wire* an absolute reference.[1] The web – as a source of information – suddenly allows people to do without the little hole-in-the-wall shop stuck in the basement of London's street-level stores. And the discs issued in highly limited editions, ranging from the unorthodox to the unlistenable but invariably appearing with impeccable artwork, become the safest Christmas present and most refined quotation on the European 'bobo' scene (remember that term?). 'Intelligent' electronic music marked, obviously, a lifestyle. And it acquired a symbolic status that, since then, only elevated music could afford. Up until the head-on collision with the earliest signs of the new economy that, perhaps not entirely by chance, had sensed and then quelled its initial business intuitions with regard to music. "Music has become a field, a landscape, an environment, a scent, an ocean. Media such as radio, television and cinema, or more recently the Internet and the mobile phone, have fostered an image of a boundless ocean of signals"[2] wrote David Toop in the *Sonic Boom* catalogue, adding gloss to the already genial conditions established with *Ocean of Sound*,[3] the text that best read and retold the essence of the question and bypassed the insidiousness of material aesthetics tied to the definition of 'sound art'. So, as much as the participants of *Sonic Boom* (Angela Bulloch, Paul Burwell, Disinformation, Heri Dono, Max Eastley, Brian Eno, Thomas Köner, Paulo Feliciano and Rafael Toral, Greyworld, Stephan von Huene, Ryoji Ikeda, Philip Jeck, Christina Kubisch, Chico MacMurtrie, Christian Marclay, Russell Mills and Ian Walton, Mariko Mori, John Oswald, Pan Sonic, Project Dark, Lee Ranaldo, Scanner and Katarina Matiasek, Paul Schütze and Toop himself) made an effort to construct 'works' (often in the form of sculpture), only a few rare exceptions turned the nature of the paradox they faced into their main focus: sound cannot be tossed into the pot (or packed into a suitcase). It escapes, flees, overflows. And it slips into the atmosphere, influencing even the most unpredictable behaviours, from dance to the need for silence. But it mainly triggers memories, projections, perceptions of place. Sound transports.

The Identity of 'Sound Art' and Its Contemporaries

Sound transports us into other worlds, confronting us with various categories of the different and the exotic. It transports us into the past and into memory, confronting us with history, tradition and our very nature. It transports us into the heart of other communities, confronting us with alternative ideas of belonging and genre. Going back to *Sonic Boom*, *Sonic Process* and *Frequencies [Hz]*,[4] it is not so much a question of what the works' nature was (and, therefore, what the nature of those sounds was), what the languages or linguistic choices were in a work tradition that, as we mentioned, invariably produces sound. It is rather an issue of how those things dialogued with the key function of contemporary art: its status as a laboratory of the present, its projected tension with regard to the real, its potentially testimonial aspects. In mentally tracing these three shows and perusing their catalogues, it becomes clear how each one posed the question of what the nature of 'sound art' is, what its place in the realm of visual art is, what the specificities of sound work are in the tension of contemporary sculpture as it measures itself against physical space and its characteristics. But – learning from past experiences of paroxystic self-confinement and the theoretical abysses of disciplines like video art and, above all, from Toop's writings and, on other fronts, from the studies of Ulf Poschardt, Simon Reynolds, Diedrich Diederichsen and (above all else) the theoretical forerunner of cultural studies, Paul Gilroy – if it is true that sound transports us and pushes us into other realms, in time and space, well then that is the question we need to address and formulate an hypothesis about.[5]

These three shows sanctioned a key moment: not so much in the identity of a discipline, as much as in the function of 'sound' works and their space from the mid-twentieth century on. And if their function is to 'transport' us, it is not so much the identity of the discipline that is on the line, as much as, obviously, our identity. Like in late modern sculpture, space and time are what spin round in the vortex of sounds. But what purely, limpidly circles and changes are our space and our time – individual and collective – and, in the broadest sense, our fragmented and exploded possibility.

Indeed, between the two centuries, perfectly mapped by contemporary art's attention to acoustic works, an anything but silent revolution blew up. It happened to us, to everyone. The way we hear the sound of things – and works – radically changed. Our sensibility, our nature, our way of acting and reacting changed. It became increasingly original, mysterious and experimental, especially from an emotional point of view. We are the ones who were transported, whisked away from the white (and even black) noise, from the tick-tick-tick of typewriters, from the electric clanking, from the silences heavy with guilt, from the clicks and cuts of the twentieth century, finally. Thanks to the increasingly less whispered triumph of the consumption and production of desires and behaviours, of self-representations and personal imaginaries and of all those little things associated with them that have, in very little time, become a pleasure-seeking or frustrated or simply normal part of everyday life.

This, deep down, is the issue that sound in art over the past century has put on the line: our identity.

And now that we are something else, and somewhere else, nothing sounds – or ever will sound – like it did before.

[1] www.thewire.co.uk.
[2] D. Toop, "Sonic Boom", in *Sonic Boom: The Art of Sound*, exhibition catalogue. London: Hayward Gallery Publishing, 2000, p. 113.
[3] D. Toop, *Ocean of Sound*. London: Virgin, 1995.
[4] The artists invited to *Frequencies [Hz]* were: Knut Åsdam, Mark Bain, Angela Bulloch, Farmersmanual, Tommi Grönlund/Petteri Nisunen, Carl Michael von Hausswolff, Ryoji Ikeda, Ann Lislegaard, Carsten Nicolai, Daniel Pflumm, Franz Pomassl, Ultra-red, Mika Vainio. The artists invited to *Sonic Process* (with, perhaps, a greater breadth of visual art) were: Doug Aitken, Coldcut, Richard Dorfmeister, Rupert Hubert, Gabriel Orozco, Flow Motion, Mike Kelley, Scanner, David Shea, Renée Green, Tosca.
[5] P. Gilroy, *The Black Atlantic: Modernity and Double Consciousness*. Cambridge, Mass.: Harvard University Press, 1993; D. Diederichsen, *Freiheit Macht Arm. Das Leben Nach Rock'n'Roll 1990-93*. Cologne: Kiepenheuer& Witsch, 1993; S. Reynolds, "Generation E: British Rave", *Artforum*, XXXII, 6, February 1994, pp. 54–57; U. Poschardt, *DJ Culture*. Hamburg: Rogner&Bernhard, 1995; S. Reynolds, *Energy Flash: A Journey Through Rave Music and Dance Cultures*. London: Picador, 1998; C. Antonelli and F. De Luca, *Discoinferno. Storia del ballo in Italia dal 1946 al 2006* (1995), revised ed. Milan: Isbn, 2006.

Antonio Somaini

Surveillance, Identity and Archive in the Digital Age: An Interview with Stefano Rodotà

ANTONIO SOMAINI: *Through your work as a jurist and your legal practice in privacy protection, you have often underlined the importance of governing – from a legislative point of view – the progress of information and communication technologies, such that they may play an increasingly 'virtuous' role in the production and sharing of various forms of knowledge, and in the enrichment of democratic life. Without adequate legislative control, we run the risk that new technologies will lead to a concentration, as opposed to diffusion, of social and political power, creating forms of privatisation instead of a sharing of knowledge, and result in the development of technologies for controlling and surveillance that would end up placing major limits on individual liberties. In a recent lecture you gave at Montecitorio,[1] later published as a newspaper article (in* La Repubblica, *6 March 2006), you noted some considerations regarding what the guidelines should be for parliamentary action. Provided that any attempt to indicate the right direction for free artistic practices is problematic in and of itself, in this context, what role do you think art could play? As an exhibition held in Karlsruhe back in 2001–2002 at the ZKM—Zentrum für Kunst und Medientechnologie (CTRL [Space]. Rhetorics of Surveillance from Bentham to Big Brother, curated by Thomas Y. Levin, Ursula Frohne and Peter Weibel) showed us, contemporary artistic creation seems to be highly sensitive both to the hazards as well as the allure of surveillance and panopticism . . .*

STEFANO RODOTÀ: The theme of surveillance directly deals with the representation of the self and the other, one's way of being in the world and the very construction of one's body and identity. Art has always been a protagonist of operations involving the body – describing it, its break-down into sections and re-composition and making it a direct instrument of expression and communication. **311**

The passage from observing to constructing is analogous to the process found in society's various ways of carrying out surveillance, which ranges from the observing bodies (with cameras, etc.) to their break-down into sections, their projection into abstraction and their deliberate construction to reach the end goal of social control. I'll give some examples. Video surveillance spreads far and wide (there are forty-two million video cameras in Great Britain alone) and its subject is the body as such, even if, ordinarily, the recorded images are digitised to facilitate finding images showing a determined person. In this process the body remains untouched, unlike what happens – with increasing frequency – in cases where the body is directly prepared and checked, accompanied by electronic devices that can be read from a distance or even inserting a microchip into it. Thus the body becomes just another object among many others, and can be located at any moment. The transition from observation to construction is evident, as well as anthropologically revealing. When the check specifically regards identity, operations independent of corporeity or an individual's body can be carried out, by attributing a password or secret code to the person involved, which then allow access to services (like ATMs) or to select places. The body 'lies' in the virtual realm. But what seemed to be a definitive landing – that liberation from the 'prison of the flesh' William Gibson spoke of – has increasingly revealed itself as a trap, given the ease of 'identity theft' by virtue of the many different techniques that make it possible for someone to take over others' passwords and codes. This has led to a resurgence of physicality, and the transformation of the password into the body itself through the use of biometric data (digital prints, iris scans, hand and face contours, genetic data), breaking the body down into sections and reducing the person to a fragment of that body. A third aspect is that of the body used as a communication tool, which follows individual inclinations and the climate at a given time – expressed in tattoos, piercings, plastic surgery – thus contributing to people's outward projection of feeling that the body is a permanently unfinished object, a work-in-progress. And this leads all the way to the frontier of *Body Integrity Identity Disorders*, to the request to have an undesired part of the body removed as a condition for leading an acceptable life. The state of a body no longer kept whole becomes a way of being, an extreme form of the expressive transformation that an artist carries out on the object he intervenes in.

All this brings the issue of rights into question. In opposition to the control and surveillance-based society there are ancient norms and new rules. One has to take the constitutional laws on personal freedom and freedom of circulation into account. Privacy laws assume particular relevance, and are entrusted with guaranteeing freedoms in an information- and communication-based society, with rules that deal precisely with the collection of personal information, and the interested party's right and power not to lose control of his 'electronic' body. One begins to question the significance of physical integrity, the conditions and limits of its manipulability: can parents forbid their minor-age children to get piercings? Does a person's dignity constitute a limit that mustn't be crossed by inserting electronic devices into his body? Can self-mutilation – the exposure of the body that I myself have wounded or covered in sores – be justified by the need for self-expression, by an end goal of artistic creation that, here as elsewhere, would make otherwise forbidden behaviours and acts permissible?

Thus one arrives at the root of surveillance-based society, which first and foremost is the control of bodies and minds. Itineraries of social power are drawn up, and conditions for the freedom of individual choice are defined. The apparatuses of surveillance modify the external environment in visible ways, disseminating instruments for control and surveillance such as video cameras. But they also design virtual spaces, where a multiplication of the Panopticon becomes possible, as has already happened for the thousands of English workers who

wear a *wearable computer* round their wrist that allows their employer to constantly send them orders, control their working pace and follow their every move. The physical body is increasingly an object subjected to external power, just as the electronic body can be when an employer has the unbridled power to enter the computers of his employees. It's not an irresistible trend, because in many countries – Italy in particular – the workers' statute already forbids long-distance checks on employees, and there are limits to employers' power with regard to their employees' electronic communications. And yet the realm of surveillance, exulted by the possibility of following and saving our every electronic or biometric trace, is by now an internal feature of our social organisations, and expresses a police- and market-dictated logic that only the most uncompromising practices of freedom can counter.

A.S.: *Contemporary artistic practice makes full use of the possibilities offered by new digital technologies for the production, elaboration and transmission of images – often forgetting how the spread of such technologies has so radically transformed the statute of images themselves and their capacity to record and document reality. With the passage from analogue to digital (from traditional photography and cinematic film, which used photosensitive strips, to images produced with digital photographic still- and video cameras, and to the various software that facilitates their manipulation and broadcast), images cease to be imprints and traces of external reality and become image-syntheses that can be generated even without setting something in front of a lens. This has some noteworthy implications with regard to the documentary, testimonial role of images and, in general, with regard to the entire issue of documenting and archiving in the digital age. Documents in digital format – texts, images, audio files – are much more easily manipulated with respect to other forms of recording (writing on paper, an image on a physical film strip, a sound recording on vinyl or magnetic tape). Do you think legislation should also address the statute and forms of archiving in the digital era, since these are one of the bases for passing on a shared historical memory? The possible spread of generalised scepticism with regard to all that is presumably a 'document' or 'documentary' puts us at the risk of seeing some important, unpredictable political and cultural consequences come about . . .*

S.R.: Parallel worlds exist, like 'Second Life', where we can create our double, an avatar. Forrest Gump shook hands with Richard Nixon. Any one of us can put an imaginary, Borgesian biography up on the web.
It's no longer strictly a problem of falsification. There's also the problem of the creation of a reality that calls into question precisely what we were accustomed to calling 'real', and had a point of reference in 'objective' data. The freedom to create a different reality, thought to be the sole privilege of artists and therefore immediately recognisable by its shape, grows more popular and spreads. The stable signs of identity – image, voice – have become things we can manipulate. Distinguishing between the various possible representations of a person or event becomes problematic. The very term 'document' has lost its strength.
This results, first of all, in an identity problem, which is also caused by others' continual use of parts and currents of our own lives. A new space has been created – a space not definable by our traditional criteria and points of reference – where we often look round in search of ourselves, and even encounter the mystification, the total falsification of our being. And the omnivorous search engines are there, ready to put it into absolutely anyone's hands. The right to eliminate or correct false or imaginary data sometimes isn't enough when information has entered into such a vast planetary circuit. We've little option but to seize technology like a mythological sword, entrusting it with the task of healing the wounds that

it itself has inflicted through the creation of a site where we put our *true* individuality on display, in hopes that it can be accessed through the same portals through which the false image was found.

But it's not just manipulation that causes problems, dispersion also does. Our being is already distributed over a multiplicity of databanks, each of which reflects a given 'reality' that can nevertheless become misleading when evaluated outside its full context. If someone were to discover that I had accessed a pedophile site on the Internet, what consequences could result from this information—and how does one ascertain whether it's even true? I could be a pedophile following his inclinations; a curious person, who wants to see close up what these sites are about; a person who just happened by chance upon that virtual site; a distinguished academic carrying out research. Only by setting several databanks into relation is it possible to find the real image.

Nevertheless, here we stumble onto a possible contradiction. In order to avoid the risks inherent to the Panopticon, to the negative utopia of a Big Brother who seems to materialise in the connection between all the databanks containing information related to, restrictive norms on interconnection have been introduced, and generalised access has been forbidden. In order to not be judged out of context, on the other hand, one should demand a total connection, the sole way to grasp an identity in its full and complex entirety. A possible solution – aside from the respecting of principles like correct behaviour, finality and pertinence with regard to information's use – lies in granting each individual the power to determine the breadth of connections related to each situation brought into consideration. We must determine the modes of use for our own information so that the features of our own identity aren't distorted.

From here we can begin to undertake the work of reconstructing our identity, obtaining the erasure of false or illegitimate data gathered and saved beyond the established term, the rectification of inexact data, the completion of incomplete data. This would be an endless undertaking, a never-ending search, since the recording of our each and every move is endless. The command 'know thyself' is no longer an operation that requires us to look only within; it has its basis in the possibility of gaining, from various sources, something that *isn't* other's knowledge about us, but the idea that we ourselves are in the electronic realm where a part of our lives is already taking place.

Wandering round in this new world, in which archives and archiving possibilities are infinitely multiplied, a need for new rights and new procedures emerges – rights and procedures that must try to respond to the new force represented by the fact that the archive is no longer just a place of documentation for an objective reality, but it's also a place where another reality is documented or even created. This brings about a 'right to forget' and new types of 'certifiers', to whom we entrust our 'public trust' in the nature of a given document, as it's clear that the traditional rules, with regard to falsified information, are entirely inadequate.

A.S.: *The question of copyright in the arts has always been incredibly problematic. The entire history of modern art is rife with revivals, quotations, samplings and reworkings of earlier works, and more recently this phenomenon has reached an extreme, with artists who have asserted that the 'appropriation' of others' works is a legitimate form of artistic creation: legitimate enough to bring into question one of the very foundations upon which the traditional concept of art is based – the artist's individuality and the unrepeatable originality of the artist's creations. In the digital era the appropriation and re-elaboration of pre-existing artistic content has become common practice and promoted on a broad scale creative phenomena that are potentially intriguing, albeit highly problematic from a legal point of view. Given that you've clearly lined up in favour*

of sharing knowledge and are against all forms of excessive privatisation, what direction do you think legislation should go with regard to this phenomenon?

S.R.: In legal tradition copyright law is twofold. It is both a *moral* and *proprietary* right. In the first case, it is the right to be recognised as the author/creator of a given work; in the second, it is the exclusive right to the economic proceeds of that work. Today the latter is radically called into question by those who underline how technology allows for forms of access to knowledge that shouldn't be precluded. It is also called into question by those who dispute its economic efficiency, since remuneration for the author's or creator's work could be more efficiently effected through other means. But moral right is also threatened, not so much because others can appropriate all credit for the work, but because of the manipulations such work could be subjected to. And here problems arise that are partially analogous to the ones mentioned earlier, regarding the double-sidedness of identity – that of the author or creator and that of the work itself. Indeed, the latter can be subject to alterations that make it no longer correspond to the original version: for those with access to this work, there is the question of its genuine authenticity and who can guarantee it. And then there's the case in which a work was used as the base or material for another creation: here it is a problem of limits, traditionally addressed by circumscribing the number of words, images, and sounds that can freely be reproduced without prejudicing the proprietary rights, and on the condition that the author or creator and work the citation comes from are always credited.

This is a white-hot topic: the search for a balance between the various interests at play is arduous; traditional proprietary logic is increasingly challenged by technology and the social pressure to gain an ever-broader recognition of knowledge as a common good; there are many proposed solutions in continuous evolution. I would just like to recall the fact that a provision called *creative commons* allows the author or creator of a work to make that work available to others, with graduated degrees of access and use (exclusively personal use, as material for other works, or as a point of reference in various contexts).

¹ Translator's note: A Roman Government building that houses the Chamber of the Italian Parliament.

287. Stan Brakhage
Painting Film (1995)

If it be an art, then it is intrinsically aesthetic, requiring aesthete – that is to say, it is beautiful, integrally balanced, and (as unique) of some individually discovered integrity: its appreciator is one who is capable of sensory justice and evolutionary thought, free from dogma and representational bias, because the art work's this-for-that is not clock-like but rather evolves eccentrically within, and only within, the limits of being Human. Art forms and colours, or rhythms and tones of words, progress asymmetrically or eventually settle into some complexity of beseeming haphazard composure. The art work defines a paradigm of the experienced chaos of everyday life while being in itself a construct quite distinct from it. The salad is on the table, every ruffled edge of lettuce crisp with the glitter of its own being-at-one with water and/or over lay of oil. Musically such crispness can translate pizzicato, or into some slow uncoil of overall (say oboe) curl ottone, some tome of green punctuated by drum, and so on, or it can just be distorted by dream – the limp-lettuce nightmare, crack and timbre reverberation in phosphor glint of cathected leafage, so forth.

Were I to paint the plein-air abstraction of this (as I do) onto a strip of film, my whim would be to absorb what could be seen of such lettuce, its surrounds of table and all, the very room, and then to allow into my consideration the movements of such absorption – the shifts of eye in contemplation, the electrical discharges of synaptic thought, the 'translations', as it were, from optic imprint to memorabilis.

For colour ('magic markers', dyes, india inks) I choose greens, yes, but vein them with yellows and ruffled shadow-black, applying isopropyl alcohol on a twisted pointed kleenex to thin dye lines, smudge the tones or (with alcohol flicked from a thumbed toothbrush) create circles to dab into partial-circle-curves or (with weakened, spit-diluted alcohol) do manage filigrees midst mixes of conglomerate colour.

Sometimes varieties of tone are marked directly upon the transparent 'palette' (or clip-board which holds the film strip) so that I can then make toned puddles of alcohol to dip the film into, feathering the shapes with quick twists of the wrist, pressing the film so that the dyes collect as edges to half-dried shapes and so on. More often than not the alcohol is used to erase an entire frame or collection of frames which have, so it seems, come to naught.

There is very little of 'lettuce' left after all this, but when successful, the truths of moving visual thinking are made manifest along a strip of film.

As to the 'table', strips of adhesive tape provide varieties of straight lines, after applied dyes, in mimic of eye's slippage, brevities of 'cubism', if you will, in Time, continuities of cubistic envisionment when flashed (twenty-four frames a second) through the projector and upon the motion-picture screen. Very little of geometry survives 'translation' into organic thought, so it seems to me. The meat of the mind (at least my mind) puts curve to linearity, blurs hard-edge perception. But the thought of (for example) 'the shortest distance between two points' prevails in a mix of cellular irregularities sufficient to necessitate its occasional representation.

The table is in the range of nomenclature 'yellow brown'; but the eye's retention of yellow is blue, and the afterimage of brown is often something I call 'red-black' – a very muted red, to be sure . . . more in the range of purple, say – actually un-nameable. The shifts of tone, as the mind absorbs, is understandably variable along a strip of film, but a tune undergoing melodic variations. These variations are subject to interruptions by absorption of all other tones (and shape shifts) of the surrounding room (for shape does surely affect reception of tone . . . and tone of tone in colour-chordal variance).

The plate upon which the salad sits (oval-shaped, as it happens) presents curves which tighten in relation to each other as if pulled string-to-bow,

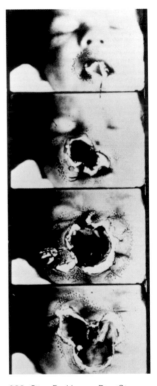

288. Stan Brakhage, *Dog Star Man: Part 2*, 1963

becoming variances of interruptive 'horizontals', 'verticals', 'diagonals' (as we name them – mimicking the language of Painting and still Photography) in the field of compositional logic for Film. Semi dried 'magic markers' can effect a line quite similar (on this small scale) to brush stroke; but these I tend to smudge with alcohol twist of kleenex until they more nearly approximate some sense of optic flickering of such. As the plate is 'white', and the film strip transparent film leader. I delicately scratch at the lines of the 'stroke', so to speak.

The truth of the 'plate' is that it affects visual absorption of the lettuce very much like a break in the sight-lines, distraction from forms, rhythmically castanet like, because otherwise its paradigm on film, its variable oval, would act as container – a word appropriate to its service *vis-à-vis* lettuce (appropriate surely in language and perhaps to description of snap-shot) but absolute non sense in respect to moving visual thought process. Such containment would preclude the peripherally perceived effects of the room, the inpouring light of the world beyond, the process of memory and expectation and, thus, would obliterate Time.

I haven't really written about the paradigmatic play of memory in this process of painting a film . . . nor do I intend to now; but suffice it that 'lettuce' perceived as a word and lettuce seen across any (however limited) 'space ottime', like we say, constitute two entirely different processes of thinking.

Let me end on three 'Tender Buttons' by Gertrude Stein:

MORE

An elegant use of foliage and grace and a little piece of white cloth and oil. Wondering so winningly in several kinds of oceans is the reason that makes red so regular and enthusiastic. The reason that there is more snips are the same shining very colored rid of no round color.

A NEW CUP AND SAUCER

Enthusiastically hurting a clouded yellow bud and saucer, enthusiastically so is the bite in the ribbon.

OBJECTS

Within, within the cut and slender joint alone, with sudden equals and no more than three, two in the center make two one side.
If the elbow is long and it is filled so then the best example is all together. The kind of show is made by squeezing.

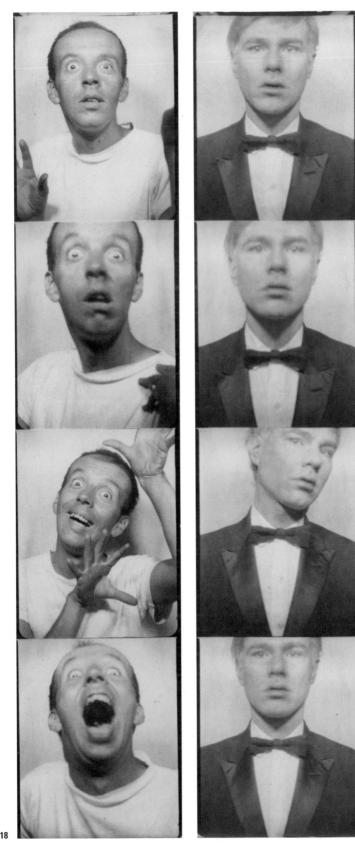
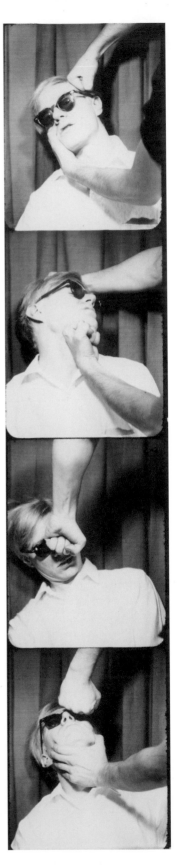

289. Andy Warhol, *Taylor Mead*, 1963–1964

290. Andy Warhol, *Self-Portrait*, 1964

291. Andy Warhol, *Self-Portrait (Being Punched)*, 1963–1964

People sometimes say the way things happen in movies is unreal, but actually it's the way things happen to you in life that's unreal. The movies make emotions look so strong and real, whereas when things really do happen to you, it's like watching television – you don't feel anything.

I have no memory. Every day is a new day because I don't remember the day before. Every minute is like the first minute of my life. I try to remember but I can't. That's why I got married – to my tape recorder with one button – 'erase'.

Ever since I was a kid I've wanted to live as fast as I could, so I always try to find ways to do things faster.

The reason I'm painting this way is because I want to be a machine. Whatever I do, and do machine-like, is because it is what I want to do. I think it

would be terrific if everybody was alike. (1968)

In the future everybody will be world famous for fifteen minutes. (1968)

The best atmosphere I can think of is a film, because it's three-dimensional physically and two-dimensional emotionally. (1971)

I like photography and cinematography more than painting now. It's because you can show more in it. There are more images, more pictures that can be created. No one can show anything in painting anymore, at least not like they can in movies. I knew that I would have to move on from painting.
I knew I'd have to find new and different things. Lots of stuff bores me. (1975)

293. Andy Warhol, *TYCORA Wishes You A Very Merry Christmas*, 1950s

294. Andy Warhol, *Christmas Card (Bergdorf Goodman Exclusive)*, 1950s

295. Andy Warhol, *Holiday Postcard ("Merry Christmas from I. Miller")*, 1950s

296. Andy Warhol, *Silver Disaster*, 1963

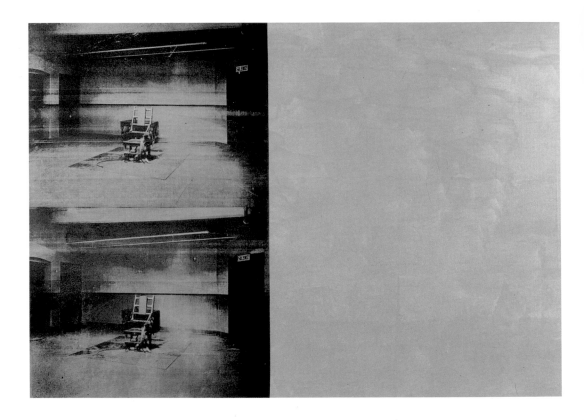

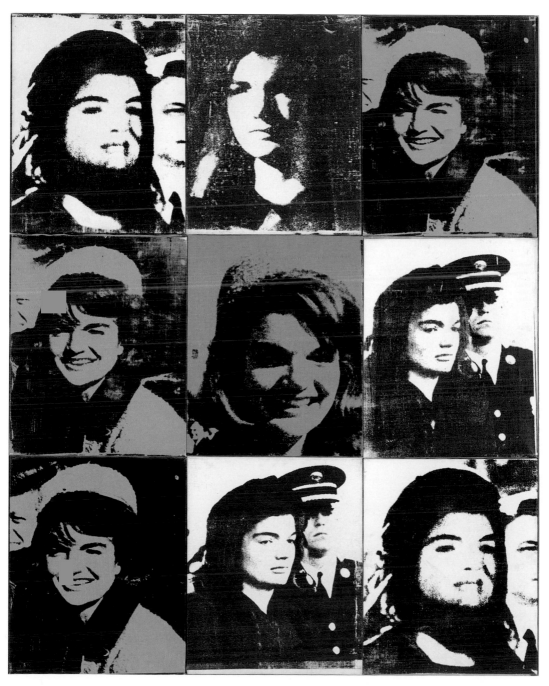

Nineteen Sixty-three – Two Thousand Five

298. Andy Warhol, *Andy Warhol's Index (Book)*, 1967

299. *Amy Vanderbilt's Complete Cookbook*, Doubleday & Company, 1961

300a. Andy Warhol, *The Philosophy of Andy Warhol (From A to B and Back Again)*, 1975
300b. Andy Warhol, *A, a novel*, 1968

301. *The Velvet Underground & Nico*, 1967

302. Diana Ross, *Silk Electric*, Cover by Andy Warhol, 1982

303a. The Rolling Stones, *Love You Live*, Cover by Andy Warhol, 1977
303b. The Rolling Stones, *Sticky Fingers*, Cover by Andy Warhol, 1971

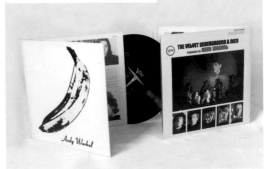

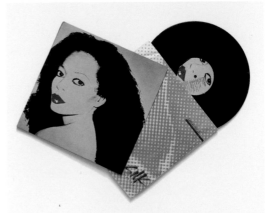

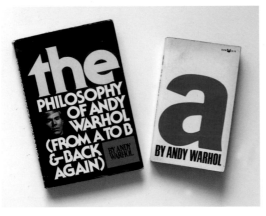

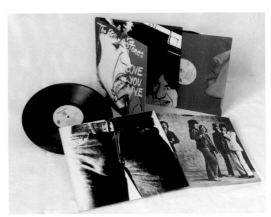

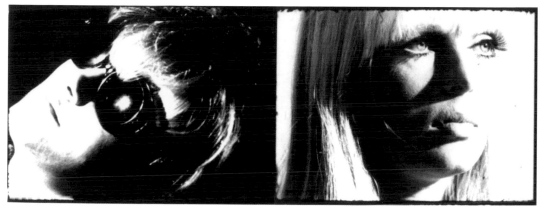

Nineteen Sixty-three – Two Thousand Five

308. Andy Warhol, *Andy Warhol's Fifteen Minutes*, pilot episode, 1985

309. Andy Warhol, *Andy Warhol's TV*, third episode, 1980

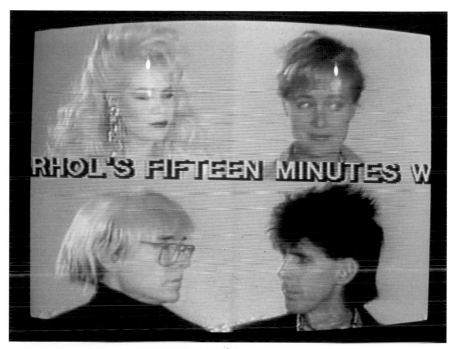

310. Robert Rauschenberg,
Susan, NYC (III), 1950

311. Robert Rauschenberg,
Rome Flea Market III, 1953

312. Robert Rauschenberg,
*Robert Rauschenberg Fulton
Street Studio*, 1951

313. Robert Rauschenberg,
Rome Flee Market II, 1952

314. Robert Rauschenberg,
Payload, 1962

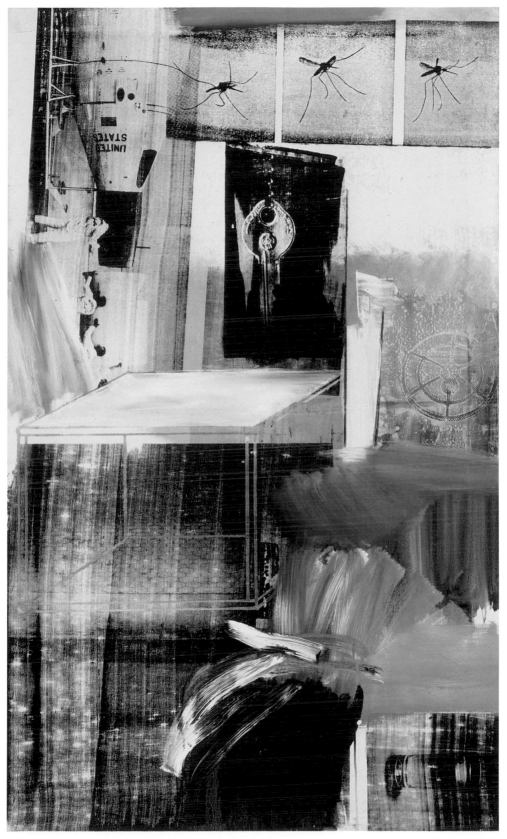

315. Roy Lichtenstein, *Modern Painting in Enamel*, 1967

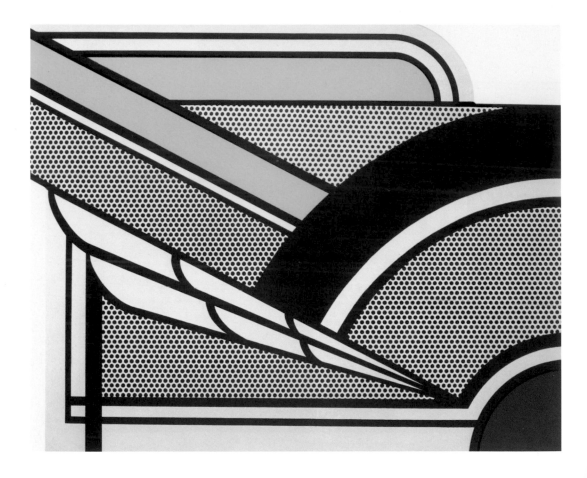

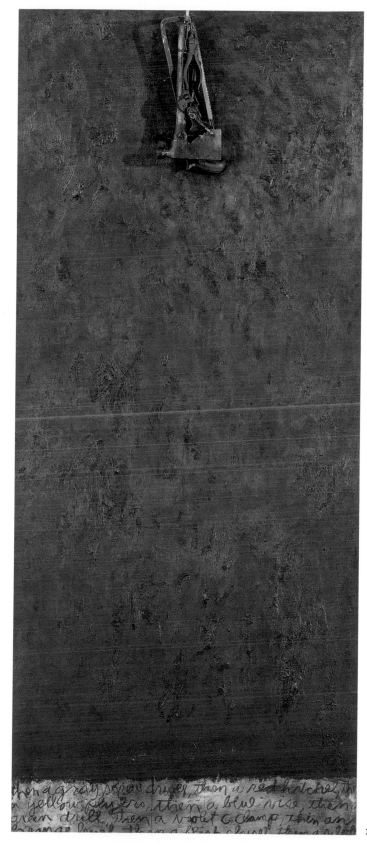

317. Claes Oldenburg, *Ray Gun Theatre*, 1962

318. Claes Oldenburg, *Sports*, 1962

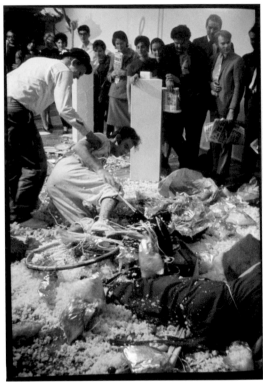

319. Claes Oldenburg, *Store Days*, 1967

320. Claes Oldenburg,
Unattendable Lunches, 1967

321. Claes Oldenburg, exhibition
catalogue from The Museum of
Modern Art, New York, 25
September–23 November 1969

322-323. Claes Oldenburg,
Coosje van Bruggen, *Il corso del
coltello: menu*, 1985

324. Jim Dine, Oscar Wilde, *The Picture of Dorian Gray*, 1968

324. Jim Dine, Oscar Wilde, *The Picture of Dorian Gray*, 1968

325. Jim Dine, Ron Padgett, *The Adventures of Mr. and Mrs. Jim and Ron*, 1970

326. Jim Dine, *The Apocalypse. The Revelation of Saint John the Divine*, 1982

327. Allan Kaprow, *Assemblage, Environments & Happenings*, 1965

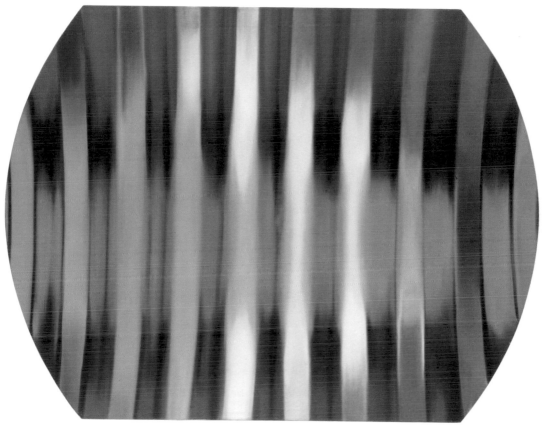

The goal and result of my 'mirror' pieces was to push art to the edges of life in order to test the entire system both (art and life) function within. After that, the only thing left to do is choose: you can either go right back to the system of 'doubling' and conflict through a monstrous involution, or you can exit the system entirely through revolution; you can either bring life back to art, as Pollock did, or bring art to life, but no longer as a metaphor . . . Every procedure of mine is now on equal footing. Every product of mine is a liberation, rather than a construction aiming to represent me; I don't reflect on myself in them, nor can others reflect upon me through my work.
(1967)

The mirror pieces couldn't live without a public, couldn't be taken on their own. They created themselves, and were recreated, according to the movements and interventions they reproduced. The step from the mirror pieces to the theatre – everything is theatre – simply struck me as a natural one.
(1969)

330. Michelangelo Pistoletto, *L'uomo nero, Il lato insopportabile*, 1970

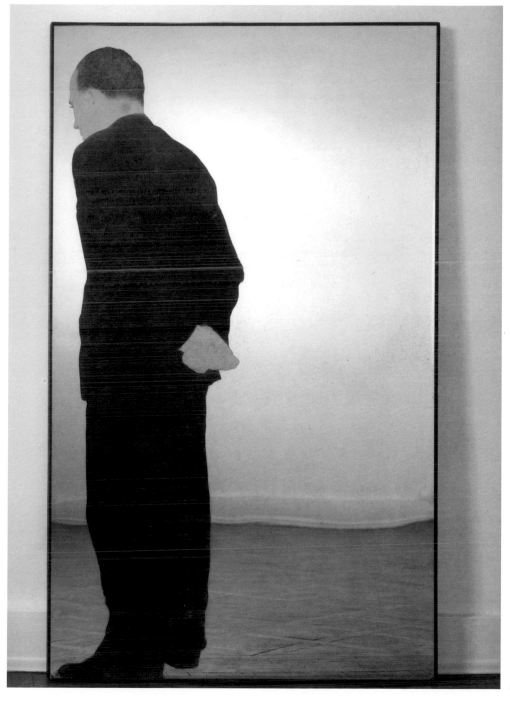

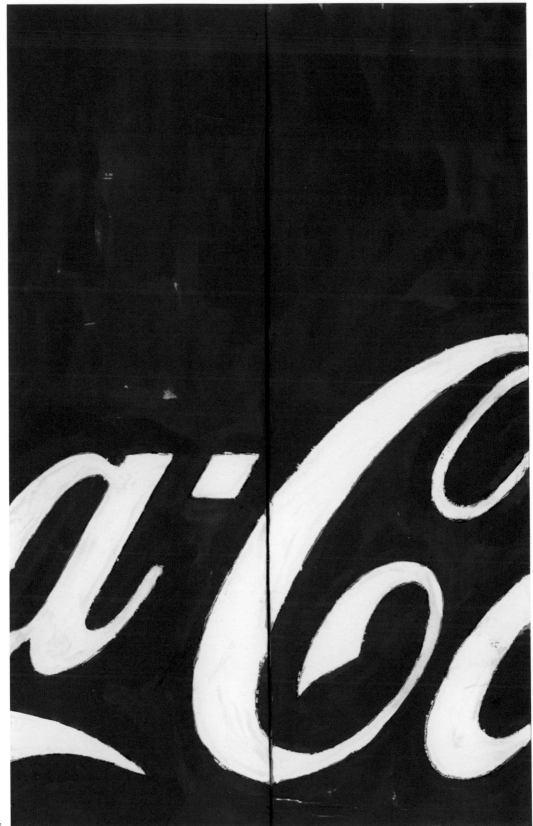

332. Mario Schifano, *Coca Cola*, 1962

333. Fluxus Group, *Fluxus 1*, 1964

334. Fluxus Group, *Flux Year Box 2*, c. 1966–1968

335. Fluxus Group, *Flux-kit*, 1964–1966

336. AY-O, *Finger Box*, 1964–1965

337a. John Cage, *Diary: How to Improve the World (You Will Only Make Matters Worse) Continued. Part Three (1967)*, 1967
337b. Allan Kaprow, *Some Recent Happenings*, 1966
337c. Philip Corner, *Popular Entertainments*, 1967

338a. Daniel Spoerri, *The Mythological Travels*, 1970
338b. Daniel Spoerri, *An Anecdoted Topography of Chance*, 1966

339-340. Daniel Spoerri, *Dokumente, Documents, Documenti*, 1971

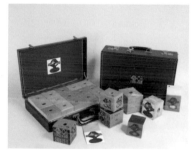

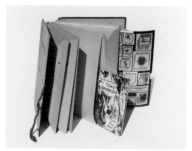

341. Arman, *Photo Stop –*
Collera, 1963

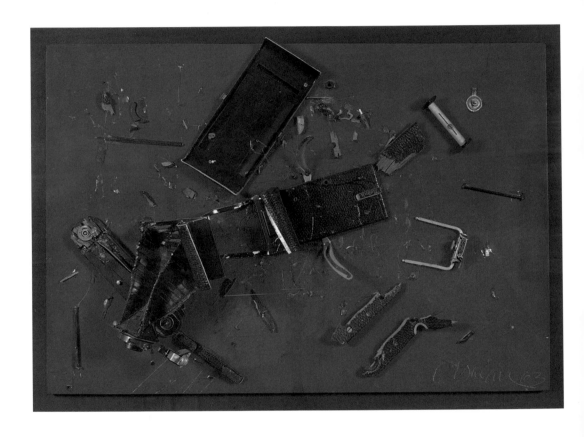

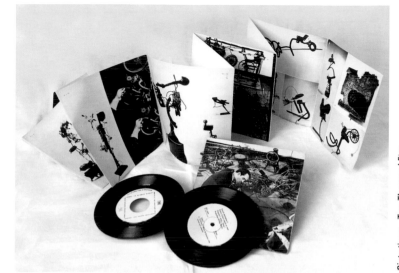

342. Jean Tinguely, *Sound of Sculpture*, 1963

343. Günther Uecker, *TV auf Tisch*, 1963

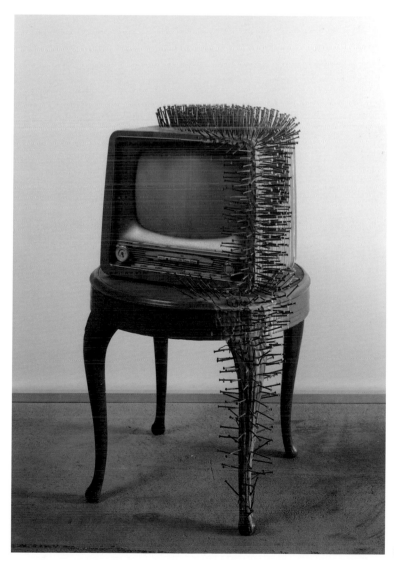

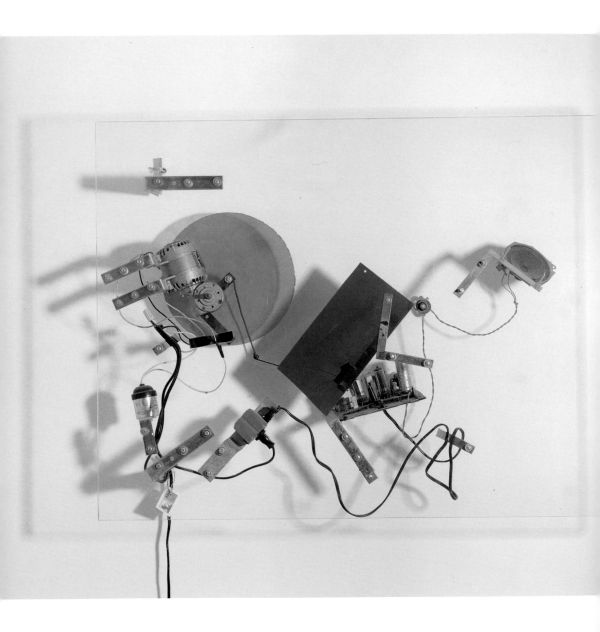

345. Robert Filliou with George Brecht, Joseph Beuys, John Cage, Dorothy Jannone, Allan Kaprow, Marcelle, Benjamin Patterson, Dieter Roth, *Lehren und Lernen als Auffuehrungskuenste / Teaching and Learning as Performing Arts*, 1970

346. Dick Higgins, *Foewgombwhnw*, 1969

347. Köpce, *Music While You Work*, 1958–1964

348. Ray Johnson, *The Paper Snake*, 1965

349. Dick Higgins, *Postface, Jefferson's Birthday*, 1964

350a. Dieter Roth, *Melchior*, 1974
350b. K. Roth, Dieter Roth, *Tslenskra Fjalla*, 1975

350c. Dieter Roth, Gerhard Rühm, Oswald Wiener, *Novembersymphonie*, 1974
350d. Dieter Roth, Gerhard Rühm, Oswald Wiener, *Berliner Dichter Workshop*, 12–13 July 1973

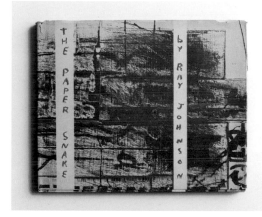

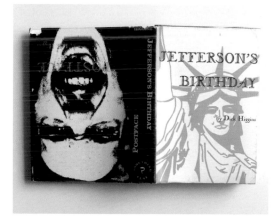

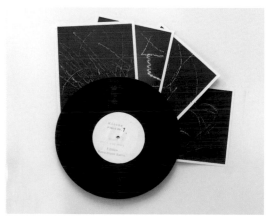

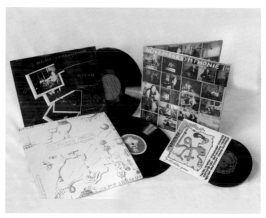

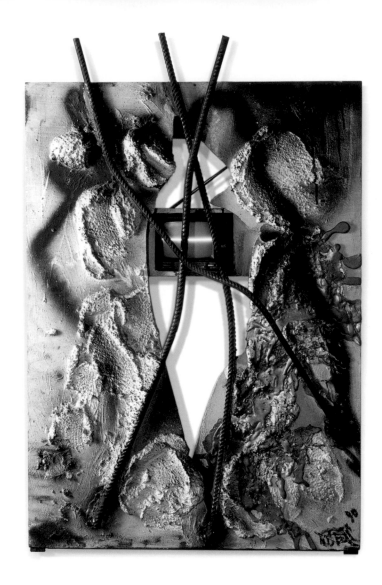

351. Wolf Vostell, *Television Revolution no. 4*, 1990

352. Wolf Vostell, *Dé-coll/age happenings*, 1966

353. Wolf Vostell, *Fandango*

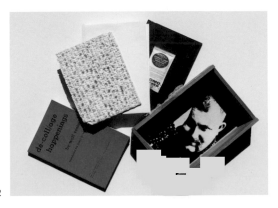

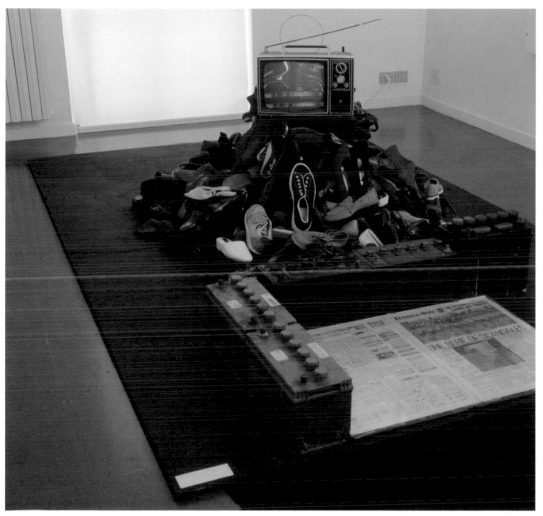

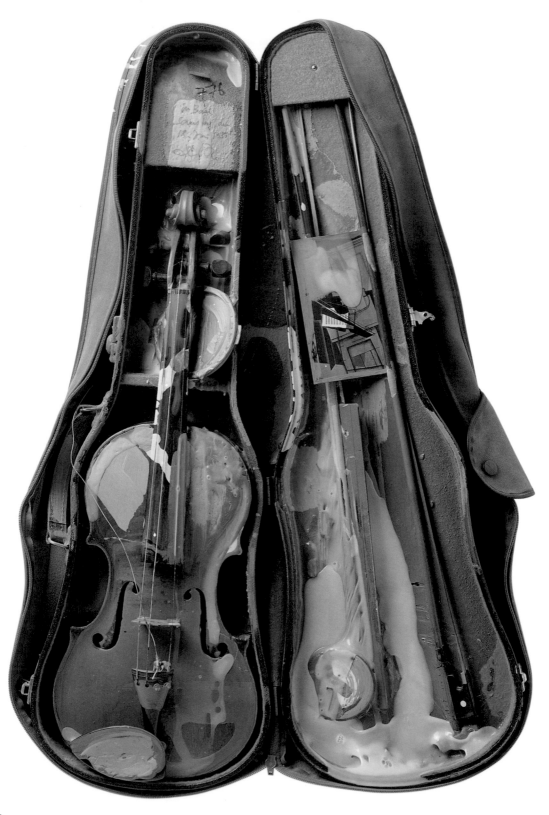

355. Dieter Roth, *Stummes relief (Erste kubistische Geige)*, 1984–1988

356. Joseph Beuys, *Silence*, 1973

357a. Joseph Beuys, Albrecht Dürer, *Albrecht Dürer & Joseph Beuys Performance at the Institute of Contemporary Art*, London, 1 November 1974
357b. Joseph Beuys, *Ja Ja Ja Nee Nee Nee*, 1970
357c. Joseph Beuys, Henning Christiansen, *Scottische Symphonie. Requiem of Art*, 1973

358. Joseph Beuys, Nam June Paik, *In Memoriam George Maciunas (Klavierduett)*, 1982

359. Joseph Beuys, *Enterprise*
18.11.72, 18:5:16 UHR, 1973

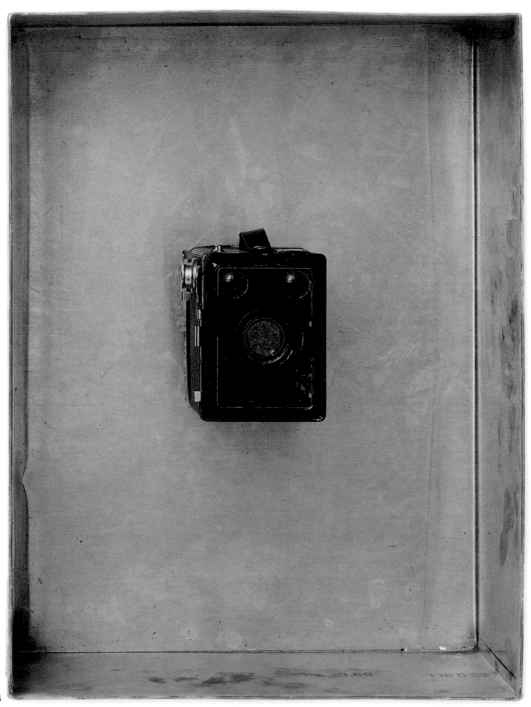

360. Joseph Beuys

Filz TV deals with information and the problem of the mass media. It is a battle against ourselves, as visitors of the information being covered. One has to feel the need to make information up for himself, so I have to act out the play by and for myself. We are once again faced with an energy that must be produced by the individual, not just by the television, by something external. The stimulus aims at making you no longer passive, to turn the thing internally, like in a piano . . .

The piano, for me, is like an animal. Its internal circulation, its heart, veins and lungs are filled by sounds and music. Normally, sound can be considered a life-giving plankton, aimed at the exterior, but if I put felt all round the piano, the sound moves throughout the internal organs . . .

My artistic language has passed through many stages: a first stage, in which I expressed myself with objects, a second, with actions; and finally the third, which I am now in, that of thoughts and concepts, which can be expressed through words and graphics . . .

Even if you take the human being as a technological prototype for information, the individual still has to pose himself the problem of the transmitter and receiver – that is, of communication. Communication, in order to work, has to pass from thought to material – that is, into a

plastic, sculptural form. But everything takes place in an extreme point, between environment one and environment two, or the natural world and the world outside of nature. The human being lies at the centre, and produces history through its creative will.
(Interview on *Filz TV*, 1972)

I am not against science, but I am against the distinction between art and science. I wrote a theatrical part in which I confirm that art is equal to man is equal to creativity is equal to science. I don't agree with the idea that the concept of art is a negation of the concept of science, but I do say it contains it. The day when artists – and I use this term to mean all creative beings – become aware of the revolutionary force of art, understood as creativity, they will understand that art and science have the same objectives. That's why I say: we are the revolution.
(1973)

It's a matter of reciprocal integration, of an osmosis, if you prefer: art must proceed according to a scientific methodology, and science according to an artistic methodology. This is how you apply my modern concept of art, wherein you can no longer draw such clear differentiating lines between art and science.
(1974)

361. Lothar Wolleh, *Joseph Beuys Aktion Filz/TV*, 1968–1970

361a. Joseph Beuys
Sitting in front of your TV, 1972 **347**

I am tired of renewing the form of music . . . I must renew the ontological form of music . . . In the *MovingTheatre* in the Street, the sounds move in the Street, the audience meets or encounters them 'unexpectedly' in the Street. The beauty of moving theatre lies in this 'surprise a priori', because almost all of the audience is uninvited, not knowing what it is, why it is, who is the composer, the player, organiser – or better speaking – organiser, composer, player.
(1963)

It is the historical necessity, if there is a historical necessity in history, that a new decade of electronic television should follow to the past decade of electronic music.
Variability & Indeterminism is underdeveloped in optical art as parameter Sex is underdeveloped in music.
As collage technique replaced oil paint, the cathode-ray tube will replace the canvas.

Someday artists will work with capacitors, resistors and semi-conductors as they work today with brushes, violins and junk.
(1965)

. . . As an adjunct to these experiments I plan to construct a compact version of electronic TV for concerts so that it can be easily transported and demonstrated to colleges. It will have unprecedented education effects since it bridges two cultures, appealing both to artistically and scientifically minded people, these two projects of experimentalism and education are aimed at a third stage – the development of an adaptor with dozens of possibilities which anyone can use in his own home, using his increase leisure to transform his TV set from a passive pastime to active creation.
(1965)

As the happening is the fusion of various arts, so cybernetics is the

363a. Nam June Paik, *My Jubilee ist Unverhemmet*, 1977
363b. Nam June Paik, *Duett: Nam June Paik/Taxis*, 1979

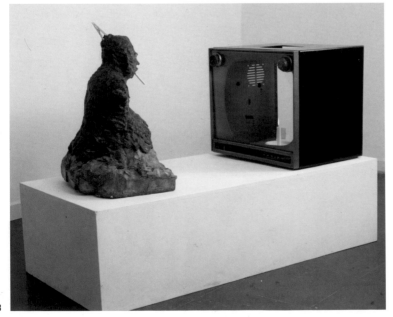

364. Nam June Paik, *TV Buddha*, 1990

365. Nam June Paik, *Family of Robot, Aunt*, 1986

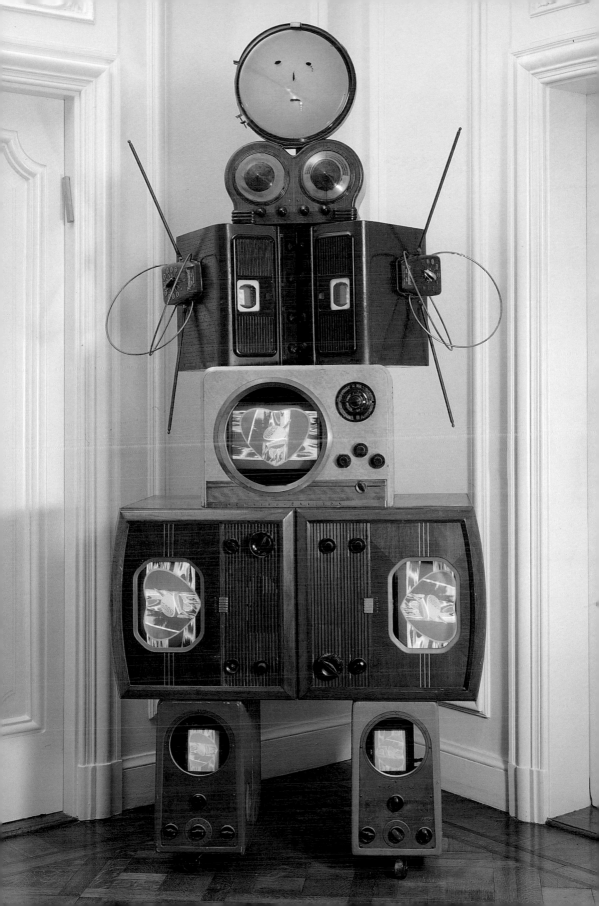

366. Charlotte Moorman, Nam June Paik, *Rare Performance Documents 1961–1994. Volume 1: Paik-Moorman Collaborations*, compiled in 2000

367. Nam June Paik in collaboration with Charles Atlas, Merce Cunningham, Shigeko Kubota, *Merce by Merce by Paik*, 1978

368. Carolee Schneemann, *Snows*, 1967

369. Nam June Paik, *Zen for Film*, 1962–1964

370. John Cage, *Catch 44*, 1971

371. Jud Yalkut, *26'1.1499" for a String Player*, 1973

exploitation of boundary regions between and across various existing sciences.
(1966)

The real issue implied in 'Art and Technology' is not to make another scientific toy, but how to humanise the technology and the electronic medium, which is progressing rapidly – too rapidly. Progress has already outstripped its ability to program. I would suggest 'Silent TV Station'. This is TV station for high-brows, which transmits most of the time only beautiful 'mood art' in the sense of 'mood music'. What I am aiming at is TV version of Vivaldi . . . or electronic 'Compoz', to soothe every hysteric woman through air, and to calm down the nervous tension of every businessman through air. In what way 'Light Art' will become a permanent asset or even collection of Million people. SILENT TV Station will simply be 'there', not intruding on other activities . . . and being looked at exactly like a landscape . . . or beautiful bathing nude of Renoir, and in that case, everybody enjoys the 'original' . . . not a reproduction . . . *TV Brassiere for Living Sculpture* (Charlotte Moorman) is also one sharp example to humanise electronics . . . and technology. By using TV as a bra . . . the most intimate belonging of human being, we will demonstrate the human use of technology, and also stimulate viewers NOT for something mean but stimulate their phantasy to look for the new, imaginative and humanistic ways of using our technology.
(1969)

The nature of the environment is much more on TV than on film or painting. In fact, TV (its random movement of tiny electrons) is the environment of today.
(1971)

Imagine a future where *TV Guide* will be as thick as the Manhattan telephone directory.
(1973)

March 1963. While I was devoting myself to research on video, I lost my interest in action in music to a certain extent. After twelve performances of Karlheinz Stockhausen's *Originale*, I started a new life from November 1961. By starting a new life I mean that I stocked my whole library except those on TV technique into storage and locked it up. I read and practiced only on electronics. In other words, I went back to the spartan life of pre-college days . . . only physics and electronics.
(1986)

372. Sol LeWitt, *Modular Drawings, Salle Simon I. Patino*, 1976

373a. Sol LeWitt, *Four Basic Kinds of Straight Lines*, 1969
373b. Sol LeWitt, *Four Basic Colours and Their Combinations*, 1971

374a. Sol LeWitt, *Lines*, 1973
374b. Sol LeWitt, *Wall Drawings: Seventeen Squares of Eight Feet with Sixteen Lines and One Arc*, 1973
374c. Sol LeWitt, *Diciassette quadrati con sedici linee ed un arco*, 1974

375a. Sol LeWitt, *Lines & Color*, 1975
375b. Sol LeWitt, *Red, Blue and Yellow, Lines from Sides, Corners and the Center of the Page to Points on a Grid*, 1975
375c. Sol LeWitt, *The Location of Straight, Not Straight & Broken Lines and All Their Combinations*, 1976

376a. Sol LeWitt, *Work Completed*, 1974
376b. Sol LeWitt, *Grids, Pour Ecrire la Liberté*, 1975

377. Sol LeWitt, *Sol LeWitt, Autobiography*, 1980

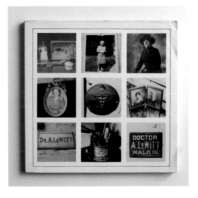

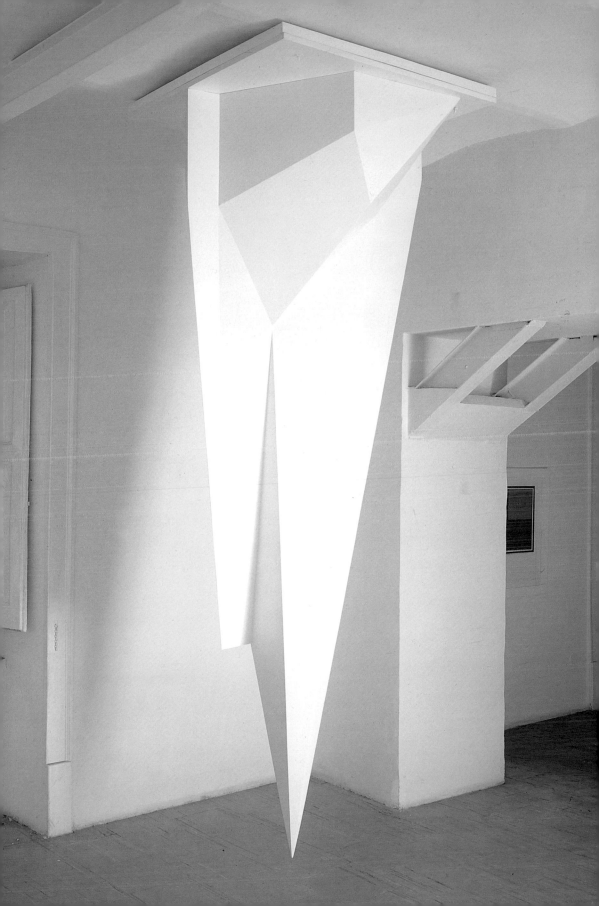

WILLOUGHBY SHARP: How did you come to use videotape in the first instance?

BRUCE NAUMAN: When I was living in San Francisco, I had several performance pieces which no museum or gallery was interested in presenting. I could have rented a hall, but I didn't want to do it that way. So I made films of the pieces, the bouncing balls and others. Then we moved to New York, and it was harder to get film equipment. So I got the videotape equipment, which is a lot more straightforward to work with.

W.S.: How did the change from film to videotape affect the pieces?

B.N.: Mainly they got longer. My idea was to run the films as loops, because they have to do with ongoing activities. The first film I made, *Fishing for Asian Carp*, began when a given process started and continued until it was over. Then that became too much like making movies, which I wanted to avoid, so I decided to record an ongoing process and make a loop that could continue all day or all week. The videotapes can run for an hour – long enough to know what's going on.

W.S.: Are you working only with videotapes at the moment?

B.N.: No, I've been working with film again. The reason they are films again is because they're in super-slow motion; I've been able to rent a special industrial camera. You really can't do it with the available videotape equipment for amateurs. I'm getting about 4,000 frames per second. I've made four films so far. One is called *Bouncing Balls*, only this time it's testicles instead of rubber balls. Another one is called *Black Balls*. It's putting black makeup on testicles. The others are *Making a Face*, and in the last one I start out with about 5 or 6 yards of gauze in my mouth, which I then pull out and let fall to the floor. These are all shot extremely close up.

B.N.: Originally a lot of the things that turned into videotapes and films were performances. At the time no one was really interested in presenting them, so I made them into films. No one was interested in that either, so the film is really a record of the performance. After I had made a few films I changed to videotape, just because it was easier for me to get at the time. The camera work became a bit more important, although the camera was stationary in the first ones.
(1970)

CHRISTOPHER CORDES: You have published four books: *Pictures of Sculpture in a Room* (1965–1966); *Clear Sky* (1967–1968); *Burning Small Fires* (1968); and *LA Air* (1970). What

380. Bruce Nauman, *Good Boy, Bad Boy*, 1985

were you attempting to do in each of these books?

B.N.: *Pictures of Sculpture in a Room* was done when I was a student. My aim was to make an object of the book to confuse the issue a little bit. It is a total object, but it has pictures – however, it is a book, not a catalogue. *Clear Sky* was a way to have a book that only had coloured pages – pictures of the sky. I like the idea that you are looking into an image of the sky, but it is just a page; you are not really looking into anything – you are looking at a flat page. *LA Air* was the same idea, but it was also a response to *Clear Sky* using polluted colours instead. Similarly, *Burning Small Fires* was a response to Ed Ruscha's book, *Various Small Fires* (1964).

. . . Art is interesting to me when it ceases to function as art – when what we know as painting stops being painting, or when printmaking ceases to be printmaking – whenever art doesn't read the way we are used to. In this manner, a good piece of art continues to function, revealing new meaning and remaining exciting for a long time, even though our vision of what art is supposed to be keeps changing. After a while, however, our point of view as to how art can function changes radically enough that the work of art becomes art history. Eventually, our perspective is altered so much that its functions just aren't available to us anymore and art becomes archaeology. (1989)

382. *Art by Telephone*, 1969

383. *Airwaves—Two-record anthology of artists' aural work & music*, 1977

384. *The Sound of Sound Sculpture*, 1958–1971

385. *Airway (Live at Lace)*, 1978

386. *Sound Texts, Concrete Poetry, Visual Texts*, 1970

387. Hanne Darboven, *Vier Jahreszeiten, opus 7. Der Mond ist Aufgegangen*, 1981–1982

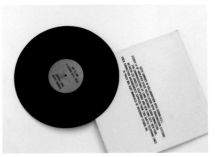

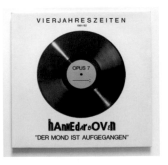

388. Carl Andre, *100 Magnesium Squares, Düsseldorf*, 1970

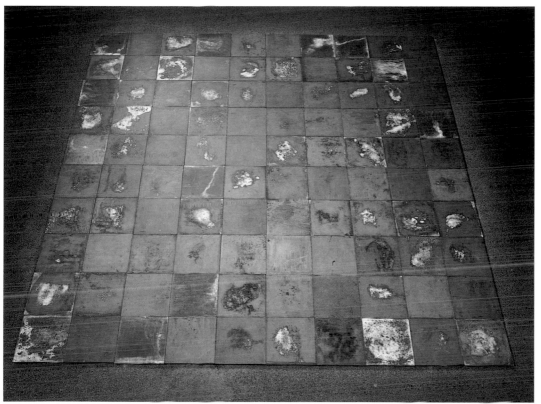

Nineteen Sixty-three – Two Thousand Five

389a. Joseph Kosuth, *Function*, 1970
389b. Joseph Kosuth, *The Sixth Investigation (Proposition II)*, 1971

390a. Jan Dibbets, *Robin Redbreast's Territory / Sculpture 1969*
390b. Jan Dibbets, *Horizon*

391a.Carl Andre, *Quincy Book*, 1973
391b. Carl Andre, *Eleven Poems*, 1974

392–407. Hans Peter Feldmann, sixteen books from the *Bilder* series, 1968–1973

408. Daniel Buren, volume from the slip-cased series *Passage tome I/VII*, 1972

409. Carl Andre, *Stadtisches Museum Mönchengladbach*, 1968

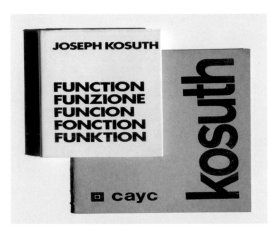

Nineteen Sixty-three – Two Thousand Five

idea, ideal (adj, hence n), idealism, idealist (whence idealistic), idealize (whence idealization), ideate (whence ideation, whence ideational), idée fixe; ideology (whence ideological and ideologist); idol (whence idolize) and eidolon, idolater; idolatrize and idolatrous from idolatry; eidetic; idyl or idyll, whence idyllic; cf the elements *ideo-*, *idolo-*, *eido-*; cf also the sep WIT, esp f.a.e.

411a–f. Issues from the magazine Art-Language, 1969–1972

412a. Ian Burn, *Mirror Piece*, 1967
412b. Terry Atkinson, Michael Baldwin, *Theories of Ethics*, 1970–1971
412c. Ian Burn, Mel Ramsden, *Unlimited Edition: Subscription (per annum)*, 1971

413a. Lawrence Weiner, *Tracce / Traces*, 1970
413b. Lawrence Weiner, *Qizas cuando removido / Perhaps When Removed*, 1971
413c. Lawrence Weiner, *10 Works*, 1971
413d. Lawrence Weiner, *10 Works*, 1971
413e. Lawrence Weiner, *Misschien door verwijdering*, 1971

414a. Lawrence Weiner, *7*, 1972
414b. Lawrence Weiner, *Having Been Done at / Having Been Done to. Essendo stato fatto a*, 1973
414c. Lawrence Weiner, *Having Been Built on Sand. With Another Base. (Basic) In Fact. Auf Sand Gebaut. Mit Einer Andern Basis. Tatsächlich*, 1978
414d. Lawrence Weiner, *Nothing to Lose Niets Aan Verloren*, 1976

415a. John Baldessari, *Throwing Three Balls in the Air to Get a Straight Line (Best of Thirty-six Attempts)*, 1973
415b. John Baldessari, *Ingres and Other Parables*, 1972

416. Michael Snow, *A Survey*, 1970

417. Michael Snow, *Cover to Cover*, 1975

418. Michael Snow, *Wavelength*, 1967

A series of photographic images portrays the artist or his studio in various 'pictures' and a few particular 'moments'. *Delfo* is a photographic canvas that reproduces, life-size, the image of the artist (myself) and the painting's stretcher, in a sort of illusionistic identity of the artist and the work. *1421965* are the numbers that correspond to the date (14 February 1965) the photogram was shot: the photographer recorded the painter in the act of grasping the canvas. The entire scene is 'seen' over the shoulders of the same photographer, as an absolute given.
(*Note di lavoro*, 1965)

In *Una poesia, Qui, Lo spazio*, the word becomes an image of itself: that is, it tends to determine the spatial metrics of its own meaning. *D867* is a photographic canvas that represents the artist in the act of carrying a picture (another photographic canvas, from 1965, which portrays me carrying a white canvas). The reproduction of a detail of a painting by Nicolas Poussin is 'doubled' such that Flora herself offers the viewer the same semblances and poses in which she has been portrayed by the painter. In some collages it is the sheet of paper itself that tends to redeem – through its role as a support – its own absolute and enigmatic presence. That happens thanks to the insertions that,

carried over from the margins to the centre, intervene as revelatory elements: they underline and define, that is, the chance and provisional confines of a surface, of an image that we'd had right under our noses and perhaps weren't even aware of.
(*Note di lavoro*, 1967–1968)

Technique . . . is the means that allows us to leave the space we are in, in order to enter that other part of space that is the work of art, and which is cancelled out precisely through technique. Deep down, art is the technique itself, used to a certain end. Technique allows the work of art to exist insofar as it removes – from the space we're in, and the environment in which the work of art is presented – that certain amount of space that constitutes the work of art itself. If we have to pass from our own daily space into the space of the work of art – and I mean the actual, physical space – then we have to cross through the diaphragm, over the border, assimilating a technique that allows us to make that leap, right? This is precisely why technique mustn't appear as is, in and of itself, but rather it must just serve us, and make itself useful as an invisible, innocuous diaphragm for crossing over to the opposite side . . .
(1969)

422. Giulio Paolini, *Diaframma 8*, 1965

423. Giulio Paolini, *D 867*, 1967

421. Giulio Paolini, *Exit*, 1996

424. Alighiero Boetti, *Gemelli*, 1968

425. Alighiero Boetti, *Fascicolo 104, Dossier postale*, 1969

427. Alighiero Boetti, *September 1984*, 1984

The *Gemelli* work was among the driest and sharpest – much like sending out the *Cartoline postali (Postcards)* in '68, at a time when you didn't dare send anything by post! That work had no 'original': I sent fifty postcards with phrases like 'de-cantiamoci su' (let's decant ourselves up: when *to decant* means 'to settle [down]', and is also a play on the verb *cantare*, 'to sing'); or 'non marsalarti' (don't sweeten yourself with Marsala wine in your old age), depending on the person the card was addressed to. 'Alighiero e Boetti' (Alighiero and Boetti) is the simplest one: just putting an *and* between two names is sufficient. It's enough as long as it functions as a theatrical act. I remember . . . one time I had done a drawing and signed it *Alighiero e Boetti*, and a woman came up who didn't know, and asked, 'Who are those two?' Then I knew everything was fine . . . They're just little confirmations of reality. (1973)

Whether the work is done by me, by you, by Picasso or Ingres doesn't matter. It's the levelling of quality that interests me: here there is a total distortion of quality as it's normally understood. And for me, a work's spread also counts a lot . . . I'd say it's a matter of fractioning the work, dividing it into fragments, as happens in film. The director has a screenwriter, a photographer/cinematographer, an editor . . . The creativity doesn't exist in the person you hire to do the work (if anything, there's a recording, like an encephalogram of his impulses): every one of my works is the result of a different type of collaboration. I am interested in primary things (the alphabet, geographic maps, newspapers . . .), also because of the impulse, the mainspring they set off, somewhere between order and disorder. There is a precise order in everything, even if it's transcribed in a disorganised manner. (1977)

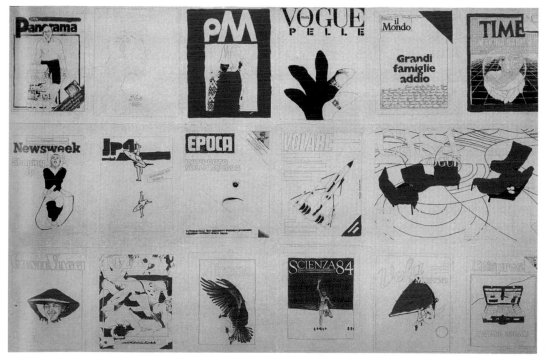

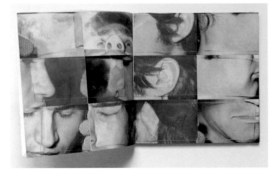

428. Mario Merz, *Fibonacci 1202*, 1970

429. Mario Merz, *Voglio fare subito un libro*, 1985

430. Vincenzo Agnetti, *Libro dimenticato a memoria*, 1969

431. Giuseppe Penone, *Svolgere la propria pelle*, 1971

432-433. Luciano Fabro, *Vera*, 1969

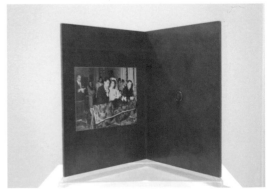

434. William Wegman, *Stormy Night*, 1972

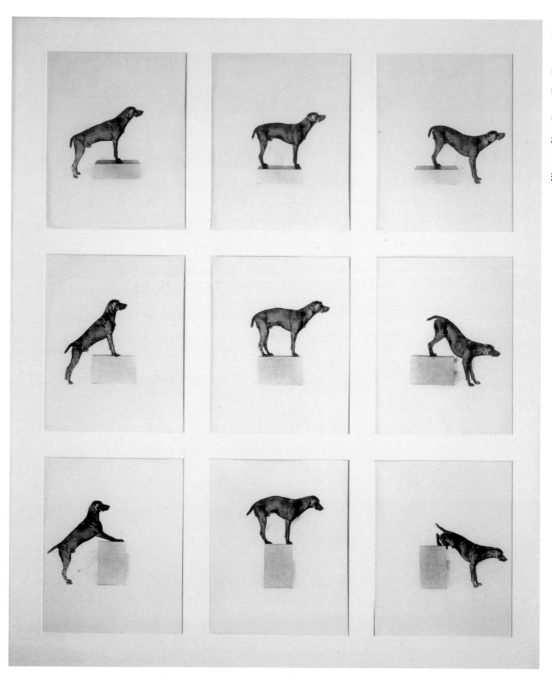

435. Edward Ruscha, *Colored People*, 1972

436. Edward Ruscha, Mason Williams, Patrick Blackwell, *Royal Road Test*, 1967

437. Edward Ruscha, *Various Small Fires and Milk*, 1964

438. Edward Ruscha, *Thirtyfour Parking Lots*, 1967

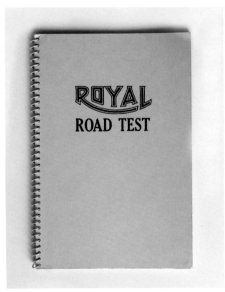

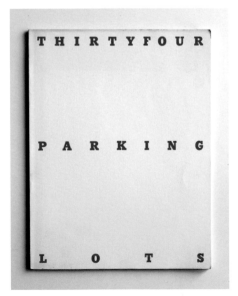

439. Bernd and Hilla Becher

440a. Bernd and Hilla Becher,
*Framework Houses of the
Siegen Industrial Region*, 1977
440b. Bernd and Hilla Becher,
Bern & Hilla Becher, 1973
440c. Bernd and Hilla Becher,
Anonyme Skulpturen, 1970

It never came to the point of deciding: the photographs simply became more important.

As we became more aware of the subject it became more complex. There is so much material that it was obviously more interesting than any interpretation we could supply. We wanted to collect the information in the simplest form to disregard unimportant differences and to give a clearer understanding of the structures. We wanted to provide a viewpoint or rather a grammar for people to understand and compare different structures. This is often impossible in their natural setting.

. . .

The groups of photographs are more about similarities than distinctions. The group is decided by the family to which each image belongs. By looking at the photographs simultaneously, you store the knowledge of an ideal type, which can be used the next time. You see the aspects which remain the same so you understand a little more about the function of the structure. Our selections are obvious but it has taken us many years to realise they are obvious. When you first see a group of cooling towers there are perhaps five different ways to form them into relationships: shape, size, materials, date and area. But as the collection expanded these categories became very crude. Within each group there are the same distinctions and more. It is not our selection that is important but what the structures teach us about themselves.
(1974)

441. Bernd and Hilla Becher,
Water Towers, 1988

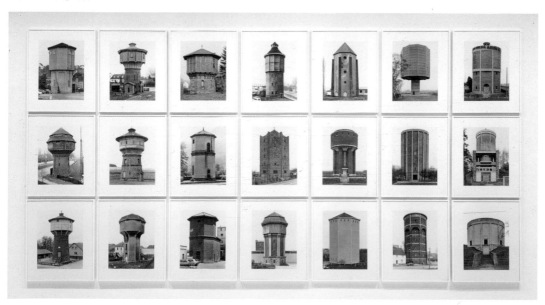

Genesis
primordial space was not economically saturated
abstract space is not economically saturated
the space we live in is economically saturated.
Utopia
subtract the space we live in from economic saturation
debate space and the quality of space in the future.
(1970)

The useless is celebrated with too much creativity.
If creativity is scarce, one is not an artist.
(1972)

443. Mario Merz, *Untitled (Una somma reale è una somma di gente)*, 1972

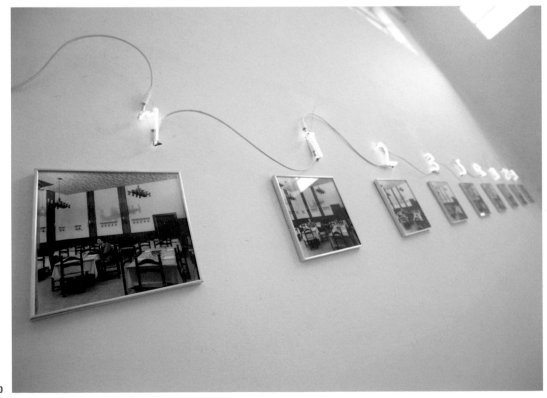

444. Gordon Matta-Clark, *Splitting*, 1974

445. Maurizio Nannucci, *Sessanta verdi naturali*, 1977

446. Hanne Darboven, *Diary N.Y.C. February 15 until March 4 1974*, 1974

447-448. N.E. Thing Co. Ltd., two calendars with photographs for the X Bienal de São Paulo, National Gallery of Canada, 1969

449. Marcel Broodthaers, *Un voyage en Mer du Nord*, Brussels, 1973

450. Maurizio Nannucci, *Poem*, 1968

451a. Hanne Darboven, *1/35*, 1973
451b. Hanne Darboven, *Ausgewählt zitiert und kommentiert*, 1975

452. Richard Tuttle, *Book*, 1974

453a. Ida Applebroog, *A Performance*, 1977

453b. Ida Applebroog, *A Performance: Say Something*, 1977
453c. Ida Applebroog, *A Performance: Sometimes a Person Never Comes Back*, 1977

454. Maurizio Nannucci, *Parole/Mots/Words/Wörter*, 1979

455. Hanne Darboven, *Quartett "88"*, 1990

456. Vito Acconci, *Notes on the Development of a Show*, 1972

457. Vito Acconci
10-Point Plan for Video (1975)

1
Video as an idea, as working method, rather than a specific medium, a particular piece – something to keep in the back of my mind while I'm doing something else. (It can bring me up front, pull me back onto the surface, keep me from slipping away into abstraction.)

2
Thinking of landscape in terms of movie (I'm forced then to treat landscape as dream, myth, history of a culture). Thinking of person, close-up, in terms of video (I'm forced then to treat person as on-the-spot news, convoluted soap-opera).

3
Video monitor as one point in a face-to-face relationship: on-screen, I face the viewer, off-screen. (Since the image is poorly defined, we're forced to depend on sound more than sight: 'intimate distance'.)

4
Starting point: where am I in relation to the viewer – above, below, to the side? Once my position is established, the reasons for that position shape the content: I can improvise, keep talking,

fight to hold my stance in front of the viewer. (At the same time, I'm fighting the neutrality of the medium by pushing myself up against the screen – I'm building an image for myself lest I dissolve into dots, sink back into grayness.)

5
But my image breaks the face-to-face contact: the viewer faces a screen of me, an image under glass, me-in-a-fishbowl. Rather than being in a situation with me, the viewer is in front of a situation about me.

6
In order to keep up my image, I should give up my person. I could be dead – and, therefore, have no recourse but this ghost of myself; or I could simplify myself into a cardboard figure (superior stance: "I'm here to give you information, that's all you need to know, you'll never get me" – or inferior stance: "I'm begging for charity, I'm not good for anything else, take me") – and therefore, give up the need for a changing and equalised relationship.

7
The alternative is to leave out my image, stay behind the scenes. The

458. Vito Acconci, *Pryings*, 1971

459. Vito Acconci, *Theme Song*, 1973

video monitor, then, can function as a middle ground, a depository for objects – an area where I, off-screen on one side, can hand things over to the viewer, off-screen on the other side. The viewer and I can be concerned about the objects while we're with each other. (Since objects are screened to begin with, since they don't talk back, their mode of presence is adaptable to the screen: their image doesn't interfere with our contact.)

8

The catch is: the screen-person might be the normal state – video might be a model for an existent situation, a socio-political ambience that turns people into screens of themselves. (The choice, then, to substitute objects could be a way to refuse that situation, to escape that control.)

9

In any case, my ground is clear: the most available showing places for my work are museums and galleries. To show my face, with the hope that a viewer will come in front of it, is to make a tacit assumption that the gallery provides a fertile ground for relationship: in effect, I'm clouding the economy and social meaning of the gallery (To use the monitor instead as a kind of gift-box, a calling-card, could be a way of saying: let's be sneaky, don't show your hand.)

10

But I've depended too much on the video monitor, needed its physical qualities as impulses for content. It's time to break out. Consider, for example, video projection: the 'punch' of video, the quality of the image coming out at you, is a punch that can be thrown, like throwing a ball – now you don't see it – there it is in the back of your mind – a punch at the back of your hand.

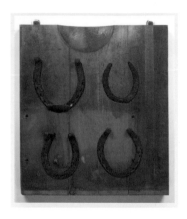

374

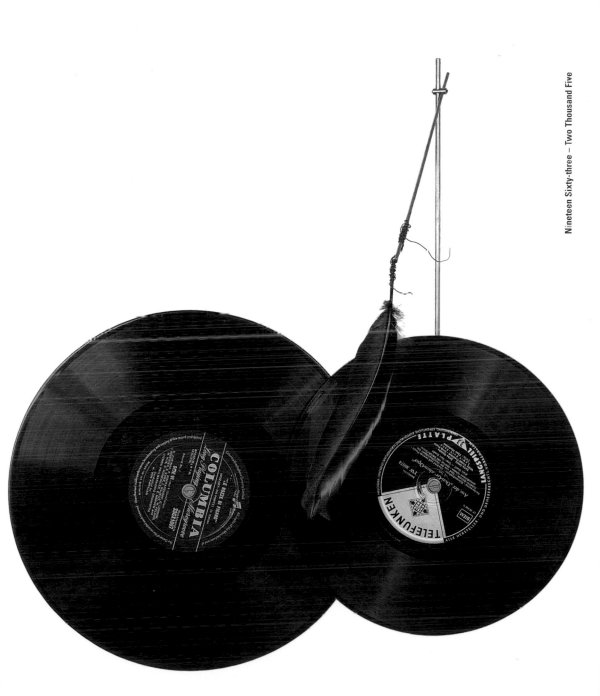

If you consider video installations, the result is rather limited: a very brief attention span that lasts just a few seconds, or a minute at most. Recently, projection times have become reduced as much as possible, down to just a few minutes, while in the 1970s they ran on for hours, like in the works of Vito Acconci and Richard Serra, following in the footsteps of Andy Warhol's films.

In any case, people began to realise that attention is captured by something dramatic, by the representation of something incredibly dangerous or sexual. Counting on a rapid-fire sequence, there's no possibility to relax. The artist should serve as oxygen for society, and bring in a fresh breath of air . . .

I went to one of his concerts where he performed a piece called *Permanent Crescendo*, for electric guitar solos, with an enormous quantity of harmonicas. The sound shook your whole body, made your whole body vibrate. It was an increasingly loud, endless crescendo. After the concert I walked out to the street, in Amsterdam, and there was a huge storm with a lot of thunder and lightning, but I couldn't hear the thunder; after the concert, everything was silent. But it wasn't a good feeling.

Ten years later I went to that Tibetan monastery where they practice harmonic chanting. In order to learn the chants, the monks have to practice for four years. They attach little pieces of fat to the end of a string and they swallow them. Then the string is yanked out, often with some bloody results (the monks spit up blood); the process is repeated until the throat is sufficiently free, and the monks manage to produce some incredibly high and low harmonics. The sounds were incredible, like hearing twenty Glenn Branca concerts at once. But the feeling was different. Why? The difference lies in the fact that Branca creates, but doesn't really know the effect those harmonics have on the body, while the Tibetan monks, thanks to their traditions, know exactly how each single harmonic functions within the body. That's the direction I want to go in. I want to know exactly how magnets, quartz, human hair and pigs blood function, in order to be capable of reaching the right condition or right emotion with mathematical precision.

464. Marina Abramovič, Ulay, *Imponderabilia*, 1977

463. Marina Abramovič, *Sound Enviroment-Sea*, 1972

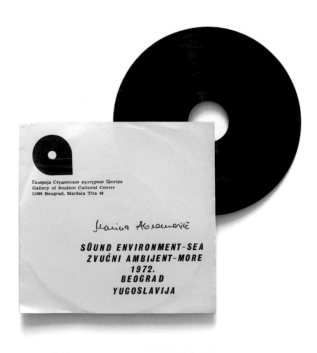

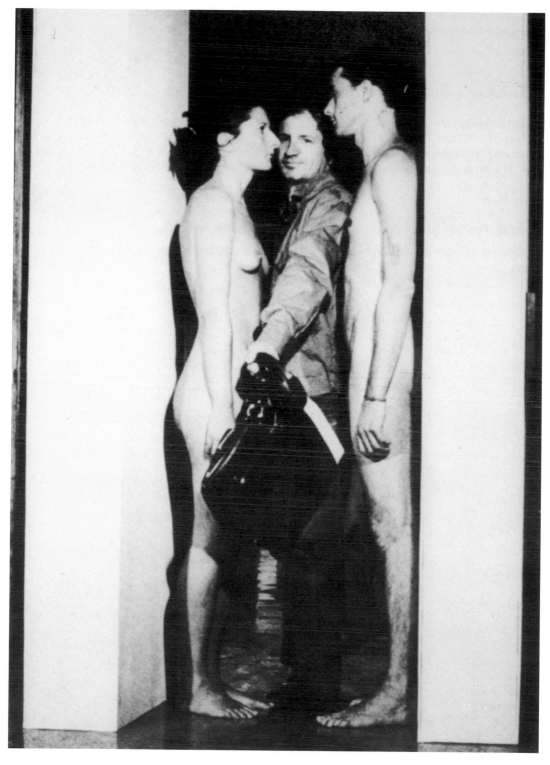

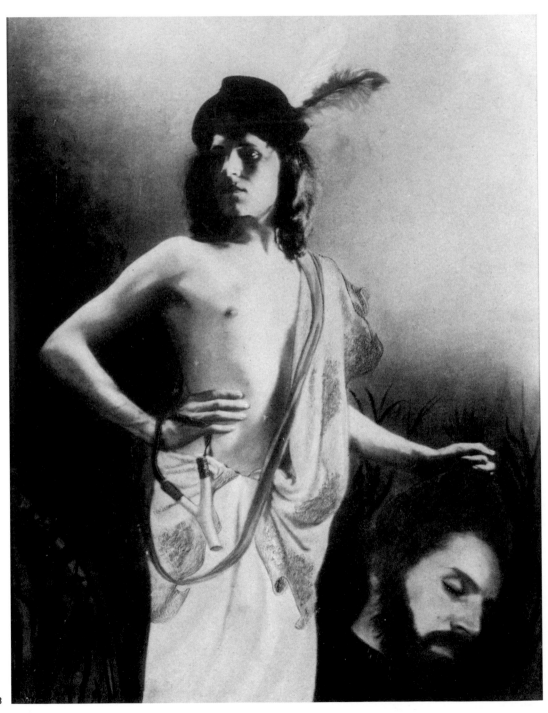

466. Luigi Ontani

467. Luigi Ontani, *Poesiae Adulescentiae*

I chose the tableau vivant in order to differentiate myself, in order not to set forth an excessively performative aspect in art. The image grants me the possibility of isolation, but also of hanging in the balance, in infinite time. In taking the photo in a specific forest, as I recall (*San Sebastiano nel bosco di Calvenzano, d'après Guido Reni*, 1970), In the picture non-picture, and in the return to the picture, although it isn't a picture through such enlargement, in the first shows I proposed my quotations of art. There is an element of excitation and citation that allows me to express both things that have to do with my life-long adventure and relationship to art, as well as other things that are stereotypes of knowledge and forgetfulness, be it Dante or Pinocchio or Bacchus . . .

They're badges, signs, things that are easier to remember but also easier to underestimate.

Although there is an entire history of performances that live out the dynamics of some occurrence – be it gymnastic, or athletic – of a progression 'toward' something, I prefer fixity .

I direct the pose, I set myself up in a pose . . . I immediately imagine that action, which then becomes a photograph, in colour, I can't help but imagine it in colour . . . its drastically conceptual nature is not a part of my personality; I dare to take another perspective – that of a deep love of painting, albeit expressed in a different way.

468. Gilbert & George, *Dark Shadow*, 1974

469a. Gilbert & George, *A Message from the Sculptors*, 1970
469b. Gilbert & George, *To Be with Art Is All We Ask*, 1970
469c. Gilbert & George, *The Pencil on Paper Descriptive Works*, 1970
469d. Gilbert & George, *A Day in the Life of George & Gilbert*, 1971

470. Joan Jonas, *Duet*, 1972

471. Dara Birnbaum,
Technology/Transformation:
Wonder Woman, 1978–1979

472. Peter Campus, *Three*
Transitions, 1973

473. Chris Burden,
Documentation of Selected
Works 1971–1974, 1971–1975

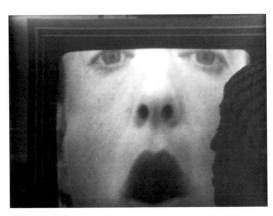

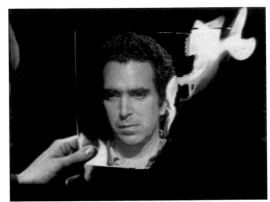

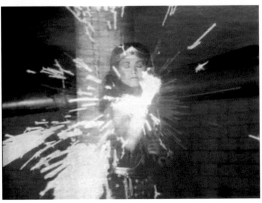

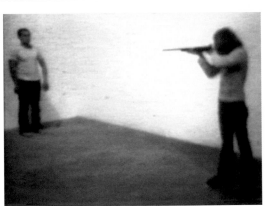

474. Paul Sharits, *Frozen Film Frame: Ray Gun Virus*, 1971 Detail

475. Paul Sharits, *Epileptic Seizure Comparison*, 1976

476. Günter Brus, Hermann Nitsch, Dieter Roth, Gerhard Rühm, Oswald Wiener, *Münchner Konzert Mai 1974*, 1976

477. Hermann Nitsch, *Akustisches Abreaktionsspiel*, 1976

Nineteen Sixty-three – Two Thousand Five

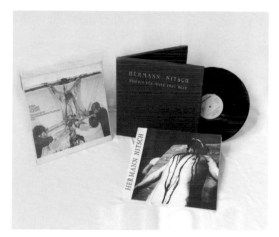

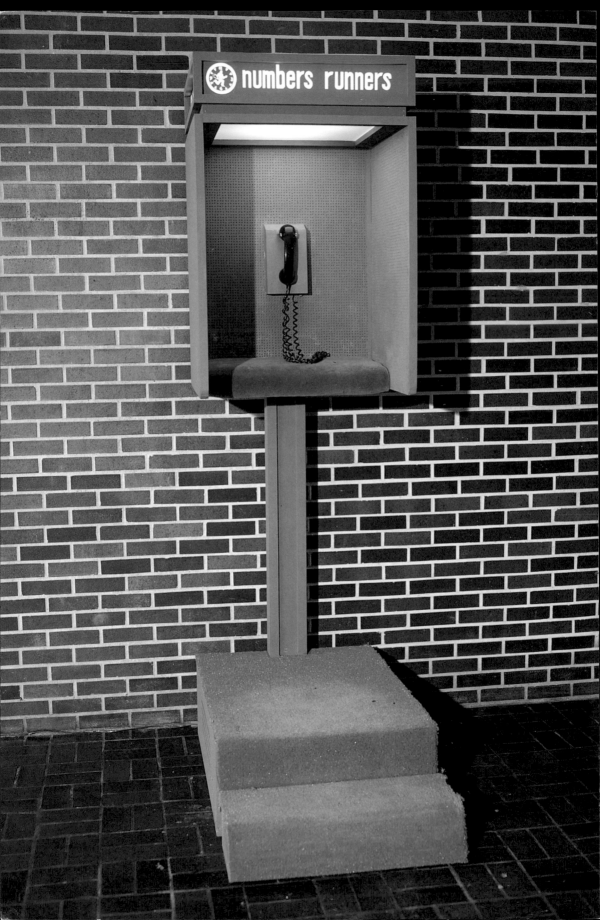

480. Laurie Anderson, *Some Notes on Scoring for Five Songs*, 1975

481. Laurie Anderson, *O Superman*, 1981

For the last thirty years, my main work has been music and performance. I have always combined several art forms. A typical large-scale work will include film or video, animations, digital processing, music, electronics and stories. But it is the stories that are the Constant thread.

The work exhibited in *The Record of the Time* is primarily the work I've done with sound; there are several threads: the violin, the voice, words, sonic spaces and alter egos, I've also included instruments and sounds that I've used in various theatrical performances.

I used this violin in a series called *Duets on Ice* in 1975 in New York City and Genoa. Prerecorded violin pieces were played through a speaker inside the violin. The violin was simultaneously played live. The prerecorded piece was a loop, it didn't have a beginning or an end. I needed a timing mechanism, a way to express duration. So I wore a pair of ice skates with their blades frozen into blocks of ice so that when the ice melted and I lost my balance, the concert was over.

The earliest performances I did were 'film performances' which I showed in 'film festivals' in the early 70s in SoHo.

These 'festivals' were usually a gathering of about ten people in a loft and we'd show each other what we were working on. I was always late to the festivals and I almost never finished editing in time for the show. So I would stand in front of the projection and play the violin and do the mission dialogue. It was like silent movies except with violin instead of piano. But I like this mix of live and prerecorded. To some extent, most of the performances I've done since then have used similar mixes.

I used this instrument for the first time at the Nova Convention in 1978. The needle is mounted in the bow and is lowered onto the record like the tone arm of a record player The record consisted of several bands of violin notes and phrases. For the exhibition we have automated this instrument.

NUMBERS RUNNERS, 1979
An interactive phone booth. The listener picks up the phone and responds to a series of questions. When the listener speaks his voice is recorded and then played back on tape delay. The conversation becomes a duet between questions and answers.

478. Laurie Anderson, *Numbers Runners*, 1979

Because I was amazed by photography, which we all use in such an overwhelming way every day, suddenly I could see it differently, as an image that, without all the conventional criteria I had previously associated with art, transmitted another vision to me. It had neither style, nor composition, nor criterion; it freed me of personal experience. For the first time it was nothing; it was pure image. That is why I wanted to have it, to show it; I didn't want to use it as a medium for a painting, but to employ painting as a medium for photography.

Illusion as a visual trick is not amongst my media, and my pictures do not employ illusionist effects either. Obviously, I don't try to imitate a photo; I want to make a photo. And as I don't care whether photography is understood as a piece of paper exposed to the light, I make photos using other media, not pictures with something of the photo in them. Seen in this way, moreover, the pictures (abstract, etc.) that emerged without photographic models are also photos. I don't distrust reality, which it is obvious I know absolutely nothing about, but the image of reality our senses transmit to us and which is imperfect, limited. Our eyes have evolved to enable us to survive, and the fact that we can also see the stars is pure coincidence. And as this is not enough for us, we do too many things: for example, painting, too, and photography, too, but not in the sense of substituting reality, here, in the sense of tools.

I cannot say anything clearer about reality than my own relation to reality, which has a little to do with the blurred, with insecurity, fleetingness, fragmentariness and other things. However, this does not explain the paintings; it explains, at best, the reason for painting them. The pictures are something different, therefore. For example, they are never blurred. What we consider to be blurred here is inexactitude, and this means difference compared to the object represented. However, since we don't do pictures in order to compare them with reality, they cannot be blurred or inexact or something different (different from what?). How, for example, can the colours on a canvas be blurred? (1972)

483. A.R. Penck, *Kontrabass Solo* (disc 1), *Mini Synthesizer Harmonix* (disc 2), 1980

484a. A.R. Penck, *Ich bin ein Buch kaufe mich jetzt*, 1976
484b. A.R. Penck, *Was ist Standart*, 1970
484c. A.R. Penck, *Ende im Osten*, 1981

485a. Sigmar Polke, *Sigmar Polke*, 1983
485b. Sigmar Polke, *Stenoblock 1970*, 1990

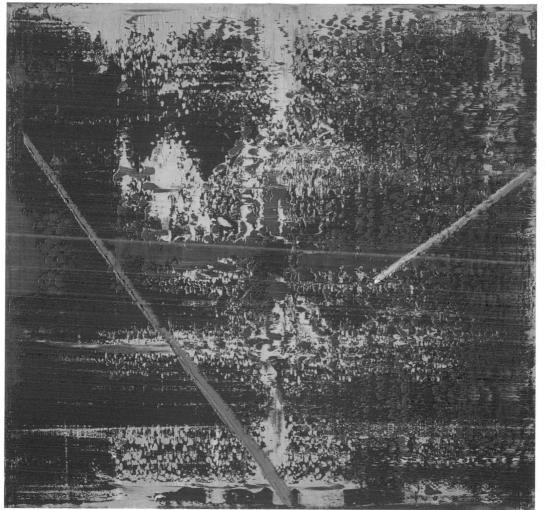

Nineteen Sixty-three – Two Thousand Five

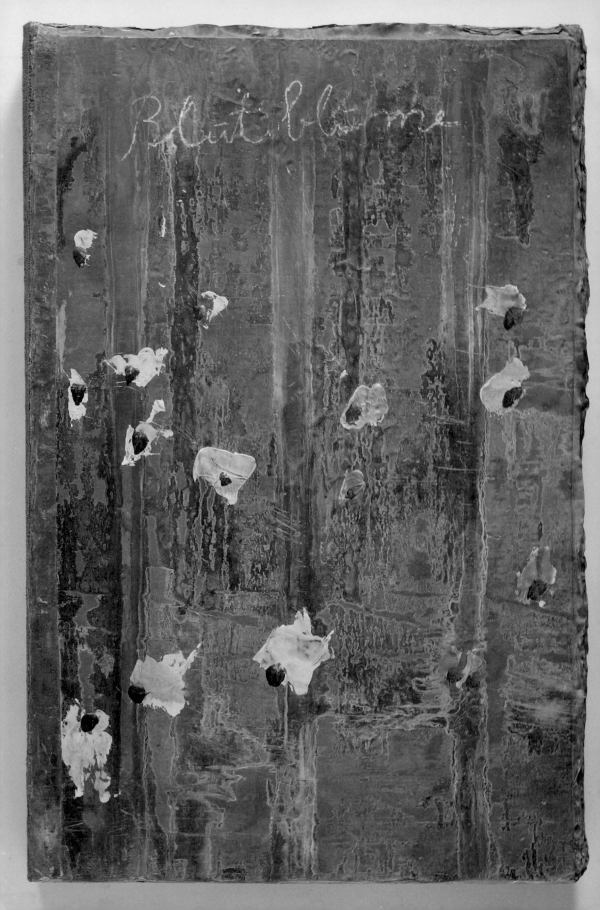

Nineteen Sixty-three – Two Thousand Five

488a. Enzo Cucchi, *Enzo Cucchi. Scultura, 1982-1988*, 1988
488b. Enzo Cucchi, *Manuale di Architettura incorretto e da accrescere*, 1995

489. Enzo Cucchi, *Cucchi 1993*, 1993

490. Enzo Cucchi, *Simm'nervusi*, 1996

491. Enzo Cucchi, *Enzo Cucchi Venti Segni*, 1998

492. Enzo Cucchi, *Enzo Cucchi Catalogo 1993*, 1993

493. Enzo Cucchi, *Enzo Cucchi, 1991*, 1991

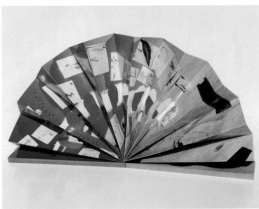

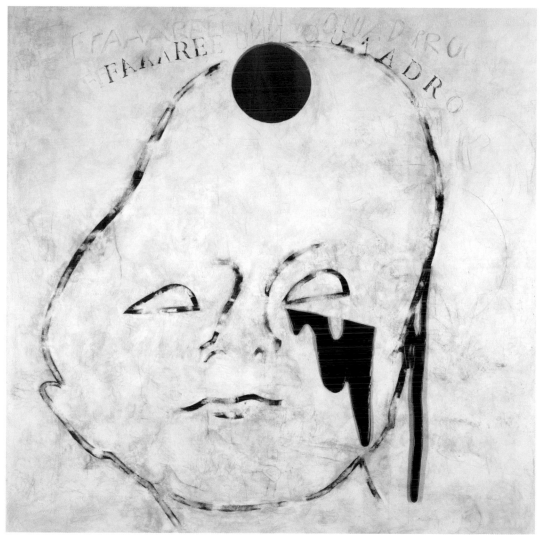

495. Mimmo Paladino, Giovanni
Testori, *Veroniche / I lini della
Veronica*, 1989

496. Francesco Clemente,
The Departure of Argonaut, 1986

497. Francesco Clemente, *Undae
Clemente Flaminia Pulsae*, 1978

498. Sandro Chia, *Pietra*, 1972

499-500. Nicola De Maria,
Tu contieni molti baci, 1985

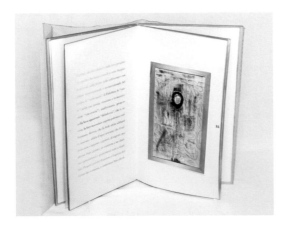

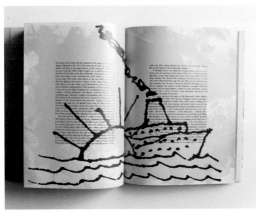

501. Julian Schnabel

502. Julian Schnabel giving a lecture at the Cuban Film School, with the poster of his film *Basquiat* (1996), during the Havana Film Festival

When I did the plate paintings I wanted to break the surface of the paintings and I like the dissonance between the brightness of the plates and the other parts of the picture.
(1991)

I think I use photographs in my drawings almost as if there were a mirror. I use them as a non-image . . . They are like a blind spot.
(1992)

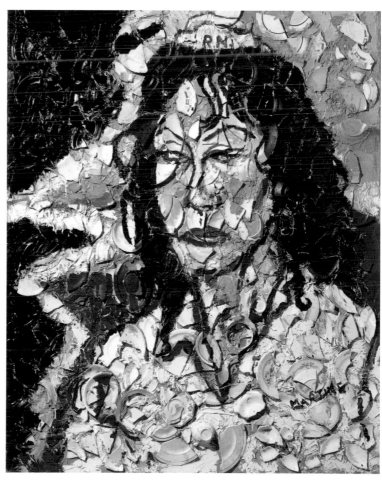

503. Julian Schnabel, *Martine*, 1987

Emotions aroused by human stupidity have given us a richer ingredient. We've had little direction but who needed it? We figured the death tolls weren't about to miss us, so we looked at magazines, bought records and went to the movies. All these sources provided distortion. We thought about building tanks from spare parts and then 'show up' in them. We especially liked TV because if we were going to stare out the window and go to another planet we wanted a good guide. We found the reality that was 'set ahead' on TV programmes gave us a sense of anticipation. Our expectations were satisfied when we turned our programmes on. We knew they'd never try to evolve a set of values to correspond to a higher intensive purpose. As far as the programmes' characters were concerned the lack of psychological estimate was never missed. Fathers were never religious mystics. Mothers didn't appear to love the flesh. Kids believed the primary interval at school was summer. Nobody's thoughts were ordered into paragraphs. Nobody's spirit was infused into dead matter. The programmes left it up to us. Their possibilities seemed real. Their intrinsic sense implied that nothing important has yet been seen or known or said. (1981)

505. Richard Prince, *War Picture*, 1980

506. Richard Prince,
*Four Women With Their Backs
to the Camera,* 1980

Nineteen Sixty-three – Two Thousand Five

Some people have told they remember the movie that one of my images is derived from, but in fact I had no film in mind at all.

In horror stories or in fairy tales, the fascination with the morbid is also, at least for me, a way to prepare for the unthinkable . . . That's why it's very important for me to show the artificiality of it all, because the real horrors of the world are unmatchable, and they're too profound. It's much easier to absorb – to be entertained by it, but also to let it affect you psychologically – if it's done in a fake, humorous, artificial way. (1996)

508. Cindy Sherman, *Untitled #91*, 1981

509. Sam Taylor-Wood,
Soliloquy II, 1998

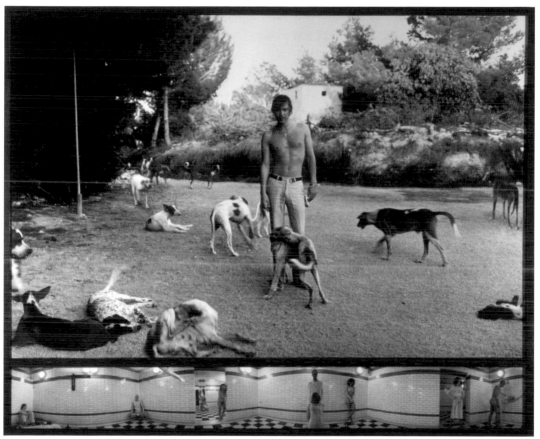

510a. Jack Goldstein, *Two Fencers*, 1977
510b. Jack Goldstein, *The Murder*, 1977
510c–k. Jack Goldstein, suite of nine titles, 1977

511. Roni Horn, three books from the series *Ísland*, slipcase from the same series containing two other volumes of *Ísland*

512. Glenn Branca, *The Ascension*, Cover design by Robert Longo, 1981

513. Barbara Kruger, Stephen King, *My Pretty Pony*, 1988

514. Roni Horn, *This is Me, This is You*, 2002

515. Michael Snow, John Oswald, Paul Dutton, Christian Marclay, 2002

516. Robert Longo,
Men in the Cities, 1980-2000

517. Robert Longo,
Arena Brains, 1988

518. Robert Longo, *Empire,*
1981, 1981
Performance at the Corcoran
Gallery of Art, Washington, D.C.

519. Shirin Neshat, *Seeking Martyrdom, Variation n. 1*, 1995

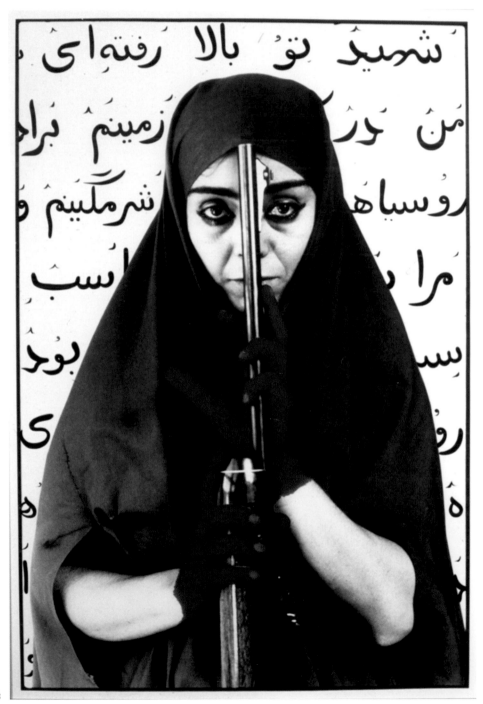

520. Christian Marclay

521. Christian Marclay,
Guitar Drag, 2006

522. Christian Marclay,
Dj Trio, 2004

I've never identified with serious music – contemporary classical music or whatever – because it's a language I can't express myself in. I can't read or write music. The first thing that had a creative impact on me was not this kind of music, though Cage and Fluxus were influential. It was the Sex Pistols and DNA – the really raw energy of punk. It was more than just music; it was very physical. It's not music that translates well on recordings, because being there, the loudness, being part of the event and the performance was really important. I was more interested in the process.

. . .

Recording technology has turned music into an object, and a lot of my work is about that object as much as it's about the music. The ephemeral and immaterial vibrations that make music have become tangible objects – records, tapes, CDs. This transmutation is very interesting to me. One doesn't necessary think of music as a physical reality, but it has physical manifestations. It can also be an illustration, a painting, a drawing. In a performance you have the visual presence of someone producing sound. In my work I'm constantly dealing with the contradiction between the material reality of the object as a thing and its potential immateriality. In a way immateriality is the perfect state; it's the natural outcome of the ephemeral. In music this aspect of immateriality is very liberating. Ideally I'd like to make art that's invisible.

. . .

In the future, recording – the frozen music of the past – will be replaced by 'live' music again. Digital music suggests the beginning of a more fluid music, an interactive and improvised music, resembling an on-line conversation. Instead of listening passively to a finite, self-contained recording, one will become an active participant in selecting, editing, sampling, looping – transforming the music in unimaginable ways. This real-time jam on the Internet will be more akin to earlier music, before the appearance of the frigid recordings. The music of the future will be constantly manipulated, always evolving, an unstable flow of sounds, never the same twice. This music will be ephemeral again, free of permanent recordings, free of marketing devices. Information will be liberating rather than controlling. I don't believe that computers will control us, but rather create such a huge fluid network that it will escape control, regulation and recording.

. . .

There is an implied violence in photography because of its cropping quality. Photography is about stealing, displacing, chopping up. The camera is a sharp weapon. I like sound recording, photography is a mechanical device that tries to simulate life. The recording and the photograph, both incomplete reproductions of nature, come together as record/album to reinforce each other in their illusion.

. . .

As the analogue phonograph record is being outmoded by the digital Compact Disc, it is an appropriate time to look back on this object that has captured the sound of almost a century for (a relative) posterity. The record medium has changed the musical message. The commodification of music has transformed the very nature of music and its role in our society, altering our relationship to musical works, performances and tradition. As a result, there is a strange perversity in the relation between a recording and the original sound; the recording seems to precede the music, as our acoustic world is more simulated by simulation. Music, one of our most elusive arts, is now available in endless reproduction. Mass production and distribution have engulfed our live-music culture almost completely, leaving us in a solitary relationship to a material object. The distance between live and recorded music is a separation of time and space, an alienation from the original participatory experience of music.
(1992)

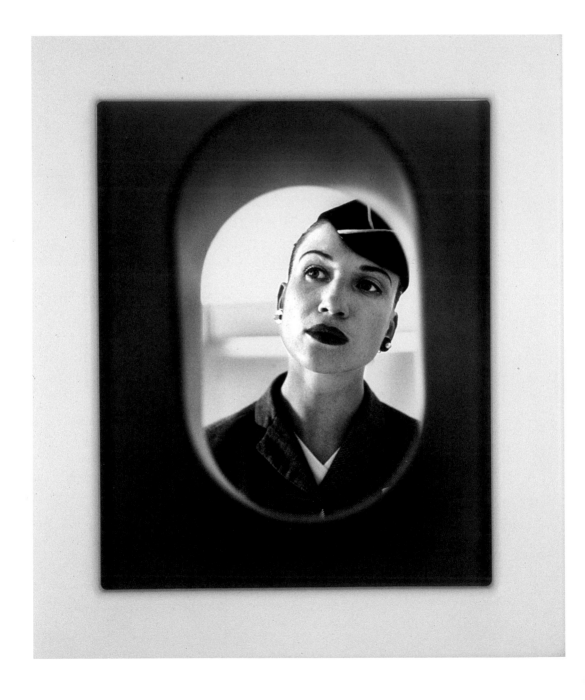

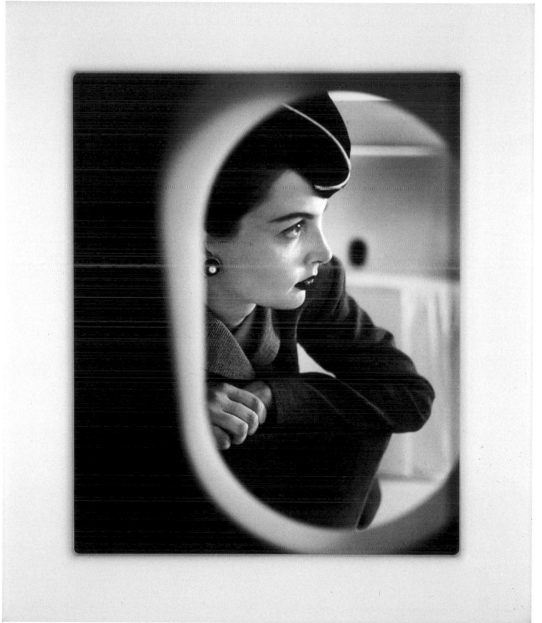

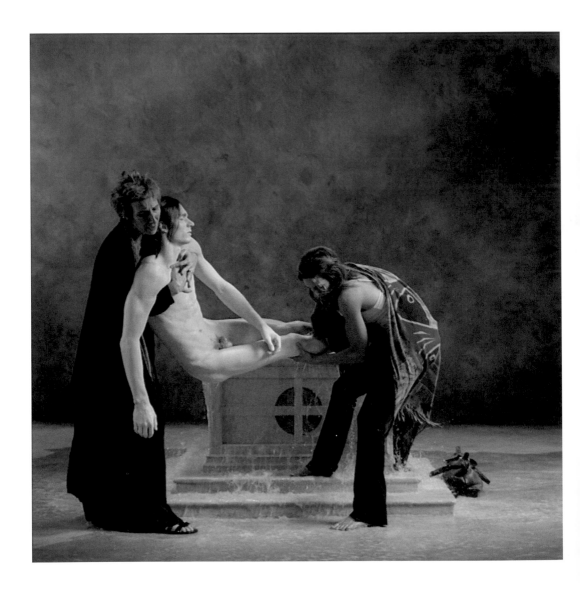

It was only toward the end of the 1960s that these attempts to imitate film were interrupted, when artists began to look more curiously below the surface, to uncover the fundamental characteristics of the medium and free the visual potential – unique for the genre – of the electronic image, which are today taken for granted, with a yawn and often a smirk, like the daily bread TV offers us. The video interrupter was designed within the first video synthesiser. Its principles were both acoustic and musical, a further evolution of the earliest electronic music systems, like the Moog synthesiser. The video camera was then the final link in the chain to be developed, a full decade after the invention of television, and it was fully integrated into the system of video editing only with the introduction of the time base corrector in the early 1970s. With the seamless incorporation of recorded material into the flow of images and the progress made in electronic editing, it became necessary to specifically identify long-distance transmissions as "live" broadcasts. Not only did video begin to act and resemble film, but it also began to resemble and act like anything else: fashion, a conversation, politics, visual arts, music.

Synaesthesia is the natural inclination of the structure of contemporary media. The material that generates music from stereo equipment, or transmits a voice over the telephone and materialises the image on a television, is basically the same. The efforts made in artificial technology have created the need for a distinction between synaesthesia as theory and as an artistic practice, and synaesthesia understood as a genuine subjective ability or an involuntary condition in certain individuals. We all naturally link sound and image. The beauty of these experiences lies in the fluid language of each personal image and its ties to the mood and situation of a given moment. As long as their individual subjective nature is understood, they will never become conventional, and so the boredom of dogma and the private theorisations of each practitioner will be avoided, for both visual musicians and musical video artists.
(1993)

Nineteen Sixty-three – Two Thousand Five

526. Thomas Hirschhorn, *Les documents
– Deleuze Monument: La Beauté Avignon
2000*, 2000

527. Pierre Huyghe, Philippe Parreno,
No Ghost Just a Shell, 2003

528. Kara Walker, *Freedom–A Fable*, 1997

529. Thomas Hirschhorn, *Material:
Public Works—The Bridge 2000*, 2000

530. Tom Friedman, *Ream*, 2006

531a. Tom Sachs, *Haute Bricolage*, 1999
531b. Tom Sachs, *White*, 2001
531c. Tom Sachs, *The Failure of Sony
Outsider and Its Triumphs*, 2003

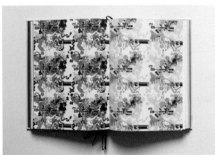

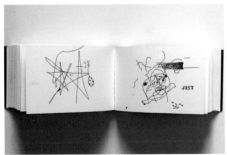

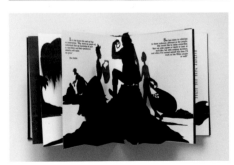

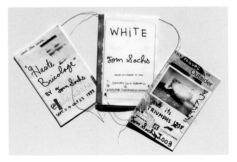

Two Thousand Seven

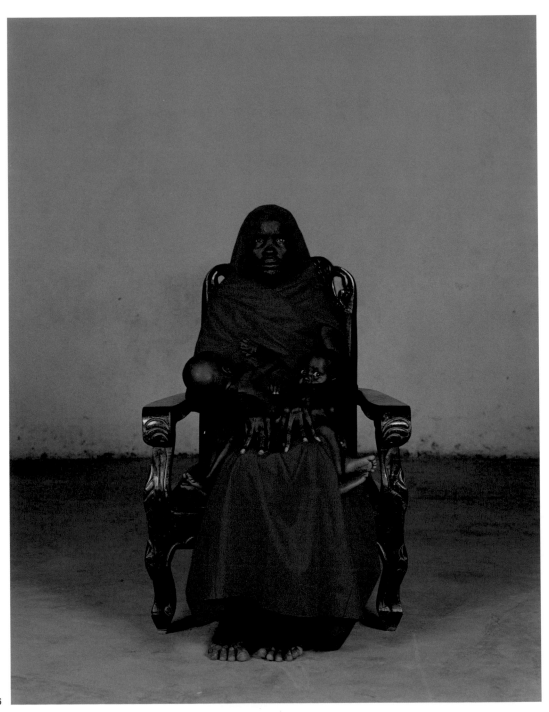

554. Vanessa Beecroft, *VBSS 002 MP'', White Madonna with Twins*, 2006

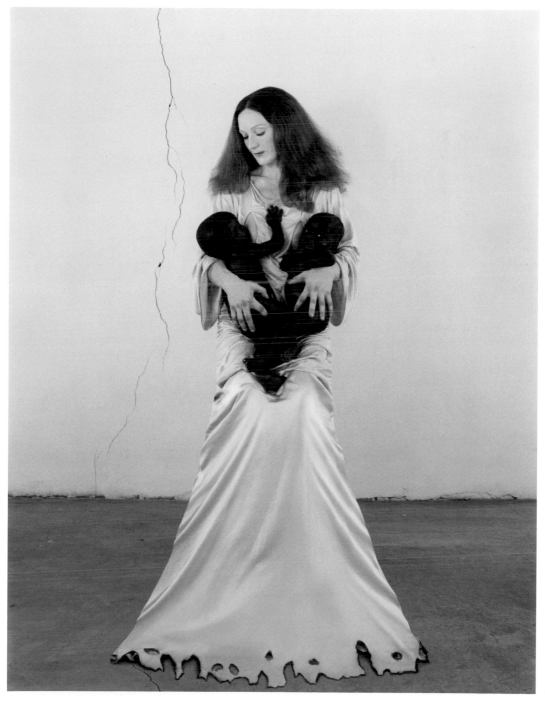

555. Gregory Crewdson, *Untitled*
(Beneath the Roses), 2003

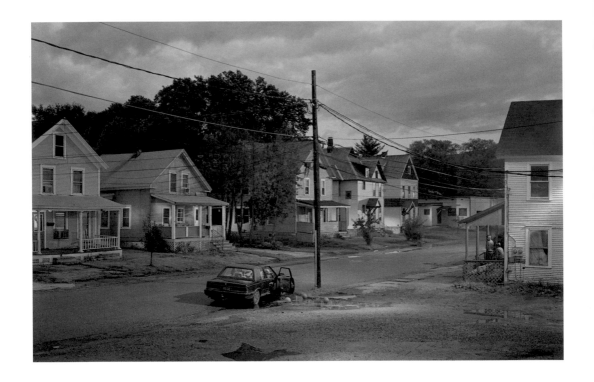

556. Gregory Crewdson, *Untitled*
(Beneath the Roses), 2005

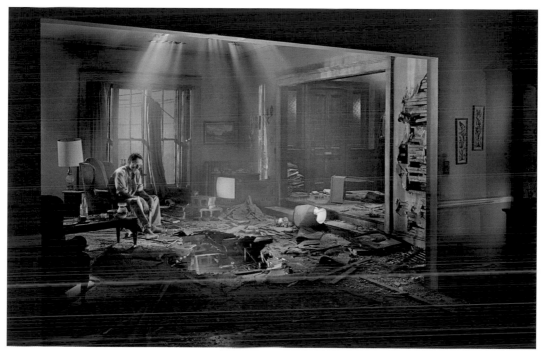

557. Yang Fudong, *Honey*, 2003 558. Yang Fudong, *No Snow on the Broken Bridge*, 2006

560. Andreas Gursky,
May Day IV, 2000

562. Thomas Hirschhorn,
The Green Coffin, 2006

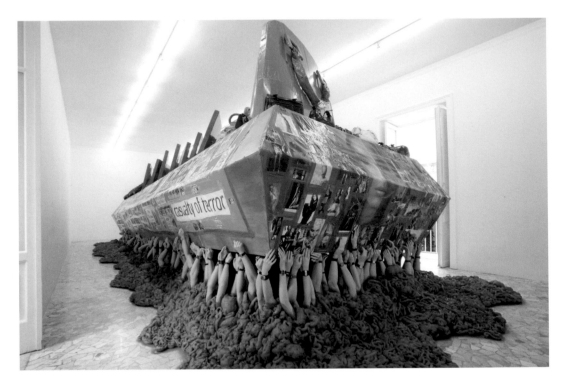

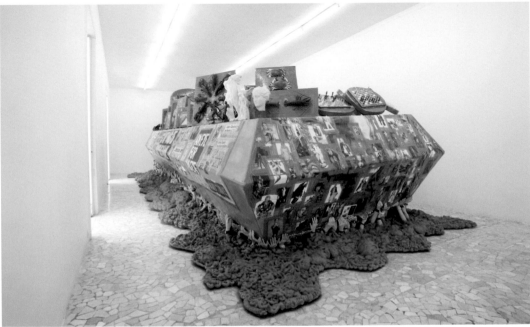

565-569. Matt Mullican, *Untitled*, 2001

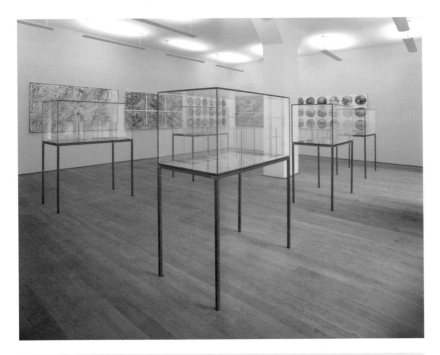

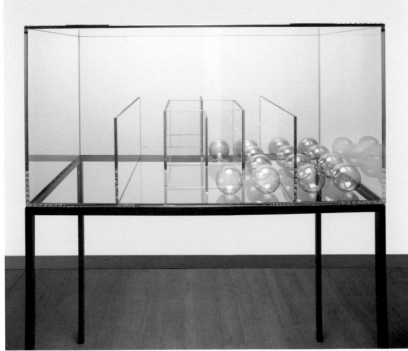

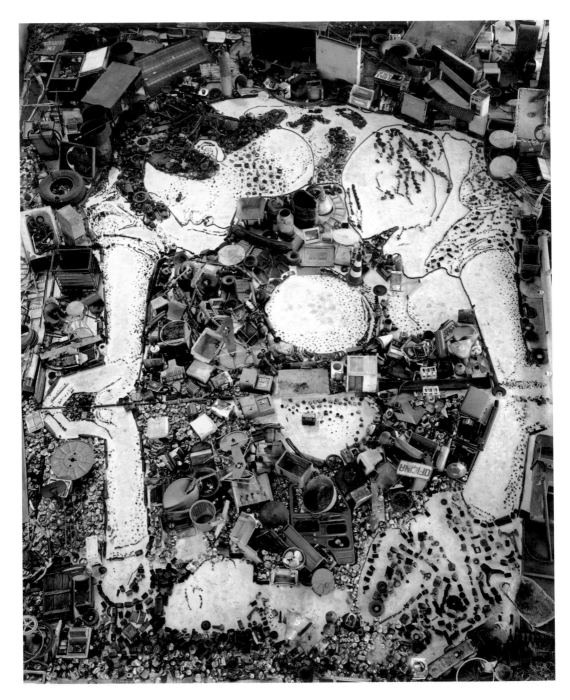

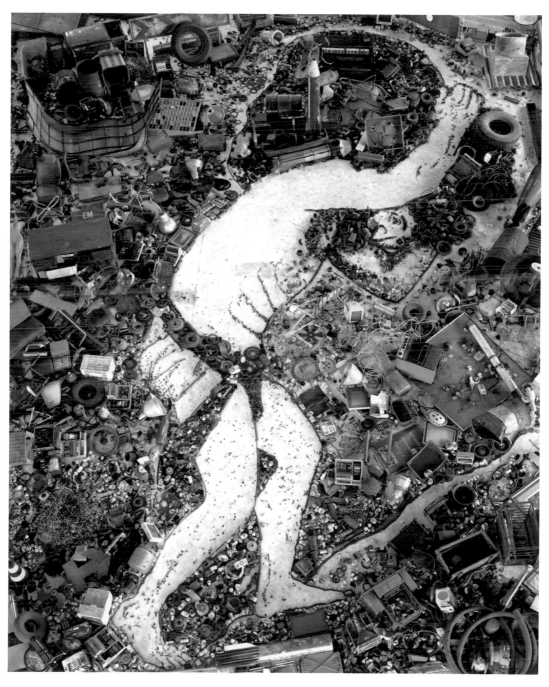

575. Thomas Ruff, *JPG RN01*, 2005 576. Thomas Ruff, *mdpn01*, 2002

577. Thomas Ruff, *mdpn32*, 2003

578. Thomas Ruff, *mdpn02*, 2002

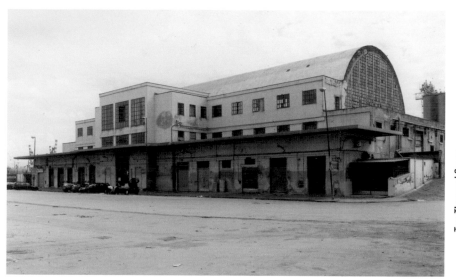

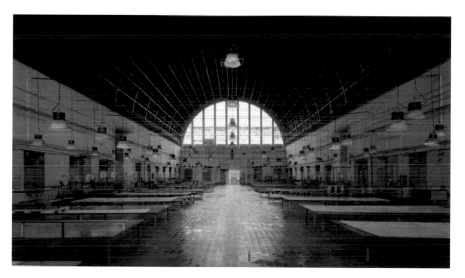

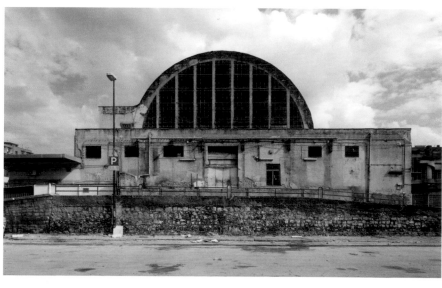

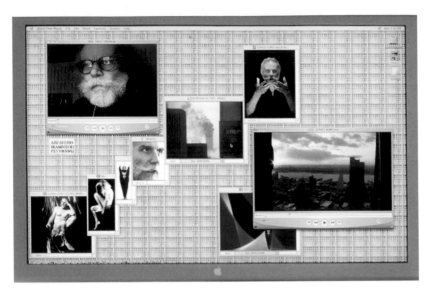

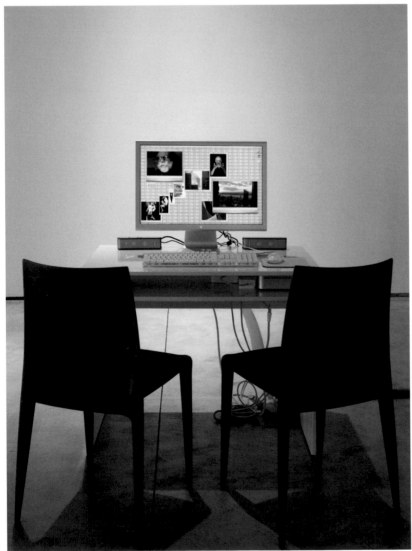

581. Thomas Struth, *Shibuya Crossing, Tokyo (Shibuya-Ku)*, 1991

Following pages
582. Grazia Toderi, *Rosso Babele*, 2006

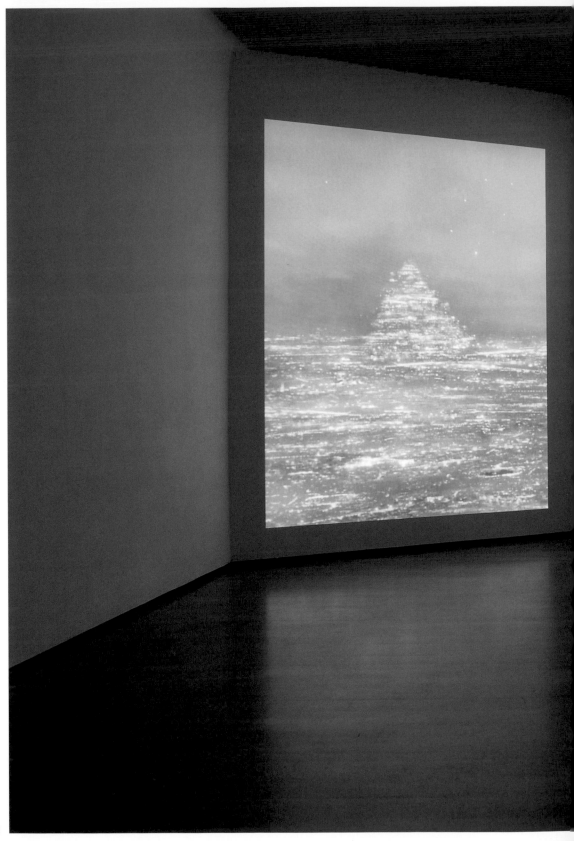

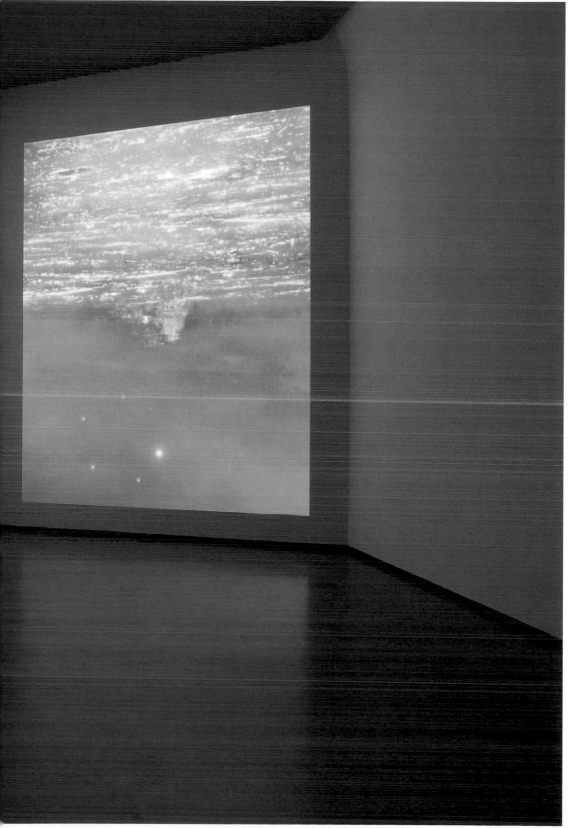

583. Francesco Vezzoli, *The Bruce Nauman Trilogy*, 2004–2006

584. Krzysztof Wodiczko,
The Hiroshima Projection, 1999

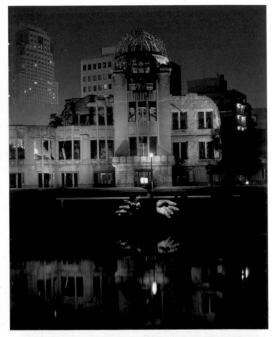
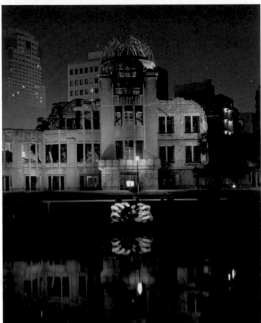
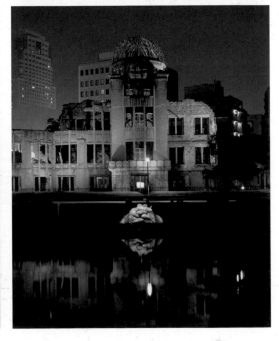

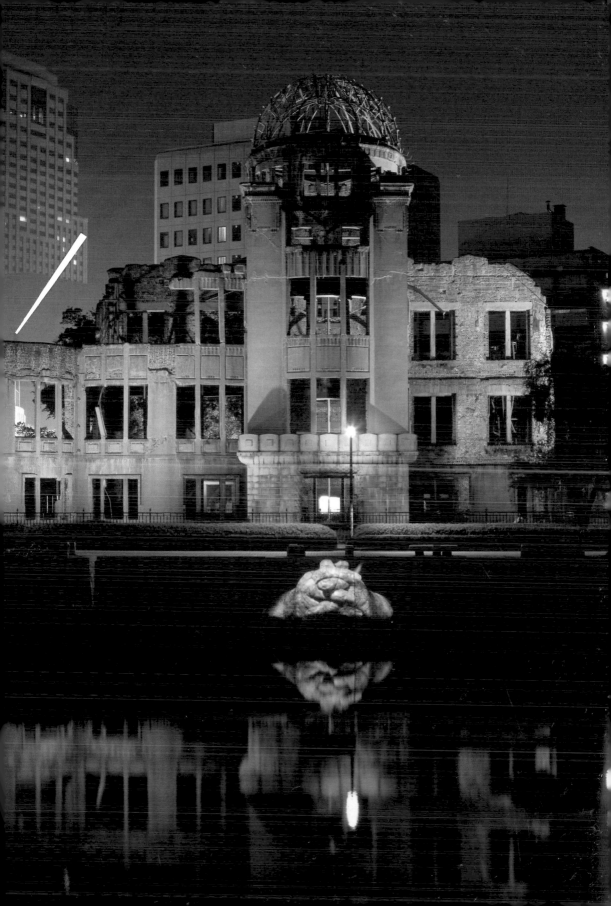

532a. Marco Bagnoli, *Clarore
Cinereo Lunare*, 1992
532b. Marco Bagnoli, *Spazio
x Tempo*, 1989

533. Tadashi Kawamata, *How
to Build Kawamata*, 1993

534. Remo Salvadori, *Ottava*, 1989

535. Stefano Arienti, *Untitled*, 1993

536. Thomas Schütte,
Aufzeichnungen aus der 2. Reihe,
1991

537. Ilya Kabakov, Emilia Kabakov,
*The Palace of Projects Kokerei
Zollverein Essen*, 2001

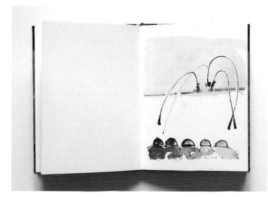

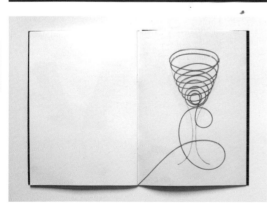

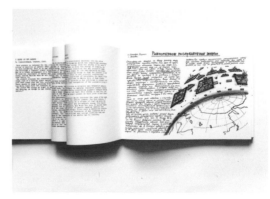

I make landscapes, or cityscapes as the case may be, to study the process of settlement as well as to work out for myself what the kind of picture (or photograph) we call a 'landscape' is. This permits me also to recognise the other kinds of picture with which it has necessary connections, or the other genres that a landscape might conceal within itself.

Plato, in *The Statesman* wrote: "We must suppose that the great and the small exist and are discerned not only relative to one another, but there must also be another comparison of them with the mean or ideal standard. For if we assume the greater to exist only in relation to the less, there will never be any comparison of either with the mean. Would not this doctrine be the ruin of all the arts? For all the arts are on the watch against excess and defect, not as unrealities, but as real evils, and the excellence of beauty of every work of art is due to this observance of measure."

This fundamental criterion of idealist, rationalist aesthetics – that of the harmonious and indwelling mean of normative abstract standard – remains important in the study of development in the conditions of capitalist – or anti-capitalist – modernity. But it is important as a negative moment because the most striking feature of historical, social and cultural development in modernity is its unevenness.

Contemporary cultural discourse, which prides itself on its rigorous critique of idealism, has almost invalidated the idea of the harmonious mean, characterising it as a phantom of rationalism. At the same time, the survival of the concept of measure, as the universal standard of value in the exchange of commodities, implies that measure is for us not a moment of transcendental revelation and resolution, but one of inner conflict and contestation – the contestation over surplus value, which implicates and binds all of us. From this immanently negative and antagonistic perspective, development can only be overdevelopment (aggravated development) or underdevelopment (hindered, unrealised development). Translating these opposites into stylistic terms, we could see overdevelopment as a sort of mannerist – baroque phenomenon of hypertrophy and exaggeration – a sort of typical postmodern 'cyberspace'. Underdevelopment suggests a poetics of inconclusiveness, filled with a secessionist rural pathos. But the 'Arte Povera' of underdevelopment is no less malformed than its opposite; both are formed by an antagonistic or alienated relation to the concept of measure, and their unity around this concept is a threshold between aesthetic thought and political economy. So, one way of approaching the problem of the 'politics of representation' is to study the evolution of a picture as it works itself out in relation to the acts of measuring which constitute its very form. (For example, in the Academic tradition the relation between the shorter and longer sides of a pictorial rectangle were subject to prescriptive harmonic interpretation.)

In classicism the work of art is made by imagining the picture's or statue's subject as perfectly harmonious in its internal proportions, and then depicting that subject in a composition, and on a rectangle, both of which are equally well measured. That is, both are exercises in harmonics. The measure and proportions of the picture themselves imply, and reflect, the serenity of ideal social relations. Baroque aesthetics expressed both this Poussinian form and others – for example, that which we may identify with Breugel's sixteenth-century 'anticipatory baroque' – oddly, complexly balanced compositions filled with bumpy, ragged, rough forms, simultaneously regular and irregular, hectic, complicated, carnivalesque and fractalised. It's inconvenient to suggest (after Bakhtin) that Breugel's grotesque, or the movement toward it, is the 'true' modern one, the one in which the negativity of modern measure, the non-identity of the phenomenon with itself, the

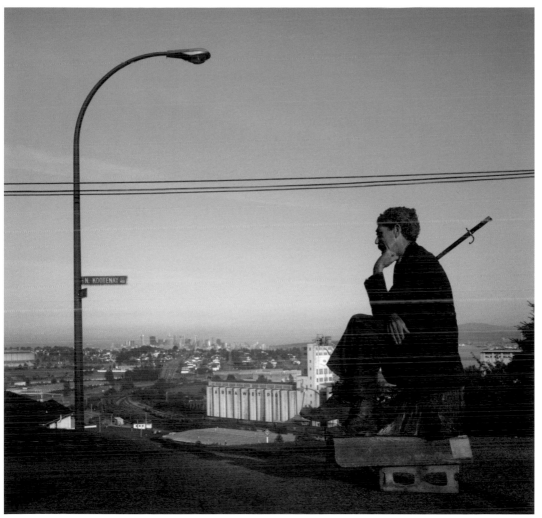

intangibility of meaning, is best made visible. I prefer to evade the polarisation implicit in such a conclusion. The negative moment of measure may also be formulated as an excess of measure, in the manner of caricature. Harmony may therefore be thought of as a special, even a 'sovereign', instance of the grotesque.

However that may be, we could anyway say that in a modern type of picture there will tend to be a distinction, or disparity (if not an open conflict) between the over- or underdevelopment of the motif or phenomenon pictured, and the still successfully measured and harmonious nature of the picture itself. The experience of the tension between form and content records and expresses mimetically something of our social experience of tormented development, that which is not achieved or realised, or that which, in being realised, is ruined – and also all

the unresolved grey areas in between, where hope and alternatives reside. Studying settlement forms is therefore not separable from working out picture-types; it's not possible to do the former without doing the latter. A successful picture is a source of pleasure, and I believe that it is the pleasure experienced in art that makes possible any critical reflection about its subject-matter or its form. That pleasure is a phantom affirmative moment, in which the pattern of development of settlements is experienced as if people didn't really suffer from it. My landscape work has also been a way to reflect on internal structural problems in other types of pictures. In doing that, it's been possible to rethink, for myself, some rather obvious and conventional things about the genre of landscape as a genre.

Most evidently, a picture tends toward the generic category of landscape as our physical viewpoint moves further away from its primary motifs. I cannot resist seeing in this something analogous to the gesture of leave-taking, or, alternatively, of approach or encounter. This may be why a picture of a cemetery is, theoretically at least, the 'perfect' type of landscape. The inevitably approaching, yet unapproachable, phenomenon of death, the necessity of leaving behind those who have passed away, is the most striking dramatic analogue for the distant – but not too distant – viewing position identified as 'typical' of the landscape. We cannot get too distant from the graveyard.

So, we could reason that the peculiar or specific viewing distance at which the picture-type 'landscape' crystallises is an example of a threshold-phenomenon or a liminal state. It is a moment of passage, filled with energy, yearning and contradiction, which long ago was stabilised as an emblem, an emblem of a 'decisive moment' of vision or experience, and of course of social relationships, too.

In making a landscape we must withdraw a *certain distance* – far enough to detach ourselves from the immediate presence of other people (figures), but not so far as to lose the ability to distinguish them as agents in a social space. Or, more accurately, it is just at the point where we begin to lose sight of the figures as agents that landscape crystallises as a genre. In practical terms, we have to calculate certain quantities and distances in order to be in a position to formulate an image of this

type, especially in photography, with its spherical optics and precise focal lengths.

I recognise the 'humanist' bias in this construction, and the recurrence of the idealist notion of measure in it, but I think it's valid as a way of thinking analytically about the typology of pictures, which, unlike some other art forms, are radically devoted to the semblances of the human being. This is just one of the senses in which we have not got 'beyond' idealist aesthetics.

To me, then, landscape as a genre is involved with making visible the distances we must maintain between ourselves in order that we may recognise each other for what, under constantly varying conditions, we appear to be. It is only at a certain distance (and from a certain angle) that we can recognise the character of the communal life of the individual – or the communal reality of those who appear so convincingly under other conditions to be individuals.

Modernist social and cultural critiques and theory have concentrated on revealing the social semblance, the social mask, of liberal idealism's most important phantom, the 'subject', sovereign, individuated and free. What has been at stake is the visibility of the determinations which, insofar as they are repressed in or as social experience, make possible the appearance of this 'ideological ghost', this creature of 'second nature'. If that were to be an artist's intention, it could probably be realised entirely through a self-reflexive approach to a 'humanist' typology of landscape as I've outlined it. In modernity's landscapes, figures, beings or persons are made visible as they vanish into their determinations, or emerge from them – or more likely, as they are recognised in the moment of doing both simultaneously. Thus they are recognised as both free and unfree; or possibly misrecognised, first as unfree, then as free and so on. Another way of putting this is that, in a landscape, persons are depicted on the point of vanishing into and/or emerging from their property. I think this phenomenology is analogous to, or mimetic of real social experience, extra-pictorial experience. The liminal condition of landscape has been for me a sort of measure, or mean. I have been trying to reflect on, and study other constructs, other picture-types which I feel have in some important senses crystallised out of landscape.

540. Tony Oursler, *Model Release, Par-Schizoid-Position, and Test*, 1992

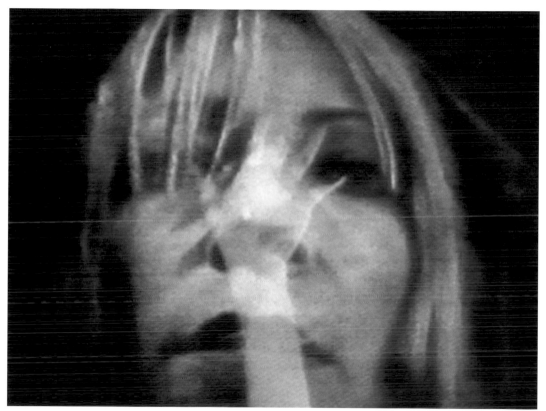

541. Damien Hirst, *The Beautiful Afterlife*, 1997

542. Paul McCarthy, *Propo*, 1999

543. Paul McCarthy, Mike Kelley, *Heidi*, 1992

544. Mike Kelley, Paul McCarthy, *Fresh Acconci*, 1995

PROPO

Paul McCarthy

CHARTA

545a. Maurizio Cattelan,
Paola Manfrin, *Permanent Food:
A Magazine about Magazines*
545b. Maurizio Cattelan,
Paola Manfrin, *Permanent Food:
A Magazine about Magazines*

546a–d. Hanne Darboven, CD
from the Requiem series,
2003–2005

547. Sür Drone, *Untitled*, 1998
Cover by Raymond Pettibon

548. Stan Douglas, *Suspiria*
Music by John Medeski and
Scott Harding

549. Pipilotti Rist, *The Cake Is in
Flames*, 2002

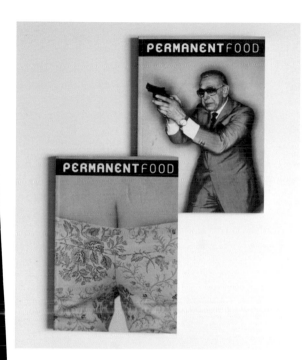

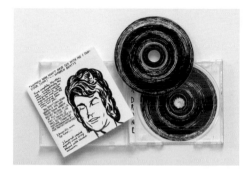

Stone-age Film-making
The technique I employ to make these films is very primitive.
Traditional animation uses thousands of different drawings filmed in succession to make the film. This generally means that a team of animators have to work on it, and flowing from this, it means that the film has to be worked out fully in advance. Key images are drawn by the main animator and in-between stages are completed by subordinate draughtsmen.
Still other people do inking and colouring. The technique I use is to have a sheet of paper stuck up on the studio wall and, half-way across the room, my camera, usually an old Bolex.
A drawing is started on the paper, I walk across to the camera, shoot one or two frames, walk back to the paper, change the drawing (marginally), walk back to the camera, walk back to the paper, to the camera, and so on. So that each *sequence* as opposed to each *frame* of the film is a single drawing. In all there may be twenty drawings to a film rather than the thousands one expects. It is more like making a drawing than making a film

(albeit a grey, battered and rubbed about drawing). Once the film in the camera is processed, the completion of the film, editing, adding sound, music and so on proceeds like any other.

What the Technique Allows
As I mentioned, I started filming drawings as a way of recording their histories. Often I found – I find – that a drawing that starts well, or with some interest in its first impulse, becomes too cautious, too overworked, too tame, as the work progresses. (The ways in which a drawing can die on you are depressingly numerous.)
A film of the drawing holds each moment. And of course, often, as a drawing proceeds, interest shifts from what was originally central to something that initially appeared incidental. Filming enables me to follow this process of vision and revision as it happens. This erasing of charcoal, an imperfect activity, always leaves a grey smudge on the paper. So filming not only records the changes in the drawing but reveals, too, the history of those changes, as each erasure leaves a snail-trail of what has been . . .

551-552. William Kentridge, *Drawing from Venice Biennale Project*, 2005